Beth —
The part[y] [...] [...]g!
Happy Graduation
and then some —
Warmest regards,
Toby

5/26/77

THE PARTY'S OVER NOW

By the same author

The New Bohemia
Close-Up
The Private World of
Leonard Bernstein

THE PARTY'S
OVER NOW

Reminiscences of the Fifties—New York's

Artists, Writers, Musicians, and their Friends

JOHN GRUEN

The Viking Press

NEW YORK

Again, for Jane

THE PARTY'S OVER NOW

1

The welter of detail that is one's own life assumes a clearer design as one recalls its continuity. One tries to conjure up a sequence which would give events the clarity they must surely have lacked as they occurred. The whole process of recollection is itself fraught with confusion. Thoughts spill out, forming a vertiginous tumble of faces, places, and things. Feelings surface, collide, and fragment, like a series of mirrors shattered upon the ground of one's memory.

It would be easy to talk about a single decade if one hadn't lived in it. It would be easy to take the years 1950 to 1960 and re-invent them. As for me, I might have preferred the nineteenth century, one hundred years totally suited to my temperament. I have consoled myself for that loss with the knowledge that I shall not, after all, talk about the fifties in sequence. That would be too grim, too historical, and too claustrophobic. It would have nothing to do with me, or the way my mind works. Besides, that vast interruption known as *life* keeps interfering.

On the other hand, a book of distorted impressions won't do either. But, of course, impressions and feelings have their own continuity. So I must trust my memory, my feelings, and my instincts. I must approach the decade with the knowledge that I have lived it minute by minute, have experienced its climate and ambiance, and have met the people who have done the same.

Some have said that the fifties was a period of gloom. There

was a war in Korea and Senator Joseph McCarthy's crusade recalled the burning of witches in Salem. Girls wore long skirts and President Eisenhower ruled the nation. Since politics and sociology have never ignited my imagination, I will ask my memory to speak only of that which has: art, music, movies, theater, and, above all, people. While I can never fathom them fully, and while I can never fathom myself at all, it is people that most completely hold my attention. I have said elsewhere that I have modeled my life on the lives of others. Since I did not know who I was, I went to others for any answer at all.

The answers came slowly. In college—the State University of Iowa—I had started out wanting to become an actor. This did not work out because as a refugee, born in France, I had an accent that seemed destined never to leave me. The drama teachers scratched their heads and controlled their smiles when confronted by a young man eager to play King Henry V, Caesar, or Othello, and making his demands in a thick European accent. Since English was obviously my problem, I quickly switched to the English department in search of British and American masterpieces that would fulfill my need both to be in contact with genius, and to clear up my own peculiar brand of English. By the time this happened, my acting ambitions had waned. Besides, by then I had met the woman I loved.

It happened like this. Desperate loneliness prompted my taking innumerable walks about the verdant Iowa campus. On many of these, I would espy a beautiful dark-haired girl, high of cheekbone and slanted of eye, and wondered who she might be. She was set apart from the peaches-and-cream Midwestern girls all around me, at least in appearance. What is more, she seemed as alone as I was. Being shy, modest, and retiring (among the first distorted images I had of myself), I did not dare approach her. Some weeks later, I learned that her name was Jane Wilson and that she was a graduate student in the art department. Armed with this information, I abandoned English lit and embraced the history of art.

Among the courses I was obliged to take was one in Oriental

art, a subject not close to my heart. But I had decided to take a master's degree, and Oriental art was among the required courses. I walked into the classroom expecting the teacher to be an aging Orientalist with a braid down his back. Instead, Jane Wilson was at the lectern. From the last row I moved up to the first. I paid strict attention to Miss Wilson's brilliant remarks on China, Japan, and India and within a week had won a date for dinner. Thus began one of the more complicated romances on this or any other campus. For one thing, the university frowned on fraternization between students and teachers; for another, Miss Wilson's mother did not find me as delightful as I naïvely assumed she would. Still, I was determined to woo and win Miss Wilson completely, and she was not unwilling to disregard the official rulings of the college. In my mind, we were meeting in secrecy, with our picnics in the graveyard, our nonchalant encounters at lectures, special screenings, or in the music room, where we would sit for hours listening to records; until it finally reached our ears that we were becoming known as "that screwball couple," and that our romance was considered serious. The head of the art department called Jane in for a fatherly chat, and urged her to abandon our relationship. But Jane's mind was made up. Later, when it was decided that we would marry, Lester Longman, the fatherly chairman, made one last attempt to save Miss Wilson from her abominable fate by offering her an assistant professorship, a hike in salary, and a lovely house on the campus environs. What he hadn't counted on was the fact that I had so brainwashed my art history teacher that she would allow nothing to stand in the way of marrying her totally unformed student and leaving for New York.

It was a simple wedding. The date was March 28, 1948. I was twenty years old and Jane twenty-two. We were wed in Oskaloosa, Iowa, where Jane's mother lived. Mrs. Wilson had arranged the whole thing. While not sold on the idea of losing her daughter to a foreigner of the Jewish faith, she finally agreed to our plans. My own parents were totally against the marriage, not so much because I was marrying a *shiksa* as because I was em-

barking on responsibilities they felt I was ill equipped to handle. Certainly I had no money, but that seemed like the least of my worries. Jane and I had vaguely agreed that she would continue teaching, and then, when I had gotten my own master's, we would go to New York and would both find jobs. At any rate, my parents kept bombarding me with telegrams imploring me to abandon such a foolish and improvident move.

Jane's mother had, of course, always been unenthusiastic about the marriage. After all, her daughter had a brilliant career ahead of her. Her teaching and her painting might lead her toward pinnacles of the scholastic or artistic life. In truth, Jane was herself somewhat uncertain about our getting married. But I was madly in love and madly persuasive. I was determined that this woman would be mine. Finally, Jane relented and we went full-speed ahead with the preparations.

At the time, one of my three brothers was living in Des Moines, Iowa—my brother Martin. I invited him to be best man at the wedding, to which he agreed instantly and happily. Jane's parents had been divorced for some years, and Mrs. Wilson had no wish to have Mr. Wilson present during the ceremony. But Jane's younger sister, Anne, and a school friend of ours— Eva Schlein—were on hand. We entered the Oskaloosa Congregational Church one early evening. It was Easter Sunday, and the church was redolent with the oppressive odor of Easter lilies. The organist, a dour-looking lady dressed in black, played Humperdinck's "Lullaby" from *Hansel and Gretel*. My bride-to-be looked ravishing in a white suit, with sleeves of the bell variety, and cuffs trimmed with silver fox. Jane's hair was piled up high on her head, making her seem more sophisticated than she actually was. In point of fact, she was in a state of fear and trembling.

Except for the company on hand, the church was empty. We were all gathered in the minister's chamber, and signed our wedding certificates. I was myself anxiously looking around for brother Martin, who was to have met us hours earlier. We waited for as long as was reasonable, but brother Martin never appeared.

I was mortified and embarrassed, but finally decided that the wedding would proceed, best man or no best man.

Jane's mother and sister and Eva Schlein took their seats in the front pew. The minister took his place at the altar. In a way, I felt as if I were giving the bride away myself. The organ continued its melancholy music, while Jane and I walked ever so slowly down the interminable aisle.

We were approximately three feet from the minister when my bride-to-be suddenly fainted.

The organist stopped playing. Jane's mother and sister and Eva were on their feet, rushing toward the supine Jane. I was standing over them all, rooted on the spot, making feeble apologies to the stunned minister. I was paralyzed, confused, and frightfully shaken. Jane's mother glowered at me, making pronouncements about how it had all been a dreadful mistake, and how the whole thing had to be called off.

My next impulse was to flee. I wanted to rush out of the church, board a bus back to the university, go to my room, pack my bags, rush to New York, and forget about the entire abortive mess. Instead, I knelt beside Jane, took her hand in mine, turned to the family and friend, and, suddenly furious, told them all to get the hell back to their pew. Jane, in the meanwhile, was reviving. She was in tears and kept apologizing to me. We went back into the minister's chamber and talked. We were both enormously upset. I had frightful pangs of guilt, realizing only too well that for one entire year I had done nothing but insist we get married. I had been blind to the possibility that her various, always amiable rejections, might have meant that she truly was not ready to marry me. And so we talked about that. And Jane said, "No. I *will* marry you. I *want* to marry you. We *will* get married." And I said, "Well, all right, then. Let's go out there and get married."

It occurred to me only later that what Jane had meant when she said that she would marry me was that she indeed *would*, but at a *later* time, at a later date—not now, right this minute. But in my anxiety I wanted to believe that she had meant for us to

proceed right then and there. And because Jane saw that I had misunderstood her, and did not want to hurt me any further (and because I think she loved me), she answered, "All right, John."

I went out and told the minister that the wedding would proceed. The organist resumed her Humperdinck. Jane and I once again walked slowly down the aisle and reached the appointed place before the minister. We made our vows and exchanged rings, and kissed.

I kept thinking that the incident of Jane's fainting would mark us for life. But I erased the incident from my mind—that is to say, we never talked about it. As far as I was concerned we had had a glorious wedding, loved each other madly, and were embarking on a life of sublime happiness, creativity, and adventure. There is no question, of course, but that our backgrounds seemed totally incompatible—at least on the surface.

Jane was born on a farm in Seymour, Iowa. Her childhood was both uneventful and solitary. For as long as she could remember, Jane's parents had been at swords' points. Mr. Wilson, first a farmer and then a civil engineer, was constantly traveling. Her mother, a woman of remarkable beauty and considerable talent (at the time I had met her she had just published a curious, compelling novel called *The Black Thorn Blooms*), was overprotective of both her daughters, but especially of Jane, who progressively and alarmingly became her alter ego. The small community atmosphere in which Jane was raised impeded experiences that would widen her emotional horizons. It seemed to close her in ways that finally produced a girl of enormous shyness and understandable self-involvement. Her feeling of isolation, which to me was translated into a quality of mystery, was apparent from the first moment we met. In short, when Jane and I met on the Iowa campus, in Iowa City, I did all the talking and she did all the listening.

I am not suggesting that Jane was a mute and passive creature throughout our courtship. She was, after all, an extremely articulate lecturer in the history of art. But privately, she tended toward long, inexplicable silences, indicative (I realized later) of

many undisclosed anxieties and fears. My rationale, at the time, was that for two people who understood each other perfectly *her* words were unnecessary. I went on the egomaniacal assumption that whatever I instigated between us, whatever I proposed or suggested or said, was perfectly fine with Jane. The fact was, my ego was mistakenly bolstered by Jane's calmly acquiescent manner, and I thought that her silences meant total approval of all my vague and half-baked ideas concerning life, love, sex, and art.

The contrast of our lives was made all too clear when Jane began to learn about me. I suppose I represented something exotic to her. It was, after all, exotic to have met a man—a boy, really—born in a French gambling town, Enghien-les-Bains, a few miles from Paris. And it was exotic that he was the product of a Russian mother and an Egyptian-born father. Indeed, my background was as thoroughly varied and confusing as Jane's was somewhat static and seemingly bland. The real fact of the matter was that when we met, Jane's inner life was far more complicated than mine. Despite the dazzle of my European upbringing— fraught with its own miseries—I had developed into an over-opinionated, overtalkative, impulsive, and aggressive young man, whose need to be noticed, loved, and admired was all-consuming.

Having settled with my parents in New York at the age of thirteen, and having always been aware that in America *everything* was possible, I proceeded to follow in the American tradition of achieving success of one kind or another at any cost. It did not matter that as an awkward teen-ager I had no idea how to reach this success. I had not even set myself the task of excelling in one chosen field, thinking I might perhaps become a great actor, a great composer, a great writer, a great photographer— or even a great critic. Given my undeflatable self-esteem, I careened from one overattenuated daydream to another. Most of my time, between the ages of thirteen and seventeen, was spent at the movies, where in the dark embrace of, say, Loew's 175th Street, I would receive an education in American manners and mores, would perfect my English, would fall desperately in love with Bette Davis, Hedy Lamarr, Rita Hayworth, or Veronica

Lake, and would contrive a life as unreal as it was desirable.

When I was not enthralled by the silver screen, I sat in the dreary classrooms of the High School of Commerce, an all-boys school then located at Sixty-fifth Street and Amsterdam Avenue. Ironically, that miserable structure of my youth later became a neighboring building of that temple of culture known as Lincoln Center of the Performing Arts.

It was not the high school I hated so much as my fellow students. The reason for my hatred was simple enough: I was thoroughly disliked by most of them. This was 1943 and 1944 and I was a refugee who spoke broken English and wore knickerbockers and berets to school, so I was despised for these and other reasons. I did well enough in all my subjects, except those dealing with commerce. The choice of attending the High School of Commerce was made by my father. He had only to hear the word "commerce" to be convinced that this was the school for his altogether too esthetically-minded son. It took me two years to graduate, and when I did, I quickly enrolled in the City College of New York. I took courses in the liberal arts and found college life much to my liking. The only flaw in this new-found happiness was the fact that I was living with my parents and that my father had strenuous objections to my attending college in the first place. He had other plans for me.

In Europe, my father had made and lost several millions as a diamond dealer. His base of operations was Berlin, but he made various stays in Antwerp and Paris. My three brothers, all born within five years of each other, led a life of great leisure and luxury while in their teens. I am told that our household harbored any number of servants, nursemaids, cooks, and the like. I knew nothing of such wealth and well-being, having been born ten years after the birth of the youngest of my brothers.

It had been made clear to me by my often unconsciously cruel parents that my arrival was not particularly auspicious, that, indeed, if a new child had to be added to the family, it could at least have turned out to be a girl, since my mother had had her fill of the male gender. What is more, I had arrived at a bad turn-

ing point in my father's diamond-dealing career. As a result of business activities totally unclear to me, my family was suddenly reduced to poverty just as I came along.

My three brothers were soon forced to find work. My father abandoned diamond dealing and took up the writing of tourist books for a German publisher. But in 1933—the year all this happened—Hitler had risen to power and my father, aware of the impending lot of Jews in Germany, carted all of us off to Milan, Italy, where we resided until 1939. Of the many periods of my life, the years of growing up in Italy were my happiest. My sensibilities began to expand, along with a love of the out-of-doors and of landscape in general. My love of music had its beginning in Milan, as did my love of art. As I was only six years old, Italian quickly became my "native" tongue, and the country itself a land I could identify with and truly call my own.

Because it was the time of Mussolini, and because the schools were never allowed to forget it, I was thrust into a political aura I barely understood. All I knew was that as a young schoolboy I became *un figlio della lupa*—a son of the she-wolf—and as an older schoolboy I was called *Balilla*—the name of a teen-age hero of the Italo-Austrian War. We were given uniforms which we wore on certain days of the week and marched through the streets of Milan singing all the melodious Italian patriotic songs. My *Balilla* uniform was particularly handsome, with a black fez-type hat, a tassel hanging from its top, a black shirt, short army-green pants, and black knee-length stockings. Crossing the black shirt were two white bands, and where the bands met on the chest we sported a beautiful, shiny letter M, which, in my naïveté, I assumed to stand for the word "Mamma."

In school I was adept at drawing, penmanship, history, and music. But mathematics was as much of a mystery to me as were the intense teachings of Catholicism—a requirement in Italian schools. Catholicism had a negative effect upon me because I was far more frightened of falling into a state of perdition than I was elated over the possibility of reaching paradise. Too, my being Jewish, though of the non-Orthodox persuasion, threw my reli-

gious feelings into the greatest turmoil. At home, we were half-hearted Jews, aware only that to be Jewish at this moment in history was not the best of all possible fates. Somehow to be Jewish meant being scared. On the one hand, my father kept insisting that to be a Jew meant being special and superior, while on the other hand it also meant being hated and persecuted. I could never reconcile myself to these two clearly opposite states. At any rate, the ambivalent feelings experienced within my home, along with the enforced exposure to Catholicism at school, contrived to confuse me utterly in matters of the soul and the spirit.

My answer to all this was to play the whole religion thing by ear, and let the guilts fly where they might. And, all too soon, the guilts began to play a most important part in my everyday life.

When I was eleven, sex started to rear its delicious head, and the drama of its awakening began to unfold within the busy confines of our large Milan apartment.

Working for us at the time was a young housemaid named Giuseppina, an avid Catholic and churchgoer. Unbeknownst to my parents, Giuseppina would steal me out of the house every Sunday morning to attend Mass at a nearby church. I enjoyed these excursions and went along willingly. Giuseppina must have been seventeen or eighteen years old, with bright black eyes, marvelous pearly peasant skin, and a deluge of black hair which she wore braided and twisted into a crown atop her head. As a blond, stork-legged, awkward eleven-year-old, I was deeply flattered by her attention. What happened, of course, was that, like all well-brought-up European young boys, I was seduced by my maid.

My sexual awakening came about one Sunday morning when Giuseppina quietly entered my room, slipped out of her nightgown, and gingerly got into bed with me. It was during that moment of half-wakefulness when one does not wish to disturb the illusion of sleep—when one feels suspended in the warmth of semiconsciousness, and the nestling comfort of sheets and blankets. There, next to me, lay a singular expanse of silken skin, and

I experienced a totally unfamiliar gentleness and tenderness, and a mad pounding of the heart.

I had dreamed of sex and was vaguely familiar with its mechanics, but nothing had prepared me for the tumultuous experience that offered itself so effortlessly in my bed. Sex had come to me. I did not have to go out and struggle for it. My heretofore self-propelled fantasies and the self-manipulations that so frequently accompanied them were suddenly transformed into what I believed to be the *real* thing. But, of course, it *was* the real thing—yes, it was the real thing—and so was the terror, because, my God! I was too young to be a father, and who wanted to marry one's maid? And what was she doing, and why was she heaving so and making those strange noises, while at the same time wearing an expression of acute discomfort? And couldn't she control her moaning a bit? Didn't she know my parents were nearby? I wanted desperately to place my busy hands over her mouth to shut her up. I was convinced my father would barge in at any moment and beat us both to a pulp. Mercifully, the moaning and the groaning abated as indeed did my own verbal and nonverbal ejaculations—the verbal ones having been emitted mostly in dutiful concurrence to my seductress's orgiastic exclamations. In short, I thought you both had to make a lot of noise.

When it was over, Giuseppina asked me to get dressed and go to Mass with her. There were a few things she had to tell her confessor.

One day, Giuseppina announced to the household at large that she was leaving. She had been offered a job in the country. We exchanged furtive glances, my mind reeling at the thought that with her departure she would also announce our transgressions. But everything went smoothly, and all of us wished her well and told her how much we would miss her.

Giuseppina and I had one last mad embrace that very night, and when I worked up the nerve to ask her about our baby, she laughed in my face, gave me a hug and a squeeze, and said, "What baby, *stupido*?!" My relief was, to say the very least, immense, and when she departed, I barely thought about her again.

As I came to learn all too soon, the vagaries of sex would continue in yet another direction for me. I am referring to my encounter with my first piano teacher, a man in his middle thirties, whose interest in me went beyond the call of mere piano exercises. It turned out that he was fond of little boys, musical or not, and for some time part of my lessons seemed more devoted to the discovery of the organ than the piano.

Having been diddled by both sexes with a minimum of trauma, and with no interference from parents or society, I assumed that that's how it was with sex. It seemed natural, there being only two sexes, that both were to be given physical recognition. Imagine my surprise when I later discovered that it was fine to fondle girls, but that if you did the same with boys, something was terribly wrong with you.

I was now thirteen years old, and again the fact of our being Jewish interrupted the continuity of our lives. The year was 1939, Hitler and Mussolini had become fast friends, and suddenly ugly little signs began appearing in the windows of familiar coffee houses and restaurants in Milan announcing: "Jews and dogs not permitted." We were also informed that Jews were no longer allowed to have or to hire Italian help. Another edict read that all schoolchildren of the Jewish faith had to be taken out of the Italian school system and placed in special Hebrew schools.

In February of 1939, my father obtained visas for my mother, himself, and me through the help of a New York-based uncle (my father's brother). Visas could not be obtained for my three brothers as they had all been born in Berlin, and the German quota for entry into the U.S. was closed. And so, on a miserable, tear-filled day, my parents, sobbing and desperate, bade my brothers farewell. We took a train to Trieste, embarked on the S.S. *Vulcania*, filled with refugees like ourselves, and sailed for New York. To make matters worse, my mother took ill—not with the usual seasickness but with appalling stomachaches which later turned out to have been a gall-bladder infection. I hardly ever saw her—she was mainly confined to her cabin—

and, besides, I had a cabin all my own and was busy exploring the marvels of so large a steamship. I also saw very little of my father. He was depressed and uncommunicative throughout the ten-day journey. There was no shaking his doldrums over the absence of my brothers, my mother's illness, and over the unknowable future that awaited us in America.

On February 23, 1939, at approximately 6 a.m., the S.S. *Vulcania* pulled into New York harbor. We were all summoned onto the decks so that we might have our first glimpse of the New York skyline and the Statue of Liberty. To my eyes, that awesome green lady rising out of the sea was a mysterious being—a benevolent giantess, a creature whose gesture of welcome seemed fiercely ambivalent. Given her stark immobility, she seemed rather forbidding, and her blind eyes and flameless, uplifted torch seemed to issue a command to prove oneself worthy of her.

The New York skyline was a mirage, and the morning haze gave it a magical insubstantiality. The city was afloat upon incandescent, weightless waters. Nothing suggested the noisy and jagged New York tempo that usually accompanied the skyline when it appeared in films. On that morning, it was a silent, shimmering city, ravishingly out of focus. I might add that, it being February, we all stood trembling and freezing in colder weather than we had ever experienced. But even the cold was a novelty and a thrill. It seemed as if America were cleansing us all with the formidable rush of her treacherous winter winds.

Upon docking, my father, my still ailing mother, and I walked shakily down the gangplank. We attended to our baggage, and were at last embraced by my uncle, my aunt, and my three young cousins, who whisked us home with them to an apartment house on Seventy-second Street and Riverside Drive.

Never in my life had I been on the fifteenth floor of any building. Inexplicably, the first thing I did upon entering their huge apartment was to turn on the radio. To my amazement, the first words I heard were spoken in Italian. I had hit upon an Italian-language station, and the man was extolling the purity of some

Italian olive oil. They seemed the friendliest of words. Still, I knew I was in America, and I was as happy as I was apprehensive.

Imagine, if you will, a thirteen-year-old boy wearing gray knickerbockers, black stockings, heavy Italian shoes, a black turtleneck sweater under a gray jacket, speaking not one word of English, and anxiously insecure over not being able to communicate with my young cousins—or any American, for that matter. It took only a few days for me to realize that we had been thrust into a household not really elated or overjoyed at our arrival. Clearly, our relatives had their own problems to cope with, and were uneasy about this new burden on their own rather wobbly financial circumstances. Nor did my mother's progressively worsening illness help to create an atmosphere of immediate or joyous conviviality. Still, there was no open hostility —far from it; the words were all the right words, but they concealed an undercurrent of displeasure.

The idea was that we would stay with my uncle for a few weeks until my father could round up an apartment and make a few contacts in the New York diamond-dealing district. Unhappily, after only a few days' stay with our relatives, my mother had to be hospitalized and, finally, operated on. The gall-bladder operation was successful, but she remained in the hospital for several long weeks. During this period, my father found an apartment in Washington Heights—on One Hundred Seventy-third Street—and he and I moved into it with a sense of relief. Some weeks later, my mother was able to come home to join us.

I must now speak very briefly about my late parents— individuals difficult to define. My father was a self-made man whose ingenuity and didactic strength held his family together through periods of both ease and strain. A man of very scant education (though fluent in seven languages), he managed to induce a strong sense of survival in his four sons. While he was anxious for us to have an "education," he was basically distrustful of books or of higher learning. Culture for the sake of culture was a

luxury he could neither understand nor accept. As for my mother, she was, alas, a study in weakness, so brainwashed by my father's aggressiveness that she was of little emotional help to her growing sons. She had the failing of *seeming* to be on our side when, in fact, her official stand was with my domineering father. For all that, she loved us, supplied us with the usual superficial amenities, attended to our immediate needs, but was not able to handle our deeper desires, to help us to have more trusting natures, or to give us a fuller awareness of our intellectual potential. Both our parents, perhaps unwittingly, deprived us of our self-esteem. As youngsters we were seldom treated as individuals, and seldom allowed to forget that the privilege of our existence was entirely due to their "largesse" and "good will."

When I graduated from the High School of Commerce at the age of seventeen, and announced to my father that I planned to attend City College, he flew into a rage and told me to go out, find a job, and become a man. The outburst included invective against my interests in music, movies, poetry, and art—all of which were, in his eyes, highly sissified. He gave me to understand that if I were to continue living under his roof, I would have to abandon these feminine pursuits, come to my senses, and behave like "every other normal human being." The hostility between us became intense and open, and I knew I had no allies in my quest for something beyond the dreams of commerce envisioned for me by my father.

Nonetheless, I enrolled in City College in 1944, continued living at home, and occasionally ran some errands for my father, who had by now re-established himself as a dealer in New York's Forty-seventh Street diamond district. Then, when I turned eighteen, Uncle Sam invited me into the U.S. Army.

In a way, this was one of the most welcome invitations I had ever received. It meant leaving my parents' gloom-ridden household. It meant travel to other parts of the country—perhaps of the world—and it meant long-sought-for independence. My parents did not bewail my departure. They were, in fact, looking

forward to the arrival from war-torn Europe of my three brothers, for whom my father had obtained long-delayed visas for entry into this country.

And so one morning I departed for the wilds of Fort Dix in New Jersey, and later, for continued training in the infantry at Camp Blanding near Jacksonville, Florida. I remained at Camp Blanding for slightly less than one year. There were no calls to arms, and the news of the day included reports of imminent peace. One sultry Florida afternoon word came to us that World War II was over. I was honorably discharged, and emerged from the army a sun-tanned nineteen-year-old, speaking with a curious Southern drawl—a skinny young fellow walking straighter than ever before and deliriously healthy.

Returning to the bosom of my family was not, of course, my idea of renewed bliss. Luckily, the G. I. Bill of Rights came into effect, and I lost no time applying for entry into some university —any university—far away from Washington Heights. Being totally unaware of the prestige of such institutions as Harvard, Yale, Princeton, or Columbia, I followed the advice of a pre-army girl friend who urged me to apply to her Alma Mater—the State University of Iowa, in Iowa City. I applied forthwith, was accepted, and embarked on five years of Midwestern life which resulted in a B.A. in English, an M.A. in art history, and an American wife—none of which I knew what to do with.

2

The year is 1949, one year after my marriage to Jane Wilson. I have just received a master's degree in art history. My thesis was entitled, "Peter Paul Rubens: Collector and Antiquarian," a subject of limited relevance to my own or anybody else's life, but unusual enough to have won me a scholarship for Ph.D. study at New York University's Institute of Fine Arts.

The kind of life Jane and I were planning to lead could not be lived in any other section of New York except Greenwich Village. It was the legendary place for star-bound people such as ourselves. We began looking around for an inexpensive brownstone apartment, and found one located at 319 West Twelfth Street, near Hudson Street. It was a parlor floor, and we were attracted by the red-brick building, the two long inviting French windows facing the street, and by the small park in nearby Abingdon Square. The rent was twelve dollars a week, and the entire apartment consisted of one single furnished room. It measured approximately twelve by fifteen feet, and its only bow to elegance was a wood-burning fireplace. Its furnishings suggested a motley crew of previous tenants: two sagging couches of indeterminate color and age, three wooden chairs, a square, peeling table, and a folding screen that had seen cleaner and better days. When our landlord showed us the place, we stood somewhat less than dazzled in our new home. I remember Jane tentatively looking around for the kitchen. The smiling landlord informed us

that there wasn't any kitchen, but that the rent included cooking privileges.

"And is there a bathroom?" Jane inquired. "Certainly," said the landlord. "It's just down the hall, and only the tenants living on this floor are allowed to use it."

But at twenty-one a parlor floor in Greenwich Village without a kitchen or private bath is decidedly not the end of the world. So we bought a solitary hot plate, upon which we dreamed of cooking fabulous meals for the legion of accomplished and celebrated friends we would shortly acquire.

We did, of course, wonder what had happened to the rest of the parlor floor, and soon discovered, through noises emanating from behind our parlor's wall, that it was occupied by an Italian couple. They turned out to be the best neighbors two newly married people could have. As it turned out, the husband worked as a delivery man for the Duvernoy Bakery Company, which supplied bread, rolls, cakes, etc., to restaurants around town.

Our Italian friends proved the sanest people in 319 West Twelfth Street. The rest of the tenants could easily be considered slightly mad. On the three floors above us, there lived, for one, a short, heavily rouged actress attending drama classes at the Stella Adler School of Acting, who supported herself as a hostess at the Five Oaks Restaurant in the Village. There was an outrageously handsome dancer, studying with Martha Graham; there was a fashion model from California who was deep in Reichian analysis and could be found in her orgone box at all hours of the day and night; and a male couple, whose sexual penchant was of the noisily sadomasochistic variety.

Two weeks passed, during which Jane, in her impulsive way, made life bearable in our apartment by painting the walls white, rearranging the "decor," buying bunches of flowers, and beginning to paint a few pictures, which I insisted we hang on our bare walls. The big problem, of course, was money. We were practically penniless, and it was at this moment that we began to depend on the kindness of strangers. Our splendid Italian neighbors, hearing our stomachs growl through the thin walls between

us, would invite us in for spaghetti dinners. The kindly truck-driver would leave bags of fresh rolls, danishes, bread, and cake in front of our door, before leaving for his rounds. Finally, Jane wrote to her father asking him for some tiding-over money, which, mercifully, arrived within a few days. We could go on living for several more weeks.

Looming ahead of us were our separate careers. I would now have to make my first appearance at the Institute of Fine Arts. Jane had already written several letters to private New York schools and colleges regarding a teaching post in art history. There had been few replies—and the pay offered was so meager that she held on, deciding to wait it out until something more substantial came her way.

In the meantime, I started going to classes. The first of these was conducted by a professor whose German accent was so impenetrable that I could barely make out a word he was saying. The subject at hand, on that first meeting, was the study of cathedral ground plans. Sitting in the darkened hall, with slide after slide passing before my eyes, and incomprehensible verbiage floating past my ears, I knew in my heart of hearts that my student days were over. I was, after all, living in New York City. I had heard about new artistic movements rising to the fore—movements created by living painters and sculptors working in studios only a few blocks from us, and I could not reconcile myself to being in an ambiance of dead art, no matter how lofty or noble, while New York was already in the grips of abstract expressionism.

On that first day at the institute—the moment my first class was over—I marched into the dean's office, thanked him profusely for my scholarship, and announced that due to unforeseen circumstances I could no longer take advantage of it. My reasons were extremely vague, and the man no doubt considered my motives highly suspect. Somehow I could not bring myself to tell him that two or three more years of art history would result in one student's intellectual and emotional strangulation. I realized, of course, that I would cease receiving the small stipend attached

to the scholarship, but I figured that poverty would be mine with or without it. So I brazenly walked away from the opportunity that might have resulted in the world's calling me Dr. Gruen.

Jane and I celebrated my willful loss of a doctorate by throwing our first New York party. The guests were the tenants of 319 West Twelfth Street. Our actress-friend announced she would be delighted to do a scene from Oscar Wilde's *Salomé*—a scene she had only that afternoon rehearsed in Stella Adler's class. We were thrilled, and proceeded to arrange our room in a manner suggesting an Art Nouveau set. We lit dozens of candles and draped our screen with a wild assortment of thrift-shop throws. We burned incense, and as the event was about to begin, bade everyone sit quietly around the room. The actress announced she would do Salomé's last love-crazed scene. She went behind our screen, then emerged wearing tons of black lace, her hair combed out wildly. She entered carrying a large round tray upon which the imaginary head of Saint John the Baptist was supposedly resting. She slunk into the center of the room, placed the tray on the floor, and began crouching over it like a tigress in heat. Finally, she began to speak her lines.

The room was tense with expectation. The candles flickered ominously in the darkness. The actress was, indeed, speaking her lines, but not a single person in the room could hear what she was saying. The girl had elected to do the entire scene in one prolonged whisper. The fact that her head was practically buried in the tray before her made audibility even more impossible. The more impassioned her sinuous movements on the floor, the less she could be heard. This would all have been simply amusing, had the soliloquy not taken nearly an hour. At last it was over, and we regaled her with endless compliments. She agreed that it was one of the best performances of the scene she had ever given. After a while, we clustered in groups, drank, smoked, and listened to the latest Frank Sinatra records.

Much later, when Jane and I were in bed, panic struck us. It hit both of us that in the morning I would have to go out and se-

riously start looking for a job. Our meager amount of money was definitely running out.

I had always thought that Brentano's bookstore on Fifth Avenue was the most elegant bookstore in New York. The fact that it had a branch in Paris added to its glamour. I had also heard rumors that stars of stage and screen came into Bretano's for their cultural needs, and that Garbo often paid the shop a visit. Next morning, then, I walked into Brentano's, made a beeline for the art books department, and announced that I could speak French, Italian, and German fluently, and wanted a job as book salesman. To my astonishment, I was hired on the spot. Thus began four years of living with books—first as an art book salesman, and later as an assistant to the book buyer. I started at thirty-six dollars a week, and considered myself in the mainstream of the art world.

Endless hours of pacing and dusting—the lot of the book salesman—did not nourish my spirit or my intellect. Who could read *one* book amidst so many of them? Besides, reading on duty was strictly *verboten*. So I occupied my time by getting acquainted with my fellow salesmen, wandering around from department to department, and keeping a sharp lookout for Greta Garbo and other luminaries. Then it happened. Garbo *did* walk in. Spotting her at once, I dashed to her side and said hoarsely, "May I help you?" Her reply was simple and to the point: "No." Deeply disappointed, I retreated a few paces but kept my adoring eyes glued upon her fabled face. Sensing my silent adulation, Garbo promptly walked out of the store.

My second encounter with the stars was Salvador Dali, who proved a thrilling contrast to the reticent Miss Garbo. He walked up to me and asked if I had a copy of his *Secret Life of Salvador Dali*. I quickly fetched the book and said, "Here you are, Mr. Dali." He asked whether I had read it, and I had to admit that I hadn't. He then said that he would take the book, and would I gift-wrap it. I did so with alacrity, and handed him the package. He now handed the book back to me saying, "Take it. It is my

gift to you. Would you like me to autograph it for you?" I tore open the gift wrapping, found him a pen, and, in the largest possible letters, he scrawled his name—and mine—upon the frontispiece. Mr. Dali omitted one vital step in the transaction. He walked out of the shop without paying for the book. Needless to say, the book still rests upon my bookshelf—Brentano's gift to me.

My next encounter was with a very short, owl-faced gentleman whom I had observed in the store on several previous occasions. He was constantly browsing in the poetry department, fingering all the volumes, but especially the series of short, fat poetry books entitled *Oscar Williams' Little Treasuries of Poetry*. These volumes were extremely familiar to me since we had been obliged to use them as texts in English lit courses. This, then, was Oscar Williams himself, greedily checking the stock of his *Little Treasuries*. I had recognized his face from the small oval photographs of the poets which were included in each collection. Being unable to resist a "name," no matter how dimly brushed by stardust, I walked up to him and announced that I had been conversant with his *Little Treasuries* for years.

This was all Williams needed to hear to become my nearest and dearest friend. He was full of questions about my life, said we must meet socially, and was, in short, prepared to take me under his wing. When I told him I was married and living in Greenwich Village, he offered to pay us a visit the very next evening. I rushed to the phone and called Jane, telling her that on the next evening we would be entertaining our first honest-to-goodness celebrity.

True to his word, Oscar Williams arrived at our door, laden with two shopping bags, one containing two dozen hard-boiled eggs, the other filled with red and green plums. A man of intelligence and a certain pixy wit, Williams also had some of the less endearing qualities of a nosy spinster. There was something rather monkeyish about him, with his long arms, short body, wide cheekbones, pointed chin, and deep-set eyes framed by cold steel-rimmed glasses. He seemed not so much to walk as to

scurry; not so much to talk as to squeak. He had a way of insinuating himself into other people's lives that could be trying and tiresome. This quality was particularly apparent when, some years later, he became the jealous amanuensis of the poet Dylan Thomas, who, on his first visit to New York, found Williams his overprotective guide to New York's intelligentsia.

But Oscar Williams had much kindness in him, and he found genuine pleasure in introducing Jane and me to the literary figures of the fifties—writers, poets, publishers, editors, mainly affiliated with the so-called "little magazines" of the period— publications like *Partisan Review, Hudson Review, Poetry*, et al.

Oscar Williams and his wife, the poet Gene Derwood, lived in a penthouse on Water Street in Lower Manhattan. This was actually an enormous office building which at night assumed a bizarre and frightening dimension. There were seedy bars all around, and dozens of woebegone drunks reeled in and out of them, or walked in a daze down Water Street. Visiting the Williamses was something of a trauma, particularly since we had to wait for several very long minutes before Gene Derwood made her way down in the manually operated elevator to unlock the front doors of the building. Miss Derwood was given to wearing long capes and big berets, no matter where she appeared, and she was thus attired the first night we met her. Under her beret, we could see that her hair was a frizzy gray. Her voice was raspy and rather sinister-sounding. From the first, we found her witchlike. Whenever she spoke, there seemed to be some foreboding message behind even her pleasantest words. She seemed to harbor some strange, secret knowledge which, were it probed, might produce some catastrophic augury. We recall her leading us into the cavernous depths of the building's elevator that first night. Once inside, she sat, silent and regal, on the elevator's small stool, clutching the operator's lever that levitated us up to her penthouse floor.

She ushered us into her living room, around which sat some of the literati of the period. They seemed a most sophisticated bunch, into which two awed upstarts moved with a certain

phony ease. The talk centered around sensitive literary matters —style, poetic innuendos, psychoanalysis, alcoholism—all this, as liquor flowed and words and ideas became more and more confusing and elliptical. Oscar Williams talked very little, but was the agile dispenser of drinks and food. Gene Derwood sat erect, occasionally adding some portentous and cryptic statement, the response to which was a charged collective silence. Jane and I decided we had been accepted into this esoteric milieu by virtue of our decorative appearance, and because we ventured no opinions whatever.

But the Williams/Derwood ménage gave us entry into a literary world which in retrospect was as formidable as it was stifling. To be in the presence of names that one had encountered in print during college years meant being in the presence of people who had, in effect, "arrived." Yet the seriousness and humorlessness of these "names" confounded us. For myself, I wanted desperately to know about their daily lives and passions, and was more curious about their feelings than about their intellects. I voiced none of these questions, afraid of making a fool of myself.

For a period that spanned nearly two years, Jane and I sat and listened to what we assumed were profundities but were actually the ponderous, self-deluding musings of craftsmen without souls. There was a leaden, inbred, self-congratulatory, and oppressive quality to their discussions. In phrases of convoluted impenetrability, these "younger writers" of the fifties would dissect matters of style and give heavy vent to opinions that seemed eons removed from what I considered the essentials of inspired literature. This was a finicky group, bent on magnifying the minutiae of great literary minds. And when they wrote about these masters they did so under the abstruse cover of the current critical language.

Indeed, the critical essays found in the "little magazines" of the fifties, with their voluminous footnotes and annotations, seemed consistently to stand in the way of the subject at hand. Because they were basically writing for each other, and even prided themselves on being out of the mainstream of public acceptance,

these writers' work—their criticism, essays, and poetry—seemed like wastelands of picayune words and arid ideas. Not that it wasn't impressive. I would read these pieces with what amounted to religious zeal. Where did they find all these words? How did they know how to fuse one complex thought to another? At the time, I was totally incapable of saying what I was beginning to feel about these writers—that they were excruciatingly dull, filled with pedantic and archaic references, delighting in obscure literary allusions, and in general giving the words "dryness" and "emotional poverty" whole new meanings.

This grim literary world was thrillingly shattered when Dylan Thomas entered the scene around 1950. The tubby, curly-headed, pink-cheeked Welsh poet was making his first visit to America, and, as I said, Oscar Williams was his shadow. At one point, you could not have access to Dylan Thomas without first being in contact with Oscar Williams. I think Thomas tolerated all this out of sheer helplessness. And Williams was helpful in introducing Thomas to a great many people who were eager to meet the famous poet.

Naturally, it was at the Water Street penthouse of the Williamses that we met Dylan Thomas. A large party had been arranged and Jane and I were among the first to be invited. It was an established fact that Thomas drank. It was an affliction that would ultimately kill him. But Thomas sober and reading his poetry was an unforgettable experience. The poetry itself was like a gust of fresh wind, compared to the dusty, contrived, and pretentious verse that we had been listening to and reading prior to Thomas's arrival in New York. Here were words touched with life. They rang true, and were filled with feeling and with singular grace. The waterbirds and herons of Thomas's poems really took wing. One could hear the whoosh of their flight as they hovered over landscapes and shorelines that shimmered through summer trees and autumn winds. Always, the poetry contained an openness and a directness, a clarity and a music, which were literally breathtaking. To hear Thomas read from his work was to be engulfed in these exhilarating climates. His voice had a ring

to it, and an inflection that gave the words a full-bodied melodic timbre, far removed from the somnambulistic intonings of most of the other poets we knew.

On the evening of the party for Thomas, the Williamses asked us to come early so that we might be able to talk with him before the other guests arrived. Jane and I came at approximately 6 p.m., and when Gene Derwood opened the door she started shooshing us profusely, pointing to a prone Dylan Thomas, snoring, and, as she put it, "resting." We tiptoed into the room, and sat in total silence for about fifteen minutes, beholding him in his red woolly shirt. Finally, Thomas stirred, rubbed eyes, and sat up. We were introduced and for the next two hours engaged in conversation. On the floor, at Thomas's feet, stood four quarts of beer.

If Thomas was suffering from a hangover, he did not show it. His conversation was as clear and as lucid as his poetry. I asked him to describe the Welsh town in which he lived, and the house that he shared with his wife Caitlin and his two small children. With precisely the same cadences that marked his poetry, Thomas went into these descriptions. Every tree, every flower, every bird assumed a life of its own. The images were so clear, so crisp, and so magical as to make the room we were sitting in appear gray and ghostly.

This was no poetic rhapsodizing from the lips of a "poet," but the simple and accurate remembrance of a place he obviously missed terribly. For nearly two hours, Dylan Thomas spoke about his birthplace. The words were simple, but the sentiments complex, made so by the quality and intensity of his recollections. As he progressed into his stories, he progressed further into the beer at his feet. At the end of the two hours, his speech became slurred and finally incomprehensible.

It was now 8 p.m., and new guests were arriving—the usual entourage of poets, critics, editors, painters, and their wives. Gene Derwood had set up a small portable easel in the center of the living room. (She had, for years, been painting small portraits of her friends—an adjunct to her life as a poet.) Miss Derwood now placed a small blank canvas board on her easel, and began

busily arranging her oils and brushes. Her plan was to capture the living Dylan Thomas in a portrait that she had been planning for weeks. This seemed hardly the occasion to embark on such a project, but we could tell by her darting, flashing eyes that she was inspired—and determined. So concentrated was her activity at the easel that she paid not the slightest attention to her guests (by now some two dozen). Oscar took care of the amenities and the drinks. Dylan Thomas was practically invisible in one corner of the room, hidden by a crowd of admirers.

People were sitting on the floor, paired on single chairs, on couches, on small side tables, crouching in every available spot. We kept wondering how Gene Derwood was going to manage her masterpiece. She had just turned off every light save a small lamp covered by a red silk shade on a low coffee table near her easel. It was the only source of light for her or anybody else. Suddenly we noticed that she had sat down on a very low rocking chair, far below eye level of her easel, and was peering through the maze of people, trying desperately to catch a glimpse of her subject. Her head bobbed in every direction, and finally she began applying brushstrokes with mad urgency.

We saw one guest, the beautiful Helen Coggeshall, imploring Thomas to read some of his poems. She had in fact brought along his collected poems and had preselected several poems which she wanted him to deliver aloud. Never unmindful of a beautiful woman, Thomas listened to her beseechings and seemed ready to comply. As Mrs. Coggeshall handed him the volume, he fell to his knees, lifted her tunic, and plunged his head beneath it. Stunned, the elegant, well-bred Mrs. Coggeshall allowed the poet to nestle only momentarily. Then she gently pushed him away, pressed the open volume of poetry into his hands, and commanded, "Please, Mr. Thomas, *do* read!"

Thomas lurched to a standing position, tore the book from her, ostentatiously turned it upside down, and proceeded to give a mock reading consisting solely of loud mooselike bellows and nonsense syllables, a ten-minute blast of cacophonous sounds without, of course, any relation to the work clenched in his hand.

All the while he was gesturing madly, like a Roman emperor in the throes of an epileptic seizure. It was during this oration that Gene Derwood reached the peak of her inspiration, feverishly applying stroke after stroke upon the minuscule canvas. It was also during this reading that Oscar Williams elected to serve dinner, which consisted of mashed potatoes—period. He wove zanily in and out, balancing paper plates, some of which came close to falling upon the heads of the guests.

Thomas had now finished his "reading" and collapsed into a mumbling heap onto an empty chair. Polite conversation ensued, but the atmosphere became oppressive and uncomfortable. The mashed potatoes were being consumed in a desultory manner and it became apparent that the party was over. The only person totally unperturbed by the proceedings was Gene Derwood at her easel, and we saw that she had indeed done a portrait of Dylan Thomas—a portrait of a red-haired man in a red shirt in a red light. Amazingly enough, she had caught much of the frenzy exhibited by Thomas during his performance.

Glancing over at Thomas, we now saw an unreachable, exhausted man on the brink of another long alcoholic sleep. The evening with Dylan Thomas had come to an end.

3

My life at Brentano's bookstore was getting me down. It was not difficult for me to see that selling books could never be my life's calling. I had been a salesman for nearly two years, and I had decided that it was time either to move up in the book business or get out of it. One brisk sunny morning, I walked into the office of Brentano's president and asked to be given a better job at a better salary. To my surprise I was told that something more interesting might possibly turn up for me, but that I had to wait. A few weeks later I was told that an opening had become available in the book-buying department, then located in the upper reaches of the store. I accepted the post with alacrity, since my salary would be nearly doubled. I was now an assistant book buyer, and it would be my job to assist the head buyer in her various chores. This person was Miss Lillian Friedman, a woman of tremendous energy and alertness.

Since Miss Friedman's dealings were exclusively with men, she did her utmost to behave like "one of the boys." It was a matter of self-defense, as well as being part of an American tradition which requires that ladies in the business world must be as tough as, if not tougher than their male counterparts. In reality, Miss Friedman's lacerating and iron-willed behavior hid the inevitable heart of gold. She was an excellent book buyer, a splendid idea-woman, and a real wit. We got along famously, and exchanged thousands of bons mots, sarcasms, and complaints. For the next

two years I checked on the company's vast stock, took care of reorders, and did some buying when Miss Friedman was out of town or on vacation.

In the meantime, Jane's life took several dramatic and unexpected turns. She had been painting diligently in our tiny apartment, doing figures, still lifes, and a few imaginary landscapes. Her career was not particularly active, though the idea of being with a New York gallery was very much on her mind. But in the fifties it was not easy to get into one. You had to be very much in the mainstream of the art world. Your work had to be talked about and to be recommended to dealers, preferably by established artists. To be an artist in the fifties was still a very private thing. Artists were truly a breed apart and the art world in general was fairly small and closed. There were far fewer galleries in New York than now, and to be accepted on a gallery's roster meant you had truly arrived.

Around 1952, Jane was one among dozens of young painters with quite a bit of work on their hands and no place to show it. By this time we had made a number of friends, some of whom were painters already showing with New York galleries. We had gone to the famed Cedar Street Tavern, then located at Ninth Street and University Place, and had watched artists such as Willem de Kooning, Franz Kline, and Jackson Pollock drink and talk into the small hours of the night. They were usually surrounded by younger artists, all of whom were eagerly hanging upon the words of men who were by now vital figures of the abstract expressionist movement.

At the Cedar Bar, we were in the company of such young artists as Larry Rivers, Mike Goldberg, Jane Freilicher, Joan Mitchell, Al Leslie, and Grace Hartigan, and poets and writers such as Frank O'Hara, John Ashbery, Harold and May Rosenberg, Tom Hess, and long before their dealer days, Leo Castelli, Ivan Karp, and Richard Bellamy.

It was here that Jane was approached by the painter Felix Pasilis, who told her that a group of fellow artists had decided to form a cooperative gallery, since they felt the time had come for

artists without galleries to take matters into their own hands. Pasilis, Wolf Kahn, Richard Stankiewicz, Jan Muller, and several others were going to rent space on East Twelfth Street and run it on a cooperative basis. That is to say, each artist would share in paying for the rent, for the printing of brochures, for mailing, and for the general upkeep of the gallery, in return for which he would be given a one-man exhibition of his work.

Cooperative galleries are no longer novel, but in 1952 it was an original and daring concept. There had been two or three such galleries prior to this, among them the Jane Street Gallery, organized by the painter Nell Blaine, and the Tanager Gallery, active on East Tenth Street. But the new venture seemed far better organized and everyone concerned threw himself into running it with enormous enthusiasm.

The gallery became known as the Hansa Gallery, a name suggested for it by the painter Jan Muller. I remember our first meeting, held in Pasilis' loft. Though neither a painter nor a sculptor, I had wanted to be associated with an exciting group of young people who were ready to set the world on fire, and I was voted in after I told them that I would organize lectures and concerts at the gallery, and promised to make enthusiastic speeches about whatever work was being shown at the moment, urging the public to buy or at least talk about the work on the walls.

The Hansa Gallery took up residence in an old walk-up tenement at 70 East Twelfth Street. The roster included Jan Muller, Wolf Kahn, Felix Pasilis, Richard Stankiewicz, Jean Follett, Arnold Singer, Jacques Beckwith, Allan Kaprow, Miles and Barbara Forst, and my wife, Jane Wilson. The group prided itself on believing in all styles, as long as the work measured up to everyone's fairly high standards. The building in which the gallery was situated was dismal and the address totally off the beaten track. Nevertheless, it was close to the lofts and studios of many New York artists, which were located primarily on East Tenth Street, in an area which was much later to be called the East Village.

The Hansa group may have been compatible as far as art was

concerned, but not as regards its members' personalities. As the gallery began to function any number of violent personal clashes took place, with hysterical outbursts by the more high-strung artists. Countless decisions had to be voted on, and there was always someone totally against one policy or another. Tempers invariably ran high.

These chaotic, unnerving meetings were presided over by the gallery director, a tall, even-tempered, and entertaining girl named Anita Coleman, who had been suggested to us by John Myers, who was running his own gallery, the Tibor de Nagy, then located on East Fifty-third Street. Anita joined the Hansa after an interview which I was delegated to conduct on behalf of the gallery. I recall telling Miss Coleman to meet me at the Hotel Algonquin so that we might talk about this important post which would not pay one cent, and which would entail endless, tedious hours sitting behind a desk in an empty gallery in a desolate part of town, dealing with the wildly disparate characters that made up the group. As it turned out, Anita was ready and willing to take on the entire package, out of love and the privilege of being part of an exciting new project.

I remember making my report about Miss Coleman at a subsequent gallery meeting, and recall all manner of objections, centering mainly on the fact that Miss Coleman was not a serious person but a rich uptown Sarah Lawrence girl horning in on creative dedication. When I pointed out that she was offering her services gratis, the group relented and Miss Coleman was voted in.

She was a hard-working, splendid director, with a personality as endearing as it was easygoing. Not only did she sit in that lugubrious third floor, but she wrote endless letters to editors, museums, etc., made endless phone calls on every artist's behalf, aided in hanging every show, and more often than not provided food and wine for those artists too broke to buy their own. What is more, Miss Coleman got results. The press came. *Art News* reviewed each show and seldom failed to include a reproduction. The *Times* came and so did the *Tribune*, but perhaps even more

important, the artists came—not just the gallery artists—talked about what they saw, and in many cases brought dealers to have a look.

Little by little, the Hansa Gallery began to be talked about and, true to my word, I began to organize a series of events, all of which were extremely well attended and yielded some extra cash for the gallery's meager bank account. I charged a two-dollar donation fee for the lectures, among them a fascinating talk by James Johnson Sweeney (then director of the Guggenheim Museum) on the sculpture of Gaudí, a lecture on "Proust and Painting" by the scholar Wallace Fowlie, and a recital of international folk songs by the gifted American folksinger Cynthia Gooding.

Jane had her first one-man show at the Hansa Gallery in 1953, a show which was duly reviewed in the *Times, Tribune*, and in several art publications and which gave her the encouragement she needed. Her show included still lifes, figures, and landscapes, one or two of which sold, providing us with much jubilation and some badly needed cash. The other members of the gallery fared no less well and the Hansa provided an important beginning for their various careers. Jan Muller, who was really the leader of the group, began by showing vivid abstractions composed primarily of brilliantly colored squares. Later, he moved into a more figurative style in which horsemen and nudes would appear in expressionist landscapes. Muller had come to this country from Hamburg, Germany, and later became a student of Hans Hofmann. He was a thin, intense, highly energetic young man who developed, as time went on, a serious heart ailment. He was so poverty-stricken when we met him that he sometimes had to paint on bed sheets, there being no cash for canvas. Recognition did not come to him easily. Shortly before his death in the late fifties, he had begun to make a name for himself and his work remains forceful, intense, and lyrical.

Allan Kaprow is now a major avant-gardist. After inventing the "happening," he became a seminal influence in the art of the sixties. When he joined the Hansa Gallery, Kaprow was painting murky pictures in the abstract expressionist vein. He was a most

conventional fellow, always neatly dressed and cleanly shaven, soft spoken, and full of a charming formality. I recall that when his show at the Hansa came up, the opening was duly attended by his mother, who supplied a wonderful home-made spread of chopped liver.

Richard Stankiewicz, a dark, brooding, silent young man, began by showing witty constructions made up of found metal parts. Later he was to construct highly inventive sculptures out of numerous varieties of pipes, wheels, cogs, et al, becoming a leader in what was then called "junk sculpture" and a precursor of "funk art." Stankiewicz was usually found in the company of another Hansa member, Jean Follett. Miss Follett appeared to be a few years older than Stankiewicz, and had her own eccentricities. Her work consisted of black and white canvases, the surfaces of which usually contained three-dimensional objects—painting constructions, really—which never quite ignited the imagination of the public. Her *idée fixe* on black and white extended to her own apparel. She never wore any other colors and even affected very black sunglasses, which she actually needed for medical reasons. This artist was also given to putting exorbitant prices on her work, sometimes charging as much as forty thousand dollars for a single canvas. Since very few sales were ever consummated at the Hansa Gallery, the preposterousness of Miss Follett's prices became a great source of amusement to us all, especially since other members of the gallery were charging prices that often started at twenty-five dollars and rose to a dizzying two hundred dollars for a large painting.

Wolf Kahn was the conciliatory force of the Hansa Gallery. It was he who mediated all squabbles, cajoling and laughing, playing peacemaker in every altercation. He showed sensitive, moody landscapes in the style of Monet, which brought a romantic touch to the gallery roster. Kahn has gone on to acquire a reputation for imaginative and very personal landscapes.

Miles and Barbara Forst, married and extremely handsome, were the free spirits of the group. They gave marvelous parties and dinners, and at a time when drinking was the accepted vice

of artists, were ahead of their time, making inroads into the drug scene. Both Miles and Barbara were involved with the Hofmann School artists, and painted large, unrestrained abstractions. Jacques Beckwith, a charming though unnervingly quiet young man, held a job as carpenter-cabinetmaker and as a painter was involved with the square. He liked to work in very small sizes and produced any number of intensely charged small canvases. Felix Pasilis painted wonderfully lyrical florals. They brimmed with hot Bonnard colors and amazed everyone by the great discrepancy between his turbulent personality and his vigorous, sensitive creative output. Later, he embarked on a variety of styles, never quite finding his own voice.

The Hansa flourished on East Twelfth Street for some three years. For reasons born of greed and frustration, however, the Hansa decided to move uptown, in order to be closer to the mainstream of gallery life, which in the fifties centered around Fifty-seventh Street. The gallery moved to 120 Central Park South, to a one-flight walk-up facing Central Park. By this time, Anita Coleman had left the gallery to marry an investment broker. She was succeeded by Richard Bellamy, a scruffy, wraithlike boy, a silent watcher with no discernible gift for meeting the public or producing sales. Nevertheless, Bellamy had an uncannily prophetic instinct made clear years later in the sixties, when he ran the Green Gallery, which was to prove an important stepping-stone for every major American Pop artist.

In the Hansa days, all the artists got along with Dick Bellamy because of his intense love of art. Also, he attracted a number of new artists to the group. One of these was George Segal, who painted impressionist abstractions, employing a deep, transparent palette and a gentle, sweeping brushstroke. Segal later developed a style that would make him world famous, by covering the human figure with plaster and producing casts of figures in various stances. There was also an artist named Myron Stout who, like Jean Follett, was enamored of black and white, and painted small, hard-edge canvases in those colors.

When Dick Bellamy left the Hansa, he was succeeded by Ivan

Karp, an energetic, boisterous fellow, who ran the gallery with extraordinary vitality and enthusiasm. He had an aggressive drive that ultimately landed him a vital spot in the art world at the prestigious and forward-looking Leo Castelli Gallery, and later still made it possible for him to open his own gallery—the O. K. Harris Company—on West Broadway in downtown Manhattan.

By the time the Hansa Gallery moved uptown in 1956, Jane had had two shows there. She continued to exhibit uptown as well, producing landscapes from memory that were beginning to be talked about. They were influenced by the painterly qualities of abstract expressionism. Older artists and a number of important critics considered her work to be quite out of the ordinary. However, a number of Hansa Gallery members began to have grave reservations about Jane's approach to her subject matter, and it soon became evident to her that the gallery's direction was one with which she would feel progressively out of step. In 1958, Jane saw the writing on the wall, and in order to save the shreds of her ego, she resigned—not unhappily, since the five years with the Hansa Gallery had given her not only a name but a sense of having been part of an exciting moment in the New York art world.

The Hansa Gallery disbanded in 1959, and there is no question but that it provided a major launching pad for a good number of important careers. It was the longest-running cooperative gallery in the city, and for all the turmoil and slowness of its beginnings, it had been a small but potent force in American art.

Long before Jane joined the Hansa Gallery, it became clear that she could not possibly spend twenty-four hours a day painting, and since no decent job seemed forthcoming in the teaching profession, we decided that she might try and find a job to help our finances and to give her something else to do. Three weeks of working in a Park Avenue bookshop proved dismal. What she finally found was an entry into a world that was in total contrast to the world of art, or to Jane as a person and an artist. This was

modeling—a profession that Jane worked in for seven long years.

The idea of a painter being a fashion model in the fifties was very unusual indeed, and the art world found it utterly preposterous and infra dig for a serious painter to embark on such a frivolous profession. The fact of the matter was that Jane painted far more while she was modeling than when she was not. Some of her most successful landscapes were done at night in our small apartment. Modeling never went to Jane's head, and the idea of being a clothes horse was never one of her dreams. Indeed, Jane must have been the only model on Seventh Avenue who only on the rarest occasions visited a beauty salon, had her nails done, or became obsessed with the sort of grooming that is the *modus vivendi* of the New York fashion model. For all that, she worked steadily and well and, of course, managed to earn far more money than I did.

In the fifties an artist could do anything as long as it had an artisan cast to it. There was nothing wrong with a painter also being a draftsman, a carpenter, a postal clerk, newspaper vender, or even a window dresser, just as long as it had the proletarian atmosphere about it. As for the lady painters, it was preferable that they not work at all, or, if they did work, that they teach, work in an office, or become another painter's mistress.

The going gear for both male and female artists ran to blue jeans, overalls, denim shirts, pea jackets, and the like. It was the army-navy-surplus-store look, which carried the not very subtle overtones of "the simple workingman" with a lunchpail. This look superseded the forties' "gypsy Provincetown" look. In short, to be at all fashionable in the fifties meant you weren't very serious. As far as the women painters were concerned, their attire was invariably masculine. Joan Mitchell, one of the best of the second-generation abstract expressionists, seldom wore a dress. Grace Hartigan (who began her career by calling herself George Hartigan) tended toward bulky sweatshirts and heavy skirts. The exotic Marisol started out in blue jeans and pigtails, although

she went through several later sartorial transformations, from Aztec maiden to Rima the Bird Girl, through Nefertiti, to *haute couture* Dior and Balenciaga. Jane decided not to go along with the male-protest attire, and never wore jeans.

As time went on Jane came to the attention of the New York press. To be a serious painter as well as a fashion model made good copy and several magazines, including *Glamour, Coronet,* and *Life,* did picture stories about her. This publicity resulted in her being asked to be on one of the most famous and ill-fated television quiz shows of the fifties. For seven mad weeks, in 1957, Jane Wilson was a contestant on the *$64,000 Challenge.* One of her co-contestants was Larry Rivers. As it turned out, Jane was among the losers (after seven weeks she received a one-thousand-dollar consolation prize, and countless cartons of Kent cigarettes). Larry Rivers, on the other hand, won a fortune, and through the power of the tube became the most familiar serious painter in the nation. Jane's television exposure also helped her career, and her work began to sell.

It was at this moment that the members of the Hansa Gallery were beginning to feel that Jane's work was not going in the direction they had envisioned. In point of fact, the publicity she was receiving was anathema to the "purity" of their creative ideals. This, plus the fact that she was modeling, abetted their progressive mistrust of her art.

4

In the meantime, I had decided to quit Brentano's. The decision was prompted by meeting Barney Rosset, the owner and publisher of Grove Press. I met Barney through his first wife, the painter Joan Mitchell. When we met Joan, she was in the process of divorcing Rosset. The two had been married for a number of years, having met in Chicago, where both had been born. Both their families were exceedingly well off, and as individuals each had enormous drive and ambition. They were young and, at the time, it was Joan who had the "going career." Barney had vague hopes of breaking into film making. He had, in fact, already produced a documentary, but seemed undecided about what to do next.

At the beginning of our friendship with the Rossets, our function was to bear witness to their endless fights. It was like a game in which a naïve audience was needed for "the performance." I vividly remember one dinner party Jane and I gave in our brand-new, freshly painted apartment on Bleecker Street. We had finally moved out of West Twelfth Street, and the first thing Jane insisted on was immaculately white walls. It was an intimate little dinner—just the four of us by candlelight. Things started out smoothly enough, until Barney noticed that Joan was reaching for a second helping of food. "I wouldn't eat that, if I were you," interjected Barney, "you're getting fat around the middle." With that, Joan took a ripe tangerine out of our fruit bowl, stood

up, and aimed it with enormous violence at Barney's head. Barney ducked, and the tangerine landed with splattering force on our virgin walls. Thus began one of the more memorable of their many fights, with a barrage of four-letter words filling the air, mercifully replacing the tangerines.

Joan Mitchell was among the most talented of the second-generation abstract expressionists. She began to show her large, volatile canvases at the New Gallery, and later at the Stable Gallery, then located on Seventh Avenue at Fifty-eighth Street, and once an actual horse stable. Joan's work was related to landscape by the wind-blown rush of paint that covered her canvases. Shot through with lyrical passages of color, the paintings were personal, fresh, and forceful. Joan was an extremely ambitious and competitive painter, in full possession of her creative faculties.

In conversation she categorically eschewed any concessions to femininity. She adopted a one-of-the-boys stance without sacrificing her basic female demands or interests. She was a passionate creature, given to feeling things without restraint and, while she expressed herself in a language designed to shock, there was an endearing honesty about her flights of emotion. She became extremely successful, selling her work to important collectors and museums, and remained in New York until she fell in love with the French-Canadian painter Jean Riopelle, who worked and lived in Paris. While continuing to show periodically in New York, Joan Mitchell chose to make her life in Paris, where she now lives and works in a house once occupied by Claude Monet.

Our friendship with Joan Mitchell was of the rollercoaster variety, either total hatred or total love. Joan found me to be lacking in artistic focus. My life was too vague for her. I had no hard-core drives, which was infuriating to her. She liked Jane well enough, and made a point of attending her openings. Still, though she consistently praised Jane's paintings, she seemed not altogether convinced about their timeliness or relevance.

We saw quite a lot of Joan. We also saw a great deal of Barney Rosset, and as time went on, Joan and Barney began to be on friendly terms again. I recall a Thanksgiving dinner party at Ros-

set's at which Joan, two former girl friends, and a new love, Loly Eckert, were present. It was Barney's own little family. He loved—and perhaps still does love—to bring together individuals who can create some sort of spontaneous combustion.

There was much cheerfully aggressive banter and gossip during dinner, and later we put on records and danced. One girl had brought along her eight-year-old daughter, who was put to sleep on a couch in the same room. The music awakened her, and when she saw that I was dancing with her mother, she set up a howl that put all of us on edge. No matter how often she was told that I was really a very nice man, the little girl would not abandon her vociferous objections. There was nothing to do but to find another dancing partner.

I danced with Joan Mitchell, and during the dance told her she looked very beautiful. She stopped in her tracks and, inexplicably, burst into tears. She ran from the room, and when she re-emerged, she did not speak to me for the remainder of the evening. Bereft of yet another dancing partner, I now turned to Loly Eckert, who said she did not feel like dancing, but made room for me on the couch and proceeded to tell me that she was furious with Barney for having invited his ex-wife and his ex-girl friends. The fact was, Loly was Barney's new girl, and she quite naturally thought it malicious that Barney would do such a thing. Then she and I talked about our own immediate past.

I had met Loly at Brentano's. She had been a salesgirl in the children's books department during the time I worked there, and I learned she had just arrived from Germany. I thought I would befriend her. She had a Dietrich look about her—a certain languorous quality that was most enticing. She looked very run down, and had obviously been the victim of hard times. We used to have coffee together and she told me how she had been married to a German, and had borne him a child which had died of malnutrition during the war years. When this happened she divorced her husband and involved herself with a number of artists, actors, and painters, leading a strenuous Bohemian life. She seemed to have been the darling of many creative worlds in various cities

in Germany. Finally, through relatives living in this country, she came to New York.

Loly Eckert lived in Greenwich House down in the Village, and she wanted to make a life for herself among the writers and painters in the city. Jane and I invited Loly to dinner and on several occasions asked her to come with us on excursions to bars or parties. I had always suspected that Loly really wanted to meet a man who would give her both financial and psychological security, and it dimly occurred to me that the just-divorced Barney Rosset might find her interesting. At the same time, I knew that Barney was by no means the stable kind of man Loly had in mind.

One evening, I ran into Barney Rosset at the Cedar Bar. We sat together, and Barney began telling me how lonely he had felt since his divorce from Joan. Didn't I know someone who could appease his loneliness? I told him about Loly Eckert. "What's her phone number?" said Barney. I gave it to him, and right then and there he called her. When he emerged from the phone booth, he told me she couldn't see him that evening, but that it would be all right for him to call her again.

The two finally met and hit it off. I did not consider their relationship ideal, since the high-strung Barney seemed ill suited to the seemingly passive and shy Loly. Nevertheless, the divergencies of their personalities seemed to spark a mutual need. Barney's generosity toward Loly made itself felt almost at once. He sent her to expensive doctors, to an expensive dentist, and the like. After a few months Barney Rosset and Loly Eckert became man and wife, attended by Jane and me as matron of honor and best man.

5

Barney. He became a central figure in my life. He fascinated me. I liked his wiriness, his nervous intensity. There was something electric in him—and something devious as well. His mind was quick, his intelligence arresting. Never particularly handsome, he was attractive by virtue of his tremendous vitality. There was nothing that did not interest him, and his enthusiasm was catching. He grinned a lot—and he laughed obsessively. He was hysterical and rather mad in those days, but always interesting.

At the time we met—it must have been in 1952— undecided about what to do, he ran into a young, insolvent publisher who had recently started a small press with three pieces of esoterica: *The Verse in English of Richard Crashaw, The Confidence Man* by Herman Melville, and *The Selected Writings of Mrs. Aphra Behn.*

These books were all published by the tiny firm, called Grove Press, which at the time was located at 18 Grove Street in Greenwich Village. Rosset bought the press and its few titles and set up shop in a brownstone on West Ninth Street, which was also his residence. He stored the newly acquired books in a back room, carted the few incoming orders to the post office, and launched Grove Press under his aegis and editorship.

Whatever his thoughts about embarking on a publishing career, I don't think Barney Rosset ever dreamed of becoming the

great liberator of the printed four-letter word. These were the pre-*Lady Chatterley's Lover* days, before the Marquis de Sade and Henry Miller's *Tropics*. Barney had not yet latched on to a gold mine by publishing such authors as Samuel Beckett, Jean Genet, Eugene Ionesco, William Burroughs, and Jack Kerouac. And it was many years before he would make several more millions by establishing Evergreen Films and importing such films as *I Am Curious (Yellow)*.

Barney had always been interested in offbeat literature, and in 1952 the idea of publishing certain little-known classics appealed to his quirky intellect and individuality. He published wonderful little books in the early days of Grove Press—minor classics such as Radiguet's *Count d'Orgel* and Alfred de Vigny's *The Military Necessity*. Of course, many of these titles were imports from abroad and could be obtained for little money. Still, it was a matter of selection, and Rosset selected well.

Barney's enthusiasm communicated itself to me and, while still working at Brentano's, I thought how splendid it would be to join his venture. I was aware that Grove Press could not afford to hire too many people. One day, however, without any suggestion from me, Barney asked me to come and work for him. He felt I might make a fine publicity director, that he ought to have someone in his office writing press releases and making contact with newspapers and magazines.

I accepted at once, and my life in publishing began. The day I was hired, Barney and I rushed to West Twenty-third Street to buy me a desk and a chair and a typewriter—all secondhand of course. I insisted everything be delivered at once so that I could get started writing my first press release. The moment we got back to the office Rosset called the phone company to install a new phone to go with my old desk.

At the time, the staff of Grove Press consisted of Barney as editor-in-chief, Donald Allen as editor, Marilynn Meeker, who took care of billing, etc., and now me, the inexperienced publicity director. Donald Allen had come from San Francisco and I believe it was he who brought the press its Oriental titles—the

Anthology of Japanese Literature and books by the Orientalist Arthur Waley. Allen, a mild, soft-spoken, sensitive young man, did not immediately take to me. He found my publicity tactics primitive and a little vulgar. He continually made me feel as though I were offending his sensibilities. Ultimately, he got used to my ways and we were able to communicate superficially. Allen stayed with Grove Press for a number of years and finally returned to San Francisco.

Marilynn Meeker, a quiet girl with a quick and ready smile, was the most even-tempered of us all. She and I got along very well and it was good to see her graduate from the billing department to the editorial staff. By dint of her extraordinary capability, patience, and charm, Marilynn Meeker survived the endless turnover that was to mark the formative years of Grove Press.

As the months went by Grove expanded and moved to a spacious loft at 795 Broadway, immediately across the street from Grace Church. The staff expanded as well. An extremely jovial and intelligent fellow by the name of Howard Turner became an editor. He and I had a jolly time due to his singular wit and good humor.

It now occurred to Barney that the new Mrs. Rosset would make a wonderful addition to the staff, and she was forthwith hired as, of all things, a sales representative. It was Barney's notion that Grove Press titles would sell like mad if the person selling them was a beautiful and sophisticated girl with a soft German accent. It was a classy idea, I suppose, and another instance of Barney's doing things a bit differently.

As time went on it became clearer and clearer that Rosset was a highly demanding employer-friend whose involvement with his staff went beyond the call of mere business. We were really his whole life—we and the press. To have known him in those years was to be in contact with an exceedingly complex and endearingly unpredictable young man. The dark side of his personality disclosed an erratic manipulator who could toy cruelly with people's feelings and whose basic instability led to bouts of fury, stubbornness, and a disregard for simple human logic.

He was given to outbursts over the most insignificant business details—and, all too often, betrayed a certain disagreeable, spoiled quality. He had a way of whining when things didn't go right, and his aggression, usually couched in nervous giggling, always hit its mark.

Barney and Loly began to fight with almost as much violence as had he and Joan Mitchell. Loly was not one to take verbal abuse, and became highly adept at striking back. When she became pregnant, it was decided that she stay at home. She began, at this point, to take an interest in photography. Barney had just bought himself a house in East Hampton, Long Island—one that had belonged to the painter Robert Motherwell. It was in the shape of a Quonset hut, but Barney and Loly redesigned its interior, which included a thousand little gadgets for the gadget-mad Rosset, as well as a fully equipped darkroom for Loly.

I worked for Grove Press for just under one year. My job kept me busy and I believe I was useful in promoting many of its early titles. It seemed to me that the company was moving along with a certain success. The paperback explosion, spearheaded by Jason Epstein at Doubleday, gave everyone in the publishing business a tremendous jolt, and Barney Rosset was not unaware of its potential. I recall suggesting to him that he too move into paperbacks, but he rather rudely dismissed the idea, claiming it would be financially unfeasible and not in keeping with Grove's ideals. He embraced paperbacks with a vengeance some time later, despite these grand words.

Loly Rosset and I did not have much contact after she married Barney. There was no reason why we should have maintained a separate friendship, now that we were all more or less one happy family. Besides, she was ostensibly my boss as well. I began to notice that the Rossets' attitude toward me and my work changed, imperceptibly at first, but rather markedly toward the end of my stay at Grove.

Finally, the ax fell. In the most innocent manner, both Rossets invited me for lunch and calmly explained to me that the company could no longer afford a publicity director. I am certain

they went on to give all kinds of rational explanations, but I wasn't listening. All I knew was that I had been fired and, what was worse, betrayed by people I had thought were my close friends. I lost no time emptying my desk and went home to give Jane the news. I was miserably hurt, having believed my post was as secure as my friendship. The Rossets kept telling me that they wanted to keep me as their friend, but that they simply couldn't afford me any more.

It is true, of course, that while I loved the job I did not envision it as my life's work. It would have been far too circumscribed for someone who was not basically passionate about the publishing world. On the other hand, the Rossets' act of malice caused me considerable pain. Yet Jane and I continued to see them, and the Rossets made every effort to treat us like close friends. I remember one weekend being invited to their house in East Hampton and becoming violently sick from what I supposed was an overindulgence in steamed clams at dinner. But I suspected that the constant retching and night-long physical agony were due equally to the proximity of my ex-friends. The truth is, I secretly hated being with them.

Barney's private life continued in its own erratic round. He and Loly were at constant swords' points, but their young son, Peter, kept them together for longer than anyone had expected. The two divorced after four or five years of marriage, and I often wonder how things would have turned out had I not met Barney at the Cedar Bar that night and spoken to him about Loly Eckert. As for Grove Press, it has made history and Barney has become both famous and rich.

6

Music has always played a vital part in my life, and an especially active one during the fifties. One of my driving ambitions when I was young was to become a composer. As a boy in Italy I was exposed to a great deal of music in my own home and at friends' homes. What Italian household did not resound with one form of music or another? The children sang, the maids sang, the mothers and the sisters and the relatives all sang—the familiar folk songs, popular songs of the day, or snatches from some Verdi opera—and beyond all this, there were the radio, the phonograph, and bands playing in the parks.

The most singular musical event of my childhood was my first opera, seen in the open air in Milan at the Castello Sforzesco. This was a performance of Verdi's *Aïda*, a spectacle designed to spin the head of a ten-year-old, with live elephants, horses, monkeys, and dogs, spectacular sets, billowing costumes, and a cast of thousands. The music that poured out of the pit was spine-tingling, but what got to me was the sound of human voices producing unbelievable melodic beauty.

For the first time in my life I became aware of the incredible emotional force that vocal music could exert, and I began to harbor the notion of writing music for voice, the most beautiful instrument of them all.

It would be years before I actually wrote my first song. Needless to say, I soon came to the realization that one could also be

moved by music that did not include the voice, and during my New York adolescence music became the strongest contender with my passion for the movies.

When, in 1944, I arrived at the State University of Iowa, I was determined to learn to play the piano and began to do so as an adjunct to my school curriculum. There had been one or two abortive starts in New York prior to Iowa, with private teachers, but they did not add up to much. I kept memorizing everything very quickly and found simple sight reading tough going. But in Iowa I managed to improve, and was finally able to sight-read with a small measure of fluency. At the university, I also began to compose, without benefit of courses in music composition. I would take a poem that interested me and set it to music which was at first improvised on the piano and then painfully notated. This process took an inordinate amount of time and I had only myself to blame for not pursuing music instruction with greater seriousness.

The songs I wrote began to sound rather interesting but still I did not enroll in the music department. Somewhere I had the feeling I could do it without study, that the music would simply pour out of me, and that a brilliant young, self-taught composer would emerge. I struggled in this fashion through my college years, setting all sorts of marvelous poetry to music—much of it in German, French, and Italian.

About this time, I met Jane and discovered that she had studied voice, was proficient at the piano, and could sight-read far better than I. Were this not enough, she also had the temerity to possess perfect pitch. My love for Jane expanded when I further discovered that she could write down the music I was composing, thus relieving me from the dismal job of putting notes to paper. Through Jane I began to form an obsessive interest in vocal literature. We would sit for hours at the piano and go through volume upon volume of songs by Schubert, Schumann, Brahms, Wolf, and all the early Italian and French composers.

Jane sang these songs in a wonderfully pleasing mezzo-soprano voice—a voice not fully trained but with just the right emo-

tional and musical nuance—and she sang them in the languages they were written in. We pored over hundreds upon hundreds of songs, which I would accompany quite badly, but musically enough to get their sense. It was marvelous training for us both and it has become an occupation which fulfills us to this day. As I studied the masters of vocal literature, I became more and more fascinated with the song as a musical genre, and when Jane and I came to New York I continued to write my art songs, which now incorporated certain modern influences, such as Charles Ives, Stravinsky, and Poulenc. This song writing was done during the hours I was not earning a living at Brentano's or at Grove Press —at night, on weekends, or early in the morning before dashing off to work.

Having written all these songs, I was naturally interested in having them performed and began to search for singers who would sing them at recitals. I met my first victim at Brentano's bookstore, a beautiful and vivacious young woman named Georgiana Bannister who had chanced into Brentano's to visit a friend among the sales help. I had lost no time in broadcasting my desire for musical recognition around the store, and so Miss Bannister was introduced to me.

Georgiana was born in North Carolina and had sung extensively over radio and television, including numerous recitals with the NBC Concert Orchestra. When I met her she was studying on scholarship in the opera workshop of the Mannes School of Music. Hers was a fluid, lyric soprano voice particularly suited for singing contemporary music. I told Georgiana that I had composed some songs and she very kindly asked me to send some to her. Some days later I received a call from her telling me that she thought them very beautiful. She wondered if I would like to work on them with her, and I agreed immediately. We set a date and embarked on the study of six or seven of my songs. Through Georgiana I met various accompanists, one of whom turned out to be Charles Wadsworth, who today runs the Lincoln Center chamber concerts at Alice Tully Hall. Wadsworth, a sensitive pianist, also from the South, seemed to like my songs as much as

did Georgiana and one day the two performed a number of them in a private home. I was soaring with happiness over the fact that professional musicians were interested in my music and that at the age of twenty-two I was beginning to be taken seriously as a song composer.

Some months later something of a crowning achievement occurred in my musical life. While still a student at Iowa I had met a young poet by the name of John Logan. He had just converted to Catholicism, and had written some extraordinary poems inspired by his new-found religion. John inflamed my interest in poetry in general, and was among the very first to hear my songs, giving me much intelligent criticism and encouragement, and a great deal of youthful overpraise.

He and I kept in touch after our departure from Iowa, and we maintained an extremely lively correspondence. I wrote to him about meeting Georgiana Bannister and about the various little triumphs concerning my songs. At that point in John's long and incredibly checkered career he found himself teaching at St. John's College in Annapolis, Maryland.

One wonderful day, John invited Miss Bannister, me, and Jane to come to Annapolis for an all-Gruen festival. He had arranged through the college's music department for a concert devoted entirely to my songs to be sung by Georgiana Bannister, with me, the composer, at the piano. He had further arranged with the college's art department to have a one-man show for Jane Wilson. John's talent for persuasion must have been extraordinary because none of us, except for Georgiana, had any true professional status. The date was set, Georgiana and I prepared a concert that would include songs set to the poetry of E. E. Cummings, Rainer Maria Rilke, Franz Kafka, Friedrich Hölderlin, and some anonymous Japanese poets translated into French. Thus, we had a traditional program—a German group, a French group, and an English group. We worked furiously for about three weeks, while Jane was nervously getting ready for her very first one-man show.

We arrived at Annapolis drunk with a sense of celebrity.

Logan put us up in his house, held a party that same evening, and planned another, following the concert and the showing of Jane's work. The next evening, Georgiana Bannister and I found ourselves on the stage of the college's music auditorium performing as though we were Lotte Lehmann and Bruno Walter.

The audience clapped furiously and shouted bravos at two young people they had never heard of before. When the concert was over and we were all gathered at Jane's exhibition in the basement, a tall, lanky, and charming young man came up to us, introducing himself as Jac Holzman. He was a student at St. John's, he said, but was about to enter into a business venture—namely, producing long-playing phonograph records. Would Miss Bannister and I be interested in recording our recital for him? We accepted on the spot. Holzman said he would be in New York the following week and would get in touch with us. This he did, and the entire program was recorded in a studio which Holzman had rented for the occasion. I asked Holzman what he was calling his company, and he replied, "Elektra Records."

It is amazing and improbable that Elektra Records should have been launched by an album entitled *New Songs by John Gruen*. But it had happened, and I was now a recorded composer with sixteen songs covering both sides of a twelve-inch record. The concert had taken place on December 3, 1950, and the recording appeared some months later. It was duly reviewed and critics, including those of the *Saturday Review*, the *Times*, and the *Tribune*, were unanimous in their praise.

While we were glorying in this singular piece of good luck, I began to realize that my record was not selling. I kept buying copies myself and handing them out to friends and acquaintances, hoping that it would spark further interest by word-of-mouth, but to no avail. Holzman continued to record contemporary music, aligning himself with more distinguished names, such as Milhaud and Hindemith. His object was to produce recordings in which the composers themselves participated. The success he achieved was primarily of a critical nature, and Holzman came to the conclusion that there was no money in modern music in the

early fifties. He looked around him, opened his ears, and realized that New York was in the throes of the folksong craze. He quickly shifted gears and launched himself anew as a producer of recorded folk music. To this day Elektra Records continues to issue folk music as well as rock and roll and folk rock. Historically speaking, however, the company was founded with EKLP-1, *New Songs by John Gruen*.

I now sought to have my music published, and lost little time in approaching such venerable music houses as Schirmer's, Fischer's, and Peters. I made appointments, spoke to editors, left my manuscripts, and then waited for excruciating weeks and even months. Finally, word came through that contemporary songs were a risky proposition, and one by one the publishers returned my gems. Undaunted, I began to approach other singers to perform my music in recital. A number took an interest, and from time to time some young soprano or tenor would include one or two of my songs in their programs.

It had always been my dream that the famed and gifted Jennie Tourel would one day sing my songs. As a student in Iowa, I had heard Miss Tourel's recording of Prokofiev's *Alexander Nevsky* and became obsessed by the beauty of her voice. I remember writing her a lengthy fan letter in which I naturally mentioned my own music and made it clear that the fulfillment of all my musical hopes would be to hear my songs performed by her.

I never received a reply, but when I had been in New York for two years, I saw Miss Tourel on the street. I brazenly stopped her, introduced myself, and asked her why she had never answered my letter. I had deemed this such an impassioned piece of mail that it never occurred to me she would forget its overwrought content. Miss Tourel, who was at the height of her career, looked at me with great astonishment and said a few words of thanks. "Why don't you send me some of your songs?" she finally said, and gave me her Fifty-eighth Street address. I also managed to wangle her telephone number. I dashed home, put a dozen songs in the mail, and after a week telephoned her. Miss Tourel very kindly invited me to come to her apartment so that I

might sing the songs to her myself. She said she had had no time to look at them but would do so in my company. Filled with anxiety, I appeared at her door, was greeted cordially, and very soon was at the piano singing my heart out. Afterward she said that she had promised Aaron Copland to sing some of his songs and hadn't gotten around to it so far, so she did not see how she could, in all fairness, devote herself to the study of my songs, at least for the time being. She mentioned the vague possibility of her singing one or two on her next tour, specifically in Israel, where she felt my songs would be popular.

It has now been twenty years since I met Jennie Tourel. I have grown to know and love this remarkable lady and continue to adore her voice. But Miss Tourel has yet to sing a single song of mine, a fact that has remained one of the tiny thorns in my composer's heart.

One of the most spectacular voices of the fifties belonged to the soprano Patricia Neway. Gian Carlo Menotti's *The Consul* launched Miss Neway's career and she was hailed as one of the leading sopranos of the period. Jane and I had gone to see the opera and were moved by it despite the many banalities of the score. We were both deeply impressed by Patricia Neway, and began to follow her career with great interest. Some time later, we were fortunate enough to meet this marvelous singer and through a series of fortuitous circumstances, Miss Neway asked to see some of my songs. It seems she was preparing an unusual recital at the YMHA on Ninety-second Street, and wanted to sing a program of songs set to the words of James Joyce. As it happened, I had just completed a song cycle based on Joyce's *Pomes Penyeach.*

I showed this cycle to Miss Neway and she liked it enough to include it in her recital at the "Y." I was extremely happy to have been in the company of composers such as Samuel Barber, among others, in this unusual program. Subsequently, Miss Neway recorded the Joyce songs, and once again I appeared on a recording. Armed with this new small triumph, I again attempted to get the cycle published. No one would take it.

Here and there my songs began to be known in New York's music circles. Miss Bannister sang a new cycle I had just composed based on the poem "Thirteen Ways of Looking at a Blackbird" by Wallace Stevens. She sang it on the air and at a concert at Town Hall sponsored by the National Association for American Composers and Conductors. Patricia Neway included a number of them in a subsequent recital, and I began to meet several young composers who were equally passionate about song literature.

Of all the song cycles I have written, and there are quite a number, the Stevens cycle received the greatest attention. I had met the poet during one of his visits to New York, and talked about having set his "Thirteen Ways. . . ." He told me he was most flattered but that he did not have much of an ear for music. He asked me to keep him abreast of my work on the cycle, and so began a short but interesting correspondence between us.

Stevens, who was a vice-president of the Hartford Accident and Indemnity Company in Connecticut, came to have dinner with us one evening—on the very evening I finished my cycle. Of course, I planned to sing it to him but in the meantime we talked about his poetry. This burly, fascinating man, whose work, so full of strange lights, had always moved me very much, was not loquacious, and his conversation could not be called dazzling or arresting. On that evening there were no memorable exchanges about the art of poetry or the art of life. Nevertheless, when I finally sang him the songs, Stevens did seem intrigued by the transformation of his words into music.

When the cycle was later recorded by Patricia Neway, I sent him the record. I also sent him my first record, *New Songs*, which he apparently liked much more than his own cycle. But the Stevens cycle remains one of my very favorites and I was particularly thrilled when my friend John Logan published a piece about it in *Hudson Review* in the summer of 1956. Entitled "John Gruen's Settings for Wallace Stevens," it meticulously dissected the poem in terms of the musical structure I had superimposed upon it. Logan's acute observations gave my work an im-

portance and distinction I hardly knew it had.

Songs and more songs continued to flow from my highly untutored pen. Amazingly, more and more people began to sing them. Through friends of ours, I learned that the Metropolitan Opera soprano Eleanor Steber was about to embark on a government-sponsored tour of the Far East, and that she was in the market for songs by new young American composers. Miss Steber had always been a friend of American music, and had just commissioned Samuel Barber to write *Knoxville, 1915*, based on a prose piece by James Agee.

I secured an appointment with Miss Steber, went to her apartment, and once again sang a sampling of my songs. She seemed to love them, and kept a number of them for possible use on her tour. Months later, Miss Steber told me that she had indeed sung my songs in Formosa, and that they had been a great success except for the fact that she was obliged to give her recital on the dangerously sloping stage of a movie house and, just as she was opening her Gruen group, the piano began to roll toward the pit. Luckily, the piano stopped abruptly at the foot of the stage, held in check by her bewildered accompanist and a large group of people in the audience. She wanted me to know, however, that when the piano was finally back in place, she proceeded with my songs and all of Formosa seemed excited by them.

In the early sixties, Miss Steber was also kind enough to perform an entire program of Gruen songs over station WNYC. My good friend Alvin Novak was the accompanist, and it proved an exhilarating occasion, especially since the soprano gave a short commentary on each of the songs—some of which was very much her own invention. Toward the latter part of her career Miss Steber and her husband formed a recording company called Stand Records. One of their albums was a two-record set called *Songs of American Composers*, featuring twentieth-century songs by many of the best-known Americans, and performed alternately by Eleanor Steber, Mildred Miller, John McCollum, and Donald Gramm. Mr. McCollum recorded three of my songs based on the poetry of E. E. Cummings.

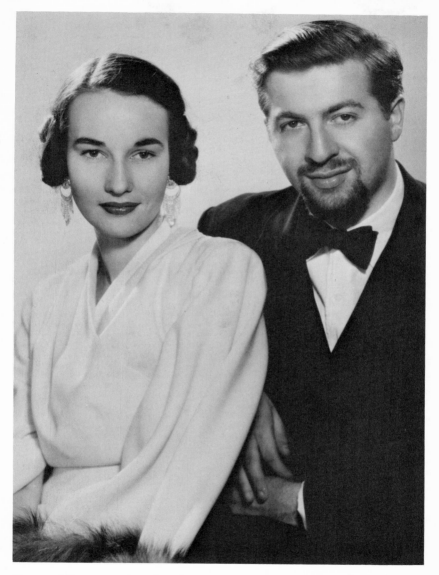

Our wedding portrait, taken in 1948. Though we were married in
Oskaloosa, Iowa, we felt that an Iowa City photographer would
lend a more sophisticated touch to the newlyweds. It was in 1948 that
I also decided to grow a beard to go along with the suave Vincent
Price image I had of myself.

My kindergarten class, Berlin, 1931. That adorable little blond boy on the aisle in the third row of the larger group, hands folded on his desk, is me in pre-Nazi Germany. Note the child across the aisle solemnly holding a Swastika flag.

In my *Figlio della Lupa* uniform.
Milan, 1936.

Riccione, 1937, my family's favorite summer resort in northern Italy.
An outing with my parents in our Fiat touring car, my father at the
wheel; my mother in striped dress sits in back seat with a friend.

At a costume ball at the University of Iowa, 1948. Jane and I came as *Sacred and Profane Love* (we let people guess who came as what), and proceeded to win first prize. A neatly wrapped gift was handed to us which was stolen at the end of the party. We never bothered to find out what we had won.

Seemingly madcap Jane, posing
for "test shots" to further her
modeling career. New York City,
1952.

Barney Rosset and Loly Eckert, just married. Jane and I were matron of honor and best man. The brick building with large window and pointed roof was the second headquarters of Grove Press, where I worked as director of publicity. New York, 1953.

Singing my heart out for Metropolitan Opera soprano Eleanor Steber. The songs were penned by me, and Miss Steber later sang them on a government-sponsored tour of the Far East. New York, 1956.

Our friend Ned Rorem, composer of much beautiful music, including endlessly gorgeous songs, as well as the author of several books, among them, the infamous *The Paris Diaries of Ned Rorem*. New York, 1960. (*Photo by John Gruen*)

Famed composer and critic Virgil Thomson, photographed in Potsdam, New York, in 1960, on the occasion of the world premiere of Thomson's *Mass*, which I reviewed for *Musical America*. (*Photo John Gruen*)

Jane as the White Bishop and I as the Black Bishop, being filmed by artist/film-maker Hans Richter. The movie, entitled *8 × 8*, symbolically dealt with chess. The man in the tree hollow is Marcel Duchamp, acting as adviser to the film. I composed most of the background music for *8 × 8*. Connecticut, 1955.

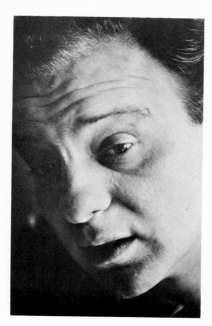

Jack Gelber, who wrote the controversial play *The Connection* presented in the late 1950s by the Living Theater. (*Photo by Paul Fusco*)

Jane greeting friends at her second one-man show opening at the Hansa Gallery (then located at 210 Central Park South). Girl talking to Jane is the wife of Ormond Gigli, a well-known photographer. Man at extreme left is the late Charles Rado, head of Rapho-Guillumette Pictures, the agency I worked for as photographer's agent. The large painting behind Jane is of Virginia Woolf and Lytton Strachey, done after a photograph. New York, 1956. (*Photo by Ormond Gigli*)

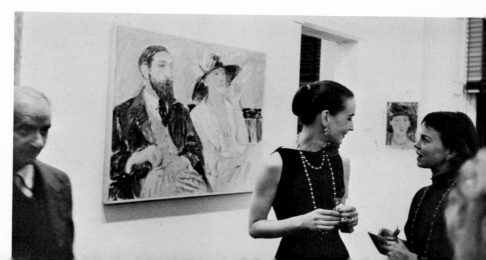

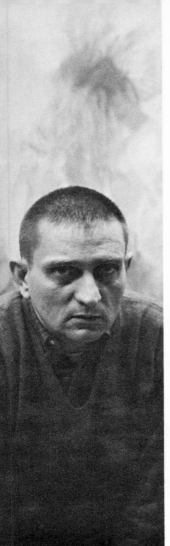

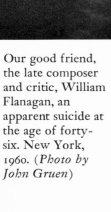

Our good friend, the late composer and critic, William Flanagan, an apparent suicide at the age of forty-six. New York, 1960. (*Photo by John Gruen*)

Jane holding our two-year-old daughter, Julia. New York, 1960. (*Photo by Ken Heyman*)

Larry Rivers and his ladylove of several years, Maxine
Groffsky, photographed in Larry's loft on East Third Street.
New York, 1957. (*Photo by John Gruen*)

We invited gallery dealer Martha Jackson (for whom I was working
at the time) to our house in Water Mill, Long Island. Larry Rivers
(next to Jane) and Clarice Price Rivers dropped over after an
ocean swim. The child holding on to Clarice is our three-year-old
Julia. 1961. (*Photo by John Gruen*)

The late poet Frank O'Hara on a weekend visit to the home of painter Fairfield Porter. Southampton, Long Island, 1962. (*Photo by John Gruen*)

Poet and critic John Ashbery photographed at our Water Mill, Long Island, home. 1962. (*Photo by John Gruen*)

Poet Jimmy Schuyler visiting the Hazan-Gruen ménage in Water Mill, Long Island, 1958. (*Photo by John Gruen*)

Poet Kenneth Koch in a characteristic laughing pose, photographed during a party in our New York apartment. 1958. (*Photo by John Gruen*)

Painter Jane Freilicher in a "film-star" pose taken in the house we shared. Water Mill, Long Island, 1958. (*Photo by John Gruen*)

Jane and poet Arnold Weinstein trying out
songs I composed for the ill-fated musical
The Undercover Lover, which had book
and lyrics by Weinstein and Frank O'Hara.
I'm at the piano in our apartment at 241 East
18th Street. New York, 1957.

A somewhat drunken snapshot during a
party in our apartment. *Back row, left to
right:* Frank O'Hara, Elaine de Kooning,
Jimmy Schuyler. *Front row, left to right:*
Arnold Weinstein, Naomi Newman
Weinstein, painter John Button, pianist
Alvin Novak, and Joe Hazan.

The climax of my song-composing career came in January of 1960, when my early champion, Patricia Neway, consented to give an all-Gruen recital at Carnegie Recital Hall. I was Miss Neway's accompanist for the occasion, and the soprano outdid herself in the performance of songs set to German, Italian, French, and American poetry. Sitting in the packed house were several notables from the music world, including the much-feared former music critic of the *New York Herald Tribune*, Virgil Thomson. The recital was reviewed for the *Tribune* by the young composer and critic William Flanagan, and for the *Times* by Ross Parmenter. Both reviews were exceptionally laudatory, though Flanagan's was particularly effusive.

The success of my concert with Patricia Neway did not result in instant fame, something I not so secretly yearned for. Surely, I thought, this would be the moment for music publishers to come breaking down my doors. Nothing of the sort happened. It was the same old story: songs don't sell, the market is flooded with songs nobody is buying. Still, I thought, they were publishing the songs of Ned Rorem, Bill Flanagan, and any number of other young composers. Why not mine?

Despite the fact that Rorem and Flanagan included me in one or two of their American song recital series, I became very discouraged.

There was one last opportunity for recognition. The soprano Alice Esty had for years given recitals, for each of which she commissioned a work by a modern composer. She had already commissioned such famed composers as Poulenc, Milhaud, Auric, and Virgil Thomson. I contrived to meet her and befriend her, and religiously attended each of her many concerts. Mrs. Esty had heard about my songs but never alluded to the possibility of my writing any for her. Finally, I boldly asked her to commission a cycle. Taken aback, she said she would consult her accompanist, the late David Stimer, her musical adviser on such matters. She did ask me to come to her apartment and sing some of my songs for both of them. Stimer took an instant dislike to me, and I was convinced that no commission would come my way.

Still I pursued Mrs. Esty until one day, obviously tiring of my tactics, she broke down and asked me to write her a song cycle. I received six hundred dollars and immediately set to work putting to music five poems by James Schuyler. The cycle was entitled *Greetings from the Château*. Alice Esty accepted it and the belligerent accompanist proceeded to study it. Shortly before Mrs. Esty's recital I was asked to come and hear her run through it with David Stimer at the piano. He accompanied magnificently and Alice Esty sang it with intelligence, wit, and musicianship. When the recital was held, my cycle proved to be the hit of the evening. I later learned that Stimer had told Mrs. Esty he would never play it again, and that he performed it under duress, to get me off his and Mrs. Esty's back.

Greetings from the Château was my last song cycle, and it was to mark the end of my song-writing career. My gift was obviously a limited one, so I gave it up out of sheer disappointment and frustration. Now I barely glance at the large collection of song manuscripts that are gathering sentimental dust.

7

When Jane and I came to New York in 1949, it had been my vague plan to apply myself seriously to the study of music—a plan that never came to fruition. But some years later I was to study orchestration with Virgil Thomson. We did not meet Virgil until after his resignation as chief music critic for the *New York Herald Tribune* in 1954. By that time we had met Frank O'Hara and Kenneth Koch, and finally met Virgil at a party following Alice Esty's performance of Thomson's song cycle based on some of Kenneth's poems.

There stood Virgil Thomson, surrounded by a throng of admirers and friends. He was talking animatedly, in his nasal, high-pitched voice, interjecting the word "baby" to punctuate his remarks. He elicited gales of laughter and it was clear that Virgil was at his wittiest, if not bitchiest. We were introduced and liked each other from the first. I began by complimenting him effusively on his music; I adored his *Four Saints in Three Acts* and considered his *The Mother of Us All* an out-and-out masterpiece. To me, Virgil Thomson's music was thoroughly exotic. I liked its leanness, its totally Anglo-Saxon economy, its American spirit and directness—and I liked the fact that the music was pervaded by the hymns and folk idioms of early America. I was not used to hearing serious music that was also simple, and had previously thought that the luxurious complexities of Romantic music held greater weight than the clean, simple lines produced

by a Virgil Thomson or an Aaron Copland.

Thomson had known his share of Greats in the twenties and thirties. He was an intimate of Gertrude Stein's and met all the writers and artists who gathered in Miss Stein's and Alice B. Toklas's home in Paris. He was justly famous as a composer and as a critic, and his influence and power, while not as great as when he was still on the *Tribune*, continued for several years after he left that paper.

After the party for Alice Esty, Virgil invited Jane and me to his home at the Hotel Chelsea, and we accepted with delight. Parties at Virgil's were marked by an abundance of celebrities, an entourage of beautiful, talented, and ambitious young men, and some of the best food to be had anywhere. Invariably, Virgil was the center of attention, holding everyone enthralled with his stories. He could speak on certain subjects—on art, for example —with tremendous conviction, totally disguising the fact that what he said was shot through with misinformation. Virgil also liked to drink and when he did, a certain vitriolic tone would emerge. In his cups Virgil would expound on the "Jewish mafia," and how it was keeping him from being one of the most performed composers of the day.

The fact of the matter is that the moment he was no longer the most powerful music critic in America, conductors and performers were no longer at his feet and were less inclined to perform his music. Not that Virgil used his power as critic to commandeer performances of his music; after all, he was a thoroughly schooled and distinguished musician whose works deserved to be performed. But it has been suggested that conductors like Serge Koussevitzky, Artur Rodzinski, and others made a point of programing works by Virgil Thomson in order to be assured of favorable criticism. Virgil vehemently denies this.

It was at this first dinner party at Virgil's that I broached the subject of studying orchestration with him. He was amenable to the idea and thus began four months of study which proved extremely valuable, as well as extremely difficult. I was slow and

Virgil was impatient. I had gotten out of the habit of studying, while Virgil had gotten out of the habit of teaching. Finally he told me I was too old to take the discipline and that I had better quit, or study with someone else. This break did not impede our friendship, and we went on seeing each other more than ever.

Years later, Virgil became instrumental in my becoming a music critic for the *New York Herald Tribune*, a post I held from 1962 until 1967, when the *Tribune* folded. Clearly, Virgil believed more in my potential as a critic than as a composer, and set about to help me fulfill that potential.

Virgil Thomson's role as a promulgator of modern American music both here and in Europe cannot be denied. In 1954, he conducted programs of American music in Barcelona, Vienna, and Paris. In 1952, he had taken his own *Four Saints in Three Acts* to Paris. Written with Gertrude Stein, this opera was among the first to employ an all-Negro cast and Virgil had the foresight to enlist such unknowns as Leontyne Price, Gloria Davy, and Martha Flowers, who were members of the chorus in the production. Two years later, Virgil would conduct his opera at the Lewisohn Stadium, with Miss Price and William Warfield singing two of the leads.

In the fifties, contemporary music had a true flowering. Nineteen fifty-one and 1952 saw the spectacular rise of Pierre Boulez and Karlheinz Stockhausen. John Cage's visits to Europe in 1948 and later had a strong influence on the European avant-garde. In England, Benjamin Britten was rising to fame. While the music of Shostakovich had declined in popularity in Russia, it found continued admiration in America and Western Europe. In France, Francis Poulenc became a major figure. Electronic studios, already operating in Paris, were established in Milan, Frankfurt, and Tokyo. Finally, around 1960, the electronic boom hit New York, with Milton Babbitt and his followers engaging in their brand of technological noodling.

Throughout the decade Thomson championed these composers, writing about them, conducting their music, or giving lec-

tures that illuminated their importance. This challenging work is described by Virgil in his autobiography, *Virgil Thomson*, published in the mid-sixties.

Today, Virgil is in his mid-seventies. He still lives, as he has for the past thirty-five years, in his extraordinary apartment at the Hotel Chelsea—and he continues to travel, lecture, and occasionally to conduct his music. In 1969, I went to see Virgil Thomson at the Chelsea. We shared one of his delicious dinners and sat surrounded by the paintings of Florine Stettheimer, who did the marvelous cellophane sets for *Four Saints in Three Acts*. There were paintings by Maurice Grosser, a long-time friend of Virgil's, by Leonid, by Roger Baker, and, among the younger artists, by John Button. The heavy mahogany woodwork, the solid Victorian furniture, the carpets, the books and other objects collected through the years gave the place a look of nostalgic eclecticism. Virgil lives in great order and is punctilious to a fault. On the piano periodicals are stacked according to date, and his music cabinets are carefully labeled. Save for a slight deafness, Virgil has not changed in twenty years. He is still the dapper gentleman whose suits are made for him by Lanvin, who sports the crimson rosette of the French Legion of Honor, awarded him in the forties, and his conversation never bores for an instant.

"What was I doing in the fifties? Well, I was writing on the *Tribune* and I was touring the country and I was composing. I would write one solid, chunky orchestral work a year, bring it through first performance, not necessarily conducted by myself, but see it through a premiere with one of the good orchestras. I also did from forty to sixty appearances a year, lecturing and conducting.

"Then, in 1954 I resigned as chief music critic for the *Herald Tribune*. By this time, you see, I had reviewed all the artists that there are, and all the kinds of music that there are, so that, say, for six novelties a year, you go on repeating yourself. I saw boredom like a distant horseman on the horizon. And so I thought, like your mama always said to you when you went visiting, 'Always leave before you're tired of them and before they're tired of

you.' I was making perfectly enough money to live independently, and so I went to the managing editor and said I wanted to quit. They couldn't understand why I didn't want to go on working for the *Herald Tribune* forever, but I had watched it all.

"I had seen Europe busting out with a new and brilliant musical modernism. America in those years saw the development and success of two conservative composers, Roger Sessions and Elliott Carter. You see, we offered this kind of conservatism, while Europe offered the radical modernism. We already had offered to Europe John Cage, who went there in 1948 and taught them a good deal. Pierre Boulez will always put in his books and articles that Europe wouldn't be quite the same without John Cage. He's a little niggling about it, but he is loyal to mention it.

"John Cage was active from the time he started composing in the early thirties in California. But he came to New York in, I think, 1941, and immediately started getting himself concerts and radio broadcasts, and making a position for himself as a leader of advanced modernism. The old prewar modernism had gone rather stodgy and there wasn't much of it left. And so the people who were to turn up in Europe after the war weren't there yet. So Cage represented a position comparable to what Varèse and Ruggles had represented around 1920. It was the beginnings of a rather new, wonderful, and strict-thinking kind of modernism. As soon as the war was over, Cage was right off to Europe; we got him Guggenheims and things like that. He went off to look at the Europeans and to let them look at him and his music. He impressed them a great deal. He wanted to play ball and to play chums with them. That they would not do. They were not taking on an American. They would take his good ideas, but they would not have any American move in on them and tell them how to operate. Cage is an operator and a leader by nature, but they wouldn't have him.

"It is perfectly true that I helped to further his career. I was the person who reviewed him constantly, when nobody else was reviewing him. And I was the person who either saw to it, or helped see to it, that he got Guggenheims and Fulbrights and all

those various things that he got. Not that Cage wasn't awfully good, and pushing himself. But, in my very solid position at the *Tribune* by that time, my influence, my recommendations, and above all, my reviews of his work, my explanation of it, all served a great deal. Now, I was not a hired plugger for Cage, but I was a friend of Cage and of his music. I liked it, and I think I understood it, and I explained it. I don't know why I liked his music, just as I don't know why he liked my music. But he went to the trouble of writing a whole book about it—or half a book, I should say, because Cage talked about my music while a woman by the name of Kathleen Hoover wrote about my life. The book was called *Virgil Thomson, His Life and Music*.

"In the fifties, I grew tired of music. I didn't get tired of music from going to concerts. I got tired of music because practically all the people of my age at the same time were getting tired of music. Today, no musician over fifty can bear the stuff. You see, we like the idea of music but we can't bear the sound of it. It sounds too awful. It's off pitch.

"I did enjoy picking a lot of quarrels while writing for the *Trib*. I think the biggest of my quarrels was with Serge Koussevitzky. That came right at the beginning of the fifties. I wrote a defense of a man named Moses Smith. Moses Smith was a former music critic for the *Boston Herald* who, when he retired because of a terribly advanced case of arthritis, wrote a life of Koussevitzky. It was a favorable and loving biography of the conductor. He wouldn't have embarked on it if he hadn't admired the man. But in the course of recounting Koussevitzky's life, he brought out the fact, hitherto concealed from Boston, that Koussevitzky had been married to someone else, prior to his current marriage. This would not have been of any consequence, had it not been for the fact that Koussevitzky had left a poor wife in order to marry a rich one. Koussevitzky didn't want that story told. He got powerful law firms and sued. You see, the very rich and successful man was suing the poor, sick man for telling a perfectly true story which the rich man didn't want told.

"Well, I mobilized the *Herald Tribune* and its lawyers, who

said, of course, I had every right to come to Moses Smith's defense. I was not trying to influence the judiciary, but I was trying to inform the public of what the facts were and what the legalities were. As it turned out, the case was dropped. But Koussevitzky was sore as hell, as you can imagine. Nonetheless, not long after that I received a letter from him, which I have in my files, which was full of affection for something nice I said about him when he retired.

"I also was in a war with Arthur Judson, who, as you know, ran Columbia Artists Management and who also ran the New York Philharmonic. That was also in the fifties. Oh—I was in full battle array for that one. This was in the time when Artur Rodzinski had been hired as permanent conductor of the New York Philharmonic, and he was a very good conductor. Now, Rodzinski had been hired under the condition that there would be no strings attached, meaning that he had absolute authority over repertory, guest conductors, soloists, etc. Well, like everybody else connected with the Philharmonic in those days, he discovered that Arthur Judson was running this orchestra, not only over his shoulder, but under his nose. Rodzinski was told who he could and couldn't hire as soloist and so forth. Talk about strings attached—those were not strings, they were chains. Anyway, Rodzinski finally denounced the management and accepted a job in Chicago.

"I justified him in my column and the *Herald Tribune* published editorials in his favor. When the argument was brought forth that he had left the Philharmonic for a better job, I pointed out that there is no better job than the New York Philharmonic. Anyway, after that, Arthur Judson, who was a very powerful man in those days, wouldn't touch me with a ten-foot pole, except to express his animosity. Of course the *Tribune* loved these exposés; newspapers like controversy. And they like controversy with quite powerful people, unless it is somebody who could actually embarrass the newspaper. Those would only be Washington people—they wouldn't be New York capitalists, or social leaders or anything like that. The *New York Times* or the *New*

York Herald Tribune would not let themselves be pushed around by Columbia Artists or any other kind of organization like that.

"People often ask me whether I would have preferred working for the *New York Times*. The answer is no, because the *Times* is prissy. The *Times* never liked distinction, you know; they don't like intellectually oriented reporters or critics. The *Tribune* did. The *Tribune* was the only paper on which an educated, intellectual man had no shame of being there.

"Oh yes, I forgot to tell you that I once called Toscanini a liar in my column. He had signed a release sent out by the NBC Symphony offices explaining that Leopold Stokowski had been relieved of his commitments as a part-time conductor of the NBC Symphony Orchestra, because it was not good for the orchestra to have two conductors. I simply pointed out that the orchestra had far more than two conductors—it had guest conductors most of the year. Toscanini only conducted ten concerts. Besides the NBC Orchestra wasn't a house orchestra; it was only on weekends that they had rehearsals of a final concert. Otherwise the players played for any show there was and under any conductor. Toscanini could not have been ignorant of this when he signed that statement. That Monday I received a phone call. I was told the Maestro was upset and he'd like some kind of retraction. I told the voice at the other end that there is no retraction to be made, but that if Mr. Toscanini wished to write me a letter saying whatever he wanted to say, I'd be delighted to publish it, as would the paper. 'Of course,' the voice replied, 'the Maestro will never write a letter.' 'In that case,' I replied, 'I'm entitled to say that that release was a phony.'

"What was behind all this was that Toscanini, and the Firestone Company, which sponsored the NBC Symphony, didn't like Stokowski because he programed too much modern music. I know this because Stokowski came to see me one night and we had a little supper right here in this apartment and he told me, 'If I'm let go from the NBC Symphony it is only because of my history of performing contemporary music on every program that I conduct. My record on that score has been consistent.' You see,

Stokowski had four weeks and on each program he played the Berg Violin Concerto, the Schoenberg Piano Concerto, a work of mine, and a work of George Antheil. Firestone hit the ceiling and after those four weeks his contract was not renewed.

"After I called Toscanini a liar, in so many words, I heard rumors that he wanted to challenge me to a duel. But somehow he never got around to it and he never communicated with the press or directed any kind of criticism towards me. He was too wise a star for that. But then, something peculiar happened. Eugene Ormandy was conducting a concert one Sunday which I attended and afterwards I went around to see him. Ormandy and I embraced and just at that moment who should come in but Toscanini, seeing me in the arms of Ormandy. The result of this little episode was that Toscanini never spoke to Ormandy again. Ormandy thus lost a very valued friendship. He had a great sentimental and professional devotion to the old man, but he never complained to me, and I only learned about this indirectly. When I asked Ormandy whether this was true he said yes.

"You were talking about my music having been dropped from the repertory of various conductors after I resigned from the *Trib*. The point is that anybody who was going to drop me did it very slowly and carefully. It's true that people like Ormandy did not play my works as frequently as he formerly did. On the other hand, he did continue to play them. I suppose that a number of artists played my work possibly for reasons of interest. Another number of artists avoided playing my work for the same reasons. So it all worked out more or less even.

"But I wrote a lot of music in the fifties. There were my Blake songs. There were some orchestral landscapes. The Cello Concerto was from the early fifties. The Flute Concerto is from the late fifties. There was another volume of piano études. Everything went on quietly. I composed, I wrote criticism, I conducted, I was performed. . . . My close musical and composing associates were John Cage and Lou Harrison. Ben Weber was a friend. Aaron Copland, of course, was an associate since the early twenties. That friendship went on in a general colleague relation-

ship. I was also quite friendly with Samuel Barber and Gian Carlo Menotti, also, with Norman dello Joio. Leonard Bernstein and I have always been terribly friendly. But we didn't seek each other out. We kind of operated on two sides of a fence. I didn't throw enough balls to him, and he didn't throw enough balls to me. If I had made a lot of plugs for him and he had played my work constantly, that would have been another kind of a deal. But we liked each other. In the fifties Lenny wrote a lot of musicals. There was *Wonderful Town*, *Candide*, and *West Side Story*. I liked these because I like Lenny when he's making folksy, Jewish humor. He's awfully good at it. *Candide* was a flop for him and a flop for poor Lillian Hellman. Neither of them was accustomed to flops. It hit them quite hard.

"Let's see . . . I also knew the John Cage boys—Morton Feldman, Christian Wolff, and Earle Brown. Earle Brown has had quite a bit of success in Europe. The others have sort of dribbled on quietly. And then, there was Lukas Foss. He was always around. Lukas was always a boy genius—always rising and always doing well. You must understand that none of us thought of our lives as taking place in 'the fifties,' any more than in the old Paris days, we thought of living in 'the twenties' or in 'the thirties.' We were just living, you know.

"As for my operas, there were a number of performances— or revivals—of *Four Saints in Three Acts* and *The Mother of Us All*. I conducted *The Mother of Us All* at the Phoenix Theater around 1956 or 1957. I've never had any luck with getting these operas put on at the New York City Opera, where I felt they certainly belonged. Julius Rudel didn't seem to go for them. He only likes modern German operas. It's true he's done a number of contemporary operas, but they broke no eggs. Whenever I broached the subject of doing my operas, he replied that they were not repertory pieces.

"The state of music criticism in the fifties was pretty grim. When I was hired at the *Trib* they began to realize that they had something quite good on their hands, but they didn't know whether they could handle it. By the end of two years or more, I

had fitted into the groove pretty well. I would make a little explosion here and there, which may have embarrassed them, but this was nothing compared to the very high quality of work I was turning out. So, because of that, I became their 'carnation in the lapel.' Those who have accused me of taking advantage of my position didn't know what they were talking about. I never proposed to any artist that he perform my works. The performance dates just came my way, and I accepted those dates that I liked.

"You see, I was in a position to meet an awful lot of people in those days and I arranged for a lot of people to meet one another. I remember one night giving a rather large party for Stravinsky, who had told me he wanted to meet Boulez. Stravinsky was going twelve-tone at that moment. So I gave this large party and Stravinsky very carefully came late. He came in, say, at half past ten. He and Pierre Boulez met like two comets. They sat on that sofa over there by the wall and for two hours spoke only to each other. The moment they stopped talking, Stravinsky got up, said good night, and took his leave. Pierre was very excited because they had apparently made some deal. Later Pierre was invited to Los Angeles to do those 'Evenings on the Roof' and Stravinsky made things easy for him and Boulez established a solid beachhead there. Soon after, of course, Stravinsky conducted in Paris at the modern concerts instigated by Boulez. I heard that Stravinsky was not a success and he was furious. I understand they have not been such good friends since that time. But what I'm trying to bring out is that their brief and intense love affair started right here in this very room."

Virgil Thomson and I no longer see each other as often as before. He keeps busy, but the waning of his power and influence in the music world has left him more or less embittered. In the sixties, Virgil Thomson completed his last opera, *Lord Byron*. He had for years tried to find a suitable librettist; he then met the playwright Jack Larson, who wrote a libretto, and the opera was completed. At one point the Metropolitan Opera Company took considerable interest in *Lord Byron* and Virgil had hopes of hav-

ing the world premiere at the Met. But when the work was auditioned, the Met inexplicably dropped the project. Virgil was crushed and, when I asked him about it, claimed that certain powerful board members at the Metropolitan were his enemies. For many reasons, including his past record as the most powerful, and certainly the greatest music critic in America, he may have alienated any number of people who could have been helpful to him after his retirement.

It was at a party at Virgil Thomson's that Jane and I met Ned Rorem. We had heard about Ned for a number of years, and in the late fifties I had heard Leonard Bernstein conducting the New York Philharmonic in Ned Rorem's Third Symphony. The music was decidedly romantic and lush—eons away from the more fashionable experiments of John Cage or Morton Feldman. Ned's music was permeated by the French sensibilities of Debussy and Ravel, yet marked with a certain diffidence and Puritanism straight out of the American tradition. The music I heard was totally accessible and totally expert and there was little doubt in my mind that Ned Rorem was a young composer of remarkable talent. Yet, at the time, there was still an odd, soft core to his music which suggested an internal vision not fully realized.

I did not come to Ned's songs until later, and then realized instantly where his genius lay. Rorem can take a poem and transform it into sound with absolute inevitability. He understands the secrets of the art song—knows that all music stems from the sung expression, and instinctively finds the precise phrase and cadence that lie hidden in the written word. Being deeply entrenched in the art song myself, I was quickly drawn to Ned as a composer who spoke my language and from whom I could learn.

My first meeting with Ned was memorable mainly because of Ned's acute state of inebriation. His behavior was not particularly offensive, and given his extraordinary good looks, there was something rather touching about his intoxication. I think that his slurred and for the most part incomprehensible ravings had to do with his lost youth. His drinking brought out his total self-in-

volvement. A kind of petulant yearning, a sentimental narcissism made itself felt as he blundered from friend to friend. Finally, he leaned against a wall, moving his head from side to side, and slowly slid to the floor. At one point I helped him to his feet, and he clung to me almost as if to a life raft. In a moment some friends took him by the arm and he slowly left the party.

We met again, often in the company of Bill Flanagan, and little by little became friends. When Ned was not drinking, he could be both brilliant and entertaining. His manners were gracious and his talk consistently revealed an aristocratic point of view. The elegance of his speech and his no-nonsense approach to music and to all the arts presented the image of a man of highly refined sensibilities.

During the fifties, Ned had lived in France. Like John Ashbery, he was drawn to the intellectual ambiance of Paris and to French esthetic tradition. He met the French intelligentsia of the day and moved among them like a beautiful young god. The austere yet innocent look of this American youth endeared him to people like Cocteau, Poulenc, Auric, and Milhaud, and especially to the doyenne of Parisian artistic circles, the Vicomtesse Marie Laure de Noailles. In Europe Ned decided to write one work in every musical genre, producing a symphony, a quartet, a trio, a choral work, and vocal music in smaller combinations. He also kept a diary, published in the 1960s in several volumes, the first of which—*The Paris Diary of Ned Rorem*—became something of a *cause célèbre*. The book contained entries of a devastatingly personal nature about practically everyone he knew in France, just as his *New York Diaries* revealed a great deal about his American friends.

Today, Ned Rorem enjoys the double fame of composer and writer. He has recently branched into the field of social commentary by writing articles for leading New York newspapers and periodicals, expounding on subjects that ranged from the Beatles to the absence of serious women composers. He and a good friend share an apartment near Central Park West in New York —an apartment filled with books, paintings, and innumerable

photographs of Ned taken with the famous and the infamous. I went to see him in May of 1969, and speaking like a man accustomed to autobiographical revelations, he told me how he journeyed through the fifties.

"My decades are easy because I graduated from high school precisely in 1940. The forties, therefore, were my years of deciding who I was, and it was a question of almost flipping a coin as to what I was going to be when I grew up—a composer or a writer or a poet or a dancer, or what have you. By 1950, I guess I knew.

"In 1949 I went to Europe. I had been living in New York, which was the magic city to me while I lived in Chicago, where I was born and bred. New York was always the mecca toward which everyone knelt. But, as a child—a Quaker child, fairly puritanical although from a broad-minded background—I was always attracted by things French, especially French music. So I didn't become French by living in France; I was already French at home in Chicago, and later in New York. The magic of any place usually wears off sooner or later and the magic of New York wore off. It never wore off in Paris. All the time I was in Paris I felt myself being safe. Even today it's a fairy-tale land where I am at home and safe. At the same time, I do not feel particularly nostalgic about Paris. Oh, I languish for my lost youth. But I languish less for people than for smells, or for certain weathers that I knew in France.

"I went to France for the same reason everybody else in America went to France—we went looking for what were then stylishly called 'our roots.' I found out, in the same way that Jimmy Baldwin found out, that my roots were not in France, but in America. The point is, we weren't really looking for our roots, we were trying to get away from our roots—though we didn't realize that. We were living the life of movies we'd seen, with Jean Gabin or Arletty acting in them. As it turned out, my life in France was not the life of the American expatriate. That wasn't the France I knew at all. It was much more French. It was also the French of yore, because the people I knew were so much

older than myself. My France was the France of successful sur-realists who were already dated. Also, my French was better than most of the .other Americans', even better than Gertrude Stein's, whose French was dubious.

"And so I met Cocteau and Poulenc and other figures I had worshiped from childhood. Suddenly they were made of flesh and blood just like me. And that was strange, because how can great people be just like me (knowing what I was)? Meeting Cocteau—who had more decades of self-realization than any-body I can think of—was indeed extraordinary. Even to meet him once was to know him. And he laid himself out on a platter, to be admired and to be loved. He had four decades in which he was the model inspiration of the young. And for him, that's what counted. No artist cares about what his peers think of him, after a certain time. He cares only what young people think of him. I got to France just as Cocteau was being replaced as a model of inspiration. He was being thrown out the window by admirers of Sartre and Camus. And Sartre and Camus were people who artic-ulated about life and art far more than did Cocteau.

"I think that a lot of my French education was learning what articulation was all about. That's what the French are, you know—articulate. Even today the French are still interested in words, albeit, and this is important, not in the so-called creative arts. They are articulate in criticism for itself. And in criticism of criticism, which has now become a big thing in America.

"And so I met The Greats. And I also met Marie Laure de Noailles—a woman of power, intelligence, glamour, a certain beauty, unthinkable wealth and influence, and a real talent her-self, who had been Cocteau's girl friend between the ages of nine and fourteen. She had learned much of her whole verbal style from him—the firecracker repartee, etc. She was a woman of infinite culture, who knew every work of Henry James in Eng-lish, by heart, which is a good deal more than I could say about myself. People have suggested that when Marie Laure met me she fell in love with me. But, what falling in love means to the French is not what it means to the English or to Americans. I

guess she was in love with me, but finally the relationship melted into friendship within a year. There were problematic tears and hysteria in that year. But in those years I did things to people that were perhaps terrible—I maneuvered people according to my whim. At the same time, I was terribly genuine and terribly sincere. Nobody does anything without being repaid in one way or another, and all our sins are paid for and all our virtues are paid for, and we work for what we get. Nothing falls into our laps—I'm convinced of that. I suppose that if I were not spoiled, and I was terribly spoiled, and if I had not manipulated people, I probably would not have written the kind of music I did write. I would have written a different kind of music. Not necessarily better music, but something else.

"Marie Laure was by far the most important person in my French life, because I saw her for every meal of every day for seven years—from 1949 to 1956. There was something very schizophrenic about Marie Laure. I remember overhearing her one day as she spoke about me to Balthus. I heard her say, 'Isn't Ned the most divine, intelligent, beautiful, gorgeous thing that ever walked the face of the earth?' Another time, perhaps in the company of Paul Eluard, she might say, 'Ned is the most spiteful, self-involved, narcissistic, ungrateful person I've ever met. I've been feeding him now for seven years and what does he do? He uses my house as a hotel.'

"That was Marie Laure: the eternal feminine. Any woman becomes uninteresting to me when she is being feminine. It's when they use their minds that they interest me. So, the schizophrenia between the silly feminine female and a woman who could think things through with logic were simply two different people. But Marie Laure was also a third person. She was a housewife. She didn't dust furniture, or things like that, but she did raise two daughters and married them off well, and she lived in comparative congeniality with the same man for forty-five years. Whether she and her husband saw each other every day or not is beside the point. They telegraphed or telephoned or left notes for each other every day for forty-five years.

"I hope you realize that the people I am talking about are not even legendary in France today. I was recently told that Marie Laure, before her death in 1969, was in Paris during the May 1968 riots. She was out on the streets in a Rolls-Royce with Yves Saint-Laurent beside her, riding around picking up wounded students. Marie Laure, who was stylishly Communist in the thirties, during the Spanish war, got out on the steps of the Sorbonne and started expressing herself—and nobody could have cared less. 'Go back to your Goyas and shut up,' the young people shouted at her. You see, the whole mystique of the salon and of the people who ran salons no longer interests the young French people. That is how it is.

"In the days I was living in France, Marie Laure was still considered an intellectual and artistic force. She had two houses and her husband had two houses—that makes four houses. All of them were beautiful. The house in which I stayed on the Place des Etats-Unis was, I think, the most beautiful house I ever saw in my life. It had fifty rooms and a kind of solid edifice that you don't find in America. I mean, it holds up, and the gardens hold up. You can't bomb it away, and it's not likely to become a slum in two years. The house has been there since the last century. Money doesn't bring taste necessarily, but in this case . . . well, it did. There was not an object in these fifty rooms that was not worth beholding and contemplating for hours. To live and work among three huge Goyas and several hundred other paintings by the best artists from the fifteenth century to the present was, to say the very least, unusual. There were the paintings; there were the objects, in between which were bouquets of flowers sent daily from the South of France, perfuming the octagonal rooms and the rooms of every shape and size. There was the ballroom and the dining room, with the sea-green marble tables, which could seat fourteen guests each—or the smaller, daily dining room with the blue marble table which could seat twelve. And there were the mother-of-pearl ceilings.

"It was not like living in a museum, because a museum implies austerity and impersonality. It's like living in beauty. I assure you

I am not trying to brag about my living quarters with the Vi-comtesse de Noailles. I can live in one room in a hotel very easily. But it amuses me this very moment to think that my breakfast was brought up to me every day. Actually, when I come to think of it, to emphasize surroundings is to emphasize a sense of luxury which, as I said, I do not need. What I need is a private bathroom. If I had a choice between all the paintings in that house and a private bath, I would choose the private bath. Marie Laure, by the way, hated to go to the bathroom, and if she did, she would do it with the door open so as not to miss out on any conversation that was going on in the next room. That's very French.

"At any rate, Marie Laure had a salon, and there I was introduced to everyone who was anyone. Marie's time for receiving was lunch. So everyone came for lunch, which ruined their day, but her tables were so succulent and the company so enticing that you allowed your day to be ruined. Balthus came, and he brought Dora Marr, Picasso's mistress. Balthus, a Polish Jew, was terribly attractive in a Jean-Louis Barrault sort of way. In his mental style, he is a man of infinite culture. He seemed always slightly impatient with the frivolity and the life-style of Marie Laure. He likened me to Hawthorne. He said that I evoked New England. Of course, that's the Frenchman's idea of what New England is. He fancied nymphets, the kind that appear in his paintings, and the kind that appear in his drawings—particularly those for *Wuthering Heights*, in which he shows little girls getting spanked. One day Marie Laure and I visited Balthus at his château. He took us down to his basement and the entire basement was a replica of a set he had designed for Ugo Betti's play *Island of Goats*. The château had something like fifty rooms, of which forty-eight were uninhabited. It was all very Edgar Allan Poe. Balthus doesn't live there any more; he has moved to Rome and he has recently been elected head of the French Academy in Rome—the place Debussy hated so much. But I remember Balthus as being a big crybaby and a terrific whiner. As everybody knows, he works very slowly at his paint-

ings. As a result, he has a lot of time to be official in Rome and to cry and whine.

"Balthus usually appeared at Marie Laure's with Dora Marr —another crier. I never met Françoise Gilot, who wrote this really very good book about Picasso, but I knew that Gilot sent Dora Marr into a fit of green and livid fury because she was the lady who had ruined Dora's life. Picasso was Dora Marr's life. She was very much a woman of her decade, which was the thirties. She was terribly political, terribly concerned with the working man. Dora was also a painter, like many of the women in Picasso's life. But she had a style very much of her own. Her portrait of Alice B. Toklas, for instance, is something only Dora Marr could have done; it's not a Picasso picture. Dora was beautiful and very intelligent. She liked me for a very long time. She also did a portrait of me in black and orange, as well as a portrait in the pointillist style. But I suspect that Dora, in the years I lived with Marie Laure, thought of me as something of a gigolo. It was only when I began seeing people not with Marie Laure that Dora and also Balthus had a certain respect for me as a person.

"I think one of the things that Marie Laure liked about me most was the fact that I would get up after lunch and say, 'Excuse me' and go to work in my room. This, no matter where I was or with whom. That's how I got the catalogue of music I now have. And the kind of music I wrote was not really French music. As Virgil Thomson once said, when asked what is American music: 'It's very easy to write American music. All you have to do is be American and then write any kind of music you wish. If I write what used to be called French music, I was writing it long before I went to France. France itself didn't influence me. In point of fact, in France, I was discovering who I was as a musician. I am American and I am a musician, therefore I am an American musician. That doesn't necessarily mean that I write music which deals with the clichés of open plains, etc., that Aaron Copland made so famous.

"In France in the fifties nobody listened to anybody's music unless they were told to do so. But then, that has always been the

case. France is the least musical of all countries; by which I mean, the French are geared to respond with their eyes; France is a visual nation. The French composer has had to look elsewhere for acceptance. The big composers in France—mainly Boulez now—left France not only because they were not appreciated, but just in order to make a living. If I was performed in France it was because I had arranged the concerts myself.

"I met an awful lot of French performers. I loved them, though I'm not sure that they performed their own music as well as other people's—that goes for singers as well as pianists. I loved the sound of the French voice for many years—that sort of white, nonvibrato sound. I no longer like it, even as I don't like my own songs to be sung by intelligent but terrible voices. I don't want understanding, I want beauty.

"During my stay in France I retained contact with American publishers and American performers. But when I returned to New York in 1957 I was not received with open arms. Then, in 1959, Bernstein did my Third Symphony with the New York Philharmonic. That was a big-time performance that, more than Lenny knows, was helpful to me. Then I got my job at Buffalo as a professor and at a very good salary. That was amusing because I was still young—thirty-four—and was called 'Professor.' I guess that was when I became really professional. And I began to write about music. Actually from 1958 on I have made my living from being a composer.

"Then there was my *Diary*. Marie Laure kept a diary and it's she who started me rekeeping my diary, which I began in 1945. Poulenc also encouraged me to keep it. He kept a *'journal de mes mélodies'* in which he would, after the fact, dissect how he wrote a song. My diaries are terribly fifties. They're full of self-pity and self-advertisement and they're full of 'Oh—be still, my heart.' It's the kind of thing that you don't hear a young person say today. You don't hear them say 'I love you.' You hear them say 'Love,' but not 'I love you.' You don't hear them say 'I'm going to commit suicide.' They might say 'We shall commit suicide together.' Today everything is communal; it's all anonymous. They

need an audience: 'I shall burn myself if you will watch.'

"I don't think Americans keep diaries. I don't think it's an American literary form. I think *Portnoy's Complaint* is something of a diary, but Philip Roth had to go and change his name and make the character tell everything to a psychoanalyst. A diary is not necessarily something more honest; it's just a different form. Anyway, my diary reflects the fact that ninety per cent of my time was spent at home working hard, writing music, and not out getting drunk, or crying, or lacerating myself for love. My diaries indicate what I want them to indicate. Had it not been for Robert Phelps, who talked me into it, I might not have thought of publishing them for many years. But to quote Jane Freilicher, 'I love to see my name in print, even in the telephone book.' But my Paris diary reflects the fifties as I saw them, much better than anything I could say here. Of course, once it was published, it somehow changed my life. I am more furtive now as a person —more careful.

"The fifties to the sixties was my drinking decade. I have not, as of today, had a drop of any kind of alcohol for about a year and a half. I've been to a lot of parties, for example, and nobody seems to be lurching around any more. Today people smoke pot and take drugs. I don't do that either. But I do miss drinking. I miss it madly. I miss the person who used to drink. God knows, I drank enough to last twenty people a lifetime. I've been told that I'm an utterly different person when I drink: an absolute split. The minute a drop of wine touches my lips I begin to be this other person—an infantile regression takes place. An alcoholic is a person who cannot decide when and when not to drink. I would say that I could not be categorized as an alcoholic because I have such a puritanical sense of order, and because I am ambitious. I compartmentalize things. For example, I would know that I would get drunk on a certain Wednesday at 5 p.m. at a certain party, but that I would not get drunk before. An alcoholic doesn't know whether he won't get drunk within the next hour.

"When I drank, I became guilty. Guilt is such a healthy stimulus to an American creator, because it keeps him out of mischief

in order to create. European drinkers, and I've known many, don't feel guilty at all. Jacques Dupont, who is France's leading set designer, drinks like a fish, and one day I said to him, 'But Jacques, don't you wake up the next day feeling terribly guilty?' And he said, 'Never. It never occurred to me to feel guilty.' But this never happened to me. I would indulge my hangovers and I would weep and scream as all Americans do. I still have dreams about it. Drinking is what a drinker makes of it. The point is, it meant so much to me. The problem is not necessarily contained in the glass—contained in the liquid. The problem is contained in my point of view about the liquid, and no amount of psychoanalysis is going to change that point of view.

"I have a very dim view of analysis. I was analyzed for a year and a half in 1947 by a deep Freudian. It was the kind of analysis that I don't think exists at all any more, because I was on the couch and did all the talking. Today we've got therapy. I don't believe in it poetically, and I don't believe in it in a practical way. Of course, I'm speaking strictly for myself.

"Finally, the fifties made me what I am and I can't take it back. That's why I am so despondent when in the sixties and seventies I look around at people who are not concerned with works of art—with seeing things through. The fifties were a time of individual self-examination in every area. It doesn't seem to exist today. I think that art has changed its definition for the first time ever. The word itself has become a dirty, silly word to the younger generation. People always say to me, 'Oh Ned, you've had it easy. You've had all the advantages.' I don't know if that's true or not. To a large extent, one makes ones own advantages, or one puts oneself in a passive position so that active people will come and do things to one. There is no such thing as passivity. Yes, I got what I wanted, as we all get what we want. Of course, you must have a sense of adventure. I suppose the decor of my upbringing was exceptional. But what I produced within it is what counts. The decor was really a cloud in which I lived and out of which I will never descend."

Ned Rorem, raconteur par excellence, lives beautifully but aus-

terely within the aura of his life. The glamorous, incantatory days of his youth seem to be over. The fifties shaped Ned Rorem, and among the people who shaped him, prior to his Paris years, was Virgil Thomson, with whom he studied orchestration. Virgil, whose life was shaped extensively during the twenties in France, gave Ned yet another reason for embracing the French sensibility. For me, born in France though never raised there, Virgil and Ned became symbols of how my life could have been affected had my own formative years taken place in France. But because both composers made their separate decisions to return to the United States, renouncing their expatriate status, I readily came to the conclusion that New York was, after all, the city for American composers—the city most receptive to the widest variety of musical talent. In the fifties, Paris was no longer *the* city for the artist. It had lost its claim to New York.

8

My life as a composer spanned a few short years in the forties, and took slight wing in the fifties. In addition to writing songs, I wrote several film scores for certain underground movies, the most notable of which was *8 × 8*, a feature-length work by the German painter and film maker Hans Richter. This was a film about chess which in Richter's hands assumed surrealist and Dada proportions and which starred many of his friends, among them Marcel Duchamp, Max Ernst, Arp, Tanguy, Alexander Calder, Dorothea Tanning, Frederick Kiesler, and Jean Cocteau.

Richter, who had made *Dreams That Money Can Buy* in 1944, was a remarkable though incredibly disorganized film maker. In *8 × 8*, Jane and I played the roles of chess pieces, and of course I worked very closely with Richter on the musical scoring of the film. When I went to see it for the first time, I realized to my horror that Richter had doubled or tripled the tempos of most of my music so that it sounded more like a sound track for Donald Duck than the elusively surreal sounds I had originally conceived. Richter later confessed to me that he had done it purposely since he thought it would be more appropriate for the images on the screen.

The film was made in 1957 and for me it was, to say the very least, a fabulous experience meeting the artists who appeared in it. It was thrilling to talk with Marcel Duchamp, who spent a

good portion of the filming sitting in a tree hollow. He talked not about art but about chess and was, in fact, technical adviser on all chess matters in Richter's film. One of the most spectacular sequences was a chess game in which the various artists moved around a gigantic chessboard drawn on the front lawn of Richter's house in Connecticut. Inexplicably, this sequence was cut out of the final print of the film, but a photograph of it appears in Marcel Jean's *The History of Surrealist Painting,* showing Jane and me in the foreground.

I also did the score for a documentary made by Alexander Hammid for the United Nations. It was called *Workshop for Peace* and was my most elaborate and ambitious film score. In the underground area, I did *The Mechanics of Love,* a film directed by the late Willard Maas and Ben Moore. This one called for a zither score, which I improvised while watching the completed film. The zither and I were very fleeting acquaintances, but I happened to have picked up the instrument in a junk shop in college and loved to pluck away at it.

The Mechanics of Love, ultimately shown at Amos Vogel's Cinema 16, one of the most enlightened film clubs of the fifties, seemed very daring for its time. It offered a sidelong glance at the art of lovemaking and starred a handsome boy and girl shown in the nude. Only the breasts of the girl, however, were ever in total evidence, the rest being hinted at through tricky lighting. Interspersed in the love-making sequences were images of a deeply Freudian cast—loaves of French bread being cut, subway trains rushing through black tunnels, dripping faucets, egg beaters in furious motion, and the like. It was all terribly obvious, but had a certain primitive charm.

Willard Maas was an underground film maker whose activities had been recorded and praised by the New York film intelligentsia. A short, stocky man with unbounded energy, he took a great interest in Jane and me, and when the film was completed he invited us to a screening at his home in Brooklyn Heights. Jane and I put on our best in anticipation of yet another Gruen event, and arrived at Maas's penthouse. We were greeted at the door by a

tall and somewhat forbidding woman. She was playing hostess in place of Maas's wife, the late film maker Marie Menken, who happened to be out of town.

Most of the people there were unfamiliar to us. The drinks on this occasion consisted of a very pretty-looking punch with strawberries, lemons, etc., floating innocently in the bowl. It became apparent that the punch was a lethal combination of various liquors, a mere sip of which was inflammatory. This punch, for which Willard was justifiably famous, had been prepared by the hostess.

A movie projector was set up in the living room, which contained numerous tall glass cases full of strange dust-covered objects, among which were stuffed birds, old photographs, and personal mementos. We were all asked to sit where we liked and the lights were turned off. I was very nervous about my zither score, barely remembering what it was I had composed. From the very first the projector would not work. Willard started shouting instructions to the handsome young men who dominated the guest list. In the interim the tall, intimidating hostess came around with the punch bowl, asking us to dip our cups once more into the satanic brew. We sat in darkness for over an hour, becoming more and more restless and less and less sober. Finally, it became obvious that there would be no screening that night, and Willard Maas asked everyone to have a good time, eat some dinner, and drink more punch.

We observed that the party was getting something more than lively. In one corner of the room, we saw Willard Maas on the floor flanked by two of his male guests, rolling over one another. Moving out onto the terrace of the penthouse we heard screaming and sobbing from a couple standing silhouetted against the New York skyline. The man, who was the star of *The Mechanics of Love*, was battling it out with his wife, who in turn attempted to strike him. At this point, Jane retreated to the living room, while I lingered on, riveted by the violent scene in progress. Then I too came back into the living room, where I was suddenly approached by Maas's hostess.

She was dressed most properly in a white rayon blouse closed at the neck, long sleeves with frilly cuffs, and a black skirt. She wore her hair pulled up into a bun on the top of her head, service-weight hose, and ground-gripper shoes. She was a towering woman, close to my own six-feet-two. The size of her hands was Michelangelesque. With the determination of one possessed, she took one of her enormous hands and lunged for my crotch. I was stunned. To be in the grip of this woman was as painful as it was terrifying. We both stood there, among the writhing bodies on the floor, and spoke not a word.

I looked into her eyes in disbelief, attempting to disengage myself. She began to murmur soft, unintelligible intimacies. At this moment Jane appeared beside us. She did not see the position I was in and began to make small talk with the woman who still had my vital parts in her grip. I turned to Jane, saying, "Darling, we must leave." But the lady would not let go. It was at this moment that Jane noticed my predicament. She remained still, in quiet disbelief. It now became imperative for me to do something. Since I was no match for the woman's obvious strength, I suddenly embraced her passionately, causing her to release her grasp and let go of me. I remember shaking hands with her at the door, and thanking her for a wonderful evening. She was full of apologies about the projector.

I finally *did* see *The Mechanics of Love* months later at Cinema 16, and found my score as obvious and undistinguished as was the film itself.

My penultimate bout with the zither provided the background music for a full-length off-Broadway production called *Fire Exit* by V. R. Lang. Bunny Lang, as she was known, was a gifted young poet and playwright whose life was cut short by cancer in the mid-fifties. She was a product of the Poets' Theater in Cambridge, Massachusetts, and the play was given its first performance there. It was brought to New York by the Artists' Theater, headed by John Myers. Myers's long-time friend, Herbert Machiz, directed *Fire Exit*, which was performed in the Amato Opera Theater at 159 Bleecker Street, around 1955.

Fire Exit was a long and convoluted retelling of the Orpheus and Eurydice legend, updated and set in Miami Beach, as well as "somewhere in France." It was decided that the musical score would be played, live, during every performance, so for three or four days I found myself the sole occupant of the Amato Opera's huge orchestra pit. Zither on my knee, I plucked for all I was worth during the interminable course of the play. Each night, I emerged from the theater with bloody fingertips, proud to have been a part of what we all thought was a deeply avant-garde production.

My last zither experience was also under the aegis of the Artists' Theater, which in the summer of 1955 found itself in the Lakeside Summer Theater at Lake Hopatcong, New Jersey, giving another new play its world premiere. It was called *The Crime of Innocence* by one Norman Vein. Herbert Machiz again directed, the painter Paul Georges did the sets, and another artist, Peter Stander, the lighting. Set in a tiny fishing village near the southern end of Chile, somewhere on the Straits of Magellan, *The Crime of Innocence* was about a girl's blood contaminating the fishing waters of the village and causing all the fish to die. The girl was naturally deemed to be a witch and neither priest, friend, nor lover would help her out of her desperate situation.

It was not, to say the least, one of the most memorable Artists' Theater productions, but there I was, sitting in the wings again, plucking away at my beloved zither. This time I had taped all my fingers. The only trauma connected with that production was that after one particularly impassioned speech Rachel Armour, the star of the play, would rush off stage each night to where I was sitting and sob and wail right into my ears, just as I was at the height of my musical rendition.

My affiliation with the Artists' Theater came to a close with its production of Lionel Abel's biblical drama, *Absalom*, presented at the Harlequin Theater, 122 Second Avenue, in 1956. *Absalom* was again directed by Herbert Machiz, with decor and costumes by the gifted Robert Fletcher. It starred George Gaynes, Irma Hurley, Leo Lucker, and Richard Astor, among others. This

time, my score was to be extremely elaborate, and it occurred to me that it might be interesting to join forces with a young Japanese composer, Teiji Ito, who besides being extremely talented, owned a great number of percussion instruments—drums, wood blocks, and bells of every sort. *Absalom* was to have a sumptuous production and I wanted the music to be equally gorgeous.

Teiji Ito was willing to collaborate and I visited his house for several weeks in order to pretape our joint composition. Teiji was living with Maya Deren, a legendary underground film maker of the forties and fifties. Miss Deren, who died in the late fifties, was well known for her highly surreal, often dreamily poetic films, some of which, such as *The Meshes of the Afternoon*, had been done in collaboration with her former husband, Alexander Hammid. Maya Deren wore an Afro hairdo before it ever came into vogue, and her Slavic features, delicate and subtly voluptuous, hid an energy that was positively unhinging. She was a high-strung and volatile woman, whose zest for life and for anything creative seemed inexhaustible. She was also something of a mystic and involved herself in voodoo and Zen.

I believe it was at Maya Deren's Greenwich Village apartment that I had my first puff of marijuana, a drug that seemed to be consumed in great quantities in that household.

On the many occasions that I worked with Teiji, Maya was present, giving advice and frequently leaping around the room, executing mad, improvised dances to the sounds of the drums and bells that we were playing on. Her aggressively unbridled vitality finally became a hindrance to our work. Still, she was a free spirit, full of a driving primitive exuberance.

Our score was considered a great success when Abel's play opened. The play, a most poetic and intelligent piece, nevertheless suffered from an excess of verbiage which continually arrested the dramatic flow of the story.

We were in the middle of the play's brief run when I noticed that Maya, who came to every performance, was displaying open antagonism toward me. Her attitude was confirmed when I re-

ceived a ten-page letter from her accusing me of having undermined Teiji's part in the writing of the score, and claiming that it was mainly Teiji who was responsible for the music. She then proceeded to tear apart my character, using the most popular Freudian jargon of the day, concluding that I was unhappily married and that this state of affairs caused me to behave in a dishonest manner. The letter ended my relationship with Maya, who later married Teiji, and died a few years after that.

The Artists' Theater, which operated between 1953 and 1956, was among the first theatrical groups to present plays by serious writers and poets. It put on sixteen original plays in which writers, painters, and composers of the day were invited to place their talents at the service of the theater. Together with the Living Theater, with which I also had a brief brush, it was the most avant-garde group around. Beset by financial problems, poor audiences, and a bevy of ill-chosen plays, it nevertheless provided many thrilling evenings, notably *Try! Try!* by Frank O'Hara, *The Heroes* by John Ashbery, and *The Bait* by James Merrill.

The Artists' Theater was spearheaded by John Myers, who, at the time, was also running the Tibor de Nagy Gallery. It seemed to me that one of the chief problems of the Artists' Theater was John Myers' insistence that every production be directed by his friend Herbert Machiz—though Machiz was not altogether lacking in talent. The first recipient of the U.S. State Department Fulbright Fellowship for Theater Research in Paris in 1949, he became an assistant to Orson Welles and, in New York, directed such notable revivals as *Cabin in the Sky* by John Latouche and Vernon Duke. He had a real flair for fast-moving, bright comedies and could elicit lively performances from receptive actors. In directing poetic plays, however, Machiz seemed invariably out of touch and heavy-handed. Without fail, each Herbert Machiz production for the Artists' Theater contained one or two devastating lapses in taste; a vulgar or jarring note appeared, and the play sank to a level of abysmal triteness. Machiz once confessed to me that these intellectual plays were not his cup of tea, that he was cut out to direct Noel Coward.

This may all appear ungrateful on my part, since Myers and Machiz enlisted my services for the Artists' Theater, but the fact remains that this far-sighted venture would have profited immensely by the use of a variety of directors rather than one who was, finally, ill equipped for the job.

One of the most fascinating theatrical figures of the fifties was a spirited young woman named Julie Bovasso. She was among the first to bring European playwrights to the attention of the New York public. In a small theater at 4 St. Mark's Place, called the Tempo Playhouse, she produced, directed, and starred in such plays as *The Maids* by Jean Genet (alternating the roles of Solange and Claire every other night), *The Lesson* by Eugene Ionesco, and Michel de Ghelderode's *Escurial*. It was for the latter two plays that I was asked to supply the music. Miss Bovasso called me and said that she would pay me seventy-five dollars for a pretaped score for both productions. I set to work, and was quite happy with the results. As it turned out, Miss Bovasso never paid me the seventy-five dollars and to top it all off, lost the tape of my score when the production of *The Lesson* and *Escurial* closed. Still, it was a small price to pay for the opportunity of being part of this unique theatrical event.

Julie Bovasso was a remarkable actress and director, then married to the painter George Ortman. George did the sets for *Escurial* while Julie directed. *The Lesson* was directed by Bill Penn and had settings by Lester Hackett; Julie played the female lead. Later, Julie Bovasso altered the shape of her nose, probably because she felt she was not pretty enough to be asked to perform in Broadway plays or in movies. For all her intelligence and courage in bringing unknown European playwrights into the open, she nevertheless harbored ambitions for commercial stardom. There were few post-nose-job jobs, but I do recall going to see Julie in the Broadway production of *Witness for the Prosecution*, in which she had a small but effective role. We lost track of Miss Bovasso for several years, only to meet her again in the late sixties when she became a member of Café La Mama, writing, directing, and starring in her own rather vacuous plays.

Certainly the most exciting avant-garde theater group in the fifties was the Living Theater, run by Julian Beck and his wife, Judith Malina. The Becks were the zanies of the fifties and practically invented the off-Broadway movement, doing plays by Pablo Picasso, William Carlos Williams, and any number of writers not associated with the theater.

We ran into the Becks at hundreds of social events—play openings, gallery openings, film openings—and at parties, where their presence would invariably stir comment. For one thing, the Becks liked to dress in the same kind of bargain-shop clothes Jane and I were fond of—musty velvets, turn-of-the-century jackets, and so on. For another, the Becks were deeply committed to all kinds of social causes. They were the original injustice collectors, and would march for peace, and for the legalization of prostitution and of abortion, among many others.

What is more, the Becks seemed the most sexually liberated people we had ever met. They were a curious, very engaging couple whose courage we all admired. Judith Malina, like Julie Bovasso, chose to have her nose fixed. When we knew her, she had one of those sharply defined cameolike faces with an aristocratically beaky nose that seemed absolutely in scale with the rest of her features. But she must have felt her nose was a detrimental feature, marring an otherwise perfect face. Like Julie's, Judith's nose job was a mistake, at least from my point of view, because when both women reappeared on the scene, their faces seemed vacuous and ordinary.

The way Judith and Julian ran their Living Theater suggested they were either out of touch with, or totally unconcerned with, the realities of business or even simple organizational efficiency. How any of the plays they produced, directed, and acted in got put on remains a mystery to this day. But despite the chaos, performances were announced and the plays would be given their run. Julian, with his Christ-like, ascetic face, was an extremely sweet man, whose persuasiveness and charm made actors and stagehands work for him for practically no money at all. Judith seemed always the more aggressive of the two and, while diminu-

tive in size, evinced real power as a director and as an actress.

In the mid-fifties, the Becks rented space at Fourteenth Street and Sixth Avenue, which they converted into a small and intimate theater of the avant-garde. Here they produced one of the most electrifying plays of the fifties, Jack Gelber's *The Connection*, a deliberately grim, starkly realistic study in dope addiction that was so harrowing and immediate that both men and women in the audience fainted during performances. In fact, a nurse was hired to be in attendance throughout the run of *The Connection*. Gelber exposed the nightmare world of the junkie, and presented for the first time on an American stage the hair-raising details of a heroin injection and the suffering and torture of the addict.

There were so many innovative facets to the production— jazz musicians performing on stage as part of the action, blacks and whites enmeshed in situations going beyond the color line, and language that seemed improvised on the spot—that critics did not quite know how to write about it. Gelber's vision came so close to the mark that they felt impelled to deny *The Connection* its merit as theatrical fare, calling it a mishmash of impressions and an undisciplined melange of surreal ideas.

When Jane and I attended *The Connection* we were stunned by its power, by Judith Malina's brilliant direction, and by its superb acting, notably by the gifted Warren Finnerty. We were amazed by the freedom of language, and by the fact that during intermission one of the blacks in the cast approached people in the lobby and talked to them about "how it feels to be a junkie." It was the Living Theater's first attempt at audience participation, and it was as distressing as it was unheard of. Despite uniformly bad opening-night reviews, the play continued to run for a number of weeks, then became something of a landmark when *The New Yorker* magazine suddenly came out in its favor. Business picked up and *The Connection* became the most talked about play of the season.

Shortly after it opened, Jane and I met Jack Gelber and his attractive wife, Carol. Now that Jack's first play was a hit, the Gelbers were lionized and appeared everywhere. When the run of

The Connection ended in New York, it was turned into a film by the talented Shirley Clark and was also given a production in London. Neither the film nor the London production captured the kind of interest and box office that had been anticipated. Gelber's second play, *The Apple*, and third, *Square in the Eye*, were failures, and as the years passed, his name declined in popularity, plunging him into understandable depression and dissatisfaction. He began to teach, and made some screen adaptations, which sustained his family during these years. In 1968, his play *The Cuban Thing* opened on Broadway, starring Rip Torn. It was an immediate fiasco, leaving Gelber more distraught than ever.

When I called him to ask whether he would talk to me about *The Connection* and the fifties, he refused, saying that he couldn't bear to relive the bad years. Some months later, however, he agreed to talk about the year of his success and some parts of his life:

"I was born in Chicago in the Mount Sinai Hospital, on the eighth floor at 8:08 a.m. and I weighed eight pounds and eight ounces," he began. "The date was April 12, 1932. My father's name was Harold, meaning 'commander.' My mother's name is Molly. I was their first child. I believe there was a miscarriage before I got on the scene. They had been married some time. My mother told me later that she didn't know very much about sex when she got married, and didn't have very much help from anyone, and was quite terrified.

"My father is a sheet-metal worker today. He was a sheet-metal worker when I was born. His father was a tinsmith who became a sheet-metal worker because that's the way the craft unions became consolidated.

"I grew up when it was still possible to see men going to the forest preserve to shoot rabbits. We moved around an awful lot. My mother and father quarreled a lot, so they split up a lot. We lived in many different apartments in Chicago. My family comes from a working-class background. My mother's family all came from Bessarabia. My mother's father died when she was thirteen. He died of pneumonia after being out in the snow dead drunk.

My mother and father met and got married in Chicago. Chicago is not a Jewish city, as New York is. It has many fewer Jews, and what Jews there are live in concentrated areas. When I was ten years old, we moved to a neighborhood on the Near West Side, which was Irish-Italian Catholic. There were big gangs always beating each other up. I went to the local elementary school and did very well there, skipping a lot of grades. I got out in 1945. That year I went to John Marshall High School. In high school I began reading a good deal and listening to a lot of jazz. I was in the high-school band as a tuba player, but I got thrown out because I goofed off so much. Later, I was good enough to be in the orchestra and in the senior band. I faked a lot of the fingerings. Anyway, I began listening to a lot of jazz and going to strip houses with friends and reading James Joyce. After high school, I went to the University of Illinois, and became a chemistry major. I continued listening to jazz. I guess the people who attracted me the most in the jazz world were the listeners rather than the musicians. I liked the listeners because they were either prostitutes whom I wanted to fuck, or people interested in literature—so it was one of those scenes.

"I was very lonely, very isolated, with no money and a feeling of complete worthlessness. But I became aware of the Near-North-Side scene of Chicago where the jazz world met the literary world and the painting world. Maxwell Bodenheim was very accessible at that moment. And Nelson Algren was around. His *The Man with the Golden Arm* was published in 1947 and we all read it. It became quite apparent that all the people who did things in Chicago had to leave Chicago. Everybody knew that. The painters knew it. The poets knew it—everybody. When I started at the University of Illinois [Chicago campus], I really couldn't get with it. I took writing courses. After two years I left and went to Champaign-Urbana, 135 miles away. I read a lot and was very encouraged by people in the writing department. My last year there I met Randall Jarrell, who came to teach a writing course. I remember once handing him a novel I had written called *The Amoeba*, which followed the biological process of mi-

tosis. He read it and then called me into his office and said, 'I'm sorry, Jack, I just don't understand any of this.' I think I fell three stories right in the chair. It took me a long while to recover from that.

"There were theater people on the campus, but I didn't like them. They offended me, partly out of my own provincialism, partly out of their own narcissism, and partly out of the isolation in which they worked. Because of the academic atmosphere, I thought that the theater there had absolutely nothing to do with anything. The values seemed all wrong. I had no real friends. No girl friends that I really liked. I graduated with lots of troubles, both from the school's point of view and my own point of view. Finally, I bullied my way to get this sense of accomplishment—this business of graduating. I got my bachelor's degree in 1953.

"I went to San Francisco, but San Francisco didn't challenge me at all. I was floating—doing some painting, drawing, writing, keeping it to myself, keeping my eyes open, having a good time. I still was not sure about what I wanted to do or how I wanted to do it. I knew I could never do anything with the college education I got. There was no way for me to deal with that. I mean, I couldn't go out and become a reporter for, say, the *Sacramento Bee*. It wasn't my personality. I felt very much like a man without any substance. I had nothing to back me up. So I didn't really try anything. So I came back to Chicago for two or three months and got a job so I could have some money. My father helped me to land a job as a sheet-metal worker, and I worked way up high on the Prudential Building. There were safety belts, and it was pretty safe, but I still was scared. I got enough money together and then I found somebody who needed to have his car driven to New York, and that's how I landed in New York.

"I got a job at the U. N. working nights as a mimeograph operator. From the U. N. job, I got a chance to take a vacation. In the meanwhile I had met Carol and we got married. When I got my vacation, Carol and I went to Haiti, which is where I wrote *The Connection*.

"The story about how I wrote *The Connection* goes back some time. You see, when I was in San Francisco I tried to write a story about the scene I was in. At that time, Allen Ginsberg had just come to San Francisco, and there was a whole movement called 'collective expressionism,' which was like a Dada movement in which pianos were smashed and paintings were pissed on. Ginsberg would read 'Howl' in the toilet. The whole thing was pretty destructive, but they were provocative events and very stimulating to my imagination, as I always had this streak of destructiveness in me. There was also a kind of outrageous, popular view of jazz at that time. You know, the drug addict in *The Man with the Golden Arm*, or that play, *Hatful of Rain*. Anyway, jazz musicians were always being portrayed as something rather creepy.

"So when Carol and I went to Haiti, I brought along my little portable typewriter and I was going to try and do something with all of these ideas and elements. Very quickly I arrived at an idea of how to deal with it all and I wrote *The Connection* in about a week—it was a rough draft, of course. When we got back to New York, I quit my job at the U. N. and tried to figure out what to do with this damn play.

"I found Julian and Judith Beck through a man named Norman Solomon. Norman was a painter who had worked for the Becks when they were doing the Picasso plays. Norman was a strange one. He read my play, much to my unhappiness, because I didn't want to give him one of my only copies. But he read it, and he said I should go see the Becks. Before that, I called the Phoenix Theater, because I had heard that this guy Houghton was doing new plays. When I called, Houghton's secretary told me they were only doing Nobel Prize winners. Then I called the Becks.

"The Becks were very nice. I went up to their place to personally hand them the play. They lived at 789 West End Avenue on the second floor. It was a giant apartment. When I walked into it, it looked sparsely furnished, with your ubiquitous butterfly chair and your hassock and your rug. It was all very middle class

to my eye, since I was living in a rat-infested apartment on Fifth Street. They had a library with books up to the ceiling. Julian's paintings were on the walls. They were very sincere and obviously knew something about drugs. They were asking me the right questions. They were not corny. In short, they were *people*. Julian represented himself as an intellectual anarchist. Also, he and Judith were vegetarians at the time. They also seemed to be sexually askew, to say the very least. First thing, they handed me a big scrapbook of their former productions. While I was looking at the scrapbook they went into another room to look at my play. Then they came back and said they couldn't read it just then, so we sat and talked about my life and their life.

"What I didn't know at the time was that the Becks usually read their scripts on the toilet. They had maybe seventy or eighty scripts piled up near the toilet seat, and I was told much later that Judith began reading *The Connection* while on the toilet, then Julian would read it when he went in there, and then (I was told) Judith went in again, opened to a page of my play and started screaming out to Julian, 'It's terrific, it's great.' Anyhow, that's how *The Connection* first got read by the Becks.

"I called them back in two weeks and went over for a conference. Now remember, there wasn't an off-Broadway scene at the time. The Becks' experience wasn't what you would call professional. They were talking about 'we'll give you three per cent of the gross and we'll do this and that.' It was all very vague and all done on a handshake. There wasn't a contract, and they said they couldn't give me an advance, but that they were definitely going to put on *The Connection*.

"The play went into production around April 1959. I stayed away, but then I called them up. They seemed to be desperate, panicky. They wanted me to come down to the theater on Fourteenth Street immediately. They were looking for me. (Of course, I was in the phone book—but that's irrelevant.) So I went down and they asked me if I knew any Negro actors, and did I know any jazz musicians. Suddenly, I was completely involved and it was a terrific self-education, self-indoctrination, a learn-as-

you-go thing. I suddenly felt very worth while. I mean, I was doing real work and I was very good at it. I learned about acting, about actors, about the theater. *The Connection* needed fifteen actors in it, but I saw literally thousands of actors. Finally, we cast it. Judith directed it. She's a very good director, although she gives you the illusion that 'anything goes.' But the play began to take shape. Of course, the musicians were always late. They were always troublesome. They were always high on heroin. They had to be replaced almost every week during a rehearsal. Some of the actors didn't know anything about drugs, and went through the play behaving as though they were drunk, instead of on drugs. There had to be a whole educational process for the square members of the cast.

"The outstanding part for me in connection with *The Connection* was the event that centered around one of the characters in the play. Actually, it was about an actor in the cast who played the role of Cowboy. We hired him because there simply wasn't anyone else who could come near that role. He had been a librarian, I believe, and hadn't acted for a while. During rehearsals he was very withdrawn and sulky. During our first preview he was inaudible. Judith, Julian, and I were, of course, concerned, but Judith kept telling me that he'll 'come up.' He didn't come up. Finally we had a talk with him and the next day he came in and he began shouting on stage. Then, at one point, he walked off stage. Someone else had to quickly go on for him. All of us realized that something was radically wrong with this young actor. We ran backstage, when he had walked off, and we realized that the boy had gone stark, raving mad. He was terribly frightened of performing. He hated himself for being a performer. Julian, saint that he is, grabbed two nembutals and shoved it down his throat and said, 'You are an actor! You must go on!' And he convinced this son-of-a-bitch—poor man, really—that he had to go back on stage. And he went back on stage and gave an electrifying performance. Of course, he was making up all the lines himself—or, at least most of them. The other actors were loose enough to play with him and get through the performance.

Now, mind you, this was our second preview for the public. This actor went through the whole play and, as I said, did a fantastic job despite the fact that he didn't stick to the text at all. When the performance was over, we rushed backstage and the first thing we saw was that this kid had started picking up things and throwing them at the other actors and trying to kill people. He went completely berserk. Judith and Julian had to take him to Bellevue.

"Now, if I said that I, Jack Gelber, had to take him to Bellevue, I don't think I'd be saying anything extraordinary. But for Judith and Julian, to take anyone to Bellevue was a terrific crisis. They did not believe in any vested authority to interfere with anything and anybody. For them to institutionalize this man— for his own protection, which I think was the only damn thing they could have done—caused them a great deal of pain. Anyway, that was the end of our Cowboy. Naturally, we had to replace him and we found Carl Lee, who was the son of Canada Lee, a very great actor in the thirties and forties. Judith got him on the phone. He was a maître d' at the Café Bohemia in Greenwich Village where Charlie Parker and a lot of other people played. Judith called him and he learned the part and he was sensational.

"And so, *The Connection* opened and it received very bad reviews. Judith Crist was exceptionally unkind. And a man named Louis Calta of the *New York Times* was equally unkind. 'A farrago of dirt,' he called it. There was a man named Jim Davis, I believe, of the *Daily News*, who walked out on it, and a guy from the *Journal-American* asked that I be arrested and that the play be closed as obscene. It upset a lot of people. But the Becks were very tenacious. For two reasons. One, because of their unswerving belief in my work. And two, because of their own survival. If this play didn't go, they didn't go. The whole damn place would have fallen apart. So they held on and just then, my son Jed was born. And we had a '49 Ford and we went to see Carol's mother and father in California. I was very depressed at the reception of my play. I didn't think I'd write any more plays.

I didn't think I'd write any more at all. It was a wretched and completely castrating experience.

"We got to California. We stayed around for a month and nothing really happened. My royalties were about thirty dollars a week. The play was running in repertory with William Carlos Williams' *Many Loves*. When I got back to New York, things suddenly turned for the better. *The New Yorker* had come out with a very favorable review and people began going to it, and it just blossomed. It finally became a very big box-office success. This frightened the Becks completely. Because the Becks needed to fail fianancially in order to preserve their esthetic dignity. Anyway, I was getting some money and I was feeling better about writing and so I wrote another play called *The Apple*.

"In the meanwhile, I was sort of delighting in my success with *The Connection*. Of course, I wasn't really getting rich on it, and that was fortunate because I don't know if I would have had the incentive to go on quite the same way. Still, I was always fighting with the Becks about money because they could have made me a lot richer than I was. At any rate, I suddenly had fame without fortune. I found myself on Fifth Avenue and Park Avenue in salons and that sort of thing. Of course, Carol and I were both well aware of fame's transitory nature. We knew about the bullshit of it all. But we loved it. We loved meeting new people. And some of the people we met became good friends—people like Kenneth Tynan, Peter Matthiessen, Terry Southern, Harold Humes, George Plimpton. And we met a great many rich people and a lot of painters and writers and musicians. But all the fame business didn't last.

"For one thing, the Becks, because they were so politically minded, realized I wasn't of their ilk. And I wasn't sexually of their ilk. I always felt that they cut me out of their central thinking, as they never did Paul Goodman, at that time, or even Kenneth Brown (who wrote *The Brig*) a little later. I know it sounds egotistical, but when *The Connection* was done, on opening night people applauded—and that was the end of that. When *The Brig* was done, Judith went out and took a bow and then

brought Ken Brown out for his bow. I found that very peculiar behavior. I mean, that sort of thing had never happened before in the Living Theater. I didn't quite know how to take that. I felt, 'what the fuck?' You know, like if you're going to do the bowing bit for one playwright, why not for another?

"Not only didn't I sleep with Julian, I didn't sleep with Judith. I found them—how shall I put it?—not very appealing looking. They are absolute sweethearts in their own way, but they were driven by panic, driven by a nervous anxiety that led them to sleeplessness and overanxious behavior. They found it necessary to always have this element of panic in their daily lives. I am by nature a lethargic person, and I don't like false panic. I can't do that at all.

"Anyway, Shirley Clark made a movie of *The Connection* and then I got an offer from London to put the play on there. I took seven of the original cast members to England. The Becks did not like me taking the seven people to England. I could probably have insisted that the entire production go there, including Judith. But had I insisted, I don't know whether the people in London would have gone through with their promise of putting it on. Judith didn't direct it in London, and maybe she should have directed it. Maybe I should have insisted that Judith repeat her directorial job. I don't think it would have made a difference for the play, but it would have made a difference in our relationship.

"The play didn't do well in England, and my relationship with the Becks became tenuous. The situation was very delicate. The Becks became resentful over the fact that people were saying I put the Living Theater on the map. It was a very touch-and-go situation. A lot of ego was involved. Now, of course, we've both gone our separate ways. They've made their life in Europe with the company and made big names for themselves. I hear they've disbanded. Actually I thought they did a suicidal thing in going to Europe. They knew it, and I warned them and I prophesied correctly, and I don't think they were very happy that I did.

"When they were performing over here in 1969, I sort of became their middle-class connection. They called me about a pe-

diatrician. They called me about this and that because they knew they could trust me. They were very cordial towards me. Not an ounce of hostility. Very open. Very warm. I felt the same way toward them.

"I would certainly admit and agree that the Becks and their Living Theater were the first avant-garde force on off-Broadway. That was in 1952. They were the first to do plays by poets and they did Picasso's play *Desire*. Then they were kicked out of the Cherry Lane Theater where they started, but continued to put on plays in a loft at One Hundredth Street and Broadway. Then they got some money together and built their place down at Fourteenth Street. The quality of their work was very high indeed. They had the ability and the taste to use elements from society and theatricalize them. That was their gift. They had no gift at all of working with trained actors and they had no gift with classical plays, which they tried to put on. Still, they were an important force in American theater."

9

Throughout the fifties, Jane and I ran around like crazy. We were everywhere. We went to concerts, plays, movies, galleries, museums, and to the Cedar Bar, where all the artists met. We gave dinner parties, we accepted endless invitations, and tried our best to stay abreast of as many artistic milieus as possible, with the object of seeing as much as New York could offer, and by the same token, of being seen everywhere, and as often as possible. We were free agents, with no children, and our only responsibilities were to earn enough money to pay the rent and buy a few good-looking clothes, and to work and make names for ourselves.

When my job at Grove Press came to an end, I wondered what to do next. I knew that a nine-to-five job was not for me. My bout with Barney Rosset taught me the ugly realities of being dependent on someone else for my living. Jobless, I paid my weekly visit to the unemployment office, collecting something like twenty-four dollars each time. But we were by no means starving.

Jane's modeling career had suddenly zoomed, and she began to bring home more money than we'd ever seen. We now embarked on a life more in keeping with my movie fantasies of how glamorous young couples should live in New York. The Village was beginning to get on my nerves. It was all very well to be Bohemian, but it would be more fun to live where the rich live.

Scouting through the *New York Times* we saw advertised a brownstone parlor floor-through on East 72nd Street between Park and Lexington. The rent of $150 a month seemed reasonable even in the fifties, so we promptly took it.

In a little while our huge bedroom also became Jane's studio. Despite her full-time modeling job she would return home at six, fix our dinner, and then set to work painting landscapes. The arrangement was just fine except for the matter of my being totally dependent on her income. Old-fashioned notions of a husband supporting his wife were gnawing at me, despite the fact that I tried to be blasé about it. Jane complained not at all and handed over her checks to me in the most casual manner. But a few months of this was quite enough. I had to do *something*, besides writing songs that no one would publish, or composing scores that earned me neither money nor fame. One day it occurred to me that I might make a wonderful agent. But what kind?

I decided to become an agent-entrepreneur in an assortment of fields. My office would be my living room—the address was fancy enough—and I proceeded to have some glorious stationery printed as well as thousands of calling cards. Thus "John Gruen Enterprises" was born. Alexander Hammid, the film director, was my first client; William van der Veert, the photographer, my second; and the folk singer Cynthia Gooding my third. As the months flew by, the sum total of my efforts on behalf of my clients was one minor job for Bill van der Veert. I became thoroughly depressed and decided to lay "John Gruen Enterprises" to rest. My three clients—who suddenly began doing quite well on their own—did not consider my dropping them as fatal.

This dismal turn of events caused our lives to take something of a nosedive. Not only was Jane bringing home the money, but she was also receiving a good deal of attention from the art world, and people began calling me "Mr. Wilson." I started going out by myself, and leading something of a messy life. Not previously given to drink, I now found the bottle of some inter-

est. I kept very late hours, acting out the role of a misunderstood, defiant "loser," and proceeded to make Jane singularly unhappy.

One morning, bleary-eyed and hung over, I noticed that Jane was in the apartment when she should have been at work. She didn't seem to be ill. Seeing me awake she said, "I've given up modeling." "But you can't," I said. "What about the rent?" Jane put it quite simply. "We're leaving Park Avenue. We're moving back to the Village, and you are going to find a job." Rubbing my eyes in disbelief, I realized she meant every word. I also realized that she was saving our marriage as well as my sanity.

We had been living uptown for exactly one year. With all of my desire for chic, I soon found those elegant uptown streets incredibly dull and dead. The sight of doormen walking poodles simply did not compare to the bustle and ferment of the Village. Jane was right; we had to get out of there—and fast.

Returning downtown was like returning home. We found another brownstone parlor floor-through, at 241 East Eighteenth Street, not directly in the Village, but close enough to make it seem so. The only thing remaining was for me to find a job, which I did after a few weeks. While the job occupied six long years of my life, I can easily sum it up in a few words. I became associated with a photographic agency called Rapho-Guillumette Pictures, run by a diminutive Hungarian gentleman named Charles Rado. Mr. Rado sensed my potential as an agent right away. The difference between my own attempts at agenting and working for Rapho-Guillumette was that this was a well-known firm concentrating on the sale of American and European photographs taken by men and women of distinguished reputation. It was an established business and all I had to do was put my powers of persuasion to use on its behalf.

If my identity was still unclear, I now at least had a base and a weekly paycheck. All my resolutions about not being at the mercy of a "boss" had gone by the wayside, but there were many occasions when I was ready to walk out the door. Charles Rado, who died in 1970, was a past master of the art of being difficult. Mild-mannered and gentle on the surface, he could be

maddening in the office. His treatment of several young secretaries who appeared during my tenure there was, to say the very least, neurotic. Rado would go into paroxysms of trembling rage over a letter misfiled, a photograph misplaced, a phone call unreported. Beleaguered by a series of habitual nervous tics, Rado could create an atmosphere of insupportable tension within the confines of the office.

At the same time, he was possessed of some endearing qualities. If he liked you, he would be your friend for life. In spite of the many tensions of the early years with Rado, he never failed to be generous, thoughtful, and kind. There were bonuses, unquestioned loans when I needed them, and gifts. Rado also took a great interest in Jane's work, and was among the first to buy several of her paintings.

During the six years at Rapho-Guillumette, I learned a great deal about photography, the world of advertising, the magazine world, and, of course, continued my hectic social careening, making new friends in art, music, literature, and the theater. I worked very hard and I played very hard, and the frantic pace took its toll. At the age of twenty-seven I came very close to suffering a nervous breakdown.

Imagine my terror when I suddenly found myself besieged by the most severe anxiety attacks. Where had they come from? What had I done? There were no obvious answers. What was horrible was that these unnamable anxieties would assail me at the most unexpected moments: walking down the street, eating dinner, lying in bed, working, talking on the telephone, being with friends. It was unfathomable. I tried to remember all the thoughts that passed through my head before an attack, but was invariably at a loss. I recall having to stand in doorways until the seizure passed. One attack was so severe I had to enter a restaurant early one morning and sit down without being able to tell the waiter what was wrong. I was rooted to my seat, unable to communicate anything. Even when the man kindly brought me some brandy, I could not speak.

The symptoms of these attacks were always the same. My heart

would begin to pound furiously, there was shortness of breath, dizziness, and a sudden realization that I might collapse and die. Each time, I would try to convince myself that it was momentary, but there were times when the attack would last for hours. I could not believe it. These things simply could not be happening to me. Clearly, something had to be done, and the answer, of course, was psychoanalysis.

In the fifties, psychoanalysis was the great spiritual and moral healer. To be in analysis was to be in step with the times. Neuroses of every kind found their name and label through the advent of this amorphous science. I had nothing against analysis, as long as it was undertaken by others. I considered myself perfectly well adjusted and decidedly not in need of it—not, that is, until my anxieties beset me.

And so I became part of the army of psychoanalyzed men and women, each with his own special set of problems. For me, it was a question of really getting to know who I was—an area of terrifying vagueness. For a twenty-seven-year-old, married for seven years, having no real focus, still uncertain about his goals, possessed of a boy-genius complex, and filled with dubious artistic aspirations, the question was particularly disquieting.

For me, analysis was like going to school about myself. Relentless twice-weekly sessions for three years made me realize that clear and final answers do not exist. What did come home to me was that I had a very superficial contact with my own feelings, and that I tended to align myself with people who were masochistically inclined and with prospects which were destined to fail. My only anchor was Jane. But even there, I had gone out of my way to wish to break the bonds that held it in place. Finally, psychoanalysis taught me to have a more optimistic view of myself and to deal with my problems in ways that did not entail hurting myself and others.

The intervening years have washed out much of what I went through during analysis. I do know that in a matter of months during analysis, my anxieties abated and the fabric of my life be-

came smoother. There is no question but that analysis was a major event for me.

The three analytic years occurred while I was working for Rapho-Guillumette Pictures, and also coincided with the time Jane and I met Virgil Thomson, who was instrumental in getting me a music critic's job at the *New York Herald Tribune*. In fact, my music reviewing began while I was still putting in time at the photo agency.

I started out as a "stringer." Stringers were more or less qualified people not on the staff of a newspaper, but trusted with outside assignments. Jay Harrison, who was music editor at the *Trib* during that time, had asked Virgil whether he knew of someone who could cover concerts with some intelligence and sensitivity. Virgil gave him my name, and I began reviewing three to four concerts per week. My dream, of course, was to be a *Trib* staffer with my own byline.

The *New York Herald Tribune*, located at 230 West Forty-first Street, boasted a city room of enormous size, with dozens and dozens of desks at which sat men in shirtsleeves, hunched over typewriters, clutching at phones, pushing pencils— thinking, discussing, writing, editing, making decisions, arguing, cursing, and doing all the frantic things that would ultimately result in a morning edition. The hum and noise of that city room were more than music to my ears. At the beginning, I only rarely visited the *Tribune* during daytime hours, but when I did, the excitement of the place was inebriating.

Since my job entailed going to concerts at night, I would return to the *Trib* building when things were relatively quiet. The Lively Arts Department, as it was called, was not in the city room, but on the floor above. A music reviewer was obliged to leave a concert before it was actually over, since the deadline for copy was around 11:00 or 11:15 p.m. I would arrive at the *Tribune* building around 10:20 p.m., take the elevator to the sixth floor, dash to a typewriter, and start writing furiously to meet the deadline hour.

Never having written to a deadline, I was usually in a panic, my mind racing and my eye constantly on the clock. My first review for the *Trib* was on a concert given at Town Hall by the Spanish guitarist Carlos Montoya. It was a short and singularly awkward piece. Next morning it appeared in the entertainment pages, without, alas, a byline, for in those days, stringers were only permitted to put their initials at the bottom of their reviews. My ego was somewhat shattered by the inconspicuousness of the signature, but the other stringers had told me that sooner or later people would come to know who this J. G. was.

On subsequent nights my nervousness subsided, allowing me to notice other writers typing *their* reviews: Walter Kerr just back from seeing a play, Walter Terry writing up a ballet, Paul Henry Lang, the paper's chief music critic, writing about a major concert, and Jay Harrison doing *his* music review. One of my costringers was Bill Flanagan, who had noticed my severe case of nerves as I typed the Montoya review and had come up to me to tell me not to worry so much and to take my time. He had left his own review waiting in the typewriter to put me at my ease, a fact that endeared him to me forever.

Bill and I saw each other a great deal outside of our music reviewing activities. He was not what one would call handsome. On the contrary, he had a rather surly face, although his eyes, of a startling blue, were intense and hypnotic. It soon dawned on me that Bill's tastes were of the homosexual variety—the kind that extolled the life and artistry of Judy Garland, Bette Davis, and Tallulah Bankhead. I don't mean to suggest, however, that Bill Flanagan was one of those screaming virtuosos of trivia. There was nothing outwardly effeminate about Bill, except for the fact that he liked to bleach his hair (inexplicably insisting that he never did).

One of the most intellectually stimulating people I have ever known, Bill could analyze a piece of music with the deftness and precision of a surgeon, and he could talk about friends and acquaintances and stars with a kind of bitchy insight that nevertheless took people's vulnerabilities and weaknesses into account. I

suppose the major event of his personal life was his long and tur-
bulent friendship with Edward Albee.

Edward Albee, in the early fifties, was usually silent and mo-
rose, a sideline presence who did a lot of avid watching. Bill
Flanagan was the interesting one then, and Edward merely an
uncommunicative hanger-on. Bill told me that when he came to
New York City in 1948 from the Eastman School of Music in
Rochester, New York, he lived in a sleazy place on Eighth Ave-
nue called the Garden Hotel. One night, a fellow student at
Rochester came to visit Bill and brought along a young man by
the name of Edward Albee. Edward was twenty years old at the
time. According to Bill, that meeting proved unmemorable, but a
subsequent meeting resulted in a tie that lasted for more than
eleven years.

"I was working very hard one night, trying to finish an orches-
tra piece," he told me, "and so, I wanted to stay up all night and
what one did was to go out and buy some Benzedrine inhalers,
crack them open, dip them in hot tea, and get sort of stoned. As
it happened, Edward came around that night and I turned him
on and I stopped working and we listened to *L'Enfant et les Sor-
tilèges* by Ravel. We both freaked out and suddenly communica-
tion became abundant. I guess that was how it all started.

"At the time, Edward was living with his foster parents in
Westchester. But when he turned twenty-one and came into a
small inheritance, he moved to Manhattan and took a place on
Tenth Street in Greenwich Village. Edward did not get along
with his foster mother and, of course, it is a fact that he never
knew his real parents. I believe he was adopted at the hospital,
and I would suspect that his real parents were people of some
breeding because I'm sure that the family he moved into would
be certain that they weren't getting a mongrel, or something.

"Edward doesn't know whether he's English or, as he likes to
fancy, an American from the South. Anyway, he took the place
on Tenth Street, but just then I went to Europe for the summer.
While I was there I received very long, entertaining letters from
Edward. And when I came back we saw a great deal of each

other, and then, in 1952, I went to Europe again and asked Edward to come with me—and he did. So we spent the summer together, and that's when I started working on my one-act opera, *Bartleby*. We were living in Florence and Edward, who had notions of becoming a writer, started work on some really dreadful novel. His work was talented but terribly self-indulgent and sophomoric.

"When we came back, we started living together in a very nice building in a good part of New York's Chelsea. But we were terribly poor and had no jobs. One day, when I was forced to sell my copy of Stravinsky's *The Rake's Progress*, I decided this is too much, I've got to get a job. And so, we both worked as Western Union delivery boys only on weekends. The branch we worked for was located on Broadway and Seventy-fourth Street. Out of that came Edward's play *The Zoo Story*. But for the time being, we were still terribly broke and so we decided to do something terribly Bohemian, like getting a sixteen-dollar-a-month apartment on Henry Street on the Lower East Side. All too soon we found that we were spending most of our time going up to the Village to use the public baths because we had no bath or shower in our apartment. Finally, after seven or eight months on Henry Street, we moved to the Village.

"It was around that time, and right out of thin air, that Edward wrote *The Zoo Story*. We are now in 1958 and Edward was going through a very bad personal crisis. So he showed me *The Zoo Story* and I was literally thunderstruck because it had absolutely nothing to do with what he had written before. In fact, he *did* write a play just before *Zoo Story* but it was all in rhymed couplets and was of a perversity of the highest order. It was after I'd read the awful play that I said to Edward, 'Why don't you write about what you know?' And so he wrote about what he knew.

"I was terribly impressed with *Zoo Story* and thought something should be done with it. So Ned Rorem and I began passing the play around to people. One of these was Herbert Machiz, the director, and Herbert thought it was a lovely play, but he missed

the boat sort of, in the grand manner, because he wanted to do *The Zoo Story* but he didn't know what to do about making a full evening of it. Nobody knew what to do with one-act plays in those days. In the meantime, the play was shown to people like Thornton Wilder, Aaron Copland, and Bill Inge, who all thought it was terrific. Herbert Machiz finally asked Edward to write another play to go with it. And so, Edward sat down and began to think.

"Just then, we happened to have bought a reissue of an old Bessie Smith record, and the program notes on the record jacket were very eloquently written, telling how Bessie Smith had died, and all the rest of it. These notes gave Edward the idea for a play which turned out to be *The Death of Bessie Smith*. Both Herbert Machiz and John Myers rejected it out of hand. And so, Edward sat down and wrote another play which I believe was called *The Dispossessed*. But that went down the drain too. Then Edward wrote *The American Dream* and Herbert Machiz didn't know what *that* was all about. And so Edward just got fed up. I think Herbert has never forgiven Edward, nor me, for his never having done *The Zoo Story*.

"On the other hand, Edward was very unhappy because nothing was happening to his own work. And so one day, I decided on a hunch to send *Zoo Story* to my good friend and teacher, the composer David Diamond, who was living in Florence at the time. David, I knew, had done a lot of work for the producer Cheryl Crawford, doing theater music for *The Tempest*, *The Rose Tattoo*, and the Olivia de Havilland production of *Romeo and Juliet*. He knew a lot of people in the theater, and even though he was isolated in Florence, I thought it was worth sending him the play. The funny part about it was that when Edward and I were in Florence together in 1952, David and Edward did not hit it off at all—there was really great hostility between them. But, I sat down and wrote a letter to David and asked him to forget about all ill feelings and soon thereafter he wrote back a violently enthusiastic letter saying he had read the play and that he had sent it to an actor he knew named Brown, who made a

tape of it, playing both parts himself. This actor then sent the tape to a German agent in Berlin who flipped over it and decided to produce it together with Beckett's play *Krapp's Last Tape*.

"A little notice appeared in the *New York Times* about this production and John Myers called me up and asked if I would use my influence to get Edward to let Herbert Machiz do both *The Zoo Story* and *Krapp's Last Tape* in New York. I told him I had no influence on Edward at all and that I thought a producer by the name of Richard Barr had gotten a hold on the whole thing and was planning to do it himself in New York. The rest, of course, is history.

"It was in 1958, just around the time of *The Zoo Story*, that Edward and I broke up. Then, I went back with him again for a year which was an awful period for us both. After that I left once and for all. But we remained friends. Edward's play *The American Dream* was done very shortly after *Zoo Story* and it was decided that my one-act opera *Bartleby* should be done with it. This double bill opened at the York Theater in New York and *The American Dream* was a raging success, while *Bartleby* was deemed the disaster of the century. I think the critics just didn't know what to do about an opera on off-Broadway. But then I could see their point because it was an unfortunate combination. *The American Dream* was a very brilliant and funny comedy, while *Bartleby* was a grim and dour work. And it was done with two pianos instead of an orchestra, which was a mistake. Anyway, we all agreed that *Bartleby* must be replaced with something else and so they got Valerie Bettis and her company to fill the evening. If my opera was unsuccessful, Valerie Bettis was a disaster and the theater was empty again. Finally, Bettis was replaced by Edward's *The Death of Bessie Smith*, and the bill took shape.

"People have often thought it odd that to this day I have never known a moment of jealousy about Edward's fame. I've always taken great pride in his success. And I might say, he's been the same way with me. On that one point we've never had anything but the best wishes for each other. But I watched Edward's rise

to fame sort of surrealistically because I was very much inside of the situation. I suppose in some way or another I helped Edward creatively, that is to say that although I was never a spectacular success during the fifties, I was managing—getting performances and writing music. And I think that the whole experience of living around somebody who was effectively creative did an awful lot to bring about a similar desire in him. It's been written, not by me but by other people, that the sort of musical texture of his plays very probably grew out of a long association with a composer and thinking in those terms.

"We broke up just as Edward's fame started to grow and I felt somewhat upset over the fact that our breakup deprived me of the pleasure not of sharing his fame with him but of taking part in it. I didn't have any lust for the money part of it, and as I say, there was never a moment of envy. For one thing, most composers don't know that kind of success. I mean, we don't get it unless we write scandalous books or something. It's just a different world. And Edward, after *Who's Afraid of Virginia Woolf?*, was more famous than Aaron Copland.

"With *Virginia Woolf* all hell broke loose, especially after people began to think that the two characters of Martha and George were really myself and Edward. It was strange. There was a friend of mine—this boy in Detroit—who had never even met Edward. And he came to New York and he saw the play, and was absolutely horrified with disbelief at the character of Martha because it sounded to him like the way I talked and behaved. Actually, I don't know how much my personal style rubbed off on Edward and how much his rubbed off on me. It's hard to tell. As far as the play itself was concerned, it's been said that playwrights write out of some central conflict, like Tennessee Williams with his mother and his sister. Certainly Edward's conflict with his mother was central—and with me. It would be hard to say if *Virginia Woolf* was any more about one than about the other.

"The whole question of the central characters really being two men is really not germane. Certainly, nobody has ever demon-

strated it from the text. Unless you can demonstrate that indeed this is true, there is no proof. And if there was an intimation that Martha and George were really two men, I don't know how conscious it was. I honestly believe that if the rumor mills had not started churning, everybody would have gone to that play and taken it at face value. The homosexual interpretation only came along later.

"Edward took his fame very much in his stride. I could never understand the utter coolness with which he accepted it. It would have seemed to me that if I'd been treading water for the years until I was thirty and suddenly this had happened, I'd have been jubilant, simply to have found my identity. But it really had no noticeable effect on Edward in terms of his life style. He moved into a better apartment, but he still slouched around the Village in his leather jacket, his crew cut, and his sneakers—even after *Virginia Woolf*. It wasn't really until about 1965 that he began to take on the air of wealth and fame and all the rest of it. I remember the opening-night party for *Virginia Woolf*. It was a relaxed party because it was a Saturday night opening and the reviews wouldn't appear until Monday; so it couldn't turn into a wake. And I suddenly saw Edward and everybody else there, and I watched him walking around the room, and watched everybody else looking at him like he was a walking million-dollar bill. It must have been rough on him because all of a sudden his friends seemed to change in their attitude towards him. It was thought, later on, that Edward became too aloof and too grand for his friends. I can remember, after the play opened, how people used to call *me* with messages for Edward. It was as if a wall had gone up between Edward and the outside world—that wall that fame erects. I was suddenly the go-between.

"Edward and I were not living together then, but we did continue to be close friends. One couldn't simply break it off for good. There was too much emotional investment put into the relationship over too long a period of time for either of us to feel that it could be just thrown away. Edward didn't really change radically with his off-Broadway successes, but I think something

did happen after the Broadway smash of *Virginia Woolf*. What I saw happen was that what Edward was interested in—and I don't mean in a bad way—was power. *Virginia Woolf* gave him that. But he made good use of his power. For example, he started the Playwright's Unit with Richard Barr and Clinton Wilder. He helped young, unknown playwrights. That was a big thing for Edward. Also, he became very rich. *Virginia Woolf* set a precedent as being the first play which did not open out-of-town. I mean, today you don't take a serious play out of town any more. And Richard Barr, the producer, got the thing on stage for forty thousand dollars. Also, Edward had some sort of fantastic deal where, if the play was a success, he got half the producer's share—a tremendous amount of money while the play ran.

"Of course by now Edward has had his share of failures, but he is capable of accepting failure with a detachment that is absolutely unrivaled by anybody I've ever known. When *Malcolm* was such a disaster, Edward simply got on a plane and went to the Virgin Islands and that was that. Failure doesn't seem to get to him. The point is, that he would have gone to the Virgin Islands even if the play had been a smash. I think *Tiny Alice* is Edward's most talented play. I thought it was very badly done on Broadway—it was destroyed, miscast. They had great actors, but they were the wrong great actors, particularly John Gielgud. And it was badly directed by Alan Schneider. It was done like a Bayreuthian high school production—that's what it looked like to me. You don't really see the value of the play until you read it. I was shocked seeing it after I had read it because I thought that in spite of Edward's imperfections as a playwright—and God knows he's got them—*Tiny Alice* really looked like he had something big—bigger than *Virginia Woolf*, bigger than anything before or since."

Bill Flanagan and I sat talking in his apartment at One Sheridan Square—the first place he had really loved. The room was flooded with sunlight. There were plants around and paintings and photographs on the walls. I noticed the small oil-on-paper Jane had given him when he was in a hospital recovering from a

serious drinking bout. Bill had periods of very heavy drinking and, as he lived alone, it was often difficult for him to call for help. I remember once when Bill drank himself into a stupor and took to his bed. No one knew exactly how long he had lain there and it was days before anyone thought of calling him. When his phone wouldn't answer, some of us went to his place and banged on the door until he finally stirred to open it. He was a deeply unhappy, somewhat sullen and bitter person, and he had difficulty sustaining the various liaisons he formed after his break-up with Edward Albee.

My friendship with Bill Flanagan centered on a mutual respect for each other's music and each other's ability as music critics. Bill's songs were invested with an extraordinary lyricism and he had written a number of orchestral pieces which were equally affecting. In 1964, Bill and Edward Albee were commissioned to write an opera for the New York City Opera Company, a work to have been entitled *The Ice Age*. Bill told me that Edward had given him a very long act, but that he had somehow been unable to get it going musically. He also said that finally Edward lost interest in it because, as Bill put it, he didn't know how to finish it.

"The rumor was going around that *The Ice Age* would never be finished," Bill told me. "My career was just stalled dead at the time and then there was a kind of explosion because Julius Rudel got very unhappy about nothing getting done on the opera and quite understandably found it much easier to ride me about it, rather than Edward. Finally Edward accepted the responsibility, writing a letter to Rudel, saying it was his fault, that he would finish it one day—and that got me off the hook."

On August 31, 1969, Bill Flanagan was found dead in his apartment at One Sheridan Square. He was forty-six years old. None of us knew the exact cause of death, but it seems likely that alcohol and barbiturates took their familiar toll. In 1970, a memorial concert of Bill's music was staged at the Whitney Museum, a gathering that drew together various figures from Bill's life. Virgil Thomson's eulogy seemed in excess of Virgil's actual feelings about Bill's music. Ned Rorem accompanied several of Bill's

songs. On hand was Edward Albee, who said a few words before a presentation of his short play *The Sandbox*, which had music by Bill Flanagan. There was Aaron Copland, Bill's former teacher, who told the overflowing audience about Bill's talent as a composer as well as a critic. The evening was a great success—the kind of success Bill had never experienced while he was alive.

10

On September 2, 1958, Jane gave birth to our daughter, Julia. It was an event of purest joy. While we had consciously avoided having children for ten years (to be young and free in the pursuit of careers was the most important thing), Julia's arrival, very much planned and very much wanted, deepened and intensified our lives. She was a healthy and beautiful baby and provided us with a long-sought-for sense of unity and privacy. But becoming parents did not alter our way of life. Jane continued to paint and, in 1960, John Myers asked her to join the Tibor de Nagy Gallery. It was a major turning point in her career, for she was now part of a group emerging as an important creative force in American painting.

Showing at the Tibor in those days were Larry Rivers, Helen Frankenthaler, Grace Hartigan, Fairfield Porter, Jane Freilicher, and Robert Goodnough, among others. It was a lively, varied, and brilliant group of painters, all of them championed and tirelessly pushed and publicized by the gifted, erratic John Myers. From the first, Jane did well at Tibor de Nagy, and she soon established herself as one of the best landscape painters in the country. The Museum of Modern Art and eventually the Whitney Museum acquired her work for their permanent collections, and other museums, public collections, and private collectors throughout the country were buying her paintings. With the aid

of John Myers, Jane's professional life now seemed secure and full of promise.

For my part, working at Rapho-Guillumette Pictures during the day and being a music stringer for the *Tribune* at night were very demanding, and all I could think about was finding a way to quit the photo agency and get myself hired on the permanent staff of the *Trib*.

Heading the Lively Arts Department of the *Tribune* was a rather fierce lady by the name of Judith Crist. She was the editor of the Sunday entertainment section, and spent several nights of the week putting the section together. Assisting her was Dave Paley, a first-rate copy editor and a gentleman to whom I would later be tremendously grateful for simplifying and "cleaning up" my rather turbulent prose. These two exchanged verbal fusillades while working together, with the four-letter words getting a thorough and dazzling workout.

I had dimly heard that Judy, as everybody called her, was not a person to cross. She was tough, and given to speaking her mind in no uncertain terms. In those days, her Bette Davis eyes seemed to glower with ferocity when things were not going right. An alumna of the Columbia School of Journalism, Mrs. Crist had been on the *Tribune* for some twenty-one years, starting out as a woman's page reporter, then doing crime reporting and other general assignments. Her stories were consistently terse, clear, and unmuddled. As a female reporter she must have met her share of discrimination, but she was clearly out to be as good as, if not better than the boys. When I started at the *Trib* in 1960, she had just landed the Lively Arts editorship, a job she combined with writing off-Broadway drama reviews.

One evening, Judy Crist and Dave Paley invited me to join them for a drink at Bleeck's, located on the Fortieth Street side of the *Trib* building. Bleeck's was a friendly place, alive with the boozing tradition of the newspaperman. I wasted no time making an ardent pitch for being hired on the permanent staff. They informed me that I could only land such a job if someone dropped dead or retired. In the meantime, they suggested I continue to

"string" and, more important, that I improve my writing. They felt my reviews had a certain elegance, but tended to be convoluted.

Thereafter I made certain that on the evenings they were working, we'd all call it quits with a drink. I thoroughly enjoyed their company and the gossip and bitching that accompanied the many drinks we consumed.

I was now entering my sixth year at Rapho-Guillumette, and becoming more and more restless and dissatisfied with the job. I decided to quit and look for an interim, even a part-time job which would tide us over until the great day when I was hired as a permanent *Tribune* staffer. I began half-heartedly scanning the *New York Times* want ads, and my eye fell on one for an art gallery director. I called the number and learned that the job would be with the Martha Jackson Gallery, located at 32 East 69th Street.

Martha Jackson herself answered the phone and we made an appointment to meet. The gallery was among the most elegant on Madison Avenue. Mrs. Jackson (who died in 1970) seemed a woman of great strength and ambition, though given to a certain calculated vagueness when it came to sorting out the details of my job.

And so began a one-year bout as director for a most distinguished gallery, which boasted names such as Louise Nevelson, Antonio Tapiès, Karel Appel, Alfred Jensen, John Hultberg, Sam Francis, Paul Jenkins, a string of first- and second-generation abstract expressionists, and closets full of Klines and De Koonings.

It was my job to sell paintings, to help hang shows, and to keep the gallery artists informed about all matters that might concern them. I was given an elegant office and shared my duties with another "Gallery Director," John Weber. It soon became evident that Mrs. Jackson was the prime mover, however, and we were merely there as the hired help.

Weber and I fought for as much independence as we could get, and after a time managed to accomplish a few things on our own. The gallery was exceedingly popular and we had a constant

stream of visitors, clients, and artists, many of whom were eager to join the Martha Jackson stable. Martha had an uncanny business sense and a genuine feeling for new trends, enabling her to latch onto artists such as Tapiès, Francis, or Jenkins, whom she would groom, publicize, and launch into international recognition. In those years Martha Jackson kept an apartment on the top floors of the gallery, where she would entertain clients or friends, or call us into private meetings. She lived alone, her sole companion a beautiful and terrifying macaw called Chucky. I loathed and feared that bird, not only because it made unbearable noises, but because it was allowed to roam freely about the gallery and on several occasions nipped at my ankles. Chucky loved only Martha and Martha was mad about Chucky. She would walk around the gallery with the bird on her shoulder, looking like a latter-day witch.

During my tenure with the Martha Jackson Gallery, I established myself as an excellent salesman, a gift about which I had reservations since too often I was obliged to sell paintings by artists I did not really like or believe in. I was appalled at the ease with which I could be persuasive about works by the English painter William Scott, the Canadian Yves Gaucher, or any number of minor talents. But because I was working on a commission basis as well as on salary, I relegated my artistic judgment to the back of my mind and sold as much as I could.

As the months went by I began to realize that Martha Jackson was a woman of a certain devious complexity. She loved intrigue and nurtured it at every opportunity. She also liked to set one staff member against another, playing favorites to suit her current whim. Mrs. Jackson's son, David Anderson, who helped run the gallery, was often embarrassed by his mother, who treated him like an ineffectual temporary employee. More than once she pointed out certain qualities in John Weber or me, suggesting that her son take an example from them. She would make fun of his ideas and reduce them to negligibility. Finally, David and his wife decided to move to Paris to open a gallery of his own, which was backed, naturally, by Martha Jackson. But at least he

was out of her clutches and could work with a measure of dignity.

Mrs. Jackson's treatment of her artists was no less depressing. She made demands on their time and attention which went way beyond the boundaries of such relationships. I believe she was coming to the end of an affair with one of the gallery's major artists, and an uncomfortable atmosphere of disillusionment prevailed whenever the two would meet.

I am not suggesting that Martha Jackson did not get along with her artists—she enjoyed being with them, genuinely liked doing things for them, and wanted to "own" everything about them. In many instances she lent money to artists in need. On the other hand, she could be incredibly vague and noncommittal, and got into several severe business muddles over the works of Louise Nevelson and Alfred Jensen. Just as I began working at the gallery both Nevelson and Jensen left in a huff, trailing threats of lawsuits behind them.

Martha also enjoyed keeping artists in suspense. She would make promises to them about shows, dine with them, visit their studios, and talk to them on the phone, dangling them and then dropping them as easily as she took them on.

Mrs. Jackson was not oblivious to the stirrings of Pop Art in the early sixties. She did not like the movement, but she did like individual painters—such as Jim Dine, to whom she gave several successful shows. At the time, I suggested she take on Andy Warhol, who had just painted his first Campbell's soup can. I took Martha to his studio and tried to convince her that Warhol would undoubtedly emerge as a major figure. She bought a few canvases to hang in her office, but ultimately decided against taking Andy on.

One day, I stepped into the gallery's private elevator and to my horror found Chucky, the macaw, as my companion. I pushed the button and we began to rise. Suddenly, the elevator got stuck between floors, and Chucky became restless. I warned the infernal bird not to come near me and kept my foot poised for the swiftest kick I could muster. I had by this time rung the

emergency bell and heard people coming to liberate me. Greedily eying my ankles, Chucky began to move in. He started to nip and I started to kick. He let out a terrible screech, and, outside, I could hear Martha's echoing screech, asking if Chucky were all right. I told her that Chucky was fine but that I was bleeding to death. At last the elevator moved and Chucky on foot, with wings outspread, preceded me to freedom. I told Martha it was either me or the bird.

The best thing that happened at Martha Jackson's was a telephone call from the *Herald Tribune* saying that I was to come in to speak to Judith Crist about a permanent job. On the appointed day I presented myself at the *Trib* and was told by Mrs. Crist that the chief art critic, Mr. Carlyle Burroughs, was about to retire and that they would need an art reviewer to assist Emily Genauer, who would now move into the chief art critic's spot. Judy told me that there were other people being considered for the job, but she knew of my M.A. in art history and promised to put in a good word for me.

After a few weeks I was hired under the title of Associate Critic of Art. It was an exciting moment despite the fact that I still had my sights set on music criticism. Ironically, on the very day I was hired a member of the music staff, Francis Perkins, decided to retire. Since I was already committed to the Art Department, another man—William Bender—was hired to replace Perkins. It was a crushing disappointment, and at one point I asked Judith Crist, "Why can't I do both? Why can't I continue to do music reviews at night and be an art critic by day?" My wish was granted and I became the first critic on a major New York newspaper to do criticism in two fields—all, to be sure, on one salary.

Needless to say, I abandoned my carpeted office at Martha Jackson's to work in cluttered quarters, at a desk a fraction of the size of what I had been used to, and in the midst of chaos. The year was 1962, and I was now a full-fledged newspaper critic allotted all the advantages, respect, honor, resentment, and jealousy that came with the job. I began writing and finally began seeing

my full name above stories, reviews and, later, interviews. I worked frantically, running around to galleries and museums, attending concerts three or four nights a week. I had finally found my place, my focus, my identity, and my future.

11

But the *Tribune* years belong to the sixties. I must again project myself back into the fifties—the very early fifties, at that—for those were the years when Jane and I and all our friends were trying desperately to find ourselves.

We were in our early twenties, an "attractive couple" constantly being taken up by older people who would invite us to their homes—usually in Great Neck and Scarsdale—to supply a whiff of Bohemia. I, more than Jane, was given to making all sorts of hopefully shocking pronouncements about the art scene. We were in demand and we took to the attention like ducks to water.

Cash and security were the last things on our minds. All we wanted was to "live," and let the future take care of itself. We only needed money for rent and food; the rest was a question of using our ingenuity to make this "living" as interesting as possible. Elegant clothes were expensive, so we rummaged through various *schmatta* shops in and out of the neighborhood, coming home with twenty-five-cent to one-dollar evening gowns for Jane and all sorts of theatrically cut suits and jackets for myself. This mode of apparel was by no means fashionable in the tailfin fifties, and even artists did not venture beyond a studied unpretentiousness. But we wanted to look *outré* at any cost, and the cost was sublimely within our means.

We appeared in moth-eaten velvets, twenties spangles, turn-

of-the-century custom-made laces, thirties Harris tweeds, and an assortment of aging shirts and turtlenecks. We transformed ourselves into apparitions out of a latter-day *Great Expectations*, and when we made our entrance into so studiedly proletarian an ambiance as the Cedar Bar, heads did turn and note was taken. But we did not go to the Cedar simply to be seen; we also wanted to belong.

We had been going to the Cedar for a number of months meeting, say, Joan Mitchell or Barney Rosset, and as we sat talking we would watch the door to see who was coming in, or look around to see who was already there. In one booth there might be Bill de Kooning and his wife, Elaine, talking with Franz Kline and his girl of the moment; in another, Larry Rivers talking to Frank O'Hara, Joe Le Sueur, and John Myers; and elsewhere, Herman Cherry sitting with Jack Tworkov and Jackson Pollock. At the bar might be standing John Cage, Morton Feldman, and Earle Brown. Later on, Harold and May Rosenberg would walk in, or Milton Resnick and his girl friend Pat Pasloff, the gracious John Ferren and his wife, Clem Greenberg with Helen Frankenthaler, or Norman Bluhm, or Philip Guston. There was much coming and going and the place reverberated with talk, laughter, and exclamations.

What were they like, these people? I was anxious to get to know them, to share their confidence, to know how their work was going. All of that, however, came later. Because we appeared again and again at the Cedar Bar, we got to be on a more friendly footing with the habitués, and ultimately, their ritual of booth-hopping became our standard activity. I discovered that the artists, composers, poets, and writers at the Cedar were not necessarily holding deep "artistic" conversations, or eagerly shaping tomorrow's art movements. This they did in the privacy of their studios, or within the confines of the Artists Club, a far more serious meeting place for the exchange of ideas during the early fifties. The "Club," as it was called, was first located on West Eighth Street, close to the Hans Hofmann School (a seminal breeding ground of second-generation New York School

painters). Jane and I were not regular members of the Club, but we knew it to be the scene of the most heated and exciting confrontations between artists of the abstract expressionist group.

Artists came to the Cedar to relax, to drink, or to find a partner for the night. But it was also a place that typified the atmosphere of the creative fifties. For one thing, the fifties was a drinking period, and artists were off in their corner shaping a world of art that was still private. America had not yet become infected by the culture bug and painters and sculptors of that generation were not the darlings of the public. For the most part they were men and women working in shabby lofts, improvising a livelihood by teaching, or by taking on jobs that were mostly unrelated to their work as artists. Everybody was struggling and almost no one made money from the sale of work.

By 1950, of course, abstract expressionism had been given its name, and men like De Kooning, Kline, Pollock, and Guston were already its chief practitioners. The movement really came into its own under the name of the New York School and flourished well into the early 1960s. Its stylistic impetus was established immediately after World War II had seriously disrupted the energy and focus of European art movements. In fact, many of Europe's leading artists had come to America before and during the war, settling primarily in New York and working alongside the ranks of American painters and sculptors. Artists like Max Ernst, Mondrian, Léger, André Masson, Jacques Lipchitz, Chagall, André Breton, Dali, and Duchamp, all of them out of the European avant-garde, brought their personal esthetic and beliefs into a milieu that was, on the whole, friendly and receptive. It was as if Paris had been transplanted to New York, and this sudden influx of sensibilities encouraged more and more experimentation.

Or at least that is how it seemed. Actually, American painters had been absorbing the lessons of such European schools as cubism, expressionism, and surrealism even during the Depression, which is popularly believed to have been a period committed only to the exploration of social realism. The thirties also saw the rise of the WPA project—the Works Progress Administration,

) 1 2 9 (

a Federal agency created by the New Deal to alleviate unemployment, which put artists to work creating murals for public buildings, teaching, etc., and caused the rise of an artistic community out of which grew friendships and, ultimately, styles of an avant-garde nature.

In the forties, most of our artists were in the process of refining their stylistic discoveries, and received scant public attention. The sophisticated American public looked to Picasso, Braque, Matisse, and other giants of the Paris School as the promulgators of modern art. This was as justifiable as it was inevitable. On these shores, American modern art was accepted by a close-knit group of admirers whose encouragement and dedication gave artists some *raison d'être* for their struggle. Even the Museum of Modern Art, which opened in 1929, was not immediately receptive to the artists destined to shape the New York School.

By 1950, most of the older artists Jane and I met had had important exhibitions and made far-reaching contributions to the art scene in general. Some of their work had already received attention in Europe. Pollock, for example, was now a figure of major importance in American painting, and Gorky, De Kooning, Motherwell, Kline, and Rothko were coming into their own. By 1950, American art had changed radically and artists of my own generation were beginning to come under its potent influence.

By 1953, my own life had meshed with a group of artists who were at the forefront of the New York School. Through a young poet, Arnold Weinstein, and his wife, Naomi Newman (who had sung my songs at various recitals), Jane and I found ourselves in the midst of poets, painters, and writers whose respect and affection for one another was positively inspiring. Jane Freilicher, a talented young painter who became one of our closest friends, introduced us to Larry Rivers. Also in this coterie were the poets Frank O'Hara, Kenneth Koch, John Ashbery, Jimmy Schuyler, and Kenward Elmslie, along with the dance critic Edwin Denby and painter Fairfield Porter (both of whom were several years older than the rest of us).

The younger members of the group were busy at self-discov-

ery, while the older ones assumed the role of father-confessors and sounding boards. Frank O'Hara led us to Bill de Kooning and his wife, Elaine, and Bill brought us in contact with Franz Kline. And so it went, until we were in the midst of a milieu brimming with activity and complex personal relationships.

From the very first I had a fixation on Larry Rivers, one of the most volatile and dazzling young artists of the fifties. It wasn't his art that intrigued me so much as his personality. There was something wildly restless about him. Since we were all in our twenties, a certain insanity was *de rigueur*, but Larry's was particularly compelling because he lived in the midst of utter chaos. An intense, wiry, not particularly appetizing-looking young man, he exuded an incredible electricity, and a most seductive and potent sort of sexuality. One felt one could throw oneself into the gutter with Larry Rivers and emerge purified. His rather brash and outrageous demeanor hid an enormous and continually operative sensitivity.

His real name was Irving Grossberg, and he was born August 17, 1923, in the Bronx. Before he started painting seriously, he had been a jazz musician and had played with Shep Fields, Jerry Wald, and Johnny Morris. Larry had once been married to a woman named Augusta Burger, who had left him with two young sons, one from her previous marriage. She had also left behind her mother, Mrs. Birdie Burger, an endearing lady who lived with Larry and helped raise the children. Birdie Burger died in the mid-fifties, having been immortalized in hundreds of drawings and many paintings.

When I first met Larry, I knew none of this; in fact, I thought his interests were strictly homosexual. But Larry's sexual penchants never took precedence over his career. He was fiercely ambitious, and he knew the value of his own talent. No matter how messy his life became, he let nothing interfere with his art. By 1953, Larry had attended Hans Hofmann's school both in New York and in Provincetown; had had a one-man show at the Jane Street Gallery; had made his first trip to Europe; was hailed by art critic Clement Greenberg (in the *Nation*) as being a better

painter than Bonnard; and had painted his first major work, *The Burial*—done after Courbet's *A Burial at Ornans*. Larry Rivers's dealer was John Myers of the Tibor de Nagy Gallery, where Rivers exhibited until 1962.

Recently I went to see Larry Rivers and we spoke of those early days.

"In 1950 I was twenty-six—and I was painting very hard in a little apartment on St. Mark's Place. No. 77. W. H. Auden lived above me. I thought that in order to call yourself a painter you had to prove it by first doing a lot of work. I thought an artist is a guy who worked very hard. And so I worked very hard. At the time, I was also being tortured by a certain girl—the torture coming through to me as meaning love. It was Jane Freilicher, the wife of my best friend, Jack Freilicher. Jack was a jazz musician and we played together. By 1950, Jane had moved out of her husband's apartment. But I didn't want her to live with me. Later she revenged herself by running off with somebody else."

Larry and I are sitting in his vast studio on East Fourteenth Street. He is twenty years older, but has retained his trimness and volatility. We sit facing one another because Larry has decided to do a drawing of me while we talk. He is wearing a green corduroy jumpsuit, unbuttoned at the chest, and gray boots. When he smiles he has very deep dimples—or are they wrinkles? He has chosen to draw me on shocking pink paper. He holds two pencils in his hand, drawing with one and pointing the other in my direction. Around us, the studio is inundated by dozens of works in progress—drawings, cutouts, oil sketches, and sculptural fragments, destined to be attached to the larger-than-life-size painting-constructions Rivers is currently producing. When Larry is drawing he becomes more relaxed, a relaxation absent under ordinary conditions. As he draws I ask him about studying with Hans Hofmann.

"He liked me. He was the first serious artist—I mean older person—who seemed to take me very seriously. He made me realize that I was peculiar. He laughed at some of the things I

said—and he left me alone. I noticed that he paid less attention to me because I had the feeling (that was my conceit), that there was no use talking to me because I'm going to do it my own way anyway. But, you know, I was just going to art school, trying to sort of paint my own way. I never got hung up on those fucking, silly 'push-and-pull' things that other kids picked up and thought were going to solve all sorts of painting problems. Anyway, I certainly never became an abstract expressionist. I guess I was painting like Bonnard.

"In the opening years of the fifties there were times when I thought and behaved pretty much as though I were queer. I had had a certain experience that will make you understand this. I think I decided, as a young man, that it was really hopeless to try and make any sense out of the jangled and jumbled thing called 'male-female relationships.' So it seemed to me that queerdom was a country in which there was more fun. And I met some extraordinary queers. Let's face it, there are queers and queers. Also, I think when I saw Cocteau's *Blood of a Poet*, my knowledge that Cocteau was queer affected my response to the film. Of course, I was a child when I saw it, but I had a long talk with Frank O'Hara about it. There was something about homosexuality that seemed too much, too gorgeous, too ripe. I later came to realize that there was something marvelous about it because it seemed to be pushing everything to its fullest point.

"I talked to Frank about Cocteau, and I told him that he seemed to me like a swollen, beautifully colored snake, all wrapped around his homosexuality. Anyway, I began thinking about it much more—about queerdom—and I saw these guys more than I saw any woman. We were friends. No sex yet. Their language was so new and fresh and marvelous—I mean, like switching the roles, and calling everybody we knew by girls' names. That was very funny. But, I don't know. I wasn't out of the Bronx by that many years. As far as the actual sexual act is concerned, I think it began out of a sort of sense of exuberance. Some of the new friends I met seemed to have a great desire for me. No girl I knew up to that point made me feel that anything

about me was that compelling. Some of these people really seemed to flip over me. For the first time in my life I could think to myself that someone thought I was gorgeous.

"I mean, that was such a surprise. Rather necessary at moments. You know, what you go through in your early twenties. It's a pretty difficult period as far as knowing who you are, what you are going to do—and all that shit. Like everyone else, I warmed up to flattery in the most obvious way. So there were one or two evenings in which a whole bunch of us got terribly loaded—something like that—and we'd flop into bed and kid around. What's so bad about that?"

Larry Rivers now gets up and looks for some scissors. He returns and begins to cut out one eye in the drawing of me. Then he cuts out the nose. Then the lips. He picks up some cardboard and pastes the nose and the lips on it. Then he cuts them both out again, this time with the cardboard backing. With the paste brush, he now reattaches the nose and the lips to the drawing so that both jut out from the face. He does all this very swiftly, as I urge him to talk about his first meeting with his dealer, John Myers, the man who was instrumental in putting Rivers on the map.

"John Myers. Clem Greenberg told him to look at my work. We met at Louis', a downtown haven of Bohemians, located near Sheridan Square. It's been torn down and there's a Chemical Bank standing in its place. Actually, Louis' was an early kind of Cedar Bar, and there, that night, I met John Myers, who was sitting in what, if any term can cover it, was a hanky-panky cross-legged position at the bar, with a sort of Oscar Wilde smile on his face. I don't know exactly what he said to me, but it could have been: 'Say, you're Larry Rivers, eh? Clem Greenberg told me all about you. . . . We have a gallery uptown, and we . . .'

"He seemed fantastically knowledgeable, and he dropped these French words. Myers brought something else into the whole thing of homosexuality for me. For one thing, he was slightly older than the rest of us. Also, he was involved in other things besides art—he was a puppeteer, and was involved in the thea-

ter. He seemed to have some kind of relationship with the sur-
realists, which seemed like being in touch with history. We were
all name-droppers, but he really was the king. Anyway, that
night he said he wanted to see my work and I think he had al-
ready decided that he was in love with me—or rather, that he
wanted to make it with me.

"And so, we talked and we made a date for him to come to my
studio and look at my work. He flipped by what he saw and
promised me a show. Anyway, John Myers really fell for me in a
very big way. He was on the phone with me every two hours.
He searched for me all over town, if I wasn't home. He wouldn't
stop phoning. And he helped me a lot. He would call people up
and ask them to give me money."

Rivers pauses to find a cardboard box, which he proceeds to
cover with some special Op-design paper. He affixes the drawing
of my head to the front of it. He removes it again and cuts out
the oval of my face and reattaches it onto the front of the box.
Rivers has done a kind of drawing-construction of me and now
seems satisfied with the way it looks. He puts it to one side.

Larry's obsession for work must not have escaped John Myers,
who, aside from his personal involvement with Rivers, must have
sensed the genuine artist in him. Larry Rivers was clearly the
bright light of the Tibor de Nagy Gallery, then located on Fif-
ty-third Street near Third Avenue. It was owned by a Hungar-
ian, Tibor de Nagy, who stayed in the background while John
ran it. It was one of the best galleries of the period, concentrating
on works by young artists, both figurative and abstract. John was
an indefatigable champion of their work. In addition to his in-
volvement with his gallery, Myers was also active in running the
Artists' Theater, and later was highly instrumental in helping the
young poets of the day, establishing the Tibor de Nagy Editions,
which published the works of poets such as Frank O'Hara, James
Schuyler, and many others. He also made possible the collabora-
tion between his artists and poets and playwrights, instigating a
meeting of talents that invariably produced interesting results.
When the Artists' Theater mounted Frank O'Hara's play, *Try!*

Try! Larry Rivers did the sets. It was John Myers' special gift to bring various creative forces into play with one another—something unusual in the fifties, and which was taken up like mad in the sixties.

At the same time, there was something frantic and unresolved about Myers. Volatile as he was, he alienated many people. When his star artists began to leave the gallery, there was no end to the recriminations. Suddenly he began reviling the very artists he had gone to such lengths to champion. When Grace Hartigan left Tibor de Nagy, her furiously affronted dealer called her every name under the sun and bad-mouthed her behind her back to all listeners. The same thing happened to Helen Frankenthaler. When Larry Rivers decided to follow suit in 1962 by going to the Marlborough Gallery, all hell broke loose. His departure was almost more than Myers could bear and invective flew with a vengeance.

Larry Rivers recalled the turmoil:

"John Myers was terrific. He helped me in every way—with money, with introductions, with articles about me—things like that. I know the role he played in my life. But one can't remain indebted forever. You see, I was with him for years and we benefited mutually from one another's relationship. But he was so unbelievably possessive, and I couldn't take it any more. So, at one point, we made a very graceful separation and we continued in a very nice way, being friends. And we went on in this way for a while. And I want to say, here and now, for the future, so that it's put down: John Myers was very important to me. He was a marvelous, intelligent, sensitive, nutty, sad man, and there was something in him which could never really put out that special flame of his. He's still got it.

"By the time 1962 rolled around, we were very different people. We really weren't seeing each other that much and our relationship became rather routine. Also, he began to realize that my choices were wider, juicier—and so I left him and the gallery. Perhaps I could have behaved differently, and there are many times I think to myself, 'It could have gone a different way'—I

could have stayed with him, for example. But I went with Marlborough. When that happened John Myers flipped his lid. He sued me, he wouldn't speak to me, he talked behind my back, and it became really crazy."

Larry Rivers's homosexuality, rampant in the early fifties, finally became more and more of a pose than an actual fact. Soon after we met him, he began seeing a girl named Maxine Groffsky. One of Larry's outstanding drives was attaining the unattainable. The moment anybody turned him down, he turned on. If he couldn't win somebody's friendship, sexual or platonic, he'd pursue them until the resistance was broken down. During Larry's homosexual period, he seemed the pursued, not the pursuer. But when it came to making it with girls, he was decidedly the aggressor.

By 1953, or thereabouts, Rivers had purchased an inexpensive frame house in Southampton, Long Island, and every summer he would take his two sons and his ex-mother-in-law there to work and play. Jane and I spent our summers in nearby Water Mill, sharing a house for several successive years with Jane Freilicher and her second husband, Joe Hazan. The Hamptons had already become an established summer colony for artists, from Jackson Pollock and De Kooning to Franz Kline.

There was a nightclub in Water Mill called the Five Spot, an offshoot of the jazz place located on St. Mark's Place and Third Avenue—a place where we went to hear some of the famous jazz figures of the period. Larry Rivers and his friend the artist Howard Kanovitz played jazz at both clubs. One evening our waitress at the Water Mill Five Spot was a good-looking girl whose body, clad in a tight skirt and shirt, immediately caught our attention. Larry lost no time in making rather obscene overtures right on the spot. The waitress was particularly aloof to Larry, but nevertheless kept hovering around. This sexy girl was Maxine Groffsky, who came from New Jersey and wanted to spend a summer away from her wealthy parents in the creative milieu of the Hamptons. What is more, Maxine had had something of a past and was trying to get over an affair with Philip

Roth. She later partly inspired the central character in Roth's novella *Goodbye, Columbus.*

Suddenly Larry became a habitué of the Five Spot, and soon he and Maxine were seeing each other away from the club. For the next four or five years, they developed a highly involved relationship. Maxine came to New York and pursued a life deeply committed to Larry's, being something of a mother to his children, taking care of his business needs, and generally civilizing his life.

As the years progressed, Maxine and Larry considered getting married, and around 1959 some actual plans were made in that direction. During this period Larry's sons were becoming teenagers and Birdie Burger, who had helped raise the boys, was already dead. Something had to be done to keep Larry's never very disciplined household in shape. It occurred to both Larry and Maxine that a housekeeper was definitely in order.

I believe it was in the winter of 1960 that Larry engaged a Welsh girl by the name of Clarice Price. No one was prepared for Clarice—not even Larry. A buxom girl with a beautiful face and complexion, she exuded enormous sex appeal. Her energy was boundless and she was full of good cheer and humor. Clarice was in her twenties and had been a music teacher in a Welsh school. Delighted to be in America and deeply impressed by being thrown together with artists and poets, she quickly adjusted to the dizzying tempo of Larry's life. Larry's sons liked Clarice from the first. On the surface things began to run very smoothly. Larry worked hard in his studio, while Maxine, who had decided to take a job at Random House, commuted between New York and Long Island, staying in Southampton only over the weekends.

One Sunday morning I paid Larry a visit and came upon the following scene: Maxine in the kitchen, brooding over a cup of coffee, Larry in the living room, fidgeting with a drawing, and Clarice sprawled on the couch reading the Sunday *Times* and nibbling at chocolates. The two boys were out on the lawn. A decided tension was in the air, and from Clarice's excessively

cheery "Hello" I got an inkling of which way the wind was blowing. Maxine offered a curt greeting, while Larry seemed glum and disconcerted. Larry asked me to come into his studio with him, and there I learned that the inevitable had happened: Larry and Clarice had become lovers.

Not surprisingly, Maxine and Larry's plans fell through and Maxine departed for an extended stay in Paris. The wedding that did take place was between Larry and Clarice. A year later a daughter, Gwynn, was born to them, and two years later came Emma. Maxine in the meantime has gone on to become the Paris editor of the *Paris Review*, a post she holds to this day.

I should mention Larry's bouts with drugs, which he took way before the LSD generation came on the scene. Pills and injections seemed to give him a heightened sense of reality. Through it all, he worked feverishly, producing canvases full of energy and originality. Painting always within the figurative style, Larry produced works that broke up reality into jumpy detail. Always an extraordinary draftsman, he painted vast canvases that were stories from his life. A kind of messy logic directed his brush or pencil—figures appeared in fragmented sections, spilling across the canvas like so many fugitive thoughts. But this seemingly improvised style contained a basic, unified structure.

Larry painted his friends, his surroundings—the things he knew about. He would also tackle monumental projects such as interpretations of historical subjects. Intrigued by Leutze's nineteenth-century paintings of *Washington Crossing the Delaware*, he reinterpreted the subject, distilling from it a tremulous essence altogether moving and original. Larry later painted the story of the Russian Revolution, in a mammoth painting-construction which retold the events of that political upheaval.

Rivers' private life continually overlapped his creative life, but when things got out of hand—especially with drugs—he had the courage and the insight to obtain treatment. His sense of self-preservation has always been astounding, though he is one of those artists who thrives on danger. He still dons a helmet and races his motorbike at unbearable speeds.

Larry's capacity for friendship is remarkable; his friends are the friends he made in the early fifties. John Ashbery, Kenneth Koch, Arnold Weinstein, Bill de Kooning, Jane, and I are all people Larry has painted or drawn over the years and with whom he still has a close rapport. He is still friendly with the many girls he had been involved with, including the beautiful Maxine, who, on her periodic visits to New York, seldom fails to see him.

Larry has always been a showman—as well as a showoff. Early in his career he was called the Gershwin of the Easel. With the advent of Pop Art he became the Elvis Presley of the Easel. Larry can live with these appellations, and there is a measure of truth in both of them. For one thing, he is a born "personality kid," for another, he has a natural curiosity and delights in gossip, though not in moral judgment. Ever since we've known him, he has enjoyed the company of the young, the neurotic, the lost, and the bizarre. In the early days, his parties always included strange, unhappy types who mingled dreamily with the poets, painters, and musicians. Larry invariably played his saxophone with a number of talented black jazz musicians. The squeak and honk of Larry's playing pervaded these evenings, not always with musical results. But at the time everyone was thrilled to have a live combo and we all danced the pretwist dances. The boozing went on for hours and couples of all sexes wandered off into corners, necking shamelessly.

A number of Larry's friends have written about him, among them Frank O'Hara. In a memoir published in a catalogue for a Rivers traveling exhibition he wrote: "Into the art scene of the fifties Larry came rather like a demented telephone. Nobody knew whether they wanted it in the library, the kitchen, or the toilet, but it was electric. Nor did he. The single most important event in his artistic career was when De Kooning said his painting was like pressing your face into wet grass. From the whole jazz scene, which had gradually diminished to a mere recreation, Larry had emerged into the world of art with the sanction of one of his own gods, and indeed, the only living one."

12

Frank O'Hara and Larry Rivers formed a friendship as intense as it was complicated, which lasted until Frank's death in 1966. One could call it a passionate friendship because it contained an element of sexual attraction, but it was more than that, because the friendship spilled into creative areas in which both poet and artist were involved. In any event, Larry and Frank were bound together by love and respect for each other's work, as well as by the similarity of their chaotic life styles.

This, in Larry's words, was how they met: "Frank O'Hara, who was going to Harvard, came down from Boston to go to a party at John Ashbery's. The year was 1950. It was a very classy party, with many members of the *Partisan Review* group. It was all sort of very uptown and I as usual was on the make for anything . . . I liked—you know, boys, girls, animals, dogs, houses—anything. Anyway, in walked Frank O'Hara and he seemed very funny—this boy with an Irish broken nose in army pants and sneakers. I mean, he was a Harvard product, but sort of very funny in the midst of these people. I was told that he would like me, and I had already heard a lot about him. And so, we were at this party, drinking like crazy, and at one point Frank and I went behind some curtains and he said, 'Let's see what a kiss feels like.' It was as if we were experiencing a kiss for the first time.

"From then on, we began to hang around with each other.

That was when he finished school and came to live in New York. We saw each other at least once a day. We talked about art, about painting, about poetry. It was fantastic. We'd go for long walks, we'd discuss everything—you know, it was very exciting. By this time he was also a friend of Jane Freilicher's—this was one of the bigger friendships of the period. Somehow, you couldn't tell if he was a very good friend of Jane's so he could keep in contact with me, or a good friend of mine, so he could keep in contact with Jane. It was all quite ambiguous at the time."

Frank O'Hara's version of his meeting with Larry was published in the same catalogue mentioned earlier: "I first met Larry Rivers in 1950. When I started coming down to New York from Harvard . . . friends had said that we would like each other. Finally, at for me a very literary cocktail party at John Ashbery's we did meet, and we did like each other: I thought he was crazy and he thought I was even crazier. I was very shy, which he thought was intelligence; he was garrulous, which I assumed was brilliance—and on such misinterpretations, thank heavens, many a friendship is based. On the other hand, perhaps it was not a misinterpretation: certain of my literary 'heroes' of the *Partisan Review* variety present at that party paled in significance when I met Larry, and through these years have remained pale while Larry has been something of a hero to me, which would seem to make me intelligent and Larry brilliant. Who knows?"

We met Frank O'Hara at the home of Naomi and Arnold Weinstein. He struck us immediately as someone we wanted to know. He was a frail young man, inordinately thin but also rather languid. He never behaved in a frantic manner; on the contrary, he seemed continually in repose. It was the energy of his mind that generated the excitement we all felt. We first saw him sitting on a couch with his good friend and long-time roommate Joseph Le Sueur. They were deep in conversation, with Frank doing all the talking. Frank loved to talk.

The other clue to Frank's inherent excitement was his eyes. They were an incredible blue—an Irish blue, candid and inno-

cent. Everything he said seemed so utterly fresh—even his gossip and bitchiness. His response to people was immediate, as was his response to art in general. Of course, Frank liked to drink. His capacity for alcohol was truly monumental, but he always held his own in terms of acute observation and perceptive banter.

Because I was deeply involved with composing, music was the subject Frank and I discussed at the Weinsteins' party. Frank told me he could play the piano—not terribly well—and that he was especially fond of playing the French composers. We launched into a discussion of Erik Satie and Frank proceeded to extol his marvelous opera, *Socrate*. We went to the piano and tried to recall Satie's *Gymnopédies*. Frank then asked me to sing some of my own songs, which I did. Later, Frank went up to my Jane, and they talked about her painting. When Frank talked to you, he made you feel everything *you* did was of vital importance and interest—at least for the moment.

One of Frank's most endearing qualities was his capacity for being a sort of father-confessor to all his friends. Joe Le Sueur wrote about this with great insight.

"Then there was the inordinate amount of time devoted to helping friends who came to him with their troubles. It was while we lived on University Place that he really came into his own as a sort of confidant-confessor—except Frank, unlike an analyst or priest, did most of the talking. He was a born talker to begin with, and he especially liked giving advice, which often came down to nothing more than encouragement: *You can do it, all you have to do is make up your mind; you've got lots of talent, so what's stopping you?* Etc. etc. But it wasn't what he said that counted, it was his authority and passion, along with his marvelous understanding of a friend's needs, that made the difference. And there were times when I thought he was in love with at least half of his friends, for it was possible for him to get so emotionally involved with them that it wasn't unusual for him to end up in bed with one of them and then, with no apparent difficulty, to go right back to being friends again afterwards. That was always his way in the years I lived with him. He didn't make

distinctions, he mixed everything up: life and art, friends and lovers—what was the difference between them?"

While Jane and I adored Frank, and were always comfortable and delighted to be with him, we were never the object of any intense emotional involvement on his part. It may have been because Jane and I had each other, and were not severely in need of a father-confessor. We therefore did not experience the kind of rapport Frank had with, say, Larry Rivers, Grace Hartigan, Jane Freilicher, Mike Goldberg, Joan Mitchell, Le Roi Jones, the writer Patsy Southgate, the poet Barbara Guest, the young dancer Vincent Warren, or the poet Bill Berkson. With each one of these, he lived out a whole life.

What I remember best about Frank was our collaboration with Arnold Weinstein on a musical, which was destined to have a turbulent eight-year history. It all started around 1956, in the Weinsteins' living room. Frank, Arnold, and I sat around, and as sometimes happens, the atmosphere was ripe for some sort of on-the-spot collaboration. We were all trying to tap each other's resources, hoping to come up with some masterpiece that would be relevant and astonish the rest of our friends.

To digress for a moment, I was engaged in some offbeat musical noodling which involved poets reading their poetry while I improvised appropriate background music on the piano. On several evenings, Frank, Arnold, John Ashbery, and Kenneth Koch came to my house to tape-record my experiments. John Ashbery brought his just-published book, *Some Trees*, and I remember improvising on both the piano and the zither as John read one of his enigmatic works. Kenneth Koch read some of his funniest poems to my—I hoped—hilarious accompaniments. There was a poem by Frank O'Hara I especially liked entitled "To the Film Industry in Crisis." For this poem I decided to have a piano roll be the accompaniment—we had a Steinway Duo-Art, which played piano rolls by the hour. The roll I chose was a popular song of the thirties, and as it played I beat out a rhythm with brushes on a drum. On this occasion I asked Frank and Jane Freilicher to read the poem together. I assigned each specific lines to read and

the result seemed wonderfully *outré*.

I asked Barney Rosset to listen to these tapes. Barney had just evolved the idea of a radio program that would publicize, as well as dramatize, some of the new Grove books. After hearing my tapes, Barney suggested that a half-hour program be devoted to young New York poets. I enlisted the same friends to retape everything we had done, in order to eliminate the errors and giggles on the originals. While the broadcast did not set the world on fire, it may have given my poet-friends some measure of recognition in a period when new poetry did not have the popularity it enjoyed during the sixties.

To get back to the afternoon in Arnold Weinstein's living room, the three of us, Frank O'Hara, Arnold, and I, decided to write a full-length musical comedy which, in a flash of inspiration, after sketching out its theme, I called *The Undercover Lover*. Arnold would write the book, Frank the lyrics, and I the music. The theme dealt with an unhappily married man who kept promising his mistress he would divorce his wife. The mistress keeps waiting for this to happen, but the hero postpones the confrontation because he feels it would break his wife's heart. When he finally summons up his courage, his wife is delighted, and carries on several affairs with men who take her all over the world. Deeply shocked at this course of events, the husband begins to pursue his wife in the hope of winning her back. The mistress in the meanwhile keeps waiting and waiting and waiting. Finally, the husband and wife are reunited and settle back into domesticity, whereupon the husband resumes his affair with the mistress.

This farcical plot was splendidly enhanced by Weinstein's irony and wit, and by O'Hara's touching, candid, and clever lyrics. As lyrics were handed to me, I set them to music in a style that incorporated a Kurt Weill languor and sassiness, with a certain Poulenc-Mahler influence from my art songs. When Arnold also began to write his own lyrics, I found myself besieged by some very lengthy poems.

We sang some of the songs to friends, most of whom urged us

to go full-speed ahead. But Frank began to lose interest in *The Undercover Lover*, since he had just been appointed head of the International Program at the Museum of Modern Art. Arnold and I plowed ahead on our own and finished it—not without endless fights, most of them having to do with Arnold's working habits, which were maddeningly undisciplined. I wrote twenty-seven songs for the musical and devoted the better part of a year and a half to completing it. The saga of *The Undercover Lover* would take pages to relate. Let me simply say that ultimately Frank O'Hara was pretty much out of the picture, although Arnold and I continued to acknowledge his part in the collaboration.

Through some miracle the musical received a full-scale production at the summer theater of Adelphi College in Garden City, Long Island. It starred Murray Hamilton, Rae Allen, William Hickey, and Joy Claussen, and was directed by David Brooks. It was an exciting moment and the excitement became delirium when the producer of the comedy hit *Luv*, Mrs. Claire Nichtern, optioned it for a possible Broadway production. Arnold and I did endless revisions, none of which seemed to work out. The option was dropped and *The Undercover Lover* remains unproduced in New York.

For eight maddening years Arnold Weinstein kept dropping our project to pick up others, some of which saw the light of day, but all of which failed. Arnold's feelings toward Frank O'Hara during our collaboration indicated that he felt betrayed and he often expressed animosity toward Frank. Ironically enough, after Frank's death in 1966, Arnold began to talk of the possibility of reviving our musical, "for Frank's sake." Suddenly, Frank's part in our project assumed a proportion Arnold had earlier gone out of his way to minimize. I read Arnold's biographical insert in the program of the ill-fated 1970 production of *Mahagonny*—the Brecht-Weill opera Arnold adapted into English. He lists his various plays, including *The Undercover Lover*, whose authorship is attributed to himself and Frank O'Hara. The composer's name was markedly left out.

But back to Frank. Jane and I saw a great deal of him throughout the fifties, and were continually impressed by his energy, his good humor and, of course, by his work. Frank talked very little about his poetry, which was beginning to appear in publications like *Partisan Review, Folder, Accent, New World Writing,* and *Poetry.* Later, the Tibor de Nagy Gallery Editions put out his slim collection, *A City Winter and Other Poems.* In 1958, Frank's first major volume of poetry, *Meditations in an Emergency,* was published by Grove Press. He came over to the house one day and handed me a copy. I asked him to inscribe it and with typical offhandedness, he wrote: "For John—Looking forward to our recital in Town Hall and later at the Sands—Frank."

Today, Frank O'Hara is something of a legend. The young poets of the sixties and seventies have made him their hero. He has influenced their style if not their mode of living. His legacy to them is an essential freedom unhampered by the literary strictures of earlier poetry. Frank's best poems celebrate the accessibility of all things, and are written in a simple, direct, and even conversational style that continually illuminates the everyday moment. Frank's poems are never verbose. He wrote about the happenstance events of his life and the lives of his friends, whom he frequently mentioned by name.

One summer, in the late fifties, Frank appeared on the beach at Water Mill in the company of a very young, outrageously handsome, and sullen young man. His name, we learned, was Bill Berkson. He was obviously a new friend—another person destined for one of Frank's intense relationships. The two were inseparable on that summer day, giggling, gossiping, and having a splendid time. At one point we watched them doff their bathing trunks and race into the sea, a shocking thing to do at the time. Frank loved to swim and he could stay in the water for hours, sometimes venturing far out to sea.

None of us could get very close to Bill Berkson. He eyed us suspiciously and we were more impressed by his rudeness than by anything else. He made it clear from the first that Frank was the

one person he was interested in. But he was only nineteen, and probably terribly ill at ease. Bill was the son of Eleanor Lambert, a distinguished fashion consultant in New York, and William Berkson, a well-known newspaperman who had died when Bill was still a young boy. Bill had left Brown University in the middle of his sophomore year and had come to New York to go to Columbia. He had also taken a spring semester at the New School, where he enrolled in a poetry course given by Kenneth Koch, who was instrumental in his meeting Frank O'Hara.

Bill and Frank were as inseparable as Larry Rivers and Frank had been years earlier. Gossip ran along the usual lines in our crowd—namely, that Frank and Bill Berkson were lovers. In this instance the gossip seems to have been wrong. While Bill was extremely handsome, dressed with exquisite taste, and was a constant companion to the gifted young homosexuals we all knew, it appears he never went to bed with any of them, including Frank. It is, of course, possible for a man to fall madly in love with another man, on a platonic level, and Bill had fallen in love with Frank O'Hara.

Bill was among the last people to have had a close friendship with Frank. I wanted to speak to him about it, and so I asked him to have a drink with me. Frank O'Hara had been dead for three years and Bill's memories were still very fresh:

"Kenneth Koch," he began, "said that Frank would probably become something like a germ in my life and it's true, I became infected, which seemed in a way proper for a certain period. I met him at Jane Freilicher's one evening and he was immediately interested. He was attending to my every word, and I had a lot of words at that time. I was very talkative and I wanted to make my presence known in a certain way. We spent practically the entire evening shifting elbows on our hostess' mantelpiece. I don't actually remember what we talked about, but it all ended up that I was to bring him some of my poems, which I did a few days later. I went down to Ninth Street where he was living and I remember Joe Le Sueur was there and I remember particularly the butterfly chairs—always butterfly chairs—and Frank sitting

in a butterfly chair. He always had them and he seemed to look great and comfortable in them. At one point he showed me a new batch of *his* poems. They were all love poems and they seemed very delicate and slight. Somehow I couldn't get them. I couldn't read the score. So I couldn't get the pattern. I couldn't get the voice. They seemed like translations of a certain kind of French surrealist love poem. Like Eluard—but different.

"And so I said to Frank, 'I don't think being in love is very good for your poetry.' It was very clear that he was in love in the poems but this was something I couldn't take at the time. It may have had something to do with French sentimentality that had never been done in English. Nobody had ever written that sweetly, I don't mean in English proper, but in modern English poetry. Modern English poetry practically damned the love poem. And Frank and Kenneth Koch did a lot to bring it back.

"Kenneth did it in this idealized way that seemed a little bit re-moved and extremely beautiful—like a tableau which had to do with a kind of platonic situation. I mean, the loved one—you love this person, you make love to her, you have this thing and through her blossoms the imagination. Frank had this other thing which was like you are walking down the street and you fall in love and suddenly you're in the bedroom and you're in bed, and the next thing you're reading and the next thing you're making coffee and the next thing somebody calls you and the next thing you don't love each other any more. Anyway, I later learned to hear Frank's poetry and to know it.

"I guess I began by imitating him. And John Ashbery, too, oc-casionally. And Kenneth Koch, also. I mean, those three were running around the tracks of my mind in a certain way—one out in front at different times. For a long time I couldn't under-stand that the people Frank mentioned in his poems were really living people that he knew. I thought they were invented charac-ters. That wasn't the case with Kenneth's poetry. I got his poetry because I knew Kenneth's voice. And I knew how Kenneth read his poems, and I knew from his instructions how his poems were to be read and what they meant.

"Actually, I learned a lot about Frank O'Hara's and John Ashbery's poetry in Kenneth Koch's course. He was a terrific teacher. He was fantastic, energetic, very inspiring. He was a teacher who made you believe that you should be crazy about poetry, and that it was interesting to be a poet. In his class he talked about the poets he liked. He talked about Auden and Stevens and William Carlos Williams, and he talked about the surrealist poets, like Max Jacob and Apollinaire. And, since he was always interested in love poetry he talked about Breton and Eluard. And then the odd thing was that he also in the same breath would talk about Frank O'Hara and John Ashbery. He didn't really mention his own poetry too much, except that you got to read his poetry out of curiosity and then you realized that he didn't teach you things that he didn't practice himself.

"He taught you things that he knew about how to make a poem, how to keep something interesting, how to keep yourself going, and how to write a poem when you don't have anything particular in your mind. That is, he taught you techniques of getting in touch with yourself, with your 'heartline' sort of. And that was terrific. Then he talked about Frank and John, as if to say, 'This is where it is at' in a very strong way. Actually, Kenneth was always very strict about contemporary poetry. He doesn't give an inch, where, say, Frank O'Hara might give an inch to poets like Michael McClure or Olson. Kenneth might dismiss somebody like Beckett. He'd say, 'Why do you want to see all those sick people walking around on the stage? All those people groaning and making those horrible sounds?' Frank was always extremely generous about others, and he would say something like 'I can read Charles Olson's work, but I don't really enjoy it. But you've got to admit that it is a fact—it's there. You can't think about contemporary poetry without Olson's name coming up, therefore he's there, therefore he's part of your mind.'

"Kenneth wasn't like that. Kenneth wanted what he wanted from poetry. He wanted everybody to give him that wild, kick-in-the-ass pleasure that you must feel in your diaphragm. And

that's it. He always did and he still does want everything to be exciting. Every single minute. And so, he made you feel that that was what poetry was all about. To really get in there and sit up straight. Be lucid, don't just blabber, but see things magically.

"Kenneth had an enormous personal effect on me during the time that I studied with him, and before I was so close to Frank, who had maybe a more traumatic effect on me. Finally I came to think of myself as a poet. And Kenneth sort of brushed all other speculations aside. The idea was that you write poetry and then you're a poet and you're as much of a poet as anybody else, and you think of yourself as a poet all the time.

"As for Frank O'Hara and I, well, he sort of impinged himself on all of our psyches—all of us who knew him personally. Larry Rivers once said that there are at least forty people who could say Frank O'Hara was his best friend. So I was one of those. He was central to my life. And my friendship with him became completely enveloping. It became a totally tuned-in and dramatic fact. We had this tremendous love thing between us. We collaborated on poems. We read other poems, we read each other's poems. And we did all the things that various other people have done with Frank—go running to the theater, always in a hurry to get there, always out of breath getting out of a taxi, being at the New York City Ballet. Bursting into tears there. Just going wild—and those tremendous palpitating discussions out in the lobbies and in the bars across the street.

"So with Frank you were doing all these things. Going to this event and that event. It was a kind of life style and it had so much to do with Frank, with his pace, which I loved—I loved that speedy thing. I suppose people were thinking that Frank and I were having a love affair. All I can say is that we had a love between us that was this frantic, great thing—but we never slept together. We didn't kiss very much, except we hugged an awful lot and you know, kissed each other on the cheek a lot—at parties, which used to horrify some people. I guess a lot of people would categorize Frank as a homosexual. I don't believe he was. I think he was supersexual. I mean, I know some things about his

sex life—mostly what I learned after his death. And I know some things that he told me. But I don't know very much about what he was like in bed, or what kind of a lover he was.

"In his poems, for example, there isn't the constant relish of the idea of sex. Sex doesn't always seem like such a great thing. Frank just had an affection for people, and this affection became a super, or superlative thing. The thing about Frank was that he was a centripetal force that held everybody against the drum. He held them together. And it wasn't just the poets. He had a way with a slightly older generation of painters—you know, people like Bill de Kooning, Franz Kline, or Barney Newman. Frank got along with everybody in a certain very straight way, and there were a lot of younger people, like Joe Brainard, who was very close to him. And like the great friendship he had with Larry Rivers's son Stephen.

"There was also a whole drink mythology connected with Frank. He used to say that he drank to kill boredom. He used to say, 'I drink to the extinction of my personality.' It was like Max Jacob saying that personality was the persistence of error. That it was a persistent error. So Frank sat there with his gigantic persistent error, because his personality was of the largest scale. And he drank to destroy the error."

Bill Berkson, Larry Rivers, and Edwin Denby all spoke at Frank O'Hara's funeral in the small cemetery at The Springs, near East Hampton, Long Island. It was the summer of 1966, a scorchingly hot afternoon. A gathering of some hundred and fifty people, mostly artists and writers living in the area, came to pay their last respects. A few weeks earlier Frank O'Hara had been visiting a friend on Water Island, a community on Fire Island. One night he and a group of other people decided to take a beach-buggy ride near the ocean. At one point the buggy stopped in its tracks and everyone got out to see what had gone wrong with it. Frank was standing apart some feet away. Suddenly, an oncoming beach buggy appeared and hit Frank. He fell unconscious, and had to be taken to a hospital. He suffered a great number of internal injuries and required a series of speedy

operations. But the damage was so great that Frank died a few days after he was admitted to the hospital. He was forty years old.

Self-destructive during the last years of his life, Frank still seemed indestructible. His death came as an enormous shock to all of us gathered under the great elms at The Springs cemetery. Larry Rivers spoke, giving a description of Frank in his hospital bed two or three days before he died. It was a hair-raising evocation of broken bones, blue skin, and horrible wounds. During the speech Frank's sister fainted and had to be carried to her car. I don't know why Larry chose to be so insistently graphic, but perhaps he wanted to get as close as possible to Frank during those last days, and he wanted to give us a sight of Frank that none of us had ever seen. It was an odd, repulsively detailed talk and many of us later upbraided Larry for it.

As I stood in the cemetery, part of the large semicircle around Frank's grave, I recalled my own last meeting with Frank, which had occurred some two months earlier.

There had been a plan afoot to make an underground movie, the script of which would be written by Frank's writer friends. I believe it was Joe Le Sueur who dreamed up the idea for the film, which was to be called *Messy Lives*. Frank, John Ashbery, Arnold Weinstein, Kenneth Koch, and a dozen other writers and poets would contribute the scenes. It was to have starred the people who wrote the various scenes as well as all of our painter friends. I was asked to write a song which would open the movie and which would be a parody on all of those Hollywood films that start out with a song under the credit titles. The words were to be supplied by Frank, and so he came over to our apartment one evening ready to write the lyrics for a song called "Messy Lives." He came without any idea of what he would write, deciding to make up his poem on the spur of the moment, as I would also make up the music.

I handed Frank some blank paper and a pencil, while I began to find an appropriate melody to launch the song. In a few minutes we had the first line: "We lead such messy lives." From then

on it became smooth sailing, as Frank wrote stanza after stanza, and I invented new musical phrases. When it was all finished, I dragged out my tape recorder. We must have taped the song ten or twelve times, refining it here and there, although Frank never altered his lyrics. As I stood in the tiny cemetery of The Springs the melody of that silly song and Frank's voice singing it came vividly into my head.

After the funeral a number of Frank's closest friends went to Patsy Southgate's nearby house and drank a great deal. A year later Bill Berkson compiled a book that honored Frank's memory. Commissioned and published by the Museum of Modern Art, it is titled *In Memory of My Feelings*. Bill asked thirty artists to illustrate a selection of Frank's poems. The list of names represents the people Frank O'Hara was close to during his life, and who were equally affected by him: Nell Blaine, Norman Bluhm, Joe Brainard, John Button, Giorgio Cavallon, Allan D'Arcangelo, Elaine de Kooning, Willem de Kooning, Nikki de Saint Phalle, Helen Frankenthaler, Jane Freilicher, Michael Goldberg, Philip Guston, Grace Hartigan, Al Held, Jasper Johns, Matsumi Kanemitsu, Alex Katz, Lee Krasner, Alfred Leslie, Roy Lichtenstein, Marisol, Joan Mitchell, Robert Motherwell, Reuben Nakian, Barnett Newman, Claes Oldenburg, Robert Rauschenberg, Larry Rivers, and my wife, Jane Wilson.

Bill Berkson wrote an afterword to this handsome volume: "It was fantastic to notice how much he knew—his day-by-day awareness of the slightest tremors in the atmosphere—and how much he thought about so much of it! He could even sort out the relevant from the massively banal—a herculean task in today's ingeniously absurd 'information' world. In the talk of last night's concert or this afternoon's gallery opening or tomorrow's little magazine, his distinctions seemed to strike from nowhere, stunning the room. A very special, somewhat overloaded genius, you might say."

A beach group shot. *Back row:* Robert Rauschenberg (holding on to tree stump), Jasper Johns (head peeking out behind tree), Roland Pease. *Middle row, left to right:* Grace Hartigan (leaning against tree); Mary Abbott (sitting on tree); Stephen Rivers, son of Larry; Larry Rivers in straw hat; Herbert Machiz in sunglasses; Tibor de Nagy; John Myers; Sondra Lee (in front of Herbert Machiz). *Front row:* Maxine Groffsky in sunglasses; Joe Hazan and his wife, painter Jane Freilicher. Water Mill, Long Island, 1959. (*Photo by John Gruen*)

A group shot taken on the patio of our Water Mill house. The occasion was our daughter Julia's third birthday, to which we invited only grownups (with the exception of Bill de Kooning's little daughter and two of Anne and Fairfield Porter's teen-age children). *Back row, left to right:* Lisa de Kooning (little blond child); film director Frank Perry and his wife, script writer Eleanor Perry; John Myers; Anne Porter; Fairfield Porter; interior designer Angelo Torricini; pianist Arthur Gold; Jane Wilson; poet Kenward Elmslie; painter Paul Brach; Jerry Porter (behind Brach); Nancy Ward; Katharine Porter; friend of Jerry Porter. *Second row, left to right:* Joe Hazan, Clarice Rivers, Kenneth Koch, Larry Rivers. *Seated on couch:* Miriam Shapiro (Brach), pianist Robert Fizdale, Jane Freilicher, Joan Ward, John Kacere, Sylvia Maizell. *Kneeling on the right, back to front:* Alvin Novak, Bill de Kooning, Jim Tommaney. *Front row:* Stephen Rivers, William Berkson, Frank O'Hara, Herbert Machiz. Water Mill, Long Island, 1961. (*Photo by John Gruen*)

Another patio group shot—another party. *Back row, left to right:* Trumbull Higgins, unidentified guest, David Oppenheim, artist Waldo Diaz Balart, unidentified guest, Janice Koch (wife of Kenneth), Jasper Johns, Jane Freilicher, Jane Wilson, Clarice Rivers, writer Harry Matthews, Ellen Oppenheim, Stella Adler, Joe Hazan. *Front row, in wicker chair:* poet Barbara Guest. *On couch:* Larry Rivers, Mrs. Lukas Foss, violinist Jeannette Medina and her husband, Grove Press editor Richard Seaver; Brigida Diaz-Balart. *On folding chair:* Maxine Groffsky. *In butterfly chair:* Joseph Rivers. Water Mill, Long Island, 1961. *(Photo by John Gruen)*

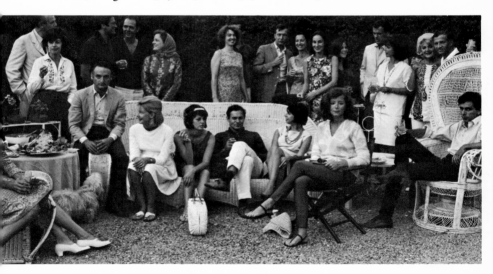

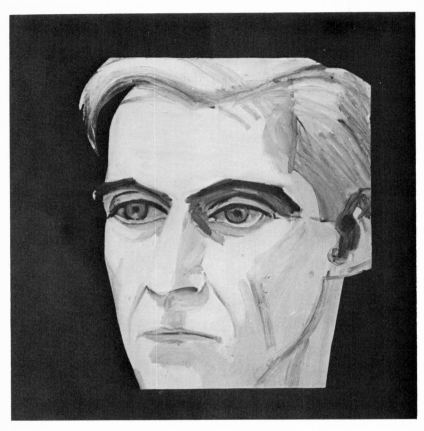

Edwin Denby, painting by Alex Katz, 1964. *Courtesy Fishbach Gallery.*

The art critic Harold Rosenberg, his daughter, Patia, and his wife, the writer May Tabak, in Washington Square. New York, 1950. (*Photo by Ibram Lassaw*).

Art critic Clement Greenberg with painter Helen Frankenthaler at sculptor David Smith's place in Bolton Landing, New York. 1951.

Painters Helen Frankenthaler and Robert Motherwell on their honeymoon at St. Jean de Luz, France, in the spring of 1958.

Helen Frankenthaler and David Smith, taken at Helen's studio apartment on West End Avenue. Painting behind them is Helen's famous *Mountains and Sea*. New York, 1956. (*Photo by Burt Glinn*)

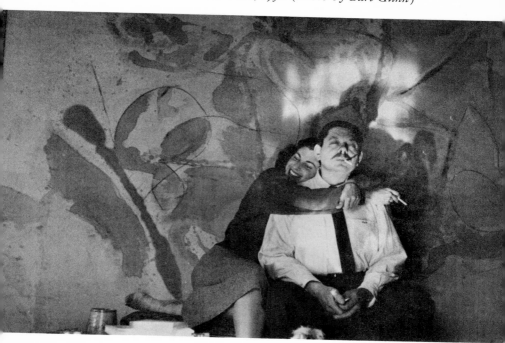

Mark Rothko and Robert
Motherwell on the beach. Cape
Cod, 1959. (*Photo by Helen
Frankenthaler*)

Marisol and Larry Rivers came for a drink
at our apartment before driving to
Connecticut to attend a Christmas party
given by Dr. Arnold Cooper and his wife,
Pat. This was the party during which
Marisol was given several presents meant for
other people by an inebriated relative of
the Coopers'. Marisol categorically refused
to return the gifts. New York, 1957. (*Photo
by John Gruen*)

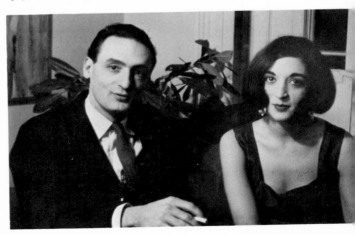

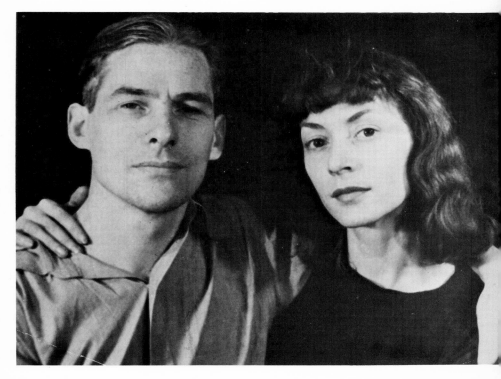

Willem de Kooning and his bride, Elaine de Kooning, in a portrait taken shortly after their wedding. New York, 1944. (*Photo by Ibram Lassaw*)

Ruth Kligman in her "traveling" outfit has just arrived with de Kooning to spend a weekend with the Hazans and us. Water Mill, Long Island, 1959. (*Photo by John Gruen*)

Bill de Kooning walking, prophet-like, on the beach during a weekend he spent with the Hazans and us. Water Mill, Long Island, 1959. (*Photo by John Gruen*)

Bill de Kooning and Ruth Kligman take the sun on the beach.
Water Mill, Long Island, 1959. (*Photo by John Gruen*)

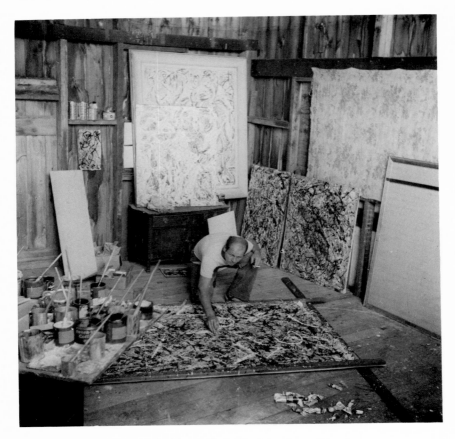

Jackson Pollock painting in his studio in Springs, Long Island.

Jackson Pollock and his wife, the painter Lee Krasner, walk from Jackson's studio in Springs, Long Island.

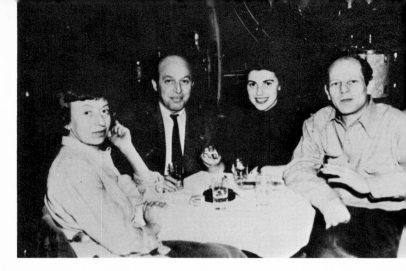

At Eddie Condon's, New York City, Lee Krasner Pollock,
Clement Greenberg, Helen Frankenthaler, Jackson Pollock.
New York, 1951.

Art dealer and artist—the remarkable Miss Betty Parsons,
photographed in the late 1950s. New York. (*Photo by Alexander
Liberman*)

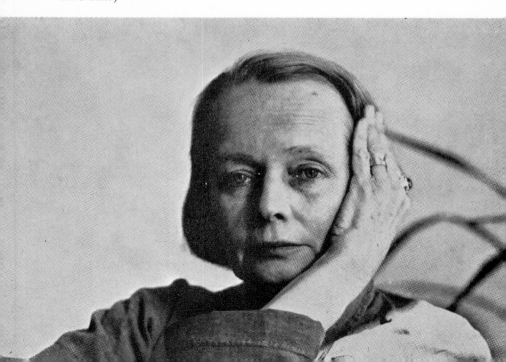

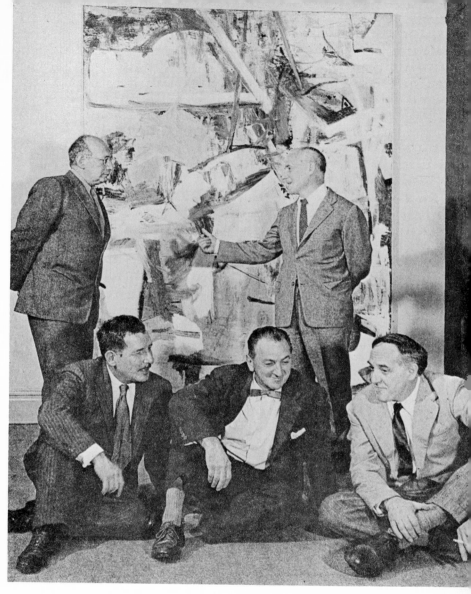

Group photograph taken at the Sidney Janis Gallery (then located at 15 East 57th Street) on the occasion of Bill de Kooning's one-man show in 1956. *From left to right, standing:* Mark Rothko and de Kooning. *Sitting:* Franz Kline, art dealer Sidney Janis, and Philip Guston. The painting in the background is titled *Easter Sunday*. New York, 1956.

Artist Adolph Gottlieb. (*Photo
by F.K. Lloyd*, courtesy
Marlborough Gallery)

Sculptor Philip Pavia in the company of his art dealer, the late
Martha Jackson. The pretty girl on the left is a niece of
Mrs. Jackson's. (*Photo by Syeus Mottel*, courtesy Martha Jackson
Gallery)

13

John Ashbery has been our most elusive friend. Today John, along with Kenneth Koch and the late Frank O'Hara, has become a major poet. Just as a faction of the young was inspired by Frank, another faction has looked to the work of John as the vital force in contemporary poetry. Kenneth continues to disseminate the poetry of the twentieth century by teaching courses at Columbia University and elsewhere. Of the three, Kenneth made teaching his life, and it is a calling eminently suited to his character and temperament. His awards included a "best teacher" citation and he has recently initiated a fascinating course involving the teaching of poetry to children. Kenneth, with his effusiveness, his high good spirits, and his enthusiasm for the written word has taken the study of poetry far beyond the academicism of previous approaches.

Frank O'Hara and John Ashbery did not embrace the academic life, but aligned themselves with the New York art world, landing jobs of distinction in the field of art. Frank became an associate curator of painting at the Museum of Modern Art, while John became an executive editor at *Art News* magazine. Frank started out by heading the Information Desk at MOMA, and John by writing short art reviews for *Art News*. In each case the pay was minimal and the two, like the rest of us, were in continual financial straits.

Jane and I met John Ashbery in 1950, at the house of Morris

Golde, a generous, loyal, and supportive friend of all the artists, poets, writers, and composers of the period. (Indeed, parties at Morris Golde's were highlights of the fifties—and continue to be so to this day.) John had just graduated from Harvard and, like Frank, had come to New York to make his life. He had always wanted to be a poet and even in those days there was something mysterious and inaccessible about his work. For my part, I could never quite make out his language, his imagery, or his "voice." A friendly person, John was nonetheless difficult to get to know, and our encounters resulted in mere chitchat. Perhaps I came on too strong, and caused John to withdraw. But to this day, we have not had a full-fledged conversation. When we meet there is nothing but friendliness between us, though of a very superficial kind. What this all boils down to is that there are some people you can talk to, and some people that you can't.

Back in the early fifties I called John and asked whether I might come look at some of his poems with an eye to setting them to music. He agreed, and I made my way to his small apartment on West Ninth Street, which had belonged to the dancer Valerie Bettis. In those days John was extremely thin and had a look of great vulnerability. His face was illuminated by eyes that were a brilliant blue-green. A prominent beaklike nose gave him an alert expression. His voice was slightly nasal, yet curiously melodious.

He showed me his poems and I began reading them. I did not take any poems away with me, but I did take away the impression of a young poet who, in his early twenties, had already found a peculiar language of his own, and I was determined to get to know him better. Later, when I asked John to tell me about his life in the 1950s, he consented, but once again kept me strangely at bay.

"I was born in Rochester, New York, and I was brought up near there. I went to Harvard and graduated in 1949. I came to New York and immediately got in touch with Kenneth Koch, who had gotten out of Harvard the year before. It was fun to be in New York, especially with him, and I didn't know anyone else

there. Kenneth was living on lower Third Avenue, of which the 'El' was then a feature. Jane Freilicher lived in the same building and that's how I met her. That summer, in 1949, I started working in the Brooklyn Public Library, just to have a summer job. But in the fall, I became horrified with this job and so decided to go to Columbia Graduate School for two years to get an M.A. in English. My circle at that time was Kenneth, Jane, and, later, Frank O'Hara. Frank was a year behind me in Harvard because he had been in the Navy, and he then went to graduate school for a year at Ann Arbor, Michigan. He came to New York to stay in 1951.

"I had already begun writing poetry at Harvard, and it was very influenced by the poetry of the forties in America. You know, the type of poet Oscar Williams put in his anthologies. Actually I still like a lot of those poets. I have been meaning to go back and read people like Gene Derwood. In those days I didn't know any poets except for Kenneth and Frank, although I remember being invited by Delmore Schwartz to some sort of a reception at New Directions, which is probably the greatest thing that happened to me when I got to New York. I guess I saw Kenneth the most. I called him "Dr. Fun," because in those days he was even more high-spirited and funny than he is today. One thing he used to do was to start talking with a certain accent, and he would continue for hours until finally, you just thought you'd go off your nut. He had a kind of hillbilly he used to turn on—and it was something!

"But talking of the early fifties, it was really a kind of depressing period for me. First of all, I didn't think that anybody would publish my poetry. That I might one day publish a book was beyond my wildest dreams. Very few people appreciated the kind of poetry I was trying to write. Poetry was very academic then. I sent my poems around and there were lots and lots of rejections. Then, in 1951, I did have a poem published in *Partisan Review* and that was a marvelous thing. I didn't think that I'd ever get into such a magazine.

"I never talked about my poems except maybe to Kenneth. I

still think that nothing can really be solved by talking about one's poetry. At the same time, I am aware that this isn't true. Anyway, that's the way I am. Also I wasn't very prolific in those days and that was because I wasn't really very happy. I was uncertain about whether my work was of any interest whatever. I still feel that way to a certain degree. At one point I felt so discouraged that I thought I wouldn't write any more. I snapped out of this after listening to John Cage's *Music of Changes* at a recital on New Year's Day 1952. It was a fantastic experience. There was a piece that lasted over an hour and it was mostly made up of disjointed chords. It had very little rhythm and it just went on and on until you sort of went not *out* of your mind, but *into* your mind. It seemed that anything was possible after listening to that. I really felt that it was a kind of renewal. And the fact that it happened on New Year's Day seemed to have a certain significance. So, the cloud that had been hanging over me gradually lifted and ever since, I've never had a period as sterile as the one between 1950 and 1952.

"All the while I had been going to Columbia Graduate School and in 1951 I received my M.A. I wrote my thesis on Henry Green. He's a novelist that's gone out of fashion now, but he was sort of a discovery around 1950. He wrote in the thirties—late twenties—and into the fifties. You know, he wrote *Loving*, *Concluding*—and they all had similar characters in each novel.

"I was always interested in music—ever since I can remember. I had very eclectic tastes—I mean, I liked everything from Cage to Chaminade. There are very few pieces of music that I can't bear to listen to. Still, I don't think I could sit through the Sibelius Second Symphony or Ravel's Introduction and Allegro for Harp and Strings, again. Of course, when I got to New York Frank and Kenneth and I kept rushing to the New York City Ballet every night it was on. I was always terribly fond of 'La Valse.' I also loved 'Opus 34,' which they don't do now—the Schoenberg, with the bandages and the hospital. And I loved 'Ivesiana,' which they still do. I also liked 'Serenade' and 'Illuminations.'

"I kept reading European novels in the fifties. I guess it was snobbish of me. I liked anything that came from Europe. I had to go to Europe to get cured of that. I think I read more American literature now, but at the time, I read a lot of Henry Green, Ivy Compton-Burnett, and Lytton Strachey—or translations from the French. I was also obsessed by French movies. I used to go to the movies ten or twenty times a week. *Les Enfants Terribles* and *Orphée* by Cocteau were two of my favorites. I saw *Drôle de Drame* about eight times. I saw *Le Million* by René Clair about twenty times. I don't know how many times I've seen *On Approval* with Bea Lillie. Of American films, I was mad about *A Place in the Sun*. Frank and I saw that together on Times Square and had to be almost carried out of the theater.

"In 1955 I got a Fulbright Fellowship. It was a miraculous thing because I had already been turned down that year, but somebody couldn't take it after all, so I got this second notice telling me that I had been granted the fellowship. And I went to France.

"Ever since I was a small child everything that came from France seemed to have a mysterious finish to it. I mean, everything that was good in art seemed to come from France. I guess it was the French sensibility that one looked to. Anyway, we left on the *Queen Mary*—all of us Fulbright students—in third class, or steerage. It was marvelous. We had marvelous bad English food. I was very excited. It was my first trip to Europe. I think one has to go to Europe in order to appreciate America. We landed in Cherbourg and I took a train. It was very beautiful. It was still summer and we went to Normandy. I had studied French in school for five years. But when I got there it took me a year before I could converse. I think it took me about a year before I really liked living in France. It all seemed kind of shabby, and sad, and seedy, and unfriendly.

"I lived in Paris for a while and then was sent to Montpellier, which is a dismal city. After a while, I managed to get transferred back to Paris and I got my Fulbright renewed. The purpose of my Fulbright was to make an anthology of modern poets

in translation. I never really brought this work to completion. In the winter of 1957 I returned to New York and I moved into an apartment that Frank had been living in on East Forty-ninth Street. I shared it with Jimmy Schuyler—whom I met around 1952. It was through Jimmy that I began writing art criticism for *Art News*, something he was doing himself at the time. I also started going to NYU, doing graduate work in French, and also teaching French at NYU in the Bronx. By that time I had turned thirty. It now occurred to me to get a Ph.D. degree, which I had wanted to work on in France. Somehow I had to get back to France, and finally I did. I never did get my doctorate, but I did get a job in Paris working as an art critic for the *Herald Tribune*. I made a very small living, but I finally managed to find other work and continued my life in Paris until I came back to New York for good."

This was as much as I got from John Ashbery about his life in the fifties. The key to John is to be found in his work, and unlocking the work is not easy. His poems are nevertheless couched in simple language. The way he puts words together produces an interior landscape filled with odd and beautiful lights around which odd, beautiful feelings come into momentary focus.

Jane and I usually saw John in the company of Jane Freilicher, perhaps the only person able to "read" his character with any real ease. A favorite of the young poets we knew, Jane Freilicher had the kind of hypersensitive but noncommittal personality that matched John's and Frank O'Hara's generally offhand, intellectual style. The ground rule of their relationship was Wit At Any Cost. They communicated in a kind of code which tended to exclude others, but which elicited giggles and laughter among themselves. There were knowing glances. There were arcane references. And there were vested insecurities. This close-knit, familial group did not consciously create an atmosphere of hostility. On the contrary, it was something of a private twittering machine that could make you nervous, but never angry. They were a self-protective covey, and to be in their midst was to be in contact with an atmosphere you *thought* was very "in," but may

have been nothing more than collective free-floating anxiety.

The guru of this group was the dance critic Edwin Denby. He was some twenty or twenty-five years our senior, but he projected an incredible air of youth. His lean, almost spectral looks and shock of white hair stood out at any gathering. As a writer, he could communicate the art of the ballet with tremendous clarity, insight, and imagination. But Denby was extraordinarily responsive and verbal about all of the arts, and was as conversant in painting as he was in music, theater, and poetry. Edwin Denby was our private celebrity and intellectual leader. Frank O'Hara, John Ashbery, Jimmy Schuyler, and the rest of the young poets we knew clustered about him to discuss Balanchine's latest ballets, Bill de Kooning's latest show, or a John Cage concert.

A soft-spoken man, whose voice bore a cultivated inflection, Edwin Denby was a product of Harvard University and the University of Vienna. Between 1936 and 1943 he wrote a dance column for the publication *Modern Music*, and was dance critic for the *New York Herald Tribune* between 1942 and 1945. But the most interesting thing about Edwin Denby was his life.

When I went to his walkup apartment on West Twenty-first Street to talk to him about the fifties, he greeted me with his usual friendliness. The place was very modestly furnished with books and papers predominating, and I noted that the economy of his writing was paralleled by the spareness of his life style. Denby went fascinatingly beyond the decade in question.

"I was born in China. Both my parents were born in Evansville, Indiana, and so I've always considered myself a midwesterner. But my grandfather was Minister to China—what's now called an ambassador. My father was his secretary there and learned to read and write and speak Chinese. Then, after he married my mother, they both lived there for another number of years. When I was born my father was no longer my grandfather's secretary. He had become a businessman in Tientsin. I was born just a year before they left. The next thing I remember we were living in Washington, D.C. Then I recall living in Hanover, Germany, for a year. I was about four or five years old. Then we

went to Shanghai, where my father was consul general. I have very few Chinese memories, however. After that my father became consul general in Vienna.

"I went to German grammar school. But then, World War I had started and so we all came home from the enemy country which we all had liked so much. We settled in Detroit. Later, my father went back into government service and we were in Washington again. By that time I was going to prep school and to Harvard. After my junior year at Harvard I decided that I didn't really want to go on with it and I came to New York. I spent a year in Greenwich Village. Then I went abroad and was away for twelve or thirteen years. That's when I started to learn dancing. I studied modern dance for three years in Vienna. It was a sort of lyric form of dancing. It's hard to describe because that particular kind of dancing doesn't exist any more. The idea was a lot of pliancy. This was all, of course, in the 1920s.

"I was also interested in psychoanalysis and in being psychoanalyzed, because that was the way one found out about it. A friend of mine had suggested that I should go and be analyzed by Sigmund Freud. It was a very attractive prospect—Freud was a real hero in the artistic community in those days—and one day I went around to his place and rang the doorbell. A very nice woman came to the door and I said, 'May I speak to Herr Professor?' She said, 'I'm very sorry, he can't speak to anybody now.' Then she apparently saw that I looked crestfallen and said, 'I will give you the address of a friend of Dr. Freud, a Dr. Paul Federn.' This was probably because Freud had just had a number of jaw operations and was probably not well enough to see anyone. I went to see Dr. Federn and liked him very much. Eventually, he arranged for me to meet Freud. I believe the year was 1924 or 1925. I was ushered into his study—the one that has been photographed so much—and there he stood. He had a marvelous laugh, and marvelous friendly, sparkling eyes that put you at your ease at once. Still, there was something slightly forbidding about those eyes. But you had complete confidence in that he wasn't going to take advantage of you, or put you down, or do

any of those things that one is afraid of as a boy in the streets meeting a celebrity. Of course, I felt myself being somewhat retarded because I was so terribly self-conscious. And besides, I hadn't thought up questions to ask him. At one point he looked at me and said, 'Is there a question you would like to ask?' I had to think of something quickly, and so I asked, 'Tell me, why is it that one can't analyze oneself?' I had been thinking of self-analysis for a long time. I thought I understood the psychoanalytic books I had been reading. But Freud paused a moment, then smiled in a very friendly way and said, 'Have you ever heard of Baron Muenchausen?' I said yes. Then he said, 'Do you remember that Baron Muenchausen pulled himself up by his own bootstraps?' Again I said yes—and got Freud's point. Of course, it later turned out that Freud had analyzed himself—at least that was the story and it seemed that among all the psychoanalysts working in those days, Freud was the only one who had analyzed himself successfully. And that was the extent of my meeting with Sigmund Freud.

"Well, I couldn't really pull myself up by my own bootstraps, and so I worked with Dr. Federn for a number of years and it helped a great deal. You see, I'd spent a winter before considering suicide. It was one of my preoccupations. Of course I didn't go through with it. Finally, I found that analysis seemed quite painful. I forgot it very fast after it was over. I believe that analysis is very good for many people who are alone and have nobody to talk to intimately and are embarrassed to demand so much from people near them.

"I started out wanting to be a playwright, but then found myself becoming more and more interested in the dance. I became what you might call a comic dancer and danced in Berlin for two or three years. Then Hitler came, so I went to France and had very little money. My parents, in the meantime, were living in Majorca and they suggested I should join them and I did. I still had no money, except for thirty dollars a month, and found that I could actually live in Majorca and even have a little house and a dog and a woman to come in and clean occasionally. In

this house I began to write a novel which I called 'Scream in a Cave.' I wrote it because I had to have an excuse to stay in my room, so I thought that what one can always do is write an adventure story. And I found out all about writing then, because I rewrote my novel three times.

"In the thirties I returned to New York and found New York more American than ever before. Three things happened to me in the thirties. One was that Rudy Burckhardt, whom I'd met in Basel, came to New York. He was a photographer and a film maker. He began making films within a year or two and I acted in them. In the first one, Aaron Copland appeared as a very engaging villain. The heroine of the film was Paula Miller, who was the wife of Lee Strasberg. She played my wife. John LaTouche played Aaron's sidekick. Virgil Thomson played a bit part. Paul Bowles wrote the music. The budget I think was fifty dollars and Paul's music was on a gramophone record and it never quite synchronized. But it didn't matter—it was very beautiful music. Paul Bowles wrote a score for Rudy's second film, and even a third and fourth later on. Unfortunately, the records got worn out and then lost. I think Paul was the greatest movie-music writer of them all; he enjoyed it so much.

"The second thing that happened to me in the thirties was meeting Minna Lederman. She was the great center and animator and brilliant genius of the whole circle of modern music in the thirties. She was also the editor of a magazine called *Modern Music*. Modern music, as you may or may not know, had almost no standing at the time, and especially in America. But she got all the brilliant composers to write for her magazine, and everybody wrote not for pay but for joy. Virgil and Aaron suggested to Minna that I write a dance column for the magazine, and so I did. Around that time I also wrote a high-school opera libretto for Aaron Copland called *The Second Hurricane*. But I was very happy doing my dance column, especially since it meant getting free seats to the ballet.

"The third thing in my life in the thirties was meeting Bill de Kooning. You see, those were the three worlds: The dance

world, the music world, and the painting world. Bill was and is marvelous. But he has changed. But the changes are all connected with his exploring things that happen to him while painting. He became more and more brilliant as the years went on because he transformed his ideas into actions. It was a matter of what you did with your ideas. Anyway, he's gone through difficult periods.

"In the forties, I got a job as a dance critic on the *New York Herald Tribune*. I got this job through Virgil Thomson, who was the chief music critic then. So I wrote pieces that I thought were very interesting because I had accumulated so many ideas by that time. But when I looked at them afterwards it turned out that they weren't very good at all. Virgil was always a model for me, and his music criticism was the greatest pleasure in New York. It was so unexpected to find anything like that in a newspaper. My job lasted three years because I was taking the place of Walter Terry, who was the regular dance critic on the *Trib* but who was in the army at the time. After the *Tribune*, I went to Mexico for a while. Later I went to Morocco to visit Paul Bowles. Actually, I wanted to find out what Moroccan life was really like. I was fascinated by the relationship between people there. It's the feudal sense of the family relation and the intensity of feeling that is possible and is perfectly sincere. And, of course, the simplicity of comfort, which means a great deal of discomfort. And the beauty of the cities. Another fascinating thing is getting used to the women. You begin to see what they look like through the veils, which change in fashion every few months. After a while, when you see a woman with the face unveiled you are quite shocked.

"One time in Tangier, at the air terminal, I happened to be walking by and a woman got out of a limousine. She was beautifully veiled, beautifully dressed, all in very fine, expensive silk, and she was telling the people that she wanted her suitcase taken from the roof of the car. She hardly spoke. She simply made gestures with her arms, which she held quite near to her body, her hands quite close down. The men understood everything, although only her fingertips showed. And I realized Oh, this is

a princess, of course, everybody understands her. It was beautiful to see. Those are things that one is happy to see. No wasted motion and no effort—complete assurance.

"I came back to New York in 1952 and the New York City Ballet had already been formed, and it looked to me absolutely marvelous, and I felt much closer to it than to the European companies. I felt I belonged to the atmosphere of the New York City Ballet. When you get to a foreign place you think Oh, how very interesting and how charming—but if you stay there for a while you begin to realize that you're outside of it. So, in the fifties in New York, I was very involved with this new and exciting company. I also made new friends. I met Jimmy Schuyler and John Ashbery and Frank O'Hara. And after a while, Frank became the closest of these.

"Frank O'Hara was a catalyst for me, although I was much older. But then, he was everybody's catalyst. My entree was that I was an old friend of Bill de Kooning's, who was a great hero of Frank's. I liked to go to the ballet with Frank and John and Jimmy. We were all mad about George Balanchine. We all thought he was a genius. He was like De Kooning—going through difficult periods, defending what he wanted to do, seeing what else was possible. Of course, when you are working with a company, it's not the same thing as working with colors and brushes. But in a sense, what's similar is that there are certain possibilities open to you and open to them, the dancers. You do it instinctively.

"Also in that period, I remember meeting you and Jane. I remember that Virgil Thomson had taken one of Jane's paintings to Paris and placed it in his apartment there. And I remember your songs and how Virgil admired them. And how you started writing music criticism, which was very amusing and very lively.

"There were some very great dancers in the fifties that I remember. There was Tanaquil Le Clercq and Maria Tallchief. And there was Eglevsky and Magallanes and Moncion. And there was Melissa Hayden. Jacques d'Amboise was gorgeous in the City Ballet's 'Figure in the Carpet,' which was also Edward Villella's

first wonderful part. They don't do that ballet any more, although all of us fans have asked for it. I wrote about many of the new Balanchine ballets, but I can't do it any more. I haven't the concentration to do it. As a matter of fact, I was quite glad that I could stop when I did because I was getting exhausted by it. It may be that the world of dancing has much less variety than that of music. But it was wonderful to do it and it was wonderful to have seen so many dancers in so many parts of the world during my lifetime.

"Did you know that I saw Isadora Duncan on her last tour in America? It was, I believe, in 1922, and I saw her in Carnegie Hall. The two pieces I remember were 'Siegfried's Funeral March' and the 'Venusberg Ballet' of Wagner. She was very slow and very simple, absorbing, and very grand. These were flashes of Isadora that I remember very clearly. She was really very controlled, which I didn't think of at that time. I don't think those particular qualities of Isadora are imitable. Of course, people would say that she had been so much better earlier on—that now she was in a very bad state, and so forth. But when I saw her, those flashes were very great—you know, they were as great as anything can be."

Edwin Denby continues to be part of our group. He has not achieved the fame or recognition of some of his contemporaries or of some of the younger poets he met in the fifties. It is, I suspect, a matter of his unassertive, self-effacing personality. He is extremely shy and not given to publicizing himself or his work. Denby has written four books, all of them very readable, superbly informative, and extremely personal: *Looking at the Dance; In Public, in Private; Mediterranean Cities;* and *Dancers, Buildings and People in the Streets.* The latter, a series of essays published in 1965, has an introduction by Frank O'Hara, in which he writes of Edwin Denby, "Like Lamb and Hazlitt, he has lightness and deftness of tone, and a sharp, amused intelligence, as evident in the method of perceiving as in the subject matter itself. Much of his prose is involved with delineation of sensibility in its experience of time: what happens, and how often,

if at all? what does each second mean, and how is the span of attention used to make it a longer or shorter experience? is Time in itself beautiful, or is its quality merely decorable or decorous? Somehow, he gives an equation in which attention equals Life, or is its only evidence, and this in turn gives each essay, whatever the occasional nature of its subject, a larger applicability we seldom find elsewhere in contemporary criticism."

Jimmy Schuyler was another "regular" of our fifties group. Jane and I first heard about him through the duo pianists Arthur Gold and Robert Fizdale, who had just recorded a work entitled *A Picnic Cantata* composed by Paul Bowles with lyrics by Jimmy Schuyler. It was a charming divertissement, and we were much taken by both the music and the text. When we met Jimmy, he turned out to be a very young, very quiet, and rather nervous young man, slight of frame, with a sweet, open face, brimming with sensitivity. He never spoke very much, but was content to sit by, taking everything in and offering some occasional witticism.

Jimmy published his first novel, *Alfred and Guenivere*, in 1958, a very special tale about two children living a complex interior life, and observing the world around them through highly charged sensibilities. An understated wit and an individual poetic aura pervade this endearing book. Jimmy liked to collaborate with his fellow poets, and one such collaboration, with John Ashbery, resulted in a novel published in the sixties entitled *A Nest of Ninnies*, an amusing look at the manners and mores of some outré young people traveling together in America and Europe. But Jimmy was primarily a poet, and his work is distinguished by an acute sense of detail and ravishing use of language.

There was always a sense of unhappiness about Jimmy Schuyler, as if he were unable to cope with whatever private demons beset him. One day I ran into Jimmy carrying a heavy suitcase. We greeted each other, but he seemed incapable of speaking. I could tell he was in the grip of a frightful anxiety attack. Beads of perspiration covered his face, and when he tried to talk he was incoherent. Finally, he managed to tell me that he was on his

way to Southampton, Long Island, for a visit with the painter Fairfield Porter and his family.

Jimmy now lives with the Porters, who seem to have adopted him as a permanent member of their family. I suspect he seized on this unorthodox solution because he needed a sympathetic milieu in order to survive his bouts of despair.

14

Throughout the fifties Jane and I moved far more among artists than musicians, partly because Jane was a painter, and partly because we were both more drawn to the painter's milieu, which was infinitely more interesting than the musical circles of the period. Artists were simply more fun-loving. They seldom talked shop, being satisfied merely to be in each other's company and enjoy the convivialities. We went to the loft parties given by New York artists, drinking quantities of liquor, dancing madly, exchanging gossip, and being happy within the orbit of our heroes, Willem de Kooning, Franz Kline, Mark Rothko, and Jackson Pollock. There we also met the critics of the period: Tom Hess, Harold Rosenberg, and Clement Greenberg, and the reigning intellectual, Robert Motherwell. We belonged to a closed society of artists and writers who knew they were good, but did not yet know they were becoming part of American art history.

Abstract expressionism had already become the first bona fide modern American art movement. Harold Rosenberg had by this time defined its meaning and purpose, while Hans Hofmann was turning out a second generation of abstract expressionists in his classes in New York and Provincetown. Clem Greenberg had written the definitive appraisal of the art of Jackson Pollock. Gallery dealers like Betty Parsons, Sidney Janis, and Charles Egan were the promulgators and exhibitors of this new abstract art.

The public was beginning to understand these rash and violent paintings, and slowly came round to buying the works of artists whose personal convictions and stylistic innovations they had rejected for years. As if on cue, informed American collectors, as well as certain Europeans, tuned in on the rush of emotion that flowed from the brushes of the abstract expressionists, learning to appreciate, if not love, the strange luminous visions of Mark Rothko and the elegant, metaphysical landscapes of Adolph Gottlieb.

The younger crop of painters rode on the coattails of these pioneers, turning out their own brand of abstract expressionism, feeling themselves a part of a successful and authentic movement, having their own shows and making their own kind of reputation. The fifties did not just produce abstractionists, however; there was a whole group of figurative painters working and exhibiting with considerable success. They were not usually looked down upon by the abstract expressionists, nor did they consider the abstractionists less worthy than themselves. A common attitude held these divergent styles in one camp. The idea was to "feel"—and feel deeply—about one's responses to the inner and outer worlds. The abstractionists offered images of their feelings, while the figurative artists invested recognizable objects with their feelings, turning their still lifes, landscapes, or figures into emotionally charged entities.

The handling of paint was also a common denominator. For the most part, brushstrokes were restless or frenzied. Color was approached with equal verve. Thus figurative painters like Fairfield Porter, Nell Blaine, Leland Bell, Wolf Kahn, Larry Rivers, Robert de Niro, Fay Lansner, Paul Georges, and Jane Freilicher adhered to the abstract-expressionist technique as well as its emotional impetus.

One of the less felicitous by-products of abstract expressionism was the rise of an art criticism that sought to explain it in a language as convoluted as it was impenetrable. The famous critics of the period invented a polemical jargon designed to keep the public eons away from the subject about which they were writing.

Suddenly, magazines such as *Art News, Arts,* and *Art International* burgeoned with endless verbiage which, far from clarifying the art trends of the period, seemed needlessly to obscure them. Critics were clearly writing for and against each other, trying to outdo each other with the brilliance of their insights. The fact is that most of the artists under critical surveillance barely understood this kind of criticism, and frequently made fun of it. When the splatters and drips of Jackson Pollock became a *cause célèbre,* critical writing rose to new heights of arcane symbolism and dense metaphor.

Harold Rosenberg, who knew the older generation of painters and sculptors during WPA days, was among the first to write about their art. He started out writing fiction and poetry, then switched to painting and, later, to criticism. Physically a colossus of a man, he presented an image of authority and intellectual force. Dominated by a fierce mustache and bushy eyebrows, his face had a rugged peasant quality out of Tolstoi or Dostoevski. His voice, marked by a slight speech impediment, was thick and raspy.

Rosenberg was death to women. I suppose his gleeful, Machiavellian looks, his imposing stature, and his intelligence made him an instant object of adoration. Although he was married to the writer May Tabak, Harold was pursued by any number of fascinating ladies.

Today, Harold Rosenberg writes art criticism for *The New Yorker* magazine, and is the author of several books, including *The Tradition of the New, Arshile Gorky, The Anxious Object,* and *Artworks and Packages.* While his particular brand of art criticism is notable for the verbal densities I spoke of earlier, his erudition and perception are admired by many. This admiration is not shared by his contemporary, critic Clement Greenberg, another impenetrable stylist, who considers Rosenberg something of a fool.

The Rosenbergs live on East Tenth Street in New York, in an apartment cluttered with objects and memories. When in 1969 he and May allowed me to come by to talk about the fifties, it was

the first time I had been to their home. The Rosenbergs were a couple one ran into at parties, museum and gallery openings, and panel discussions. May, an intense, highly articulate woman, did not always accompany her husband, but when she did, she was as much of a presence as Harold.

Jane and I never knew them very well, but our few talks were always droll and friendly. During the interview, they were cannily on guard, but good-humored about my many and varied questions. Harold did most of the talking.

"I don't think of myself as a critic writing about specific painters or sculptors. I never felt any obligation to write about anybody or anything—I wrote about art whenever it occurred to me. You see I'd been writing for quite a while before the fifties. I became interested in writing about art because I felt that some basic interests to the creative life were being pursued in painting and sculpture of that time, and had been more or less abandoned in the literary world. This is the reason why I began to write about art.

"I don't really write about problems that are distinctly—or let's say, exclusively—restricted to painting. Some people think that there is such a thing as art criticism. Or, to be more precise, painting criticism, sculpture criticism, assemblage criticism, object criticism. This to me is completely tiresome and I have never been impelled to have anything to do with it. That is, we are dealing with a condition of some creative act on the part of an individual, or a group even. This might take political form. It might take the form of action. It might take the form of silence. I didn't write about the artist, I wrote about a pervasive spirit.

"For example, I did not begin to write about art when I wrote my essay on Action Painting. I mean, I had written about art at my job, at WPA in Washington. Also, I was the editor of the American Guide Series. I wrote most of the essays on art that appeared in those books. So, I was a kind of art historian. This, by the way, was all back in the thirties. As far as art terminology is concerned, I must tell you that in Europe there had never been what I called specialized terminology for talking about painting.

The Americans feel as if they had done something terrific by their efforts to develop a terminology. Actually, all they've done is to develop a kind of classroom terminology. The terminology that I employ is the terminology of modern culture. It's bound up with experience, with poetry, with history, and with politics. The artist understands my terminology very well because it's the teminology of feeling. The art critic is bugged by it because it presumably is not specifically related to the question of painting. It can also be, however, specifically related to the question of painting insofar as painting is a creative, imaginative activity.

"Hans Hofmann never had any difficulty about my terminology, just as I had no difficulty about his terminology. Why? Because, when Hans said 'depth,' he meant a spatial relationship in a technical sense. But Hans also meant by 'depth,' depth of feeling. You see, the term is an ambiguous one; it's a metaphor. Space in painting is also a metaphor. There is no such thing as a fact in painting. Painting is through and through metaphorical. And even when you get to this cute idea that a painting is a real thing—which is what people have been fooling around with —that's a very comical kind of metaphor. It's as if, if you knocked out all qualities of something, you'd get the reality of it. So, what is it? It's Kantian metaphysics manifesting itself as a joke in the arts. That's what it is, because Kant was perfectly aware of the fact that thoughts fall into categories, so he said, let's get rid of all the categories and we'll get the *Ding an sich*—which is, of course, ridiculous because you can't ever get to the *Ding an sich*.

"But I see that what you want, John, are anecdotes about the fifties. I have difficulty with that because I don't think in terms of division of time. I'd sort of have to reconstruct everything from fragments. Let's see. . . . Around 1943 we came back to New York from Washington, D.C., where I was on the WPA. By that time I was already painting. I shared a studio in New York with Bill de Kooning. But of course, it all goes back to the twenties. You see, for me, American art history is my own autobiography. I mean, it's like this apartment. We happened to move into Tenth Street before Tenth Street became an art center. We also bought

a place in East Hampton. Then East Hampton became an art center. So it's all autobiography.

"Back in 1924 I went to law school. But I liked to draw portraits of the other students. I became an artist in law school. (I never became a lawyer.) I was living in Brooklyn then and we had a gang there. There was Dave Arkin, who's the father of Alan Arkin and a painter. There was Sylvia Marlowe; there was Israel Citkowitz, and Elie Siegmeister. So we had this gang and we talked about art, poetry, painting. In 1931 my first piece was published in *transition*. It was a short story. It was called 'A Fairy Tale.' It was a story about a homosexual who was locked up for being a fairy. And the first line of the story—which I adore—was 'Because I am a child I love to hear a story.'

"Anyway, all of us somehow connected. We were always interested in each other's work. And Parker Tyler and Charles Henri Ford had that magazine called *Blues* back in the thirties. And Tchelitchew was around. There was no demarcation, and all the psychological business didn't exist. I mean, now it's a great effort to get writers and artists together. Then artists and writers were always together and everybody used the same vocabulary. It wasn't necessary to have a specialized vocabulary—an art-critical vocabulary. The important thing was that everybody used the same vocabulary.

"But, to get to the fifties, we moved in groups. We had what May liked to call 'a flying circus.' The flying circus were people who all went to the same parties together—who'd go from one party to another. You'd say 'good-by' and a half hour later you'd be in some other house and all the same people would be there. It was all very gay. Jeanne Reynal had a big salon and she had everybody to her house. She gave big parties. It was the first time we heard Bucky Fuller talk. Everybody was a captive audience. John Cage came and talked. Actually the fifties was a very special period—a very social period among the artists, which isn't true any more today. I think always, if there's no social life, there's no art movement. The social aspect of art is of enormous importance. You see, when a group is rising to power, so to

speak, they are still a group. And then they begin to move into circles where things are happening. It usually took a long time for an artist to get into a kind of status where he'd move in important social elements. In other words, in a real traditional society, the society is there and the artist tries to move in. In our society the artist is a society. This is where the artists are very stupid. They are really the elite. People try to move in on them. And they don't know that, so they try to move in on people.

"You see, in all traditional societies up to the bourgeoisie in its heyday, the artist was somebody who was hoping for recognition from them. Today, the bourgeoisie are hoping for recognition from the artist. Consequently, the artist should really be more of a snob. The weakness of the contemporary artist is that he still doesn't recognize how the situation has changed socially. He is aware of it in some sense—he *is* a kind of a snob—but he also still behaves as if he were sort of a client of the rich.

"In the fifties there was a community of artists and they banded together and they did things together—like those movies Rudy Burckhardt used to make in which he put all the artists like Larry Rivers, Elaine de Kooning, John Ashbery, Jane Freilicher, etc. They did these things for each other; it was a self-delight.

"Then, of course, there was the Club. The Club was formed so that all the artists could get together and be with each other. For me, this again goes back to the twenties. We always used to hang around on the northwest corner of Washington Square in the summer time. In the winters we used to see each other in cafeterias. That was really the first artists' club, in the real sense of the word. In the twenties there was Hubert's Cafeteria, which was on Sheridan Square. This was a place where all the poets and painters used to meet. Maxwell Bodenheim, Eli Siegel—all the characters would meet at Hubert's Cafeteria. Then Hubert's finally closed, and we all moved into a huge new cafeteria on Sixth Avenue near Eighth Street called the Waldorf Cafeteria and this meeting place brought us right into the fifties. Then we all real-

ized that the Waldorf was getting very sordid and it became dangerous to go there. So the artists had no place to hang around. The idea sort of came up that we ought to have a protected environment, so they formed what became known as the Club, which was on Eighth Street near the Hans Hofmann school. They bought a big coffeepot and they gave out several keys, and people like Bill de Kooning and Philip Pavia and Ibram Lassaw would go there early and start the coffee. At the beginning, only a few people got together. They were the members. The membership was very important. I guess the first members were Pavia, De Kooning, Franz Kline, Lewiton, Lud Sander, Mercedes Matter, and Elaine de Kooning (the only two women)—and Mark Rothko. They started out with the idea that there ought to be discussions. De Kooning would say, 'Let's have discussions among the old-timers,' which was a great idea. These people had been around and, after all, none of us were kids any more. We were already in our forties. Bill was forty-two, I was forty, Pavia was maybe thirty-eight. And Sander, Gottlieb, and Rothko were older than we were. Jackson Pollock didn't come to the Club. He used to come to the Cedar Bar, which was an adjunct of the Club. Jackson didn't like to be doing stuff with coffee.

"The atmosphere of the Club was one of enthusiasm. They used to have meetings on Wednesday nights—those were the board meetings, so to speak. (The regular meetings were on Fridays.) But the board meetings were hilarious. I mean, they used to just kill me because the main issue seemed always to be 'who's going to sweep the floor,' 'who's going to take care of making the coffee.' Then they decided about having dues, except that nobody paid them. But we managed to make it work. Now, Landes Lewiton decided that he didn't want anybody else to be a member. Anybody who came up was automatically out because Lewiton blackballed everybody. That was another topic. Then there was the topic of how do you throw members out. For example, when I was brought up as a charter member, they asked me to come but they asked me to sit outside. This was a very formal

occasion. There was a vote with a terrific dispute. Of course, Lewiton was firmly against admitting anybody and especially a writer.

"There were no writers, you see. They were terrified of writers, just as they were terrified of people who might introduce politics—this was Pavia's hang-up. So anyway, I was sitting outside and they had this long debate. It seems my sponsors got really ferocious—they *had* to get me in. Finally, they came out and said, 'Okay, you're a charter member.' As soon as I became a member they said, 'Let's have a meeting with the old-timers and talk about the relationship between art and poetry.' This was the first thing that occurred to them, which is fascinating. So we did just that. The members sat around a table, got a couple of bottles of booze, and we talked about Baudelaire and Cézanne and the relation between Cézanne and Mallarmé—which fascinated Bill. This was the first meeting of the Club—that is, the first intellectual, organized discussion. We also had a lot of parties at the Club. We had great nights of liquor and dancing. All those characters brought records and all the artists were terrific dancers. The Club turned into Roseland."

Harold Rosenberg talked sketchily, while May interjected a few pieces of information. Needless to say, they could have spoken volumes about the fifties, but chose not to. Had we been closer friends, or shared more experiences, perhaps it would have been easier to extract some of the more personal details about the painters they had known.

Clement Greenberg was a figure we all knew in the fifties. He had been writing sporadically about art since 1939. Later, when he became an editor of the *Partisan Review*, he started reviewing art books. At that time, he had not yet begun to "see" abstract art. Then, chancing upon Paul Klee's drawing, *The Twittering Machine*, he suddenly "saw" it, and became interested enough to write about it. Indeed, it was the Klee drawing that propelled him into serious art criticism. In 1944, Greenberg became the regular art critic for *The Nation*, a post he held until 1949, although

he continued working for *Partisan Review*.

Jane and I got to know Clem around 1951 through Helen Frankenthaler, with whom he was then involved. Helen had just joined the Tibor de Nagy Gallery, and John Myers gave parties which Helen and Clem attended. Clem was something of a star-maker. He would go around to galleries or studios and discover new talent. It was Clem Greenberg who wrote in *The Nation* that Larry Rivers's work was better than Bonnard's. It was Greenberg who very early on championed Jackson Pollock. In the middle fifties he wrote and spoke enthusiastically about the paintings of Morris Louis, while in the late fifties he helped Kenneth Noland (as well as Louis) achieve a major reputation.

A man of medium height, Greenberg always had the look of an intellectual. His head was egg-shaped and prematurely bald, making him look older than his age. There was always something slightly embarrassed about him—as though he were apologizing for being there. He often wore a certain depressed look, as though pessimism were his underlying point of view.

Jane and I remember Clem Greenberg coming by the Hansa Gallery and saying good things about the work of some of its members, including Jane. But mainly he passed through our lives as Helen Frankenthaler's constant companion. The two shared an intense interest in art, and there is no question that Helen's early career was deeply influenced by her relationship with Clem. Later the two split up, and after a few years, Helen Frankenthaler married the painter Robert Motherwell. From what we could surmise, Clem Greenberg was deeply shaken and embittered by Helen's leaving him. Nevertheless, he later married a charming young woman not directly connected with the art world, and the two had a baby girl.

As I mentioned earlier, there has never been any love lost between Clem Greenberg and Harold Rosenberg, although Clem claims to retain a soft spot in his heart for Rosenberg's wife, May. At any rate, Greenberg, Harold Rosenberg, and the younger Thomas B. Hess were considered the major art critics of the forties and fifties. The three wielded enormous influence and power,

and were greatly instrumental in establishing abstract expressionism. Of course, each championed his own particular set of artists.

By the middle fifties, Clem Greenberg was slowly bowing out of criticism. He did very little writing, but still continued to look at new art, letting it be known that a lot of the big guns had lost their punch. The only painter of the period whom Greenberg continued to admire was Jackson Pollock.

When I called Clem to tell him how much I wanted to talk to him about the fifties, he seemed most agreeable and receptive about giving me an interview. He, in fact, invited me to his Central Park West apartment—this was in 1969—and we talked for nearly two hours about the period, about his role as critic and friend of the artists, about the art scene in general. Clem's apartment, large and airy, contained a fairly sizable collection of paintings, predominantly of the color-field and hard-edge variety. There were several works by Noland, Louis, and Olitski, and, unexpectedly, a large figurative landscape done by Greenberg himself. Clem offered me a drink and we began to talk.

The interview, brilliant, informative, and strewn with fascinating insights, anecdotes, and personal details about the artists and critics he had known intimately throughout the forties and fifties, put me in touch with a man who now seemed more or less disillusioned with the art world.

Several weeks later, Clem Greenberg had a strong change of heart regarding the appearance of his interview in this book. In its stead, he offered to supply me with a page-and-a-half essay on the evils of an "art scene." It was a brief and somewhat turgid text that did not begin to match the wit and spontaneity of our previous interview.

In essence, when Clem and I talked in his apartment, the subject revolved around abstract expressionism, which Clem said made itself felt by 1942 and 1943 with Gorky and Pollock. Its real turning point occurred around 1947 when, as he put it, "quality" entered the movement. According to Clem, abstract expressionism did not really become a movement until 1948, with several painters, notably Bradley Tomlin, James Brooks, and

Philip Guston, joining it. The movement coalesced when Bill de Kooning had his first exhibition at the Egan Gallery in 1948, and when Barney Newman, Robert Motherwell, and Mark Rothko founded an art school in 1949. This was also the time when artists began gathering at the Cedar Street Tavern and started to hold meetings at the Artists Club. It was at this point that Greenberg noted the emergence of an "art scene," something, he claimed, that did not exist before the fifties.

"The trouble with scenes," he said, "is that they eat up artists. The New York scene became a consumer of artists. I didn't step into it. I started to get out of it more and more. As the fifties went along, I wrote less and less. I exited from the literary and from the art world. I guess I re-entered it around 1959 and 1960."

Greenberg detested the Cedar Bar. He considered it sordid and filled with "doomed artists." He also recalled that Jackson Pollock and Bill de Kooning became the "heroes" of the period, but that they were ultimately "destroyed" by the scene. What he was saying was that by 1953, abstract expressionism, in general, began to deteriorate, and that the major artists had lost their touch and importance. He felt this about Franz Kline and others, but particularly about De Kooning, whose work, he said, began to fall off after 1949. Greenberg did not make his feelings about Bill public in print ("Somehow I couldn't bring myself to write against De Kooning's art . . . he had a way of making you feel that if you said anything against him it would be a mortal wound"). But Clem did talk it around, convinced that Bill's influence on younger artists was detrimental to their work. When this talk came to De Kooning's ear, a confrontation took place which resulted in Bill's punching Greenberg in the face.

Again and again, Greenberg alluded to the fact that "a scene kills." The Cedar Bar scene helped to "kill" the artists just as much as the scene that, during the summers, transferred itself to the Hamptons. "Those parties at the Hamptons!" he said. "They were like Walpurgis nights, when people get out of their graves and dance after midnight." Clem kept referring to the scene as being responsible for artists growing old and stale. "The thing is,

) 181 (

when you produce good art you don't age. It's when you make the scene that you age." He sees this happening today in New York at such artists' hangouts as Max's Kansas City and St. Adrian's near Bleecker Street, where another herd of "doomed" young artists is making the scene. Greenberg does feel that a place such as Max's Kansas City is far more exhilarating than the Cedar Bar ever was, mainly because the girls there are so much prettier and the atmosphere is so full of life. "At the Cedar, *everybody* looked unattractive," said Clem.

Greenberg had other complaints. A source of particular irritation was the myth that the artists of his generation were studies in fascination and profundity. In effect, Clem found them profoundly dull—with the possible exception of Gorky, Rothko, and Pollock ("when he wasn't drinking"). He considered De Kooning tedious beyond belief, and Kline "a bore." He had similar feelings about Barney Newman ("once you got to know him"). Another artist Clem found tiresome was Hans Hofmann because, as he put it, "he never let on to what he was really feeling." Greenberg also believed that most of these artists made a big show of being convivial and friendly with one another, when, in truth, they were extremely isolated and cut off from people. He called them victims of the art scene—victims of a "kind of small tragedy."

During my visit with Clem, he was exceptionally leery on the subject of Helen Frankenthaler. In fact, he told me that he never writes or talks about Helen's art in public. ("She's like a relative. I have a sister-in-law who paints, and you can never say anything about it.") He did say that he had once—and only once— written a piece in which he discussed Helen's influence on Morris Louis and Kenneth Noland because she had been the first artist to employ the stained canvas idea—an idea she had gotten from Jackson Pollock.

On the subject of his fellow critics, Greenberg was far more loquacious. In effect he began by suggesting that in the fifties art criticism was virtually nonexistent. He had very little use for the writings of Harold Rosenberg, claiming that Rosenberg could

not be taken seriously as an art critic. Clem conceded that Harold was "a very able man of enormous abilities," and "a formidable person." As for Tom Hess, who was also writing art criticism in the fifties, Clem found him to be an excellent journalist and editor, someone who could report things that went on with unusual clarity. "He's one of the best editors I've ever known, and he should write more."

Today, Clement Greenberg continues to wield a certain understated influence in the art world, although he goes out of his way to deny this. "All I can say now is, I've seen so much pass," he concluded. "I'm sixty years old—and I've seen so much pass. At the moment, I'm more interested in personal relations than in anything else. I found *that's* the main problem in life. Your career, if you have one, is something else. Today, every once in a while, I find myself talking about what's on my mind. But I don't write much any more. I'm lazy. As far as art is concerned, I just prefer good art to bad art—if I can tell the difference."

15

The Marjorie Morningstar of the art world—Helen Frankenthaler—was one of the few women painters of the fifties who did not act as if her gender were a biological mishap. She always seemed to like being a woman, in total contrast to painters such as Joan Mitchell and Grace Hartigan, who seemed affronted and enraged by their femininity. Women artists like these often made a point of sleep-and-tell, when ostensibly their aim was to be buddies at the bar. No crude words ever crossed the lips of Helen Frankenthaler. She was a tall, willowy girl with large, Picassoesque eyes, flawless skin, and a radiant smile. She dressed with taste and elegance, even at her most casual. Clearly a well-brought-up girl, Helen did not mind the image she presented. She was not about to transform herself into an aggressive, with-it artist, but there was nothing namby-pamby in her attitude about her work or in her position among her contemporaries.

Jane and I did not become great friends with Helen Frankenthaler. For one thing, she moved in a different milieu—that of the *Partisan Review* crowd, to which Clement Greenberg belonged. When Helen later married Robert Motherwell she was even more removed from our circle, preferring to lead a somewhat secluded life with Bob, a life noted, incidentally, for its staid formality and elegance. In 1971, much to everyone's surprise, Helen and Bob were divorced.

In the 1960s Helen Frankenthaler emerged as a major artist. Her huge stained abstractions received wide attention and began to be collected by major museums and collectors. She was the first woman artist of the fifties to have a retrospective exhibition at the Jewish Museum, and, in 1969, another full-scale retrospective at the Whitney Museum.

I visited Helen in the Upper East Side house which she then shared with Robert Motherwell. Comfort and charm were the keynotes of the house, with expensive furnishings and an understated taste everywhere in evidence. Helen served a delicious lunch, and talked about the past.

"I was born in New York, went to school in New York, then left New York to go to Bennington. I graduated in 1949 and returned to New York. In 1950, I shared an apartment with the actress Gaby Rodgers.

"At that time I already had a studio—a cold-water flat— on East Twenty-first Street, which I originally rented with a Bennington classmate, Sonya Rudikoff. Later, in 1951, I sublet David Hare's studio at 79 East Tenth Street. Then, in the fall of 1952, I rented another studio near the Chelsea Hotel, which I shared with the painter Friedl Dzubas. When I first got out of college, I was painting what I call a sort of American cubism. At Bennington, my teacher was Paul Feeley, and his own painting at the time was very much like Max Weber's.

"Actually, it had been a magic and productive moment at Bennington. In terms of style, when I left, I was doing somewhat Picassoid full-face-and-profile-all-at-once pictures—and doing them well. But it was still student work. Then, I started my master's at Columbia University. Perhaps one reason for this was that I wasn't able to say, 'I'm leaving home and I'm going to paint.' So, I went to Columbia and studied with, among others, Meyer Schapiro. Finally, I got tired of school. I already had my B.A. and I just wanted to paint. And, I wanted to feel New York, even though I was a New Yorker. I hadn't known the city as a young adult, or as a member of the avant-garde, or as somebody hooking in with young comrades.

"I met Clement Greenberg in the spring of 1950. Later that year he introduced me to Grace Hartigan, Harry Jackson, Larry Rivers, Bob Goodnough, Al Leslie. Al and Grace were living together then, and were making money as nude models posing at the Art Students League. I remember how poor they were; they went through a period of eating Wheatena three times a day. And I remember Larry, also poor, playing in a jazz band to help support himself.

"In the fall of 1950, I met John Myers. Clem and I were having dinner at the San Remo, and John came over and told Clem that he was going to open a gallery on Fifty-third Street, off Third Avenue. He told him his opening shows were going to be woven laces and fluorescent paintings. Clem told John that he ought to make it a serious new gallery, that there were several young painters around that were talented and worth showing. At the time, you see, there weren't any 'in-between' galleries. I mean, there was Curt Valentin or Pierre Matisse on the one hand, and then there was Sam Kootz, Sidney Janis, Betty Parsons. But nothing in between. So Clem gave John Myers the names of Larry, Grace, and several of the others I mentioned; Clem and I agreed that I should not be included at that moment because I hadn't been painting out of college long enough.

"That summer, 1950, Clem went to Black Mountain College to teach, and I went to Provincetown. I studied with my friend Hans Hofmann for three weeks, and then went to visit Gaby Rodgers, who was in a play at the Abington Playhouse in Virginia, which was near Black Mountain, where I briefly visited Clem.

"The fall of 1950 was an important time in my development. It was a moment in my life when I was learning about pictures, looking at everything I could see (often with Clem), going to all the shows, visiting studios, meeting artists, dealers. I would either see or talk to or think about Pollock, De Kooning, Hofmann, Charlie Egan, Elaine de Kooning, David Smith. There was the environment of the Cedar Bar, the Friday night artists' meetings at the Club. I was close to Al Leslie and Grace Hartigan.

"One winter evening in December 1950, John Myers, on his own, came to my studio and, after looking at pictures, offered me a show. I had done a lot of painting that fall and early winter. It was a transitional period from my pictures within the analytic cubist tradition into something much more open and experimental (but not yet the breakthrough I had in the fall of 1952 when I painted *Mountains and Sea*). I was twenty-one, and I was someone who had looked very hard at Gorky, De Kooning, and Pollock.

"The first show I was in at Tibor de Nagy was a group show, early 1951. I still have the announcement . . . a small card. Those days were fruitful and we were all living in the young, lively, active nucleus of an 'art family.' I think the luckiest thing at that moment for me was to be in my early twenties with a group that I could really talk with and argue pictures about. It was an exchange one couldn't delay *then;* something one could do without, later on. In other words, I might now see the same people, but the content and the needs of our lives are different.

"It was a relatively trusting and beautiful period, compared to what now often seems like a rat race. I think it was partly because there were so few galleries and few artists within the circle that one took seriously. Comparatively, there seemed to be little that was motivated, threatening, or contaminating—so few decisions of the ugly kind we are often forced to make today. In retrospect, it seemed far more trusting, pleasurable, and very productive. Everybody worked. There was judgment, but not so much the judgment that goes with power or with moralizing. It didn't have to do with self-righteousness.

"Steeped in this milieu, I was still very much my own girl. For example, in the summer of 1953, I went to Spain by myself. Along with being very eager to look at and talk about pictures, and experiencing the New York scene, I also had a great desire to see the world and travel and move about. Because I had some family income, I had the opportunity of independence. I went to Spain and then, the following summer, Clem and I went back to Spain together, and also made a very detailed trip of the Italian

hill towns, then to Rome and London.

"In New York, during the Cedar Bar days, Frank O'Hara, Jimmy Schuyler, John Ashbery, Kenneth Koch were, for some, the painters' poets for whom there was mutual enchantment and collaboration. But I was not really part of that intense group, because I chose a separate life. I was also inclined toward another side of the art world—doing something totally different, like going, often with Clem, to the Frick, or to the Isabella Gardner Museum in Boston, or the National Gallery, in Washington, or the Prado. And apart from the intensity of the art milieu, the work, and the people, I knew the literary world, as well.

"Later, I got to know Frank O'Hara, but I wasn't really in the line of his life. There was distance and mutual respect. It was a very straight friendship, and over the years we would have his famous luncheons of sympathy, soul-baring, or talk about Lana Turner. Still, there was a lot in Frank with which I didn't sympathize, and I like to think he knew it. One of his assets and treasures was how sentimental and romantic he was, but these were qualities that often got in the way of his eye. That's an area I get very brutal about. Sometimes your best friends don't paint the best pictures.

"I saw a lot of John Myers. John was really the father-hen of the group. He looked out for some of his painters, giving a mutual life and core. It worked, and we were all independent together. But John, along with his enthusiasm, was very possessive. I left the gallery in the fall of 1958, the year I married Robert Motherwell.

"I think, when one is first married, one wants a certain privacy. You have a new role, a new commitment. At twenty-nine and married, I was different, and available in different ways than I had been at twenty-two and single and on Tenth Street.

"My work was never directly influenced by the Tibor de Nagy group. For example, I was never involved in the return to subject matter. I loved the impressionists, but I loved them where they belonged—in the nineteenth century. After looking at and learning from and experimenting with pictures—with history

as well as contemporary surroundings—I would reach a saturation point, and then I would take off on my own. I was a loner.

"Looking back, the next period was another rapport, and that was with Morris Louis and Kenneth Noland. We had different intimacies and exchanges from the Tibor entourage. Esthetically, there were profound dimensions.

"In the fifties, I had a handful of people I respected, who had real eyes and hearts, and who were important to me in different ways. Clem was one. Friedl Dzubas was another. Also, Noland, Louis, David Smith. That's all you really need if you're not involved in a market or a social life or a certain kind of entree into certain kinds of worlds. Then, that's very satisfying.

"When I married Bob Motherwell, I had had shows in New York and in Europe—since 1951. I was still a young painter, but, relatively speaking, I was not an unknown painter. I had my style, wrist, or signature. Bob certainly had his, and I admired it. I had seen his shows at Kootz. He wasn't in New York very much, and I actually never really saw him until the later fifties. We were in comparable situations in many areas of background and outlook, and in that he was the 'youngster' of the first generation of New York School painters, and I was the youngster of the second generation.

"I am a painter. I am a woman. I enjoy both. For me, being a 'lady' painter was never an issue. I mean, gender doesn't contribute to the value of a work any more than any other adjective you can put before the word 'painter'—whether it be race, religion, economy, or culture. I don't resent being a female painter. I don't exploit it. I paint."

We were all astonished when Helen Frankenthaler married Robert Motherwell, since we had been convinced that she and Clem would ultimately marry. Bob Motherwell was not around very much in the fifties. We knew he had a wife and children and lived a life removed from the milieu of other artists. The few times we saw him were at gallery or museum openings. We had, of course, known his work. His famous Spanish *Elegies* impressed

us tremendously because they were abstractions of monumental and tragic import. There was a great deal of poetry in his work, a poignant quality that modified his brash and forceful imagery. Motherwell was also known for his extraordinary collages, small masterpieces of taste and delicacy. They were lyrical as well as economical, for Bob always managed to say a great deal with very little.

One of the few artists of the fifties with a full-fledged university background, Bob was known as an intellectual. He was well traveled, well read, and a writer of intelligence and perception. His background in the humanities, in philosophy, and his talent for research produced several important books, one of which, *The Dada Painters and Poets*, published in the early fifties, is still the standard book on the movement. A soft-spoken man, with a somewhat retiring disposition, Bob was never a part of the scene, although, in the late forties, William Baziotes, David Hare, Barnett Newman, Mark Rothko, and he organized an art school, Subjects of the Artist, which flourished for one year. Here the New York avant-garde would meet and hear discussions and lectures by their fellow artists.

When Bob and Helen were married we saw them less and less. They created a private world apart from the art scene, while still working and exhibiting in their respective galleries. Motherwell's paintings have undergone considerable change, and his latest work, shown at the Marlborough Gallery in New York, has become simplified in its abstract vocabulary; it contains a kind of window motif in which three or four lines, forming a square in the center of the canvases, establish various levels of poetic space. His color tends to be uniform and concentrated, flowing onto the canvas surface with great subtlety and understatement.

During the forties, Robert Motherwell formed a close friendship with the late sculptor David Smith, a burly, rough-hewn, highly sensitive man whose zest for life—and for work—seemed unquenchable. Already an original voice in American sculpture during the forties, he emerged as a major force in the fifties, producing monumental works of terse and unpredictable

form, brilliantly challenging laws of space and balance in abstract sculptures that were infused with an overriding power, and charged with a classic and majestic energy.

Motherwell movingly recalled his friendship with David Smith.

"I enjoyed David's companionship more completely than any artist I have ever known; he was as a member of the family, with his own key to the house I have lived in on East Ninety-fourth Street for more than eighteen years (since the birth of my first daughter). I can still hear the key in the lock of the front door turn without warning, and his cheerful deep voice booming through the house with greetings, and under his arms wine, cognac, French cheeses, and once (memorably) a side of young bear that he had shot on his farm at Bolton Landing, Lake George. If it was late, he could be drunk, always cheerfully and perhaps abashedly—he was profoundly sensual, mad about very young women, but with a stern Midwestern puritan guilt (about working, too). Helen Frankenthaler and he and I would all embrace, and in the mornings she would have a beautiful breakfast on a hot tray and a flower for when he awoke, and he would be moved with tenderness after the roughness of his bachelor's life in the mountains upstate. He was the only man I was willing to start drinking with at a late breakfast, because it was joy, not despair.

"I have had many close friends among New York artists over the years, but David Smith's openness—he was never on guard, except that he would not say anything against a fellow artist, because by having that life commitment, he was beyond reproach —only David's openness was matched to my own instincts. Moreover, he loved Helen, who had been one of his first patrons when, a very young woman, she was going around with Clement Greenberg, and who never wavered in her belief in David, nor her open admiration for him ('open' is a very important word to me). With him alone among my close circle of colleagues would I talk about certain male things—Mercedes-Benz (to which he converted me), shotguns, the wonders of Dunhill's tobacco shop, where the best dark bread and sweet butter was (Locke-Ober's in

Boston), baroque music, Scotch tweeds, the pleasures and mysteries of Europe, the Plaza over the Chelsea Hotel (I converted him), the reminiscences of a Western American youth between two world wars, in short, his whole 'Ernest Hemingway' side, so to speak, that was so adumbrated in New York City, and which, whether a fantasy or not, was a safety valve for both of us. Quite independently, we had come to roughly the same conclusions about aesthetic sources of our inspiration which, in ABC terms, might be put as any art before the fourth century B.C, cubism-*cum*-surrealism, James Joyce, Stravinsky, Picasso, the strength and sensuousness of materials themselves, and a certain 'primitive' directness. There were of course minor blind spots on both sides: he liked to go to the Five Spot to hear Charlie Mingus or whoever might be there, while I've never been attracted to popular music, no matter how great; or once, when Helen and I spent a sleepless night at Bolton Landing, her anger at discovering our mattress was not on bed springs, but on boards. (When we visited him the weekend before his last weekend, he asked Helen what make of bed to get for us; and then ten days later he was dead. Ken Noland called us to come to the hospital at Albany, and we drove north at ninety-five miles an hour through the night to get there, but Tony Caro came out with his kind face and said David had died from head injuries a few minutes before. For some months afterward, when I would occasionally come home with two items from a shopping tour—say, sea salt from England for boiled beef—I realized how deep my habit was to get one for him too. As always had he.)

"David had many deep friendships, and I would guess with each that magic gift of making you feel you alone were the one. He'd been extremely handsome when young, and in his prime with his bearhugs and warm smile had the charisma of Clark Gable, or what a wonderful animal a man is, and how even more wonderful as a man.

"On the occasion of his bringing the great hunk of bear meat, ghastly red (as much from the paprika marinade, I later realized, as from blood), it was the afternoon of a dinner party we were

giving, and he would not have it that we did not serve the bear after the smoked Scotch salmon. Helen left us at the kitchen table (with a bottle of cognac before us) for a mysterious errand, and he and I ransacked a shelf of cookbooks for a recipe for bear. There was none, so we adapted one for roast venison, with salt, fresh pepper, bay leaf, burgundy, meat glaze, and at the end, ruby port and a tablespoon of red currant jelly for the sauce. (It was superb.) There were perhaps twelve of us at the table, high on Scotch and wine and animated conversation, and Helen brought in the bear on a large platter after clearing the first course, and sat down in the middle of an absorbing story by someone. Suddenly she said, 'David, look at me!' and he burst into raucous laughter as we looked at her in an apron on a bear-suit costume that she had rented at a theatrical supply house that afternoon and, as the little bear of the three bears, began to eat roast bear, like a cannibal, but a most ladylike one. . . .

"I first met David in 1950. Marion Willard, his dealer, had sounded me out as to whether I would write a preface for his forthcoming show, to which I agreed, and it was arranged that he and I, who had never met, though I had admired his work for at least ten years before, after seeing an abstract steel *Head* of his in an outdoor show in Greenwich Village (he loved it that I remembered that head so well), would meet in a bar in Times Square around noon. After we met he said, 'I'm drinking Irish whisky with Guinness stout as a chaser.' 'Fine,' I said (after all, I am a Celt), and we proceeded to try to drink each other under the table. By midnight we had not succeeded, I don't remember where we ate (at Dorothy Dehner's?). I do remember driving my jeep station wagon back through the moonlit night to East Hampton, having a last beer to sustain me at Smithtown (or was it the name?), and wondering, before I fell into bed in a stupor, how I had made it, good a driver as I was in those days. But it was in 1958, when I married Helen Frankenthaler, that we became a trio, a special dimension in all our lives.

"His two daughters were almost the same age as mine, we both delighted in them, adored them in our clumsy way, and when he

had his daughters on leave from their mother, I helped him 'entertain' them. He loved during the summer to bring them down from Bolton Landing to visit us at the seashore in Provincetown, where I've mostly gone for the summers, and my daughters still remember their childish awe at him finding a wet, torn dollar bill in the outgoing tide. He and I both loved a *ménage*, with women, children, and friends and a bountiful table and endless drink, and we could do it unselfconsciously with each other, which is perhaps the deepest relief one peer can give another.

"And we both knew damned well the black abyss in each of us that the sun and the daughters' skin and the bounty and the drink could alleviate but not begin to fill, a certain kind, I suppose, of puritanical bravado, of holding off the demons of guilt and depression that largely destroyed in one way or another the abstract expressionist generation, whose suffering and labor was to make it easier, but not realer, for the next generation. And if they liked it cool, we liked it warm, a warmth that is yet to reappear in the art of the young generations who have, as they should, their own life styles, whether chic or hippie or what. In any case, during the last year before he killed himself in his truck—his beautiful head was crushed against the cargo guardrail when he dove into a ditch, chasing Ken Noland in his English Lotus sports car to an opening at Bennington—David subtly changed, as though, about to be sixty, the old bravado was no longer self-sustaining. That optimism that we had shared through everything fluctuated ever so slightly, he made a will for the first time (naming me, without my knowing it, as one of his three trustees and executors, doubtless because of his daughters, his sole heirs); sometimes when very drunk he would begin to talk with a touch of paranoia about other artists or his domestic life, and sometimes despair would darken a moment. Then we would wordlessly pat each other on the shoulder, and have a final drink before bed. Rothko, in the fifties, before he himself began to drink a lot, used to say to me angrily, 'Your solution to everything is another drink.' Now I do not drink at all, they both are violently dead, Helen Frankenthaler and I are splitting, and I have invited David's daughters to

visit with my daughters again this summer (1971) in Province-
town. I have felt deeply for various men during my life—
masculinity is as beautiful in its own way as femininity is in its
—but there will never be another David Smith. I am fortunate
that there was one. What freedom there is in being allowed to be
open in every dimension, to feel complete empathy.

"Earlier I mentioned Charlie Mingus. In the late fifties there
was an enormous party at the house on Ninety-fourth Street
where, at three in the morning, after the rest had gone, a few
were sitting at the kitchen table. Franz Kline was absorbed in
telling a story with that gleam of self-amusement in his smile that
Barnett Newman also had; Mingus's girl, David Smith, and some-
one else perhaps were listening attentively, when Kline half-
turned to Mingus, who was standing between him and the bar,
and said, 'Another bourbon, please.' My heart froze, during the
silence (we had had a black bartender who had departed the hour
before) as I watched Mingus's face changing, and then at last he
said softly, ironically to Kline, 'How would you like it?'
"I saw that Kline then realized what had happened but could
think of nothing but to bluff it out with 'With water, please,'
and Mingus poured Kline's drink while Kline carried on his story
(which none of us heard). The world does change. I do not think
that in similar circumstances in 1971 the incident would have oc-
curred. There has been too great a shift in consciousness, that be-
gins to make the fifties no more vivid in my memory than the
forties or thirties or twenties—indeed, to me, who was born in
1915, the least interesting of those four decades; nothing in it
means as much to me as my discovery of modernism in the 1920s,
the great Depression and Spanish Civil War of the thirties, the
Second World War and the European exiles in New York City
and the beginnings of abstract expressionism in the forties, no, not
the slow conversion during the fifties of our private art world
into *le monde*. The seventies may become the most fascinating of
all.
"I find myself nowadays more often with youngsters just com-

ing of age than I do with persons my own age: by virtue of their youth they have no vested interests and I like their ground rules: never strike a false note, and do your own thing. Their whole generation is undertaking what once only the creative managed, to find one's identity from within. After nearly fifteen years' lapse, I am going back to teaching, in order to keep learning, and perhaps to keep at bay that death instinct that ultimately overcomes us all. Whatever my motives, the young are wondrously tolerant of me and my thing, and I do whatever is in my power to help them realize theirs, whatever it may be. I am no more or less afraid than they are, for the stake is the same for all, regardless of our various ages and circumstances, not to feel dead, let alone actually to die. I predict the deepest revolution in history that is not dominantly economic in motive, for there is one still deeper concern than the economic one, the sense of love and death. Or perhaps more accurately, our society is the first in which millions of the young are enabled to contemplate philosophically such things, and in fact must.

"An artist's mind is finally, as we hoped, basically (and not decoratively) relevant to all, whether they see it or not, for it is only a medium as subtle and exact in feeling as art that can express the felt truth, which after all, is one's identity of being. There never was a generation so filled with sound and visual images as the present one of the 1970s, and they may recover an awareness that primitive man must have had as he hunted, and like him, find words and a sense of history less essential. Certainly the wheel is taking a far greater turn than in the 1950s, wherever it is going. Or so it seems to me."

16

In the mid-fifties we met Marisol, an exotic creature whose salient quality was uncommunicativeness. Her replies to questions, in a low-pitched breathy voice, were usually a short "Yes," "No," "I don't know." It was some time before we realized she was an extraordinarily gifted sculptor whose early diminutive family groups contained a primitive strength that would find full expression in her life-size figures carved out of wood. Fortunately Marisol was extremely beautiful, and at the time it seemed enough merely to look at her and imagine that she was full of mystery and fascination. In point of fact the young Marisol we knew was a sphinx without a riddle—a girl so shy and unsure of herself that conversation was out of the question. In the early days Marisol was seen in the company of several artists, all of whom were initially intrigued by her, but who ultimately gave up on her out of either boredom, anger, or pure disenchantment.

Her full name is Marisol Escobar. She was born in Paris of Venezuelan parents. Because she spoke so little, we assumed she had difficulty with the English language. Later we learned that she had attended high school in New York City and could speak English fluently. We also learned that she had an income which enabled her to travel whenever the mood struck her. She appeared and disappeared with regularity, and one never knew where she had been or why she was back. Clearly, Marisol did not belong to any particular group or faction. Soon enough,

however, it became evident that she was a compulsively hard worker, dedicated to her own particular sculptural vision—a vision that had no truck with any of the going styles of the fifties. Marisol's self-involvement was so strong that she eventually brought forth strange effigies in her own image.

She would make plaster castings of her own face, her hands, feet, and even breasts and buttocks. Her loneliness, solitude, and apparent lack of friends were undoubtedly the cause of this obsessive narcissism, but the creative results were as haunting as they were technically refined. Later, she incorporated drawing into her sculpture, making superb pencil drawings of her own face upon the wood itself. This strange, innovative adjunct to her work developed even further as she added color as well as found objects (barrels, sunglasses, or Coca-Cola bottles) to the finished products. Her work is hard to define, being a mixture of the primitive, the surreal, the figurative, and the Pop. In the late fifties and early sixties, Marisol began to have exhibitions—her first at the Leo Castelli Gallery, then at the Stable Gallery, and, finally, at the Sidney Janis Gallery. Her work took on an ever-widening scope. She produced numerous figure groups that stood magically transfixed in the gallery space, shedding an aura that was both threatening and mystifying. There was also an overriding humor in her strange pieces. Marisol had the wit and the awkward logic of a true primitive.

Everybody assumes that Marisol is a retiring girl, but when we first met her, her long silences were interrupted by some pretty wild carryings on. For some reason she was drawn to men with a violent streak. She and the painter John Grillo would often explode into real brawls, usually in front of a large captive audience. Her involvement with the painter Mike Goldberg took similar turns.

One night, the young painter John Button threw a party to which Jane and I were invited. It was a merry evening until Marisol and Mike Goldberg made their appearance. Button, a gifted figurative painter, and an endearing and witty member of our crowd, recalled the mad events of that evening.

"Marisol was running around with Mike Goldberg at the time, and they arrived together. Well, as it happened, all the painters and sculptors there were very teddy-bearish, and they were being particularly teddy-bearish with all their homosexual friends—everyone kissed everyone—and towards the end of the party John Ashbery got up and turned to Mike and said, 'Goodnight, Mike,' and they kissed on the mouth. It was all a matter of course in those days, and really didn't mean anything. Marisol, seeing this, blew a fuse, and she picked up a very large earthenware pitcher—a French pitcher that I had—and threw it across the room at John Ashbery, and John got furious and picked up a chair and threw it back at her. Both of them missed, thank God. The pitcher did not hit John Ashbery, it crashed into the wall. And when John threw the chair, he was rather clumsy, and it hit the table on which all the glasses and the liquor were. Everything broke and came crashing on the floor.

"Mike Goldberg got furious at Marisol, and he grabbed her and took her outside, and practically threw her down a flight of stairs, but she was very limber, and came crawling right back up the stairs, burst in the door, and with one extended hand, ripped Frank O'Hara's shirt right off him—in one blow, like a cat. Mike finally subdued her and saw her out the door again. Marisol has changed a great deal since that time. I mean, she used to be very wild and quite loud."

On another occasion, Larry Rivers took Marisol to a Christmas Eve party at the home of Dr. and Mrs. Arnold Cooper in Connecticut. At this gathering was an inebriated relative of the Coopers who took an instant shine to the ravishing Marisol. In his enthusiasm, he began removing presents underneath the family Christmas tree, handing them to her. She accepted each one of them, clutching them all to her breast. When the hosts noted the gifts being casually handed away, they rushed up to Marisol, apologetically saying that these were presents for the children and other family, and pointed out the fact that the overgenerous relative had clearly had a few too many.

Marisol refused to relinquish the gifts; instead she turned on

her heel, walked up to Larry Rivers, and said, "Take me away from these fucking, stingy people. Take me home." Larry drove back to New York with Marisol cuddling the gifts in her lap.

When Marisol was quiet, she could sit in a chair for hours without moving a muscle. One summer in Water Mill, Long Island, the duo pianists Arthur Gold and Robert Fizdale were giving an outdoor lunch. Nell Blaine, Jane Freilicher, her husband, Joe Hazan, Jane and I, and one or two other people were sitting around the picnic table having one of Gold and Fizdale's sumptuous meals.

Marisol was listening to the lively conversation around the table. Silent as a statue, she sat totally still for at least two hours. At one point I turned toward her and noticed, to my astonishment, that a spider had spun a complete web, filling in the triangle formed by her bare upper arm, her torso, and her armpit. When I pointed this out to her—and to the rest of the company—Marisol calmly glanced at the spider and its work, saying, "The same thing happened to me once in Venezuela. It's nothing new to me. I'm used to it."

I have always liked Marisol, and I think she has always liked me. I recall her telling me at several parties that she felt safe when I was in the room. It was a lovely thing to hear. One sad thing about her was that, given her remarkable looks and her extraordinary talent, Marisol seems never to have found a man who could sustain a long relationship with her. Her relationship with Bill de Kooning ended after a very brief period. As her fame grew, Marisol became more and more withdrawn. We learned, at one point, that she was visiting a psychoanalyst, but he did not seem to improve her love life or her social responsiveness. Of late, she has been traveling, and in June of 1969, after she returned from a prolonged trip to Hawaii, we talked.

"In 1950 I was living in Los Angeles. Before that I was in Paris. In Paris I went to the Ecole des Beaux Arts. I was nineteen. I studied painting. My work followed the impressionists. I did a lot of drawings. I was born in Paris. It's complicated to remember everything because my family kept going back and forth between

Europe, Venezuela, and the United States. We traveled not because of business, but out of boredom.

"I also studied art in Los Angeles. I studied with Rico LeBrun. Then somebody told me that I ought to come to New York and study with that Japanese teacher, Kuniyoshi, who was teaching at the Art Students League. I was at the League for two years, and I was painting just like Kuniyoshi. I remember that Kuniyoshi was never very interested in me or in what I was doing. I didn't make any friends and, after a while, I decided to leave. I went to Woodstock one summer and there I met Howie Kanovitz. He told me there was a terrific teacher in Provincetown— Hans Hofmann—so I went and studied with him and also studied with him at his school in New York. I thought he was very inspiring, but I never understood what he was talking about. I just *felt* everything. I also realized that his school was very alive. At the Art Students League there was a decadent feeling, and in Paris also—a sad atmosphere, as if you were living in the twenties. I tried to do what Hofmann was doing—the kind of painting he was doing. But since I didn't understand him, I couldn't do it very well. One time he would have a model in the same pose, and we would try to do it either abstractly or figuratively. I tried to do it both ways. Then Hofmann would come over and correct my work and make new ones himself. I saved some of them, but I've lost them since. There were nice people in the Hofmann class. I especially liked Jan Muller and Allan Kaprow. Kaprow's work was very weak, but he developed afterwards.

"In those days I was always smoking marijuana. I used to go to the class high. Maybe that's why I didn't understand anything. Also in those years I met Herman Cherry, who was a painter, and Cherry introduced me to John Grillo. John Grillo used to take me to the Cedar Bar and that's how I met all those people. I also went to the Club with Grillo. I couldn't understand anything they said at the Club. I didn't get their language—their art language. But I liked the way Franz Kline used to speak— very abstract and very romantic. It took me a while to under-

stand that they were mostly talking about things that related to their lives. At about that time, I made those little sculptures of family groups. I bought some clay and I started doing them. In New York, they were just discovering pre-Columbian art, and I became very enthusiastic about it. It looked so fresh. So I tried to copy that sort of thing.

"Actually, all those years I was going to school, I didn't have a definite idea of what I wanted to do. I knew I never wanted to get married. Also, I had the curse of not being able to communicate verbally with people. I suppose people always expected more than I could give. I stopped trying to understand. The point is, I don't get involved. But, I did get involved with a painter called Angelo Ippolito. He had just come back from Europe. Grillo was jealous of him. I didn't really like Grillo. The reason I went with him was that I was so shy I couldn't get anybody else. Then I met Ippolito. I went with him for a year, but in those days it seemed longer. The person who was really a good friend of mine was Friedl Dzubas. With him I really communicated very well. Maybe because he was European. He was very kind and very warm. But I didn't have an affair with him. I was so friendly with him that I couldn't go to bed with him. It's probably neurotic. Anyway, we were like brother and sister.

"When I began showing my little boxes with people, and when everybody began liking them, I suddenly became very paranoid. I had terrible fears and anxieties. I could hardly go down the street, I was so scared. Years before that I had gone to a psychoanalyst. Friedl Dzubas sent me to one. I always thought there was nothing wrong with me, but Friedl used to tell me that I was crazy and he made me go to one. So I went, and this man made me even crazier than I was. I never had the kind of fears that I got after my first shows. The analyst was a Greek. A young Greek. He's the one who really screwed me up, because he was talking about your insides and how your heart beats, and how you breathe—so then I started feeling that I wasn't breathing. I became conscious about breathing and I had a horrible time and I

would feel faint. Later on Bill de Kooning went to this Greek. A lot of artists went to him.

"My first show was with Leo Castelli. Castelli came over to see what I was doing one day, and he said he liked it and wanted to give me a show. That's when he first opened his gallery. I had two styles by then. I had those boxes full of little figures and then I had those wood carvings with color. I also had self-portraits with plaster faces. When I had that show I found out what I wanted to do. I developed from there. After the Castelli show I went back to Europe. I didn't do much of anything for a year and a half. When I returned to New York I realized Castelli wasn't very interested in me any more. So, I had a show at the Great Jones Gallery. The woman who ran the Stable Gallery came to see it—Eleanor Ward—and she offered to give me future shows. She was very enthusiastic. I had several shows at the Stable Gallery and they were very successful, and Eleanor was very enthusiastic. But she was kind of sneaky. Somehow I didn't trust her. But in a way, Eleanor Ward was very good to the artists because she really believed in them. She was the only person I could talk with, in the years I showed with her. She could make me feel good when I felt nobody liked me.

"I never really fit in. People always thought I was odd. So Eleanor Ward was very nice to me, but then I left her. Sidney Janis became very interested in me. He was very insistent that I join his gallery. I couldn't make up my mind for about a year, and then I started asking people about Sidney Janis. Finally, I agreed to show there, because they make a very nice catalogue and they are very organized. Actually, it's not a very inspiring gallery. But, I don't know, I like Sidney. He is like a father. And if you have any needs in relation to material things, he is very generous. He gives me an allowance so that I can live better (my own allowance isn't very big). I now have a really very good studio which I never had before.

"One time when I went to Europe, I met Bill de Kooning, who was there with Ruth Kligman. Before that I had had a little affair

with him, but it didn't really amount to much. It must have lasted three months. I hero-worshiped him. He's so interesting. At the time, he had about three women, and I was very disappointed. So I just dropped the whole thing. He was very gentle, very nice. We used to go out and get drunk all the time. That's what we did in Italy, too—Bill, Ruth, and I. We were there for six months, and I think we were all alcoholics—drinking all day and all night and making scenes. All the Italians were very shocked. I liked Ruth a lot. She was a very good friend, and she believed in me. At first I thought she was taking advantage of the artists. But then, I immediately became very friendly with her. She's very interesting, lively, amusing, and good-natured.

"Anyway, when we came back from Europe, Bill called somebody at the Museum of Modern Art and said I was a very good artist. He told them to come down to my studio. That was very unusual. He wasn't like some of the other artists I met who didn't like women to do things. Bill was very encouraging.

"I am happiest when I am working. It's the easiest thing for me. I get so involved, and I don't feel lonely. There is a lot of physical work involved, and I really get completely lost. I become a complete part of those things I sculpt. When I first sculpted those big figures, I would look at them and they would scare me. Late at night they looked as if they were alive. But I am happy doing my work.

"I am very unhappy about my love life. It gets worse all the time. Some men have told me that they would like to have somebody who thinks about them all the time. But I am independent. I can't do that. On the other hand, I don't understand why men don't want to stay with me. If I were a man and met a girl who was just like me, I would fall in love with her right away. I am really not a demanding person, and I don't like creating problems.

"People always say I am so quiet, but I used to be very violent when I was younger. I remember when I was going around with Mike Goldberg. I used to be very violent. It was probably like that because he wasn't very nice. I wish I could be like that

again. It was so open and I wasn't so afraid. Now I put all my fury in my work. That's the way I get rid of it. I work with very lethal tools, like hatchets and knives.

"I used to drink an awful lot. I think it was the influence of Bill de Kooning. I remember going to a party one time and seeing Jackson Pollock. He was terribly drunk. Suddenly, he put his face through a window. He had about one hundred little scars on his face, bleeding—like little spots—it looked like his painting. Then he grabbed me and tried to kiss me. I was scared to death.

"But the fifties were drugs for me, not drink. I didn't begin drinking until later. I smoked marijuana before I met all those people. I was high for about four years. I used to know a group in the Village who used to turn on with drugs. That was a very friendly time for me. We sort of lived together. Property wasn't so important. It wasn't important to own your own bed or your own spoon. It was a group like they have today. They would go anywhere and sleep anywhere. But I don't do any of that any more. I have begun to be very interested in travel. I'm going to go around the world. I have just been to Hawaii and so many wonderful things happened to me there—so many adventures. I want more of that.

"I am thinking that perhaps I *should* get married. But I can't find anybody. I've also been thinking seriously about having a child, and not getting married. On the other hand, I'm so afraid of being tied down."

17

When I lived in Iowa City as a university student, I used to enjoy leafing through *Vogue* and *Harper's Bazaar*. That was my fantasy life, an antidote to the dreariness of being too young, of not knowing what or who I was going to be. But I also read all the art magazines I could lay my hands on. Around 1948, when I was in the throes of getting my master's degree, I would devour *Art News*. It was the one magazine that put me in touch with New York and the living artists of the period, my first introduction to people like Willem de Kooning, Franz Kline, Jackson Pollock, and all the rest. It was also the first time I had read contemporary art criticism, which put me off, mainly because it was either too analytical or too poetic. But around that time, I came upon the name Elaine de Kooning, whose reviews appeared in *Art News*. I didn't know then that she had just begun to write and that her writings on artists like Hans Hofmann, Edwin Dickinson, Josef Albers, Arshile Gorky, Franz Kline, and David Smith were the first articles to be written about them. Although they were all well known within the art community, they had had until then been largely ignored by museum directors, collectors, and critics.

Elaine de Kooning wrote from the inside in a way that was absolutely clear and lucid. Her style was very personal and I admired it. She would get right to the heart of a painting or a piece of sculpture, describe it, and then say what she thought about it.

There was nothing fancy or frilly about her writing.

When Jane and I landed in New York in 1949, we continued to get *Art News* and Elaine's articles still stood out. The following year, we met Elaine de Kooning at the Cedar Bar. She was sitting there with her husband, Bill, and I went right over to their booth to tell her how much I liked her writing. She seemed pleased and then introduced us to Bill. The thing you noticed about Elaine was her tremendous vitality and wonderful wit. Coming from an Irish background, she had a fast and funny comeback with just enough edge to it to put you on the alert. You knew she was a person of substance, but you also knew that she wasn't pretentious and didn't take herself all that seriously. The point is, she made you feel comfortable.

It was only after we arrived in New York that we realized Elaine de Kooning was also a serious painter. We saw her work in 1953 when she had her first one-man show at the Stable Gallery. There were large canvases of basketball and baseball players, but mainly she concentrated on the portrait. These were not, of course, photographic portraits, but were infused with abstract expressionist elements. Elaine was a very good painter, deeply concerned with bringing out the essence of her subjects. Nervous brushstrokes combined to form figures and faces charged with emotional inferences which could be read on several levels.

She was quite attractive, with curly red hair, deep brown eyes, a beautifully proportioned face, and a fine figure. She was verbal, entertaining, witty, and extremely intelligent. Jane and I liked her immediately and, while we did not form an intimate friendship we saw her on and off throughout the fifties and see her still. When Jane began to have shows in New York, Elaine came to them and was highly articulate in her praise. She once bought a small landscape of Jane's that she admired, explaining that she had just sold a painting herself and that every time she sold one, she liked to buy one—her idea of the artist's "tithe."

Being married to Bill de Kooning must have posed problems for this interesting painter, but Elaine was never one to be thrown off course. She is not one of those submissive types.

Elaine is a fighter and she has always known how to fend for herself and others. Although she was a good deal younger than the famous painters of the fifties, she was their equal insofar as struggles, setbacks, and achievements were concerned. She was accepted by them not only because she became a spokesman for the movement, but because she was a terrific companion. Elaine could drink with the best of them, and she could hold forth with greater verbal virtuosity than many of that crowd. Elaine loved art, but she seemed to love people even more.

But even Elaine, with her fighter's spirit, was unable to go against fate. Around 1956, she and Bill de Kooning split up. It almost seems that the Cedar Bar was the culprit. On many nights when the place was jumping, the crowd at the bar would invariably include a set of twins. Two rather attractive girls would be sitting there, surrounded by artists, having their drinks, and slowly becoming part of the scene. They were startling to see, in the way identical twins always are, and there was an added strangeness to them in that they seemed to have appeared out of nowhere, and had no real connection with the art world. As the months went by, we noted how one girl would be sitting in a group with Franz Kline, while the other would be in a booth with Bill de Kooning. Suddenly, Elaine didn't come to the Cedar any more.

Desperation may have caused Elaine to drink more heavily than usual, but she would invariably pull herself together and continue to paint, write, lecture, and hold down teaching jobs. The fifties' saga of alcoholism among artists did not drown Elaine de Kooning, and when she came to our house in 1969, she was her old charming and witty self. She told us that she was commuting every week to Pittsburgh, where she had been appointed Mellon Professor at Carnegie Tech, and was painting crucifixions. She had some interesting comments to make about her life with Bill de Kooning and about the scene.

"I decided to get married to Bill from the moment I first met him. We took a shine to each other immediately. It actually took a couple of years before we did marry, but we really knew we al-

ways would. Anyway, in December 1943—two days and two years after Pearl Harbor—we went to City Hall and got married. I was twenty-three years old. My brother Peter and my father and Bart Vanderschellen, who was a Dutchman who fought in the Spanish Civil War, all came to the wedding—and also Alain, the cartoonist for *The New Yorker*, whose real name is Daniel Brustlein and who is a terrific portrait painter.

"Actually, the wedding was kind of bleak. Afterwards, we went to a bar in the downtown district and we all had a drink. Oh, I guess it wasn't that bleak. It was kind of amusing. But it was not festive. I mean, nobody rolled out the red carpet for us. And then we went back to Bill's studio on Twenty-second Street and we both continued to work. I hate to say this, but Bill whistled while he worked. You know, Mozart and Stravinsky. Bill could whistle these fantastic melodies. But I found it just a little, tiny bit irritating. I like silence when I work. Also, Bill would work at a very slow pace. He'd make a few strokes, then go back and sit down, whereas I continued painting away. Bill said my pace was like Gorky's—hacking away at the canvas. Bill wasn't like that.

"How did we live? The year before we were married I worked at a defense plant. Bill tried at being a commercial artist. He made fashion drawings and he made some paintings from photographs Rudy Burckhardt took of me modeling clothes. I had borrowed dresses from Klein's. The dresses were then returned. Anyway, Bill made paintings from these photographs. Fairfield Porter bought one of them. So that's how we made a living.

"In those early years, Bill kept destroying everything he'd paint. You see, he'd get furious—and he'd be depressed and angry with his work. There were always people around who thought Bill was absolutely fantastic and great. But Bill used to be extremely irritated at certain of these admirers—especially when they came around to his studio and watched him paint. I'd never encourage him about his paintings. I just thought he was great, which he knew. Also, I didn't feel at all competitive. I was painting what I was painting—and he did the same. It was defi-

nitely the relation of a student to a master.

"In the summer of 1948 Bill was invited to teach at Black Mountain College. Buckminster Fuller was there and so was John Cage, Merce Cunningham, Rudy Burckhardt, and others. I went along for the ride. It was Bill's first teaching experience. He didn't like it too much. For one thing, he only got two hundred bucks. But that was the year Bucky Fuller was to put up one of his first geodesic domes. He asked for some money to do it, but they only gave him half of what he asked. Anyway, the whole place came out to watch him put up his dome. They stood around and laughed—the Bauhaus types and the laymen. It was like Fulton when he first tried out his steamboat. I just knew that Bucky was right and they were all wrong.

"When Bill and I got back from Black Mountain College in the summer of 1948, I went up to Provincetown, where Hans Hofmann was teaching. I had once attended a lecture of Hofmann's but he struck me as being very inexplicit and ineloquent. But his students all responded to him. I rented a studio and sat in on some of Hofmann's classes. He had these enormous classes full of old ladies who came from everywhere. But there were also young students—the classes were extremely mixed. Once a week he would have all the canvases of the class put out, and he would attack and criticize them. He would praise all the old ladies and castrate all the young men. He was really like a bull elephant. But it was extremely illuminating, because it wasn't so much what he said about any one painting, but what he said about painting in general. Once, he gave a punch party. All the students thought the punch would be one of those old men's punches—just a lot of fruit juice. So everyone was downing it and in a minute everyone was down, crawling on his hands and knees, because those punches were dynamite. He must have poured in pure alcohol and a few cherries.

"While I was in Provincetown, Bill was in New York. But he came to visit me now and then. When we both returned to New York, we were pitched out of our studio on Twenty-second Street. After Bill had fixed it up and put in tremendous work and

money, we were thrown out. We could have fought it, but we didn't. We decided to get separate studios. I took a cold-water flat to paint in, and Bill took a studio on Fourth Avenue, right across from Grace Church. Neither of the places was ideal. Bill would come to my place—on Carmine Street—to sleep. We held to a kind of schedule. We'd like to get up late in the day, go to our studios, and work until about eleven at night. Then we'd be beat and we'd stroll up to Forty-second Street. We'd walk up and down that street and then go to a movie and come out around three or four in the morning. Then we'd walk back home.

"At that time, both of us were extremely involved with reading detective stories. We would wade through five each a week. Then we'd exchange them. An important person at this point was William Baziotes, who read all the latest detective stories and so we had that in common. We were crazy about detective stories.

"Living with Bill. He had this idea that he had to go out and work at commercial art. And so he'd go off and do some window displays. But every time, he would leave a little plate for me, of sliced apples and sliced cheese and chocolate. Well . . . that was fantastic. I would come into the studio and Bill wouldn't be there and I saw this plate, and I would sit down and eat the sliced apples, the sliced cheese, and the chocolates. It was, you know, very thoughtful.

"Our endless discussions would often turn into arguments. That was my whole background. No statement in my family ever went uncontested. Bill and I argued tremendously about America. I felt this country was cracked. I was eighteen years old and I *knew*. I had been brought up here. Bill felt this country was marvelous. He said, 'This is a terrific country.' He always told a story about stopping off at a train station where they poured coffee without the guy ever lifting his hand. He just poured it, and some of the coffee spilled down. And Bill thought it was grand style to do that. He said in Holland if they poured a hundred cups of coffee, the man pouring the coffee would lift his hand between each cup of coffee, being careful never to waste a

drop. Bill just admired this country.

"The fifties. There was so much self-destruction. I keep thinking of Marilyn Monroe and how she called up her shrink and said, 'I feel very sad.' And her shrink said, 'Take a drive around the block.' I think maybe that was a piece of good advice, except that she was probably lying in bed already and had taken those pills.

"And Frank O'Hara, getting killed on Fire Island, standing next to a beach buggy at three in the morning with thirty people standing around, and a car was coming, with headlights on. Everyone saw it. How can you be hit by a car with headlights which everyone saw?

"I had a spooky experience about Franz Kline's death. I went to a concert at Lucia Dlugoschewsky's. I went there with the sculptor Bob Mallary. Franz Kline, I knew, was in a hospital. I thought, like everyone else, that Franz was made to last forever. Anyway, right in the middle of the concert I turned to Mallary and said, 'Franz just died.' I said I had to get to a phone. The concert, by the way, was in an apartment and it was very crowded, but I got up at intermission and went to a corner drug store, and called the hospital. I said to the person who answered, 'I'm inquiring about Franz Kline.' And the person said, 'Are you a member of the family?' I said, 'I'm a very close friend. I've known Mr. Kline for twenty years, and I'd like to know.' The person then said, 'Mr. Kline expired seven minutes ago.' It was one of those fantastic experiences where it was on the minute. It was the most mysterious thing—and the way they used the word 'expired,' not died, not passed away.

"Franz was kind of devoured, like Marilyn Monroe was. He empathized with her. I remember visiting Franz a couple of times at two in the afternoon, when he was getting out of bed. His breakfast was beer and a Danish pastry. See, Franz didn't have the stamina. Bill has the stamina. Bill will go on a bender, but somewhere along the way, he'll want a steak. He has tremendous Dutch stamina, and it makes a difference.

"I read somewhere that 1948 was the year that heroin hit this

country in quantity and, I suppose, 1950 was the year that booze flooded the New York art scene. In the forties, we all drank coffee endlessly. Cafeterias were the meeting places. You could drop in any time between noon and three in the morning and always find some artists deep in conversation. Parties were rare and when we had them, Cuba libres were the favorite drink. We liked the taste of the Coke, not the rum.

"Of course, for the first half of the decade, the war was uppermost in everyone's consciousness. A good many of the artists were away in the army or else working in defense plants—as I did for a year before Bill and I were married. Bill kept being deferred because he was an alien until finally he was thirty-eight years old which made him 4H—or whatever the term for the age limit was.

"With rationing and food stamps, sugar bowls from the Automat began to appear in artists' studios. Sugar for coffee and tea was a crucial staple—a major source of energy in diets that were skimpy elsewhere. Charlie Egan used to cadge vitamin tablets from a doctor friend to give to artists to be taken with their coffee.

"Most of the artists had prosperous friends who invited us to dinner. Edwin Denby introduced us to the Viennese analyst Dr. Paul Federn and his wife. They were quite taken with us and would invite us to lunch every Tuesday. Our whole week began to center around that one really good meal. Our second helpings, needless to say, were outrageous. For the rest of the week, we would have to choose between the Automat, which had excellent food but small portions, and the cafeterias, which offered glop —but lots of it.

"The countermen in the cafeterias were partial to artists and would heap our plates with double portions. One counterman at the Stewarts' at Twenty-third Street and Seventh Avenue put aside a portion of his salary, which was twenty-two dollars a week, to buy paintings on the installment plan. Unfortunately, he had an unerring eye for the weakest, most derivative work. Bill, who was painting mysterious, glassy-eyed, bald-headed men

when I first met him, had a crew of imitators in the Chelsea district whose work the counterman preferred. When I made some contemptuous remarks about the imitators, Edwin Denby said, 'Don't be an "artist's wife." If you want to help Bill, don't attack other artists. Talk only about the ones you like.' I took Edwin's advice to heart.

"In 1945, I saw a retrospective show of Stuart Davis's paintings at the Museum of Modern Art that fascinated me. It was so clean-cut and without self-doubt. His work had the energy and aggressiveness of billboard art but also a kind of lyrical inevitability that commercial art never achieves. I was interested because his whole approach was so different from Bill's. I began to write about the show to clarify my thoughts and pin them down. I went back and studied the paintings several times and jotted down notes. After a month, I had an article twenty pages long (ten pages typewritten on both sides to save paper) which I showed to Edwin and Bill, who both liked it very much. I was delighted with their response and put the piece away, not feeling the need or inclination to show it to anyone else. When Edwin told Virgil Thomson about the length of the piece, Virgil said, 'I didn't know there was that much to say about Stuart Davis.'

"Some ten years later, *Art News* wanted a piece on Stuart Davis and I pulled it out of my file and was surprised to find I still agreed with it—not really surprised since I had worked on it so hard. I changed it a bit more and handed it in. I got a fan letter from Stuart Davis—the only one he had ever written to a critic, he informed me. He wrote that he kept waiting, as he read the article, for the ax to fall and was astonished to find no ax.

"I remember a crowded opening for Stuart Davis at the Downtown Gallery in 1940 and another, the same year, for Max Schnitzler at the Pinacotheca, but generally openings were rare and gallery attendance was very sparse. When Bill had his first one-man show at Charlie Egan's in 1948, nobody thought of going to the gallery on opening day, not even Bill. Charlie kept the show up long past the usual three weeks, but most of the people who came to see it were artists. Artists, in fact, seemed to be

the built-in audience for modern dancers, poets, and composers in the forties—and even more so in the fifties. Harold Rosenberg put it in a nutshell in 1954 when he surveyed a full house before a Cage-Cunningham concert and said in his booming voice, 'Here it is almost curtain time and the Lassaws aren't here yet.' Everyone doubled up laughing. We all attended every event and everyone in the audience knew everyone else. 'There's a stranger in the third row,' Harold continued. 'Throw him out!'

"Nobody expected to make any money from his work and, mainly, nobody did. Bill and Gorky were known for the prodigiously long periods of time they would spend on one canvas. They were among the very few artists who supported themselves, if minimally, by selling their work. The people who bought paintings then were not really collectors. They were closer to being patrons in that their primary aim was to keep the artist going rather than to acquire a work of art. Sometimes they didn't have very much more money than the artists whose work they supported.

"Since we were all broke and canvas was expensive, a common practice was to pull out previous works and paint out the one you liked the least to make way for a new picture. In 1945, I got my first portrait commission from a dancer, Marie Marchowsky. I was paid in full in advance—fifty dollars—generous for her and a windfall for me. I made numerous drawings; then small oils on sized paper and cardboard (the backs of pads). She liked a small head very much, but I wanted something much more ambitious and I began work on a three-foot by two-foot Masonite panel. I worked on it for a year. Finally, exhausted by the interminable sittings, she begged me for the head she had liked at the beginning and I turned it over to her, as relieved as I was to be freed from the demands of the insatiable Masonite panel. When Herman Rose suggested that he and I paint a portrait of Charlie Egan, I covered the Masonite panel with white and in one evening finished a very good painting of Charlie—I've still got it. I felt the year's work underneath had aided and abetted me. Herman, though, was working on a 'virgin' canvas and at the end of

three hours had painted only one nostril. Charlie was alarmed at the prospect of endless sittings and canceled the whole project on the spot.

"Even artists who could afford canvas were affected by the spirit of frugality and since nobody bought the work anyhow, artists tended to be overly self-critical. Fairfield Porter had painted some beautiful scenes of Second Avenue, full of a kind of Tiepolo light. I particularly liked one and asked to see it again when I visited his studio a few months later. Fairfield told me he hadn't liked it and had painted it away. I was quite indignant. I felt he didn't have a right not to like it—that the painting had a life of its own and I would have been happy to give the painting a home if he didn't want it.

"There was a good deal of this visiting each other's studios and artists were particularly eager to show their work to Bill, whose comments were always fresh, original and, somehow, inspirational. We'd go to artists' homes for dinner (a good many painters then did not have lofts and painted in their apartments) and sit around afterwards for hours, drinking tea and looking at the paintings one at a time. It was a very different experience from that of seeing all the work at once on the walls of a gallery— more intense in a way.

"Most of the artists who had patrons kept them well hidden. Jack Tworkov was a generous exception and introduced us all to a charming, vigorous collector, Alexander Bing (of Bing and Bing real estate). Bing enjoyed the company of artists and would invite groups of us to his vast apartment on Park Avenue for drinks, which he always had served with an opulent layer cake baked especially for the occasion. We loved the idea of Scotch with cake and we'd sit around happily poring over his fabulous collection of art books. Then Bing would take us upstairs to the comparatively small room where he himself painted small impressionistic abstractions of trees. He was prolific and seemed to finish nine paintings a week. They had a compulsive, static quality (he was influenced by Prendergast, whose work he owned) that we found

interesting and we made comments by the hour while Bing beamed.

"When I began writing for *Art News* in 1948, I had to limit myself to two hundred words—the usual maximum for a review. This was a painful discipline in the case of artists I thought were great. Reuben Nakian was having his first one-man show in many years, and I felt it was tremendously important. After spending a day with him at his studio taking copious notes, I chipped away at the piece up until my deadline. I had finished all my other reviews (I always saved the most difficult one for last) and had to hand them in so I went up to the *Art News* office at five one evening, and announced that I had a few m .·or changes to make in the Nakian piece. I sat at a typewriter as the office emptied out until finally I realized I was all alone in the building. When Tom Hess (the editor of *Art News*) came in at nine in the morning just as I was leaving, he said suspiciously, 'You haven't been here all night, have you?' I laughed wanly at this preposterous suggestion and fled without an answer.

"Four dollars was the fee for writing a two-hundred-word review, so writing wasn't paying any more than painting. But in the course of reviewing, I had discovered gallery openings— with free drinks. It began to seem a drink downed was fifty cents saved—a sound economical measure. Then other artists began to discover openings and other artists began to *have* openings and new galleries began to open up—shoestring galleries and co-op galleries—downtown and uptown and the Artists Club was formed and the Cedar Tavern began to be crowded with artists who didn't want to attend the lectures at the Club and were waiting for the parties afterwards. Then the Cedar became a hangout every night of the week—a festive place to go after the day's work, knowing you'd always find some friends. Then artists (Herman Cherry and David Smith) discovered the Five Spot on the Bowery, lured there by the live bands, and the Five Spot became a hangout.

"In the summers, Provincetown and East Hampton became ex-

tensions of the New York art scene. Bill and I were invited by Leo Castelli to spend the summers of 1950–52 with his family in a delightful sprawling house in East Hampton. Bill painted in an enclosed porch and I painted in an exposed porch—which I loved. On rainy days, I'd work in our big bedroom—where I painted a portrait of Leo with the whole household watching.

"Bill was deeply involved in his 'Women' series by then. His 'Women'—since he first began to paint them right after we were married—were becoming more grotesque and ferocious, and I was beginning to get quite indignant at suggestions that they were inspired by me. Hans Namuth, the photographer, was taking photographs of artists that summer and I said, 'Take one of me in front of the painting to demonstrate, once and for all, that it has nothing to do with me.' Hans snapped me standing in front of the painting and I was fascinated to discover that I became part of the painting, as though I were the 'Woman's' daughter and she had her hand, protectively, on my shoulder.

"The scene in East Hampton was, if anything, even more hectic than New York. It seemed, wherever artists converged, liquor flowed. Surrounded by drinks, drinking seemed the natural thing to do, and suddenly there was a booze explosion in the art world. The Club encouraged drinking in a reverse way: after the Friday night panel discussions, a collection would be taken for liquor, which we drank out of paper cups. The artist-bartenders, trying to stretch the liquor, would give skimpy drinks and it became a game to devise ways to get double portions.

"A great deal of the drinking in the fifties was involved with parodying Westerns—'Live fast, die young, and have a good-looking corpse'—and the idea of drinking as prowess. Jackson Pollock particularly enjoyed playing the cowboy role: 'I was born in Cody, Wyoming,' he announced proudly at the beginning of a movie of him at work in his East Hampton studio. Jackson began to make money before anyone else, and he wanted everyone to know it. He once wheeled into the Cedar Tavern, ordered a round of drinks for the artists at the bar, pulled out his wallet, tapped it, and said, 'J. P.—Those are the right initials.'

"Franz Kline was more conscious of the play-acting aspect than Jackson. With his courtly manners and drolly expressive unfinished sentences, Franz expertly invoked English-gentlemen-comedians. One night, he and I were sitting alone at a table at the Cedar when the waiter came over and said, 'Last call for drinks.' 'We'll have sixteen Scotches and soda,' Franz said grandly. 'Sixteen?' the waiter asked, looking around to see who would be joining us. 'That's right,' Franz said, 'eight apiece.' Frank O'Hara and Joan Mitchell came in from a party just as the waiter was filling up our table with glasses and gleefully joined us.

"While the night life was feverishly active, the days alone in the studios were as feverishly productive as artists tangled with bigger and bigger canvases. The communication of ideas over drinks at night was translated into an intense mutual influence in the studios. There were, of course, leaders and followers, but there was another kind of interchange that was full of vitality.

"There was a carnival atmosphere—a general euphoria as artists' sales began to catch up with their reputations. Everyone was encouraged by the fact that better-known artists were finally beginning to enjoy some prosperity—which they immediately spread around by hiring younger artists to do carpentry, plumbing, and house painting with, of course, plenty of time off to talk shop.

"Landes Lewiton, who was always making pronouncements, had a saying: 'Don't shake the money tree until the fruit is ripe.' What happened was, when the fruit was ripe, the fruit flies appeared: collectors, who bought in terms of investment; speculators, who operated without the overhead of galleries, buying and selling paintings within a week or two; and young women who were attracted by artists' names rather than their personal charms. Herman Cherry told me an amusing story on that subject. He was seated alone at the Cedar Bar one evening when a very pretty girl came up and sat next to him and began a conversation which made it clear that she was available for the evening. Herman was delighted and they went to his studio. The next morning, preparing breakfast, he asked her how she liked her eggs.

'Any way you make them, Franz,' she purred.

"Then one night the word went around that Jackson Pollock was killed in a car accident. Everyone was stunned. Even when we heard that he was cold sober at the time, everyone still connected the death with drinking—if in a reverse way: It wouldn't have happened if he hadn't been sober was the sentiment. Booze was the talisman. . . . Maybe . . .

"I left New York in 1957 to teach at the University of New Mexico in Albuquerque. It was autumn when I arrived and the cottonwood trees and aspens had turned an overwhelming gold. I adored New Mexico with its brilliant light and highly colored earth and skies. I wrote sappy letters back home about the twilights. It was a great relief to be freed from New York's gray verticality and I found myself painting on horizontal canvases for the first time in my life, and using a much brighter palette. I met a beautiful young poet, Margaret Randall, who was a bullfight fan and she and I and groups of artists would drive down to Juárez for the bullfights, which became my theme in painting for the next five years.

"When I returned to New York ten months later, I felt like Rip Van Winkle. Greenwich Village was full of coffee shops I hadn't noticed before. The openings and the parties were still going on but the guest lists had burgeoned to a point that made the studios and galleries inhumanly crowded. One by one, artists seemed to pull away from the clutter of communal life, back to small gatherings and quiet intense conversations.

"One night in the early sixties, I was walking on University Place past the new Cedar Tavern, now devoid of artists. I paused at the window of the United Farms grocery store, which always has a mouth-watering display of fruits and vegetables. I stood there, studying its splendors, and then walked on. I saw Hans Hofmann approaching me. I hadn't seen him since the funeral of his wife, Miz, to whom he had been married, I think, fifty years. He looked trim in an expensive gray suit. He was wearing his hat at a rakish angle but his light-blue eyes were sightless. He walked right past me without seeing me. I turned around to watch him,

making a pact with myself as I had done often as a child: 'If he's in this world enough to stop and look at that window, I can approach him.' Hans walked until he came abreast of the window. Then he stopped and stood there studying the display. I rushed up to him and threw my arms around him. 'Helen,' he said (like all my European friends he refuses to recognize the name Elaine), as we walked on together, arm in arm. 'Where *is* everybody? Where do the artists go to meet nowadays?' 'Nowhere, Hans,' I had to say."

On a cold winter day in 1969, I decided to go to East Hampton. I wanted to see Bill de Kooning. Bill was living in The Springs the year round. When I got there, I didn't go directly to his house, but decided to telephone him first. I called his number repeatedly, but there was never any answer. Finally, I heard a rather tentative voice on the other end. It was Bill. I explained that I wanted to come and see him and talk a bit about the fifties. He didn't seem very interested. At the same time, I noted that his voice was shaking. He said, "Why don't you call me tomorrow, say, early in the morning?" And so I did. But again, the phone kept ringing and ringing. It occurred to me to simply drive over to his house. The worst he could do would be to say he didn't feel like talking.

Just before leaving for The Springs, I tried to call him again. This time he answered, and I repeated my request. "Well," he said, "if you're coming, maybe you could bring me a small shot of whisky. I don't want a whole bottle, just two fingers' worth . . . maybe in a glass." I surmised Bill was having the shakes and was trying not to drink. I debated whether I should bring him the whisky or whether I should just say I had forgotten it. I decided to come with a bit of Scotch.

Bill de Kooning built himself a studio in The Springs that has become legendary. It is a mammoth structure designed by Bill himself, but never really quite finished. De Kooning kept changing the design again and again. Every time it neared completion, he would think of something else that should be added, so the

workers kept coming back for something like five years. But on that cold day in 1969, he told me to come to his house—not his studio.

I had no trouble finding the house, a small frame structure standing directly opposite The Springs cemetery. I knocked at the door, but there was no answer from within. Finally I tried the front door, and it was open. The interior of the living room was quite ordinary, even depressing in its 1930s middle-class way. No one was in sight, but a large television set had been left on. A dreary, hysterical soap opera was in progress. I called Bill's name, but there was still no answer. I looked into the other rooms downstairs—empty. Then I heard shuffling overhead. In a moment, Bill slowly walked downstairs. He was unshaven and looked a wreck.

It was a jolt to see America's most famous painter in this condition—to know that he was totally alone in this drab little house, to notice how his hands shook. But he greeted me with an anxious smile, and his blue, blue eyes kept looking at the paper bag which contained the liquor I had brought. "Is that it?" he asked. I gave him the bottle. "I don't think I could talk to you unless I've had a little shot. I'm kind of under the weather." He picked up a glass from a table, poured himself the drink, and quickly gulped it down.

"You know," he said, "it gets pretty lonely out here. That's why I keep the television running. What I do, see, is, I turn the TV on, then I go upstairs and lie down, and then it sounds as though there were people downstairs. It makes me feel that I'm not alone in the house."

One of the things about Bill is that no matter how bedraggled he may look, the incredible beauty and sensitivity of his face shines through. Bill's features, so pure and chiseled and refined in the early fifties, have taken on greater character as the years progressed. His physique is neither stocky nor slender, but healthily cast. He is uncomfortable in suits and ties or any sort of formal attire, preferring to wear baggy pants and open shirts.

When I visited Bill that winter, we sat in his living room—

the sound of the TV turned down, but the picture still on—
and he talked about many things—but not about the fifties.
Clearly, he is not given to thinking of himself in historical terms.
Though he is eloquent on any number of subjects, his train of
thought and his conversation center more on immediate things.

Just now, he was upset with a friend of his because on the pre-
vious night they had attended a party and he had asked his friend
not to drink since she would have to do the driving. (Bill has
never learned how to drive.) It seems that Bill's request was not
heeded, and that they very nearly had an accident on the way
home. Bill talked about the futility of drinking, and how he
could never quite understand why he did it. At any rate, he went
on to explain that he and his friend had quarreled and that she
had taken off for New York. At one point Bill got up and
showed me the many ribbons won by his young daughter, who
was quickly becoming an expert horsewoman.

Bill suggested we go visit his studio. We drove a short distance
and arrived at an enormous wooden structure which, architectur-
ally, moved in several surprising and unexpected directions. The
interior resembled a vast ship. There were ramps, balconies, stair-
cases, and jutting decks. This was not merely a studio, but an
elaborate dwelling where several dozen people could live in the
greatest comfort and privacy. At one end of the studio, Bill had
set up a wall against which leaned a canvas in progress. It was
another in his famous "Women" series. The canvas was charged
with complexity and violence, but the color was luminous and al-
most tender. Out of it shone the myriad ambiguities that have al-
ways been a part of Bill de Kooning's work.

The subject of women, which has preoccupied Bill for over
thirty years, has been fodder for critics for an equal amount of
time. They have seen in it Bill's obsessive concern with the
eternal female, observed in the most radically unfeminine terms.
These women seem to scream out of the canvases. They have the
look of being slashed and mutilated. Their faces and bodies are
contorted and suggestive of schizoid interior states. Other critics
have said that these women were goddesses, whose extravagant

emotions reach out to grapple with the calumnies of their existence. Always, there is an implied lyricism and a basic celebration of their insistent physicality.

Bill doesn't necessarily agree with any of these approaches. He told me that his women are creatures that excite his imagination as he observes them walking down the street, perhaps dressed in gaudy clothes, caught out of the corner of his eye as they pass. He finds their general physical appearance rather strange— actually rather mad—with their frequent top-heaviness, the sudden explosion of thighs and buttocks. He is interested, he told me, in the amalgams of those shapes, which he finds repeated in the faces, with their often extravagant makeup.

In the work area of Bill's studio there are several tables on which sit dozens of bowls containing various pigments. His painting materials are neatly arranged, while the floor is usually littered with drawings strewn pell-mell near his work in progress. Bill leads me to another table, on which is a pile of small ink drawings. "These are kind of interesting," he tells me. "I do these with my eyes closed. I just sit in this chair and let the pen do what it wants, without my looking—and without my thinking of anything. It's funny the things that come out, and it's terrific exercise."

Bill shows me around the other parts of the studio. As you come in the front door, you face an enormous kitchen arrangement, with built-in stoves, a long table, a mammoth refrigerator, an elaborate sink, a large area for pots and pans, dishes and glasses—all of this enclosed within a semicircular space. He now leads me upstairs. There are many rooms, mainly bedrooms, most of them unfurnished. Each has sliding-door closets. He opens one of them, which is totally empty except for a row of hangers. Bill takes one of the hangers off the bar and says, "These are the most expensive hangers you can buy. I always promised myself that one day I would own the most expensive clothes hangers available. I never wanted to see a wire hanger again in my life. Anyway, these hangers cost me $12.50, each."

As he leads me around I become more and more aware that

this studio is a dream house, never to be inhabited. There was the kitchen—large, luxurious, and functional—but no one was using it. Here were the spacious, beautifully proportioned bedrooms where no one ever slept. And here were the $12.50 hangers hanging in roomy, empty closets.

"I can't bring myself to live here," says Bill de Kooning. "I only come here to work. I always say, maybe one day we'll all move in here and I'll get rid of the little house. But I can't seem to do it. I always think I ought to have great big wonderful parties here, but I never do. It's a crazy thing."

The first time Jane and I saw Bill de Kooning was at the Cedar Bar, surrounded by people. He was laughing, he was drinking, he was enjoying himself. As we came to know him, we usually found him kind, thoughtful, and remarkably articulate, but when drinking he could be belligerent and destructive. We once saw Bill literally wreck the furniture in someone's house.

We knew him best around 1958, when he was keeping company with Ruth Kligman. Once, when Jane and I were sharing a house in Water Mill with Jane and Joe Hazan, Bill and Ruth came to spend the weekend. He was endearing and attractive, seemed very happy with Ruth, and our excursions to the beach were marked by a tremendous camaraderie. There was no excessive drinking and the weekend was extraordinarily harmonious. At the time Bill de Kooning was already famous, and his paintings sold for very high prices, but as always he gave no sign of pretentiousness or self-importance. There is a naturalness about Bill—and a sweetness.

We were all struck by the difference between Bill's former liaisons with women and his present attachment to Ruth Kligman. Ruth, a most entertaining and good-natured girl, had a kind of film-star image of herself. She looked like a plumper and taller Elizabeth Taylor. She took extraordinary care of her appearance, was deeply involved with clothes and makeup, and was the antithesis of someone like Elaine de Kooning, whose style was decidedly more austere. When Ruth and Bill arrived for the weekend, she brought along a large straw trunk so heavy that Bill and Joe

Hazan had difficulty in maneuvering it up the narrow stairs of our house. The chest was crammed with clothes and shoes. Ruth would appear in several different outfits in the course of one day, and I particularly remember one elaborate and billowy peignoir worn over a matching nightgown—a diaphanous white creation sprouting red roses the size of cabbages. This image contrasted startlingly with the rest of us, haphazardly dressed in blue jeans or bathing suits, sitting around a table in a room that could have served as a set for a Eugene O'Neill tragedy. Another outfit, her traveling ensemble, consisted of wide-legged pajamas with enormous black polka dots on a white background.

For a number of years, Ruth had ambitions of being a painter herself, and we saw a number of her large abstractions during the course of the year. I ran into her one day on Eighth Street. She told me she was on her way to her studio, and asked me what Jane did to protect her hands and nails while painting. I told her that Jane did not bother to protect them. "Well," she said, "I've decided to wear rubber gloves."

Bill de Kooning and Ruth Kligman broke up after a relationship that took them to Europe and back again. I do not know the details, and neither of them is anxious to talk about it. When I questioned Ruth about Jackson Pollock and Bill, she replied that she was planning to write her memoirs and would rather keep the information for her own book.

Back in Bill's studio, we walk around the various ramps and balconies and down the wide staircase to the first floor. He wants to return to his frame house in front of the cemetery. We arrive there and stand at the door. Bill turns, gazes across toward the graveyard, and says, "You know, I often walk around that cemetery. I walk among the graves. I stop at Jackson's grave, at Reinhardt's grave, at Zogbaum's grave, at Frank O'Hara's grave. And I talk to them. We kind of keep each other company."

18

Earlier in this book I mentioned my encounter with Jackson Pollock at the Cedar Bar. I had been sitting by myself and noticed Jackson standing at the bar, drunk. At one point he went to the men's room, then came out and approached the booth in which I was sitting. He sat down across from me without speaking, took my hand in his and lifted it toward his eyes, as a palm reader would, looked at it for several long minutes and dropped it with some anger. Then he lifted his head and looked into my eyes. He said, "You don't understand. You have never understood. No one has ever understood." With that he got up and lurched out of the bar.

Pollock was born in Cody, Wyoming, on January 28, 1912. He was the youngest of five sons, and grew up mainly in Arizona and California. He came to New York in 1929 and attended classes at the Art Students League, studying with Thomas Hart Benton. His early works resemble Benton's, and I have seen one of these, a landscape of turgid color and oddly jagged composition. In the early forties, Pollock worked on the Federal Art Project and in 1943 had his first one-man show at Peggy Guggenheim's gallery, Art of This Century. He exhibited there until 1947. In 1944, he married the painter Lee Krasner. Two years later, he and his wife bought a small house in The Springs, near East Hampton, Long Island. When Peggy Guggenheim closed her gallery, Pollock began exhibiting at the Betty Parsons Gal-

lery. In 1952, he left the Parsons to join the Sidney Janis Gallery.

On August 11, 1956, Jackson Pollock was killed in an automobile accident. Many people have described this event. Pollock, reportedly sober, was driving a convertible on an East Hampton road. Sitting in the front seat with him were Ruth Kligman and a girl friend of hers out for a visit. Miss Kligman's friend sat next to Pollock, with Ruth on the outside. Pollock was driving very fast. While taking a curve, the car skidded and hit a tree. Ruth was thrown from the car into a field and survived with minor bruises. Pollock was thrown the other way, hit the tree, and was killed instantly. Ruth's girl friend, aged twenty-three, was crushed to death under the car, which had flipped over.

Jackson Pollock was forty-four years old when he died. At the time of his death, he had had twelve one-man shows and was considered one of the most innovative and original artists America had every produced.

Many facts are known about Jackson Pollock, but no one, including his wife, has ever been able to untangle his tortured personality. In a way, his paintings, with their convoluted and complex imagery, offer a picture of the tightly coiled fabric of his inner life.

I was frightened of Jackson Pollock; the weight of his anger paralyzed me. By no stretch of the imagination could we be called friends. Jane and I saw him frequently at the Cedar Bar, but we seldom exchanged more than the barest amenities. In those years, my kind of frivolity and pleasure in *bons mots* could not possibly have appealed to him.

But I admired Jackson Pollock tremendously. There was a strength about him—a kind of irrepressible physicality that was irresistible. He also posed a threat to the people around him because he could become violent when drunk. At such times, he would flail around blindly, overturning tables, hurling verbal abuse at those he suspected of disloyalty—and even becoming physically abusive. But there was another side to him. I was present on the famous night when he and Bill de Kooning were standing at the bar at the Cedar. Suddenly, the two began to

argue, and Bill de Kooning punched Jackson in the face. One of the people standing around urged Jackson to punch Bill back. That was when Jackson made his classic retort, "What? Me hit an artist?"

I liked Jackson's appearance. When I knew him, he was already balding and he had gained considerable weight. The face was massive, with deeply furrowed forehead, and with eyes that seemed to recede into themselves. Jackson did not so much walk as lumber. He was rugged in a typical cowboy way. His hands were enormous. It is said that most of his conflicts stemmed from his mother, who was a matriarch, aggressive and domineering. Once, before his mother was due to visit him in New York, Jackson went on a three-day drunk.

I spoke to Jackson's wife, Lee Krasner, in 1969. She lives in a bright, sunny apartment on the East Side. There are plants everywhere and Miss Krasner's large and airy paintings on the walls. A dynamic, articulate woman, she has managed her husband's estate with great acumen, placing his work with the Marlborough Gallery, where Miss Krasner herself exhibits. It is easy to see that the character of her life with Jackson Pollock has marked her person as well as her appearance. Her face is lined, and her eyes have a certain weariness. I asked Lee how she met Jackson Pollock.

"I was invited to show some of my work at the McMillin Gallery here in New York. This was in 1940. The show was composed of French and American artists and it was organized by John Graham, who said that the other American artists invited were Bill de Kooning and Jackson Pollock. I'd met De Kooning before, but I had never heard of Jackson Pollock. I was terribly excited to be in the exhibition, which was an important one at the time. But it irked me not to know one of my coexhibitors. I prided myself in knowing just about everybody in the New York art world.

"Being an impulsive creature, I made fast inquiries and found out where Jackson Pollock lived. To my amazement I learned that he lived on Eighth Street, just one short block from where I lived. Then and there, I marched myself over to Eighth Street,

climbed five flights of stairs and, once on the landing, asked a man standing there to direct me to Pollock's studio. This man, it turned out, was Jackson's brother Sandy, who lived in the opposite loft. He pointed to a door. I knocked, and a tall, lanky fellow opened it. I blithely walked in, introduced myself, and, taking a good look at him, realized that I had met this man some four years earlier at a party. I remembered him because he was the one who cut in while I was dancing with someone else. I also remembered him because he turned out to be a lousy dancer. Of course, I had no idea what his work was like at the time, nor did I ever give him another thought.

"Anyway, there I stood in Jackson's studio and, for the first time, saw his work. To say that I flipped my lid would be an understatement. I was totally bowled over by what I saw.

"One work—the painting he later titled *Magic Mirror*—just about stunned me. We talked about this painting and the others and the conversation was totally easy and marvelous. He seemed happy that I liked his work so much. It was only later I learned that people don't just walk into Pollock's studio—not even his brother, who lived just across the hall. And it was only later I learned how guarded and tortured he was about his work, his person, his life.

"But we met again and a courting period began. I resisted at first, but I must admit, I didn't resist very long. I was terribly drawn to Jackson, and I fell in love with him—physically, mentally—in every sense of the word. I had a conviction when I met Jackson that he had something important to say. When we began going together, my own work became irrelevant. *He* was the important thing. I couldn't do enough for him. He was not easy. But at the very beginning, he was accepting of my encouragement, attention, and love. Actually, no one knew as much about himself as Jackson did. He knew what he was about and he knew how riddled with doubt he was. It is this which, to this day, gives me impetus about my own work. It gives me courage and it keeps me going.

"So we were married. For some reason Jackson insisted on a

church wedding. I couldn't have been more surprised. Of course, he also insisted I make all the arrangements, and so I was frantically calling churches, rounding up two witnesses, making all the preparations. We were married in a Dutch Reformed Church in New York and I asked Harold Rosenberg's wife, May, and Peggy Guggenheim to be our witnesses.

"Strangely enough, Peggy refused. I was shocked, since I thought we were friends—and I was especially shocked since she had given him his first show in 1943. Then I remembered something I had momentarily forgotten. When Peggy's book of memoirs came out—the book was called *Out of This Century* —she sent us a copy. On opening it, I noticed that the inscription read 'To Jackson.' She had not included me in the inscription and I remembered being quite hurt by this. I genuinely liked Peggy. I must not have realized that she probably resented my attachment to Jackson, and that, basically, she had very little use for women. Anyway, I quickly rounded up another witness and our wedding ceremony went through as scheduled.

"People often ask: 'What *really* killed Jackson Pollock?' 'Was it drink?' they ask. 'Was his death a suicide?' I can assure them it was not suicide. Although he had a strong self-destructive streak in him, Jackson did not wish to die. In fact, before the accident, he had re-entered analysis, intent on fighting his drinking problem. And he *did* have one!

"We were married eleven years. When he drank, it could be terrible. But on the subject of his drinking, he would say to me, 'I can't promise you anything. If you can think of it as a storm which will pass—which will be over—you'll be able to handle it.' I tried to handle it and, believe me, he tried to handle it. Throughout our life together, he tried everything. He entered analysis, he joined Alcoholics Anonymous, he worked with a biochemist, he even tried homeopathy; he did not *want* to drink. He *wanted* to be cured.

"And he did stop drinking for two full years. Between 1948 and 1950 he stopped. And I can tell you how that happened. Out in The Springs, we had a local doctor to whom I would go

whenever I had a cold or didn't feel right or whatever. He was a local practitioner, a nice guy. One day I saw him about something or other, and I remember mentioning to him that Jackson was, just then, drinking heavily. He suggested I try to send Jackson over to see him, which indeed I promised to do. Jackson hardly went to see this particular doctor, but for some reason he did go and see him. Well, when he returned home, Jackson seemed changed. And from that moment on he did not drink. Naturally, I asked him what it was the doctor told him. Jackson grew very vague. The only thing he said was, 'He's an honest man. You can believe him.'

"I was never to find out what the doctor had told him because, and this is too ironic, the one man who seemed to have found a way to make Jackson stop drinking for two years was, shortly after Jackson's visit, killed in an automobile accident, not far from where Jackson was to be killed six years later!

"There was never any conflict or competition about our respective work. Jackson had the greatest interest in my painting— even enthusiasm. He was not verbal about it, but then, he was not a verbal man, and he was certainly never given to making elaborate criticism. When I would call him into the studio, asking him to look at a painting I was working on, his only comment would be 'That works.' Or, 'That doesn't work.' Or, 'It's opened up.' Never anything else.

"As I said before, life with Jackson Pollock was not easy, but, from the very beginning, I found we thought alike. In an uncanny sense, this was truly so. We did share the same feelings about art and about many, many other things. The one feeling we did not share, however, was Jackson's conviction that art and life are one. He would say, 'You cannot separate me from my paintings—they are one and the same.' Why did I not understand this? I think it was my sense of order that did not allow it. I could not be convinced!

"As Jackson's fame grew, he became more and more tortured. My help, assistance, and encouragement seemed insufficient. His feelings towards me became somewhat ambiguous. Of course, he

had many other supporters. Tony Smith, then an architect, was among the strongest, as was Clyfford Still, whose letters and comments meant a great deal to Jackson. And he adored Franz Kline—he could talk to Franz. And of course, there was Clement Greenberg, who, from the very first, was one of his most avid supporters.

"Still, Jackson had a mistrust of the word. Words were never his thing. They made him uncomfortable. And people made him uncomfortable. In a letter to one of his brothers he once wrote, 'People bore me and frighten me.' But Jackson worked. And when he worked, he never drank. His drinking came in cycles, and it would always start before or after a painting period, never during.

"People say Jackson was a violent person. Frankly, that confuses me. I think I've been brainwashed about Jackson's violence. Actually, he was not as violent as people make out. He had an anger—yes—a terrible anger. But I think his violence has been exaggerated. He brought me a terror of another kind. I was paralyzed with fear about his well-being and safety. I would never know if he'd be home unhurt, uninjured. He sometimes drove while drinking. *That* always scared me.

"Still, there were many happy moments. I remember any number of them. I remember sitting with Jackson on our country porch—sitting there for hours, looking into the landscape, and always at dusk, when the woods ahead turned into strange, mystifying shapes. And we would walk in those woods, and he would stop to examine this or that stone, branch, or leaf. Jackson had told me about his drinking storms and how they would pass. Well . . . they eventually *did* pass—and then, it was all worth waiting for. He was marvelous to be with then. His moodiness and depression would vanish, and he would be calm—and there would often be laughter. I remember Jackson's laughter. It was wonderfully outgoing, it was warm, and there was such joy in it!

"I don't think I could do it a second time. But I wouldn't have had it any other way."

19

The art dealers of the fifties can easily be counted on one's fingers. There was Charles Egan, a small, intense, dark-haired man, all too often afflicted with the booze disease of the period; Sidney Janis, a former shirt manufacturer, early collector of European art, coauthor with his wife of several books on art, and ballroom-dancing aficionado; and Betty Parsons, an artist herself, and an ardent believer in the art of the period, whose strong and constructive dedication to some dozen little-known artists made her the single most powerful dealer of the early fifties. There was Sam Kootz, who started out showing the American avant-garde, but switched in favor of showing Picasso. There was Eleanor Ward and her Stable Gallery; Martha Jackson; Grace Borgenicht; John Myers and his Tibor de Nagy Gallery, and the Leo Castelli Gallery.

These represented the avant-garde. Among the Establishment dealers, who showed well-known European moderns and a smattering of primitive art, were men like Julian Levy, Curt Valentin, J. B. Neumann, and Pierre Matisse. American artists of the twenties and thirties had their strongholds at Edith Halpert's Downtown Gallery, as well as the A. C. A. Gallery, the Kraushaar Gallery, and the Macbeth, which also showed a few avant-garde artists. Old masters and a handful of living artists were shown at Wildenstein & Co., Rosenberg, and Knoedler's.

In the fifties, the art world was exceedingly closed. The con-

centration of art galleries was on Fifty-seventh Street in New York, and the public usually stayed away in droves. Galleries were usually small, one or two rooms at the most. Some of them were fancied up with floor plants and velvet fabric on the walls. The pristine look did not come in until Betty Parsons chose to exhibit her painters on plain white walls. As far as the avant-garde galleries were concerned, very little ever sold. A dealer like Betty Parsons would make ends meet by selling well-known French artists privately. Other dealers did the same, or were independently wealthy, or had backers.

Betty Parsons continues to operate her gallery (presently located at 24 West Fifty-seventh Street). She has lost most of the artists whom she took on in the late forties and early fifties. Among these were Barnett Newman, Jackson Pollock, Mark Rothko, Clyfford Still, Ad Reinhardt, Theodoros Stamos, Herbert Ferber, and Seymour Lipton. This astonishing roster of painters and sculptors was the nucleus of the New York avant-garde, and Mrs. Parsons had the vision to represent them when almost no one else would do so. Today, she still shows artists that ignite her imagination, young unknowns for the most part.

In 1954, Betty Parsons made a statement in connection with her now-famed group of artists: "Each artist connected with the gallery is endeavoring to communicate what he has found significant in his life. This is what makes the content important to me. You will ask on what basis do I decide? I can only answer—on the basis of imagination and feeling. This may leave you cold—that is my responsibility. And my decision is based upon twenty-five years of preoccupation with this subject, a passionate interest in this very mysterious thing, the creative, which is to my mind simply a receptive attitude toward living. I don't care what an artist is receptive to, as long as the work is alive. When their work is alive, it has vitality. This vitality must contain experience, discipline, resistance, and response—and more. Each artist that I show must commit himself in this way. Visit the gallery at any time and you will see this demonstrated."

This forthright statement makes clear the fact that Betty Par-

sons is a woman of great personal conviction, a quality not always apparent in other dealers. This integrity came across again as we talked in her gallery in early 1970.

"I first started in the gallery business in 1938," she told me. "I'd come from California and I was broke and had to find a job. So I had an exhibition of my own work—water colors—at the Midtown Gallery. The exhibition was fairly successful, and Alan Gruskin, the owner of the gallery, knew I was looking for a job, and suggested that I work on a commission basis with him for a while. So, I started in that way, selling things outside of the gallery. I stayed with Ruskin for about a year. Then Mrs. Cornelius Sullivan was looking for somebody to help her run *her* gallery, which I did. I helped her put on shows, and I helped her sell paintings and silver objects and other beautiful things. I did this for two years until Mrs. Sullivan died.

"Again I was out of a job. Then, the Wakefield Bookshop wanted to start a gallery. Somebody suggested that I run it, and they gave me carte blanche, saying that I could do anything that I liked. I started rather timidly because I had no idea whether I had the ability to select and run things. This was around 1940, and I remained at the Wakefield Bookshop for a couple of years. At one point, the bookshop moved uptown, but in the space they found there was no room for a gallery. So I was out of it again.

"I then met Mr. Mortimer Brandt, who suggested I run a contemporary branch of his gallery, as he always dealt with old masters. So I took that on. The Brandt Gallery was located at 15 East Fifty-seventh Street, and he had a whole floor. When I came in, the floor was divided between the old masters and the contemporary art with which I would be dealing. That went on for two years and it didn't really make sufficient money for Brandt. He decided to give it up and move. He said that if I wanted to go on he'd continue giving me the space. I wasn't quite sure whether I had the money to go on, but I had five friends who backed me with a thousand dollars each. And that's how I started on my own in 1946, at 15 East Fifty-seventh Street. Sam Kootz rented the other half of the floor for a couple of years, and then Sidney

Janis took it over. But from that time on I used my own name and I became my own dealer.

"I was always interested in the unknown, always attracted to the unfamiliar. I liked painting and sculpture, but I couldn't associate with the past. In this way, I ended up with some very extraordinary artists. There was Jackson Pollock, whom Peggy Guggenheim had introduced me to. He had shown with Peggy first, but she never did too much about museums or the public. I was the first to introduce Pollock to the art world and to collectors, etc. His first show with me was in 1948 and he continued to show through 1953. Clyfford Still came to me in 1947 and he showed again in '50 and '51. I gave Barney Newman his first show in 1950. Bradley Walker Tomlin had shows with me, as did Hans Hofmann. There was Mark Rothko, who had a number of shows with me.

"When I began to show this strange art, most of the New York critics were appalled and a lot of older artists and a number of collectors were exceedingly rude to me. The only critic writing for a newspaper who had anything good to say about any of my new artists was Henry McBride, who wrote for the *New York Sun*. He said good things about Tomlin. Stewart Preston, who worked for the *New York Times*, was very unsympathetic at the time. I remember his coming in to the gallery and taking one look at the work of Clyfford Still and turning right around, charging for the elevator. I rushed up to him and tried to stop him. I said, 'As a favor to me, will you please sit down for five minutes and look at these pictures. Finally he said, 'Well . . . yes . . . I see.'

"I always left my artists alone. I never interfered with the hanging of their own shows. They knew more about how to hang their work than I did. And so the artists would help each other hang their own exhibitions. I felt they would know more about how to compose the room than I would. At any rate, no matter how good the paintings looked, the public was invariably depressed by what it saw. We all had a very tough time financially. But I tried to interest the public by talking to them about

this art in a way that would stimulate them and would make them understand what it was about. I used to say that Rothko was a painter of the sublime. I called Still the eagle and the stallion—because he came out of the West and he used to ride across the prairie and look up to fantastic heights in the West. That's what his paintings were all about—those tremendous mountainous heights. Tomlin, to me, was always musical, and I would go into the kind of contrapuntal compositions he had been creating. Pollock was a kind of nervous, electronic painter to me. I used to tell my visitors to think of an electric shock, because that's how he struck me.

"What were these painters like? Well, I really loved Pollock. He was fantastically dynamic, fantastically alive, but also wild and full of protest. He was *so* real. And he always behaved very well with me. He never was difficult when his show was about to be hung. And he was never drunk when he and the other artists hung his show. Mark Rothko was always brilliantly intelligent. You may understand that all these artists were continually being rejected, but the more they were rejected, the more they realized they had something.

"Of course, I was disappointed when so many of my discoveries moved on to other galleries. I was very hurt when Jackson Pollock went elsewhere. I know that Lee Pollock, his wife, was upset when I decided not to continue showing her work. But, as I told Lee, it had nothing to do with thinking she wasn't a very fine painter, it was that the association was too painful.

"No, I didn't like it when my painters started leaving me, but I understood. After all, if they could do better somewhere else, what could I do about it? I had to accept it. The one case that really upset me terribly was a recent instance when Ellsworth Kelly, whom I had shown since 1956, decided to leave. I was selling him like mad. And still he persisted that he wanted to leave and go over to Sidney Janis. I was especially angry over Kelly going to Janis, because Janis, with whom I shared the floor at 15 East Fifty-seventh Street, tried to grab my gallery away. I fought him one whole summer in the law courts and ended up by mov-

ing out myself. But it was a fierce fight we had. I couldn't stand being on the same floor with Janis, which is why I really left. The lawsuit ended up neutral—it ended up status quo. But when I moved out, Janis took over the whole floor. Anyway, I told Ellsworth Kelly—all right, so you wish to leave me, but please don't go to Sidney Janis. But Kelly went to Janis, and I have never any wish to speak to him again.

"Then there was the case of Alfonso Ossorio, who dates ba k from the Wakefield Bookshop days with me. That's twenty years. Ossorio took off because he decided he wanted to show every six months. I will show nobody every six months. I said I've got my schedule and I can't do it. So he took off. It's wild, the reasons people give for leaving—just wild. I guess Mark Rothko left me because I just couldn't sell him. He too moved over to Sidney Janis. And Jackson left me because I couldn't sell him. Jackson also went with Sidney Janis. I don't talk to Theodoros Stamos any more. Remember that I found him and he was with me many, many years. But he became so peculiar—he was really so strange. I just couldn't cope with him.

"When I showed all these artists, many of them were terribly discouraged about their lack of acceptance by the public. I remember how Mark Rothko used to get so very upset. I used to tell him, 'Well, you know, it takes time for the public to get used to anything as unusual as this. And you *are* terrific.' I believed in them all, and I encouraged them an awful lot. But they got mad. Clyfford Still was so maddened that he just took off and left the whole scene. He went back to California. And Barney Newman was mad because it took a good ten years before the public woke up to him.

"I loved Barney Newman. He was so very intelligent and he knew so much about so many things. Did you know that he wrote three introductions for my catalogues every time I opened in a new place? He wrote a foreword for me on a pre-Columbian show which opened my Wakefield Bookshop years. He wrote a foreword to my Northwest Coast Indian Art show, when I moved to 15 East Fifty-seventh. And he wrote the foreword

when I opened here at 24 West Fifty-seventh with my Amlash Art Exhibition. People didn't know that he was a very fine writer—that he was a very well-rounded man.

"It always made me sad when my artists drank so heavily. Rothko drank and Jackson drank—and it was sad. Charlie Egan had his own problems with De Kooning and Kline. And, of course, Charlie was a drinker himself.

"When everybody began leaving me—which was invariably in the spring, when I was very tired—I'd somehow pull myself together and go out to find somebody else worth working with and promoting. That's what's kept me going. You see, I've never shown an established name in my life. My reputation is built on the unknown. It was always my aim to find the creative world —not to make money. I never compromised. I never lowered my standards to take on an artist that I thought could sell. I've never lowered my standards for *any* reason. I may have made some awful mistakes, but I've always tried to find the man who wanted to say something on his own.

"I was talking about artists leaving me. Of course, there are some who didn't. Saul Steinberg, who I first showed at the Wakefield Bookshop, is still one of my artists. And so is Hedda Stern, whom I introduced to Saul and who then married him. They were married for fifteen years. Saul Steinberg always wanted enormous space for his exhibitions, and so I got together with Sidney Janis, early on, and he agreed to exhibit Steinberg jointly with me. It's still going on. I mean you can't be namby-pamby about that sort of thing. I may not like Sidney Janis, but I get on with his sons, and I got on with his wife when she was still alive.

"I was very fond of another artist of mine, whom I showed for several years. This was Richard Lindner. He had beautiful shows with me, four of them. I sold about four pictures in four years. I could not put him over. We both agreed that it was terrible, and so we parted amicably. He went over to Cordier and Ekstrom. He went there just at the time when Pop Art was breaking, and Lindner was really in that line. The Pop Art movement broke

the ice for him. It was a question of timing. Lindner and I are still friends. Another case was Robert Rauschenberg, whom I showed in 1951. I had his all-white show, but then he moved into his photographic collage period; I'm afraid it didn't interest me much, and we parted company. But I'm very fond of him. In fact, just the other day, I bought one of his works out of a show.

"And there was Ad Reinhardt. He was with me about twenty-five years. I started showing him at the Mortimer Brandt Gallery. He was just out of the army then, and he was doing very different work from what he finally ended up with. He was very uncompromising toward his work, and I liked him very much as a friend. He and his wife were very good friends of mine. In the last few years of his life he had a thing about dealers—he didn't like dealers. He liked me, and I was a dealer, and he had a conflict about it. I had a hard time with him the last few years of his life. I could have sold many more of his paintings, but he wouldn't give them to me. What Reinhardt really wanted to do was to give his paintings away. Of course he couldn't because he had a wife and he really didn't have enough money to give his paintings away. I know he started giving some to the Tate Gallery in London. Before the deal went through, he died.

"Another artist who was with me for twenty-five years was Walter Murch. I really thought his paintings were beautiful. Of course, he was not an abstractionist. He painted those strange machines and mechanical objects, and he would throw them into a kind of eternity. His objects were never in a room or in a city or in a region. They were always in an infinite space and an infinite time. You didn't know that he always painted at night. Murch painted from midnight on, because the city was quiet, and he couldn't stand the noise. He would always paint from midnight till dawn. That's why his paintings have that still, mysterious quality. He died unexpectedly about two years ago. All the artists in my gallery admired him enormously. Rothko and Newman—all of them respected him.

"I showed Richard Poussette-Dart for a long time. He was a fascinating guy who somehow never came across to the public.

There was something in his work that one resisted. I still don't know why. Perhaps he was against the trend. Most of the artists seemed to be reducing the texture of their pigment, while Richard was building it up more and more. I always felt he was a very great poet. I think he's one of our greatest painters and I think the world will realize it sooner or later. Richard was not one of the painters who left me—he's still with me.

"I suppose one of the reasons I went into art dealing was because I was an artist myself. I started many years ago in Paris as a sculptor. I studied with Bourdelle and with Zadkine. I learned a lot about materials from Zadkine. He had a mastery over materials. Sculpture was really always my great love. But then in 1929, when the crash came, I couldn't go on with sculpture. And so I continued painting, which I had been doing along with sculpting. Then I returned to America and went to California and tried to pick up sculpting, but then it faded out of the picture because I had to take up so much time to support myself. That's when I started all my gallery work. Still I always went on painting. I painted every summer. I painted weekends, at night, at any free moment. And I still do. My style? I think my painting doesn't look like anybody else's because, fortunately for me, I have no recall on anything I see. When I paint, it's exactly as if I'd never seen anything. This is a special gift, because if I had recall, I would be painting everybody into my pictures. I don't even think about trying to be like anybody else—it's just the way it is.

"But getting back to my own artists, the ones I fought for— the ones I discovered—most of them now are with the Marlborough Gallery. I can't stand the Marlborough Gallery—and I just can't stand the atmosphere there. In all honesty, I don't think most of the artists like being there. Most of the artists that came with me always got better. I was somehow able to stimulate growth. I think that's the most important personal contribution that I have made in the past twenty-five years. I had the ability of making them see their own visions more clearly. I don't know how I learned to do that, but I did.

"Of course, today, everybody's eye seems to be on the market. It's all about money. And the public today is much more receptive to all the art they hated in the fifties. My God, I remember the incidents of vandalism in my gallery—the physical, hostile resistance. I remember Barney Newman's pictures being slashed, and I remember how some people wrote four-letter words in the white areas of Jackson Pollock's canvases. I've always said that I built my reputation on hate, not love. But you see, all those artists made it, didn't they?"

Thus Sidney Janis, whose gallery was on the same floor as Betty Parsons' at 15 East Fifty-seventh Street, became the dealer for many of Mrs. Parsons' artists. Janis has his reputation, of course. But many have said that his major reputation is based on sitting back, watching an artist grow, and then inviting him into his fold. That was one of the first things I heard about Sidney Janis when I went to the galleries in the early fifties. Actually, one usually went to Betty Parsons' Gallery because that's where the action was, and then, as an afterthought, stopped by at Janis's, who might be having an interesting Léger show. Janis started out by showing French contemporary art, and his collection was never less than first class. He and his wife, Harriet, ran the gallery with occasional assistance from his two sons, Carroll and Conrad. Mrs. Janis has since died and Sidney Janis is slowly letting his sons take over.

After my talk with Betty Parsons, I stopped by to see Mr. Janis, who was most cordial, and pleased to reminisce about the fifties and earlier.

"I went into the art-gallery business in 1948," he began. "I had given up my shirt-manufacturing business ten years before, and I was busy writing books. After the publication of our third book —Mrs. Janis collaborating—I came to the conclusion that I wasn't making enough on my art books to make a go of it, and that I had to go back into business again. The books, by the way, were called *They Taught Themselves*, *Abstract and Surrealist Art in America*, and *Picasso: Recent Years*. Anyway, if I were

going to have to go back into business, I wanted to go into something that I loved—and that was art. After all, I had been in the art world; Mrs. Janis and I began collecting in 1926. The art world was quite familiar to me, not only here but abroad, where I knew painters, collectors, and dealers.

"For example, in 1929, here in New York, I met Arshile Gorky. He was teaching then at the Grand Central School, and he had a great deal of time on his hands. We used to hit the Fifty-seventh Street galleries and the museums, and used even to travel out of town together. Gorky was terrifically verbal and terrifically informed. You'd go to a museum with Gorky and he would reveal to you different things that escaped notice. He was familiar with everything—from the earliest times to today. When he went to a museum he'd cut quite a figure. He was a gaunt, tall man and he would stand in the middle of a museum gallery, and gesticulate, and talk quite loudly about this or that painting. Whole groups of people would be attracted and he became something like a guide to them.

"I had no idea of opening an art gallery. I didn't want to turn 'professional.' I didn't want to lose my amateur status in the art world. I was very jealous of that. But, as time went on, I got used to the idea and I opened this gallery—here in this space at 15 East Fifty-seventh Street. It was a space that formerly belonged to Sam Kootz. I bought this space from Kootz, who had already decided to move. I remember, at the time, people coming in and saying, 'Well, if you think you're going to have a gallery on the level of Kootz, you're aiming awfully high.' We used to hear that very frequently.

"So I opened the Sidney Janis Gallery in the spring of 1948. But, immediately before, my wife and I went abroad and I visited Léger and his dealer, Kahnweiler. I decided to select things from both of them for an opening show in my New York gallery. The Légers were very low in value, as against today's prices. In that exhibition we included works that dated from 1911 to 1948. That was our opening show. I'll tell you at once that we did almost no

business. But it was a great artistic success.

"Later, I became interested in new American artists. When I began my book *Abstract and Surrealist Art* I went to all the studios of the artists I expected to include in the book. Among them were Jackson Pollock and Mark Rothko. My meeting with Pollock was rather interesting. While I was working on the book, I was interested in meeting some of Hans Hofmann's pupils. One of them was Lee Krasner. During the course of my visit, she asked me if I knew an artist by the name of Jackson Pollock. I said no. She then said that he was completely unknown and would I like to see his work? I said, by all means—especially if you recommend him. I did not know at the time that she was interested in Pollock in any way except artistically. At any rate, she took me to his Eighth Street studio. There stood Pollock, a dour-looking fellow, who didn't say one word during my entire visit. He was quiet and stood at a corner of his studio. He let Lee do all the talking. Jackson just listened. He was that way, until he got to know you. A very reticent man, he was. And, of course, he was cold sober. When not so sober, he did quite a lot of talking.

"There were two pictures at the studio. They were done during the previous year—and this was 1942. The paintings had a kind of all-over pattern—quite different from the earlier work which had a kind of a Mexican flavor, you know, like Orozco. Jackson had been in Mexico and was influenced by that kind of image. Anyway, I was quite struck by these two pictures and had them photographed for my book. Unfortunately, these were texture pictures, with no linear aspect, and didn't photograph very well.

"In the meantime, Jackson had begun another picture which promised to be a very good one. I waited for that one. That picture proved to be the *She-wolf*, which the Museum of Modern Art immediately acquired. Incidentally, Meyer Schapiro and I were on their acquisitions committee, and *She-wolf* was a picture we voted for. The museum had photographed that work in color,

and I borrowed that photo and included it in my book. I was lucky because it was the beginning, you might say, of the spontaneous image that Pollock was to evolve, and was to be called 'drip painting.' This was 1943, mind you, and he was not to come into that particular period and style until 1946, '47, '48.

"One of the things I ought to tell you is that American artists of my generation weren't really that interested in art dealers, as such. Nor were they interested in the reaction of dealers to their work. They didn't even think about it. For example, Stuart Davis had an exhibition at the Downtown Gallery, where not a thing was sold. Then there wasn't another Davis exhibition for years and years. But Stuart Davis went on doing his work. Another example is Gorky. Gorky never had an exhibition in those early years. He had one in an obscure gallery in Philadelphia, for which Mrs. Janis wrote the foreword. But that was in the early thirties. You see, these artists had no real idea about dealers, or how their work would be accepted. They were only interested in doing their thing. What happened was that artists would get together and just talk about paintings amongst themselves. I remember going to Gorky's studio, and Gorky would hold forth in his usual way. It was at Gorky's, by the way, that I met Bill de Kooning. He was sort of the little boy in the background—I'm talking about the thirties now—and he would sit very quietly, and Gorky took over. I recall how in the middle of one of Gorky's expositions on cubist painting and Picasso, he turned toward De Kooning and said, 'You watch this man. He's a good artist.' I still see De Kooning sitting there. He was young and impressionable, and, I think, very much influenced by Gorky and his thinking. Bill, you see, had this inherent artistic quality within him, and Gorky helped him develop it.

"Twenty-two years later I would be showing De Kooning in my own gallery. In fact, De Kooning was the first man we took on of the New York School painters. Before him, we showed the work of Josef Albers. That was in 1948. But De Kooning came to us in 1953. He had been with Charlie Egan and then, one day, he came in and said to me that he didn't have a gallery any more

and that he was thinking about a new gallery. I said we'd be delighted to have him.

"Of course, I'd been visiting De Kooning in his studio, which, at the time, was on Fourth Avenue below Fourteenth Street. He lived there with Elaine, and shared the adjoining studio with Jack Tworkov. It was at that studio he painted *Excavation*, his largest painting to date, and it was the first picture we sold. We sold it to the Chicago Art Institute for three thousand dollars. Then Bill moved around a bit. He moved to Twenty-first Street, then to Tenth Street. He's a sweet man, Bill de Kooning. He's sweet when he's cold sober; he's not so sweet when he's drunk. Bill and I have our differences today—he no longer shows with me. But despite all of that, I have a very warm feeling for him. He's being misled today, I think—probably by legal counsel. He's tied himself up with Knoedler, and he can't get out of there. He has signed a contract. Anyway, in 1953 I showed Bill. It was the 'Women' show.

"Then Jackson Pollock came with us. I still remember how, when we opened our gallery and when we were hanging our Léger show, Jackson came in and he sat on a chair, and he sat, sat, and sat all afternoon. At the time he was showing with Betty Parsons, so I didn't say anything. Finally he left. Then, almost five years later, Lee Krasner came to us and said that Jackson was no longer with Betty Parsons and he was looking for a new gallery. I remember saying to her, 'Don't you think, Lee, that the market is rather saturated with Pollock's work?' You see, there was a show every year. But Lee answered, 'Sidney, the surface hasn't even been scratched.' I remember this vividly. And how right she was! Anyway, we got together, Lee and I, and we had a verbal contract, and we gave Jackson his first show in 1954— in November—that was his month. Jackson always had a show in November. It was a magnificent show. He had changed from his 'drip' image to a kind of impasto, pigment surface, and it was more figurative, but still had the Jackson Pollock bite. The show wasn't too successful, but eventually we sold some of the paintings to a number of museums. But even at that time, we

were unable to sell the 'drip' pictures—those huge ones on which we had prices such as twenty-five hundred dollars! We were unable to sell them.

"I never made it a practice to support the artist by buying his pictures. It was a subject that always came up here. The artists used to say to me (and this exposes the artists' thinking of the time), 'Why don't you buy a few of my pictures?' And I'd say, 'Look, if I bought pictures from you, those would be the pictures that we would naturally prefer to sell. The new work, that you would do, wouldn't bring you in anything. If you need some money, we'll lend it to you.' So, we never accepted the idea of buying pictures at off-price, because of the possibility of direct competition with the artists themselves. We lent them money from time to time and got paid back eventually.

"At any rate, after Jackson Pollock came with us we took on Mark Rothko. Then we had Philip Guston and then Robert Motherwell. Finally, we had Adolph Gottlieb. We were also very friendly with Clyfford Still, who had left pictures with us. It's true that most of these artists came to us from Betty Parsons.

"You see, we were in contact with some pretty good collectors who were buying Picasso, Léger, and Mondrian. We had international names. I guess the New York artists who came to us felt themselves as being in pretty good company. I remember Jackson Pollock being very much aware of that. He saw to it that he was in a gallery that had the very best.

"When Mark Rothko came with us, he was a very modest guy. He said, 'I need only so much to live on.' And I said, 'Look, Mark, if you can't make four times what you need to live on in the first year you're with us, we don't want you.' And, of course, eventually he became a great success. The point is, his paintings got better. When he was with Betty, he hadn't really arrived at that all-over ambiance. It was a sort of broken-up image that eventually developed into a kind of color wall.

"But to further comment on why the artists who came to me were unhappy with Betty Parsons—they simply weren't doing

well enough with her. Oh, she sold a few things. But the market wasn't ready. It wasn't her fault. She tried awfully hard. And she had great confidence in her artists. Of course she felt badly when they left. But the market wasn't ready, and I think we helped to establish that market.

"People have often accused me of taking on artists after they had become established. I think that's an injustice to the gallery. An out-of-town critic started that—a man who was not too familiar with what was happening in New York. My past experience really disproved all that. For example, I met Gorky in 1929 when he was really painting like Matisse, and he went through Matisse, Braque, Gris, and then, finally, Picasso, Miró, and Kandinsky. He went through all of these before he found himself. In fact, when he found himself, he was off his friends, because he had gone to live in the country, away from Fifty-seventh Street, away from his New York influences. But furthermore, I think we can easily pinpoint that story as being erroneous by looking at the collection that I made, which began in 1927 and included unrecognized artists like Mondrian. I think there were about two Mondrians in all of America. The price was nothing, but I was interested in the good things artists were doing—not only Mondrian, but Léger and Matisse. So I wasn't going around finding out what the other collectors were buying, because no collectors had Matisse, etc.

"You know, of course, that all the New York artists that I took on—the ones who came to me from Betty Parsons, as well as others—all got up in a body and left me. How did that happen? Well, it's quite a story, and it's a story of the early sixties really. What happened was that the Marlborough Gallery established a base in New York City, and Frank Lloyd, who runs it, went around to visit my artists in their studios. He began seducing the artists with contracts, and strong advances, and guarantees. De Kooning was the only artist of mine who didn't leave —except much later when he went with Knoedler's. But, for example, Guston came to me one day and he seemed very upset

about the fact that he was offered a terrific guarantee. He felt it was so tempting that he just couldn't reject it. And that's what went on with all the artists.

"But something else happened, as well. We put on an exhibition called The New Realists—the Pop Art show which was on an international level. In it we included some of the up-and-coming Pop artists like Claes Oldenburg, Roy Lichtenstein, Jim Dine, and so forth. We had all the best artists of the movement. The show turned out to be too big for our gallery, so we rented an outside space—a store down the street. This all happened in 1962.

"Now, my older artists were very upset at the idea that Janis was taking up these younger Johnny-come-latelies—artists who expected to be recognized overnight, whereas *they* had to work so hard, and fight for their art and reputations. And so they held a meeting, I understand, and they decided that the Janis Gallery was no longer sympathetic to their work and it wouldn't be a good idea to vie with these younger people.

"Well, when this information got back to me (filtered through by the various artists), I spent a great deal of time explaining to them that their work is fifteen thousand dollars and these people's work was fifteen hundred dollars. There could not be any competition any more than there was competition when Léger's work was fifteen thousand dollars and their work was fifteen hundred dollars. Besides I told them that they seemed very happy to join the gallery when we were showing Léger, Picasso, Mondrian, and Braque, and that these European artists didn't complain when we took on the younger Americans.

"Anyway, I told them I didn't see why they should complain about our taking on a younger generation of painters. Also, I thought that one was compatible with the other—and the price scale was so different. Well, that wasn't convincing, mainly because they had this flattering offer from Marlborough.

"I know that Frank Lloyd claims that every single artist came to him on his own accord, that he never stole an artist from anyone. I think that that would be refuted by the artists themselves. I

can tell you a story that Bill de Kooning told me, namely, that Lloyd came one Sunday to his studio and that De Kooning kept pulling Lloyd's leg a lot by saying, 'Oh, you're Lloyd of Lloyd's of London.' And Lloyd said, 'No, I'm Frank Lloyd of Marlborough.' And Bill said, 'Oh, I see. You're the Duke of Marlborough.' So they had that going on for a while. But Lloyd had gone to The Springs to enlist De Kooning for Marlborough, and Bill turned him down.

"It's true that people say that I myself take artists away from other galleries—certainly Betty Parsons says this. And again, this can be refuted by asking the artists themselves. One can ask Lee Pollock, or Guston, or any of the other artists. They were free when they came with me. But the artists that Marlborough took from me were not free, although they were on the verge of being free. I mean, they had really decided that we were no longer the gallery for them. It was perhaps fortunate for them, or fortunate for us. But we went on and established many of the younger people that bothered the so-called second generation. It's just that the third generation took over.

"Now, we are probably faced with the problem of the fourth generation usurping the third generation. The Pop and Op artists are rapidly reaching a point where they're being priced too high. We are fighting that all the time. Some of these artists come in and say, 'Don't you think I should get as much as so-and-so?' And I'd say, 'Now wait a minute—let's be reasonable about it. Let's not talk about the other fellow. Let's talk about what your last year's prices were, and let's be reasonable about going up, say, ten per cent, not a hundred per cent.'

"So, one generation usurps another. And, of course, the prices go up as an artist becomes more established. I had an interesting situation in regard to Jackson Pollock after he died. There was a painting of his called *Autumn Rhythm*. Alfred Barr, of the Museum of Modern Art, had a 'reserve' on it, and Lee Pollock came in about a month later and said, 'Now Sidney, this picture has to be sold for about thirty thousand dollars.' Its price at the time, mind you, was six thousand dollars. So I was a little bit disturbed

by Lee's suggestion and I said, 'Do you think that's the right thing to do?' And she answered, 'Jackson is dead.' So I wrote a letter to Alfred Barr and told him that the picture he had reserved was now thirty thousand dollars. Well, he was so upset that he couldn't answer the letter. We eventually sold the picture to the Metropolitan Museum for thirty thousand dollars.

"We had two Jackson Pollock shows after he died. And both shows were under the blessing of Lee Krasner Pollock, who helped us make the selection. On the last show we did, we fought Lee on prices because they were small paintings. Finally, she came down to our level and we sold out the show. That disturbed her, because she felt we could have gotten so much more. But she felt that way only after the fact, not while the show was in progress. You see, she's an excellent businesswoman. So after the show, she felt we didn't do right by Jackson by selling so many of the pictures at twenty-five hundred dollars.

"In a while she came to me and said, 'You know, Sidney, I haven't got a gallery, and I have a chance to go to Marlborough.' Well, I understood, without any kind of threat on her part—she was very nice about it—that I was about to lose Jackson Pollock. But I had also developed a philosophy about it. Once an artist dies, you lose control. The estate goes in its own direction. Now Marlborough has the Jackson Pollock estate, and Lee Krasner also has her shows there. The same thing happened, by the way, after Franz Kline died. We lost control over Franz Kline's estate.

"Kline was the most wonderful guy. He was the salt of the earth. He came to us at the recommendation of Bill de Kooning. Franz had left Charlie Egan because he had difficulties there. But Franz was a darling man. He was a man who could say no to nothing. I'll jump to the last year he was alive. We had done three hundred fifty thousand dollars' worth of sales. Never once did he say, 'Look, I've got enough for this year.' Or, 'Don't sell any more because of income tax.' He never stopped us. The other artists would stop us, sometimes in March or in April. Kline just paid his income taxes and said it was a windfall. He never ex-

pected to sell his things. He was so modest about it.

"It was tough selling artists such as Kline, De Kooning, etc., in the fifties. It was very hard going. We had to work like mad at every exhibition. We had resistance on the part of the public, and the critics, and the dissenting artists who were not in the New York School. These artists, by the way, advised a great many collectors against buying this 'trash.' But there were some critics around who befriended the work, like Tom Hess and Clem Greenberg. But the critic we were most interested in, and with whom we had a real exchange of ideas, was Henry McBride. He was an articulate, erudite gentleman who was forward looking, not only in the fine arts, but in music, in the theater, in literature. He was with the *Sun* for many, many years. It was he and Marcel Duchamp who discovered Eilshemius in 1917 in an independent show in New York. Yes, McBride was very forward looking, although he was quite advanced in age. He died in his nineties—always straight as a ramrod, you know—and he was very much on the ball, and interested in what the younger people were doing.

"Did I make friends with all the artists in the fifties? The answer is no. I was not too close to the artists for a very special reason; I didn't want to be on an intimate basis with them. Their private affairs were theirs. Of course, I went to the Club, to some of the dances, parties, etc. And I visited their studios, but not so often as to make a nuisance of myself. I did spend a good deal of time with Gorky, but Gorky was never an artist of the gallery in his lifetime. During his lifetime he was with Julian Levy, and when Gorky died in 1948, which was the summer that I opened my own gallery, his widow came to us and a year later we took on Gorky."

20

We always thought of Adolph Gottlieb as a painter apart from the art world of the fifties. He seemed so dapper, so well-groomed. He just didn't seem to fit in with the milieu of the casual Bill de Kooning, Franz Kline, and Jackson Pollock. His appearance was always that of a businessman or of someone totally removed from and even unsympathetic towards the dynamics of abstract expressionism.

In point of fact, Gottlieb, while not an abstract expressionist in the strictest sense, was very much part of the art movement of the fifties. He belonged more to the surrealist faction of the Gorky camp. But we did notice that Gottlieb kept himself pretty much aloof from all the artists we used to run into at the Cedar Bar or at the Club. Today, Adolph Gottlieb is associated with the Marlborough Gallery and his reputation as an artist is very solid. His landscape-inspired abstractions sell for very high prices. His studio on the Bowery is not merely a studio, but a beautifully furnished apartment. He and his wife also maintain a residence in uptown Manhattan. In addition, the Gottliebs own a handsome house in East Hampton. We met at his studio and Gottlieb answered most of my questions regarding the fifties.

"I'm a born New Yorker," he told me. "I don't know if it means anything to you, but I was born on Tenth Street, right across from Tompkins Square Park. I guess that makes me the

original Tenth Street artist. But I left Tenth Street when I was about five or six years old.

"I was very much around in New York in the 1950s. I was a part of all the guys who hung around the Waldorf Cafeteria in the forties, and I was a member of the Club. In fact, I gave a couple of talks at the Club. But so many strange things have happened. Before the fifties, I felt I knew all the artists in New York and that they all knew me. But the art world has multiplied so much that you can't know everybody any more.

"I had my first show in 1930. The situation then was, of course, very bleak. At the time, I was classified as an expressionist, which seemed rather wild in those days. Also, I should point out that 1930 was the year of the Depression. So everybody was broke, and being broke was really no stigma. If you were an artist, you were broke like everybody else—like the brokers. The Depression was the great equalizer. Some of us got on the WPA for a while. I was only on for a short time. We enjoyed ourselves very much, despite the poverty. It was a peculiar moment in art. The country tended toward isolationism, which engendered movements such as social realism, regionalism, the American scene. In the forties there came a conflict, and these movements went bankrupt. Other things became possible. What emerged in the fifties was a crystallization of several trends and patterns.

"In 1949 I organized a panel discussion in Provincetown, Massachusetts. The subject was 'French art versus American art.' The big thing in French art was surrealism, and most of the American painters—or at least men like De Kooning, Baziotes, myself, Motherwell, Rothko, Pollock, and Gorky—were affected by surrealism. Some of them were actually tied to the movement, although most were not directly involved. I know that my work of the forties and early fifties was influenced by surrealism, but I think that, outside of Motherwell and Gorky, none of us would admit that we were surrealists. We did not accept it one hundred per cent, as Gorky did—at least, not officially. Gorky was accepted by André Breton, who was, of course, the high priest of surrealism. I don't think, for example, that surrealism could ever

have originated in this country. It would have been against the grain.

"As you probably know, I had been showing with Motherwell, Baziotes, and various artists at the Kootz Gallery. But around 1953 or '54, I left Kootz together with Motherwell to show in a succession of galleries. I was associated with almost every gallery—Betty Parsons, Martha Jackson, Emmerich, French & Co., Janis, and finally, with my present gallery, Marlborough. As a result of the shifting around, I had a chance to associate with all the artists connected with these various galleries. We all got to know each other. By the early fifties, the Club was no longer very active and we all kind of separated.

"As for my own work in the fifties, I guess Clement Greenberg did a lot to call attention to it. He wrote a foreword to the catalogue of my first retrospective in 1954, held at Bennington. And again, he wrote one in 1958 when I had my show at the Jewish Museum in New York. That, incidentally, was the first time I showed one of my 'burst' paintings, which Greenberg saw as a break toward a new direction, and which I did actually develop.

"The aura of the fifties was very different from the aura of the forties. I would say that in the forties we were artistic outcasts, derelicts, who felt they weren't part of society—whereas in the fifties, this situation, or our feeling about ourselves, was quite different. By the fifties we felt our power and strength. We felt that New York was becoming the artistic center of the world. People were reacting to our work very favorably and started accepting it. It was an acceptance on the part of an elite group. And we felt ourselves the elite. Ours was a hard-won acceptance, and we valued it since it hadn't been easy to get.

"My friends in the fifties were Hans Hofmann, Rothko, and Baziotes. Baziotes was very strange in that he gave you the impression of being a Mafia type. He could talk that way too. But, at the same time, you also sensed something very poetic about him, because he was the greatest raconteur that I had ever met. He could tell a story like nobody else. For example, he could tell you about a book he'd read, or a movie he'd seen, and it would

sound absolutely marvelous. Then you'd read the book or see the movie, and they were absolutely terrible. But he made everything sound just great. So—we had a lot of fun.

"But in the fifties, there was the business of the galleries. You see, the alert galleries of the period were aware of what our work meant, and so there was a constant game of musical chairs. Artists were being stolen by this dealer or that dealer, and there was a constant shifting around. I think I should point out that I'm about ten years older than many of the artists who were around; I'm just about the same age as De Kooning. Anyway, to go on about the dealers, Mark Rothko and I had many years of experience with them. As a result, we were kind of hard-bitten and didn't trust any dealer too much. We knew what they were up to. But we had to play the game because they were a necessary institution. It's a fact that, in those days, the dealers were the ones who discovered the artists and the new art. They were the ones who came to the studios. The museums didn't. If the museums did, they got into the wrong studios.

"Rothko was a very private sort of a guy; that's the way he was. He even objected to having photographers come to his studio to photograph his paintings. And he certainly didn't like to be interviewed. He was afraid of distortions and being misquoted.

"Anyway, I would say that in the late fifties my work started selling. When I was with Kootz, starting in 1946, I began selling paintings at very low prices and I did rather poorly. But around 1958 I began to sell well—in fact, so well that I really couldn't believe this was happening, and I couldn't believe it would last. Nevertheless, it has continued. What has happened is that a market has developed, and it's now fairly solid.

"In the forties, I was involved with an all-over sort of image in which there was no single focal point. There may have been a multiplicity of focal points. I was involved in what I call the 'pictograph,' and this consisted of frames, or irregular rectangular shapes, filling the canvas. It was all somewhat linear. The lines were drawn out at all four edges, so that there appeared to be no beginning and no end. The idea was of having disparate images

juxtaposed, which would take on a meaning that was different from the isolated image by itself.

"Then, in the fifties, I broke away from that, and using some of the shapes that I had been working with for years, I isolated them. I finally ended up with the 'burst' image, which reduced everything to two disparate images in which I dropped the idea of an all-over sort of composition, where I had a definite focal point. I felt I had gone as far as I could with the multiple focal point and now wanted to do something with a very definite focal point. This new image stemmed from the subconscious, with which my previous work had also dealt. The subconscious has been my guiding factor in all of my work. I attempt to deal with inner feeling. I reject the outer world—the appearance of the natural world. Subjective imagery is an area which I have been exploring. I was once asked by the Whitney Museum to make a comment on a show they put on called Nature and Art. I told them that, when I'm in the presence of nature, I never think about art, and when I am painting, I never think about nature.

"The reason for this is that when people talk in those terms, they have such corny notions. They think nature means a cow in a field. But to me everything is nature, including any feelings that I have—or dreams. Everything is part of nature. Even painting has become part of nature. To clarify further: I don't have an ideological approach or a doctrinaire approach to my work. I just paint from my personal feelings, and my reflexes and instincts. I have to trust these. I am a painter who deals with feelings—my own feelings. I find people who react to them must have similar feelings.

"Other painters had other approaches. I mean, Barney Newman always put a big literary superstructure upon a single line. But then, when you think of Barney Newman, you also think that he was one of the most remarkable phenomena in the history of art. I think I knew Newman better than anyone else knew him. And my word for him is *chutzpa*. I used to room with Barney Newman when we were just starting out. Barney couldn't paint at all. He just wrote. He used to write introductions to cat-

alogues for Betty Parsons. He was never an artist. If he became an artist, he became a manufactured artist. He was something of a fake—full of dialectics that had nothing to do with anything. But let's not talk about that.

"Gorky was an artist. I knew Gorky from the thirties. I knew him through John Graham, who had been a friend of mine, and of course, Gorky and Graham were very close. In those days, I guess Gorky and I were equally known among painters in New York, although I exhibited more than Gorky. For almost all his life, Gorky suffered from something that I thought was a bit unfair, which was the stigma of being a disciple of Picasso. Now, there isn't any question that for almost the entire period of his painting life, Gorky was hypnotized by Picasso. Nevertheless, I felt that the paintings were very good, and that there was room for this sort of thing. He was being unfairly punished for working in this way, and other painters, who were not even in his class—like the Soyer brothers, or Burliuk and others—who were considered admirable, were following Degas. So I thought that was unfair. Anyway, I wasn't friendly with Gorky, but I did know him for a long time. He was very difficult. He could be very caustic. But among painters, he was probably the most scholarly and astute. I mean, he really studied paintings and knew them very well. I'd run into him at galleries and at museums. I always admired what he had to say. For example, one of the things I thought was actually very funny was when he referred to social realism as "poor paintings for poor people."

"I also knew Charlie Egan. I knew him when he was working for J. B. Neumann. I never see him any more. There is a segment in the art world that thinks everything started with Egan—you know, he showed De Kooning and Kline. Actually, all that business started kind of late.

"I was never really enmeshed in the Action Painting group. But I admired what they did. I have always thought that painting was thinking in the form of action, and that the whole idea of action painting is really an old idea. It all goes back to the Renaissance when it was called 'Alla Prima' painting, where what ap-

peared on the canvas was the final, spontaneous stroke, not based upon the underpainting that medieval painting used. Like Frans Hals, or a lot of Tintoretto, where a whole garment is described with a few brushstrokes, as if without any premeditation. It just falls on without any revision. So Action Painting is not a new idea. I mean, the idea of performing this act for its own sake is not necessarily new, because . . . well, William Merritt Chase did that.

"I may not have liked some of the artists of the fifties, but I never had any fights with them. I always had my fights with dealers. Dealers, as long as I've been associated with them, have had the idea that *they* are the employers and that the artist is an employee. Unfortunately, most artists—because of the situation—have accepted this and are psychologically geared toward acting like employees. They forget that they are paying a dealer a commission. When the dealer gets his commission and gives the artist his share, the artist thinks the dealer is his benefactor. The dealer is nobody's benefactor—although there are some cases where dealers have not been just mercenary or venal. Too often, dealers act as though they were the artists. That is why it was so refreshing when Frank Lloyd of Marlborough came to me and told me that he considers himself just a business-man and that he'd like to work for me. And that's just the point. Artists don't realize that the dealer is supposed to be working for him. Of course, I was always aware of this, but I pretended with the dealers that I was dumb. When artists lose a gallery they act as though they lost a job.

"Sidney Janis was one of my dealers. I suppose he's done things that have benefited the artist. But I'm inclined to think he's ruth-less, and I don't think he has any particular feeling for the artist or his work. Nevertheless, he ran a first-rate gallery. At the time I left him, and Rothko left him, and Motherwell and Baziotes, he was the top-notch gallery. But then he took on a group of young artists and my feeling was that it was a great mistake on his part. He just spoiled his own image because he *was* the leading gallery dealer in New York. Actually, he could have retained the older

artists and taken on younger artists if he had gone about it the right way. But he didn't."

It always seemed that the sculptor Philip Pavia was never taken very seriously by any of the big guns of the New York School. The noise, after all, was about painting, not about sculpture. But Pavia was one of the stalwarts of the group, and was particularly active in the organization of the Artists Club. Pavia was always around, at the Cedar Bar, at the parties, at all the gallery and museum openings, and he was always cheerful and spirited and full of talk. It's true that he tended to ramble and didn't seem to articulate very clearly. Consequently, he was more often than not misunderstood, and finally was considered something of an amiable buffoon.

Still, this endearing man, with his raspy voice and darting black eyes, brought all the artists together and singlehandedly kept the Club going. It was Pavia who arranged for the speakers, and took care of the coffee and the sweeping and the setting up of chairs. Pavia was everybody's friend and, in his charming, muddle-headed way, managed to bring out the best in people. There was a modesty about him which gave the other fellow a sense of importance. He was truly a part of the scene because he knew everybody from the thirties on, and because his dedication to avant-garde art placed him on a par with his more erudite and more gifted contemporaries.

Pavia was not given to speaking in lofty terms about his own work; he worked quietly and diligently and produced sculpture marked by fine craftsmanship and depth of feeling. The son of a stonecutter living in Connecticut, he has always had a love for the raw materials of his art—the stone and marble which he would eventually transform into handsome, jagged abstractions that echoed the abstract expressionist precepts and sentiments.

In the early fifties, Pavia took it upon himself to publish a short-lived periodical entitled *It Is,* which collected, in a handsome format, the writings and ideas of most of the painters and critics that formed the New York School. The magazine ran for

five issues and then folded. These remain interesting documents, reflecting the didacticism of the period, as well as the intensity of feeling and belief that the abstract expressionist movement fostered.

Talking to Pavia, one gets the most kaleidoscopic picture of the movement. Clearly a mine of information, he lets fly his thoughts like a deck of cards thrown in the air. Facts and stories scatter in all directions as he hurtles through a sea of hilarious remembrances. His speaking style is a study in verbal chaos, but what emerges is a dazzling picture of people caught in the sweep of an exciting moment in art history.

"I came to New York in the very early forties," he said. "Before, I was living in Connecticut, only about fifty miles from here. I would come to New York very often. But in the early forties I moved everything, lock, stock, and barrel, right to New York. I moved to Seventeenth Street, then Eighth Street, then Tenth Street—all over.

"But I had been in New York in the early thirties also and went to the Art Students League. That's when it *really* all started. Jackson Pollock was there at the time. He was a monitor for Thomas Hart Benton, who was teaching there. Jackson always walked around wearing his cowboy hat, and had complete contempt for all of us 'foreigners,' as he called us. He loved the West and the Midwest, and he was a regional painter at the time. Jackson believed in the kind of big thing that Thomas Craven was building up when he wrote those books. You know, Thomas Craven was building up this kind of pro-American, anti-French thing.

"Jackson was very intelligent, really. He was above normal. We all listened to what he said. Now, don't forget, we were all about nineteen years old and Jackson stayed at the Art Students League for a long time. John Sloan was our president and Stuart Davis was one of the instructors. It was quite a school—very active. Gorky would come. So we had discussions—a little committee of art students. It was like the students today. We had a student revolt group. I was on one of the committees and I

would invite speakers down and the speakers would talk to us about art and art collectors. We had Lewis Mumford. And we had a Dr. Alexander, who was the artist coordinator of Rockefeller Center at the time. We held our meetings in the lunchroom of the ASL. One day I came in with a book I had just received from Paris. It was a book on James Joyce, and we would read it in the lunchroom. So we had a sort of little club there, and we were very active.

"Gorky would be in the lunchroom every day. Gorky was a friend of Stuart Davis. Stuart Davis always talked out of the corner of his mouth, and we were kind of scared stiff of him. Gorky was very sure of himself in those days. He had a beautiful, marvelous face. Our president, John Sloan, would come in and look at us in the lunchroom. Then he would walk out. It was usual for Gorky to take over. He would talk in his beautiful Armenian accent—very rich. He was a singer in a church and he had this beautiful, modulated voice, and we would just listen to this man all the time.

"The main issue at the time was the Mexican school— Orozco. There was an Orozco myth going, and a Rivera myth going. And, you know, they were building the Rockefeller Center and those Mexican murals were being painted in it. So, when we had Dr. Alexander, who asked those Mexicans to paint the murals, Gorky and Stuart Davis started attacking him. We were all worried because this man was such a high-placed person. But Gorky started in on him, attacking him about official art, and asking very personal questions, too. And Davis would ask him the most embarrassing questions.

"Around 1933 I went to Europe, which was another whole episode in my life. I didn't come back till about 1937. Then I went back to the ASL—and there was Jackson Pollock, still an art student. He was still painting regional paintings and he was still a monitor. There was a difference in him by now. He got this bad habit of drinking. Anyway, around 1937–38, the dark clouds started to gather—the war in Europe (I sound like a journalist). In fact, that's why I came back from Europe. But a whole group

of artists, the group you hear about today—were all in New York, and we were all about the same age—within about five years of each other. Gorky was our leader. I just want you to know that. And the lunchroom meant something to all of us. That lunchroom, back in the thirties, was really the beginning of the Artists Club. All the artists came—we had a clique. Anyway, Gorky would come in and we were all afraid of him. He was so impressive and such a handsome guy—six feet tall. He always had beautiful dogs—did you know that? He'd walk with these dogs. He had style. He was also about ten years older than the rest of us nineteen-year-olds.

"I remember one day, in the lunchroom, Gorky was telling Jackson Pollock all the mistakes that the drawing teacher at ASL was making—that this drawing teacher was stupid and didn't know Picasso. But Jackson kept telling him that all he knows about drawing he learned from this teacher, whose name, I think, was Bridgeman. Bridgeman wrote a lot of books on life drawing, you see. So Gorky was like our guiding star, even though, after he left the lunchroom, we would all talk against him—what a terrible person he was, and how arrogant.

"In those ASL days, I also knew Reuben Nakian and Raoul Hague. Hague was also a monitor and he browbeat all of us. He was a good sculptor, but he was hard to get along with. But it was Gorky who had the ideas. He was against the Communist idea of Rivera and Rockefeller Center. Jackson Pollock would come in and out of the scene at this time, and he was drinking already. The big point about Jackson and the Art Students League was that he wanted to be a teacher there. But they wouldn't let him be a teacher because of his bad habits.

"But I want to bring up Gorky again. See, those dark clouds were gathering, and we were all having to register in the draft. Hitler was invading Poland and the blitzkrieg was on. Gorky made a big speech to all of us. He said the blitzkrieg was wrong, and he didn't like Hitler, but he said the idea of instantaneous war was exciting, and that we should make art instantaneous. That's when Gorky started to give classes at the Grand Central

Art School. And he called his classes 'Blitzkrieg Classes.' Now, Gorky wasn't a Nazi; he said Hitler was all wrong. He was just excited about his new concept of art—that word 'instant.' This all came later—the classes and all, and I didn't go to them for various reasons. I thought I was too mature, for one. I was almost thirty. But Raoul Hague would tell me all about those classes.

"Then the war came. We got into the war, and things started to change. A lot of artists went into the army. One of the artists who went was John Ferren. I met him in Paris. He became an officer. In 1940 came the night of France's defeat. What was that French general who held the Maginot Line, and it fell in ten days? Anyway, on the night of the fall of France, we all went to see Gorky and we talked and talked. Gorky was getting very surrealist at the time, and he was getting involved with the surrealists. We went to his studio and he had these drip paintings, and he was telling us of those marvelous people he'd met, like Masson and Breton. I connect this with this one night because it was a revelation. You see, all those surrealist people came here from Europe. I thought, 'Poor Gorky is getting mixed up with all these terrible surrealists; he's going down the drain.' I remember Breton recognizing Gorky as a real intellectual.

"Now, there's another part of the story. Being a sculptor myself, I had this long training with sculptors and I knew a lot of them. I met this terrible, terrible Irishman (as Gorky called him), whose name was John Flannagan. Flannagan was the only match Gorky ever had. He spoke the most beautiful English— absolutely the finest English. And he was the nicest person in the world, except for his terrible bad habit of drinking. He was a good sculptor. He was part of this Mexican myth which was going on. You know, there was Paris and there was Mexico. I, myself, was a little confused about the two myths. My sculpture at the time ended up being like Mexican sculpture. I made huge heads, six feet high. Anyway, Flannagan liked me and I went around with him. I used to talk to him about Gorky, and I would tell him how Gorky was our leader—that when Gorky talked, nobody talked. But what I wanted to say is that, finally, we

couldn't ignore the surrealists who were all in New York. We tried to ignore them, but they were here and they were real. And this was the beginning of Eighth Street. Our group of artists got smaller and we all gravitated to Eighth Street and started to meet there at the cafeteria. That was in the forties. It was the end of the Mexican scene. Some of the surrealists went to Mexico and Flannagan used to say that they would corrupt Mexico with their terrible French art. And he and Gorky would fight about that.

"But our group of artists became smaller. We became a nucleus and we met on Eighth Street. I met Lewiton and I met Kaldis, and through Kaldis I met Bill de Kooning. Franz Kline I met through Conrad Marca-Relli and Peter Agostini. And we all met in the Waldorf Cafeteria. Jackson Pollock would come in. He'd tell us all off. He'd tell us what a bunch of idiots we all were, and then he'd leave.

"Now I want to say that this was the big confusing moment in the art world. The surrealists were coming in, you see. It was also the end of Flannagan. He committed suicide. I left him two days before he committed suicide. He was telling me there was no hope. And, of course, his drinking was a real problem. I liked him because he liked my sculpture and gave me a lot of direction. But I want to connect up. The Eighth Street idea. You see, we were the nucleus. Landes Lewiton, Kaldis, Bill de Kooning, Franz Kline, Agostini, myself, Marca-Relli, and Ibram Lassaw. Others came in later. But we were the regulars. We were the hard core. We would meet every night. Oh yes, Elaine de Kooning would come by—she'd be around. At times, Gorky would come with his dogs, but they wouldn't allow him in the cafeteria with the dogs, so we would go outside and talk to Gorky. Bill de Kooning fought him many times. I wouldn't fight him because he was The Great Gorky. And Hague kept telling me that Gorky was a genius and I shouldn't say anything against him. Another guy would come around with his dogs, who couldn't get into the cafeteria. That was Harry Holtzman. He was another product of the Art Students League. So, when Holtzman came around with his dogs, we'd go out and talk to him too. One day he said he

was going to England to bring Mondrian to America—which he did.

"But there were a bunch of toughies at that cafeteria. They'd start beating people up. They were longshoremen. They were a bad element in the cafeteria. When there was a big fight among them we'd get scared and stand outside the cafeteria—and we'd talk and talk. What I want to bring out is that this nucleus of artists ended up forming the Artists Club, away from the cafeteria. We'd all sit around a big table—eight or nine of us—and we'd have big discussions and big fights. We'd fight about the surrealists and French culture. Bill de Kooning talked about *his* Picasso, and Gorky talked about *his* Picasso. And then there was Baziotes—one of the most unappreciated of men. André Breton came out with the statement that one of the greatest artists in this country was Baziotes. Baziotes made those funny 'drip' paintings —this was about 1942. Then Peggy Guggenheim came into the picture. She was going to open a gallery, and she was going to show the leading avant-garde painters. She got Baziotes and Bob Motherwell, Adolph Gottlieb, and Jackson Pollock. And so they had this big show at this gallery called Art of This Century. The gallery, by the way, was designed by Frederick Kiesler. This show was another big turning point of the period; 1943–44 was the big turning point. We all went to this show because we had never heard of Motherwell and we had never heard of Gottlieb. We all went because of Baziotes. Did you know that James Johnson Sweeney put that show together for Peggy Guggenheim? He wrote the catalogue introduction to it. But that show was the first big melting pot of surrealism and of abstraction. It was a big transitional show. I think this was really the birth of New York as an art center—even with all those foreigners around. It was a real mixture. Jackson Pollock began bragging about being a real Irish immigrant, and I told him my father came here from Italy in 1879 and Franz Kline kept saying he was half English and half American, which was true. Nobody knew what to say, really. Nobody could put his finger on the kind of mixture everybody was.

"Then Harold Rosenberg came on the scene, and then Clem Greenberg. They were writing for *Partisan Review*. They were just getting involved in art, then. Meyer Schapiro was coming in too at the time. In 1946 came the next high point. Droves of artists started coming into the cafeteria. Jack Tworkov, Milton Resnick—I can't name them all. Pretty soon we couldn't fit around the table. So we had about four tables. Sidney Janis would come in, and Kiesler. And John Graham would come in with complete contempt for all of us. He hated the cigarette smoke and he would hold his nose while he talked to us. Now this was the beginning of everything. The whole thing was getting so big that we said, let's rent a club room. Kaldis said, let's open a restaurant. But the club-room idea stuck. Before we had the Club, we used to have big parties in artists' studios. Or we'd sit in Washington Square Park. And the years were passing. Then, in 1948, Bob Motherwell started his school and things began to get a little more sophisticated. This big art mass was moving around.

"So Bob Motherwell opened his school near Eighth Street, which was around the corner from the Hans Hofmann school. And after the classes would let out at the Hofmann school, all those young artists would try to join us. Like Larry Rivers and Grace Hartigan. There just wasn't a cafeteria to hold us. Lewiton, by the way, wouldn't sit at the same table with all the Hans Hofmann newcomers. But they all came, and Eighth Street suddenly became the center of the art world. There was the Hofmann school and there was the Motherwell school, which he had started with Clyfford Still. And the wags kept saying Motherwell was in competition with Hans Hofmann. After a while, Motherwell's school closed and NYU took it over. But the Motherwell school was terrific: they had some good speakers. Once they had Hans Arp. We all went to hear him. But when Motherwell closed his school, we all thought, let's take it over and make it our club room. But that didn't work out because NYU did take it over and they started teaching extension courses there.

"Anyway, to make a long story short, we found club headquar-

ters on Fourteenth Street, and the year was 1949. I sort of ran the club, but I had good advice from Bill de Kooning, Harold Rosenberg, and others. We had dues, and Lewiton had the dirtiest job of all because he had to count the money. Little by little everybody came—all the old painters and all the new Hans Hofmann crowd. Hans Hofmann slogans were all through the air. A lot of our painters fought those slogans. The Gorky influence was dying out and the Hofmann influence was coming in very strong. You know, the 'push and pull' or 'two-dimensional space.' And Hofmann had this beautiful German accent, and you couldn't quote Hofmann without the German accent. But Lewiton and Bill de Kooning would always try and fight the Hofmann jargon. They were trying to beat his kind of plastic language.

"Then, Clem Greenberg picked up Hofmann's vocabulary. He's kept that vocabulary to this day. Anyway, we're getting into the early fifties. And there were all these factions. There was the Hofmann school, the Motherwell school, then later, NYU, and a kind of civil war broke out. It all started with the pure abstractionists like Ad Reinhardt, Harry Holtzman, and George McNeill. They came in and they all hated the 'push and pull' idea and the brushstroke idea. And this is where it's all coming to a boil. We're in the fifties, remember—we're coming to the cream—the quattrocento, as the Italians would say. There were terrific talks at the Club. Harold Rosenberg would talk and give us wonderful slogans. And Tom Hess talked, and Tom was the only one who committed himself. He picked out Bill de Kooning as the best artist of the group. And Clem Greenberg came and said Jackson Pollock was the greatest artist. But Tom Hess is the man who really came out for one man alone. He said, 'I'm putting all my eggs in one basket'; I think that took real courage. He said Bill de Kooning was the key man. The fight was with the Mondrian lovers—Reinhardt, McNeill, etc. They would interrupt our talks and Reinhardt would say he couldn't stand wiggly brushstrokes. We used to call them the puritans, or 'the hygienic school.' Of course, they had a point and they were very smart.

These purists treated the rest of us like second-class citizens—
they were beyond Hofmann, beyond the surrealists, beyond
Gorky.

"Clem Greenberg was the one critic who always put a railroad
track in the middle of every gallery. He always said, this guy's
good and this guy's bad, the right side is good and the left side is
bad. He was always making good and bad on everything—he
never reserved judgment. He said Barney Newman was a lousy
painter. But the Club gave Newman a big party when he had his
first show. Greenberg said Clyfford Still was a lousy painter. But
the Club loved Clyfford Still. The Club recognized the good art-
ists. But Clem had this big platform with the *Partisan Review*.
And Tom Hess had his platform with *Art News*. And this an-
noyed everybody.

"Anyway, the Club went on—1949, '50, up till 1952; then the
big abstract expressionism fight began. It blew the big fuse in
the art world. Reinhardt refused to recognize the word
'expressionism'—he wanted to use the word 'abstraction.' But
the other guys wanted to put the two words together. So, you
see, the word 'abstract expressionism' doesn't belong to anybody.
Alfred Barr said he had mentioned the word two years before,
which maybe he did, but we never got wind of it. Then *The New
Yorker* magazine came out with a piece by their art critic, Rob-
ert Coates, and people said Robert Coates coined the word. But
nobody ever read *The New Yorker*. You see, the point is that
each separate word was kicking around in the American art
world. You were either an expressionist or an abstractionist. It's
ridiculous, anybody saying they invented the term 'abstract ex-
pressionist.' The Club put each of those two factions on the same
panel. Nobody coined the term; it just stuck by a miracle. In
other words, Hans Hofmann people were the expressionists and
all the Mondrian maniacs were the abstractionists. When any-
body was called an abstract expressionist, you thought they were
joking. It's like saying you're black and blue. For about six
months the art world was in an upheaval over those words.

"The Club started falling apart in the early fifties. Fame started

to come to a lot of the painters. Envy reared its ugly head. It was all very human. Life took over. Jackson Pollock was drinking more than ever. Gorky had already committed suicide. In around 1955 I started a magazine called *It Is*. I underplayed myself, but it had some terrific things in it. Everybody wrote for it. The Club had broken up by that time. The magazine was a kind of continuation of the Club between covers.

"But I keep thinking about the Club and how terrific it was. I remember how we discussed a lot of Gorky's ideas. One time he was discussing the Mondrian group. He said he didn't care what they painted, all he looked at were the four corners of their canvases. He used to say, 'What I see in your four corners tells me whether you have a painting or not.' You see, the middle of a canvas never meant a thing to him. Gorky only worried about the four corners. Then there were the ideas of Franz Kline. Franz used to say that he worried only about the sides of a canvas—the right side and the left side—that's all he was interested in. But it was Gorky who started this era of thinking in ideas. He wasn't ashamed of ideas. Nobody could call him an intellectual because he painted more than anybody. So when he talked ideas, he gave us all courage to have ideas. The trouble with Clem Greenberg is that he never really knew Gorky. If he had known Gorky, he would have opened up more.

"We sculptors of the period were really on the sidelines. There were only about a handful of sculptors—Nakian, James Rosati, Ibram Lassaw, and Peter Grippe. We didn't want to be like the painters, but we were helping the painters flush out their ideas.

"I loved Franz Kline. He was such a lovable guy—so very sweet. When I met him he never touched alcohol. He'd drink a beer once in a while, and he'd drink coffee. He was a terrible coffee hound. He was very brotherly. You see, he had this unhappy life with his wife. She was mentally ill—in and out of institutions. Franz went to England before the war—1937-38—he went to school there and learned how to draw and paint like a real Englishman. He knew portraiture, and he used to make money doing pencil portraits. I used to do portraits

too. That was one thing we had in common. Bill de Kooning used to make portraits, too—this was one way to make money. Anyway, Franz had this English wife. She was quite a lady, but she was quite sick. No children. You see, Franz brought his wife to New York with him. The war was going on. The English being so besieged affected her. It upset her terribly. I think she had nervous breakdowns—which sensitive people have. But Franz was very gentle, and nice, and he earned his living the hard way. He used to frame pictures and retouch pictures and make portraits. He was a real painter of trades—he knew everything.

"Later on, Franz went around with one of the twins—the other twin was Bill de Kooning's girl. In those days a whole bunch of us would go to East Hampton—the twins, Bill, Franz, myself, Charlie Egan, and maybe Rosati. Jackson Pollock was around too. We were a bunch. But those twins had a lot to do with the art world.

"The next girl in Franz's life was Betsy Zogbaum. She was good to Franz. She controlled him a little better. Later, they drank an awful lot together.

"I liked Bill de Kooning too. In the Club days he was always around. He was the most faithful of all. He'd come and wash cups and dishes. Harold Rosenberg always said that nobody wanted to sweep up at the Club. But Bill de Kooning and I always swept up. He was always the sweetest guy. He had a lot of depth to his character. But then, in the meanwhile, Tom Hess was building him up. And Bill always felt he was a target—and he was. But Bill never became the target that Jackson Pollock became. I mean, he came into so much ridicule at the beginning. I think that Jackson took adverse criticism very much to heart. When he became famous it sort of killed him.

"You know, I want to tell you about my three or four years in Paris—this was back in the thirties. I was a young boy. But I met Henry Miller in Paris. And Henry Miller gave me a sense of the avant-garde. He used to tell me, 'You're not worth anything unless you're in the avant-garde.' And he would say, 'Look, Pi-

casso and Matisse aren't anywhere. It's the surrealists. They are alive. Salvador Dali is greater than any of them.' Miller was wrong, of course. But the idea of the avant-garde was beautiful to me. I had this idea that art ahead of its time was the sweetest thing. The sweetest is art that would blossom in ten years. And I had that sweet-tasting thing in me. And I wanted to bring all this to the people at the Art Students League. And then, the Artists Club sort of put it all together and made it all come true."

21

It is August 26, 1970. We are in Water Mill, Long Island, in the carriage house we bought eleven years ago. We have just returned from our neighbors, the painter Warren Brandt and his wife, gallery-owner Grace Borgenicht. The Brandts were giving their annual picnic, to which hundreds of people—mostly artists, their families, and friends—were invited. We have been attending these picnics for years. People bring their own food and sit in clusters on the beautifully kept lawns of the Brandt estate bordering Mecox Bay. The Brandts supply the booze, which is consumed with enthusiasm.

These picnics are gatherings of men and women grown older, people whose lives and whose art came to fruition in the forties and fifties, and in whose eyes can now be discerned the anxieties of age, disappointment, or resignation. There are some who register contentment—even fulfillment. It is a melange of familiar faces re-encountering one another across the outdoor sawhorse bars, across the volleyball nets, across the big blue pool, across twenty-five years of time.

Today there is much talk of death. Mark Rothko has just committed suicide. Barney Newman died of a heart attack. John Ferren is dead. Ad Reinhardt is dead. Jackson and Franz and Wilfred Zogbaum and David Smith—all dead. Frank O'Hara is dead. We listen to this talk, and I think, "My God! This *is* the graveyard of the fifties."

But the party goes on and people mill about talking animatedly

about the changes in the art world—about the death of Pop Art, the death of Op Art, the boredom of Minimal Art, the vacuity of Conceptual Art, the tiredness and predictability of color-field painting, the passé sanctity of hard-edge art. Where had it all gone? What had happened to the "artist in his corner"? Indeed, what happened to abstract expressionism?

No one could bring himself to say that it had become Art History, that it is, in effect, a closed and buried chapter. Today, abstract expressionism neither shocks, upsets, nor enrages anyone. This first internationally innovative American movement has vanished with the fifties, although it is, in a way, commemorated annually at the Brandts' picnics. The masters, of course, remain— as do their widows.

As Jane and I and our eleven-year-old daughter, Julia, wander through the family-reunion atmosphere that pervades this picnic, I keep wondering whether I shouldn't have interviewed dozens of people for this book—other artists, other critics, other dealers. Perhaps I should have included collectors and museum directors, or close personal friends of that period, for here they all are, milling around on a summer afternoon. I *could* have. But I chose, instead, to speak only to those people whose life and whose art exemplified the period for me. Hindsight inevitably influences and colors such decisions.

I did not want to write a history of the fifties. I did not want to write *historically* about art—or music, or theater, or movies, or poetry, literature, or criticism. I wanted to write about what we were all doing and feeling *then*, because *then* had not yet become history. Above all, I wanted to write about *my* fifties and Jane's fifties, because that was the decade in which we lived with a guilelessness, exuberance, and intensity that can occur only in one's twenties. Jane and I were in that frenzy of not wanting to miss anything. Everyone we knew seemed possessed by that very same frenzy—it was a taken-for-granted condition, and nothing could stop any of us, because everything was so new, so fresh, so exhilarating. And we pretended that part of that excitement was created by us. Well . . . the party's over now.

Index